# JOURNEY IN TIME

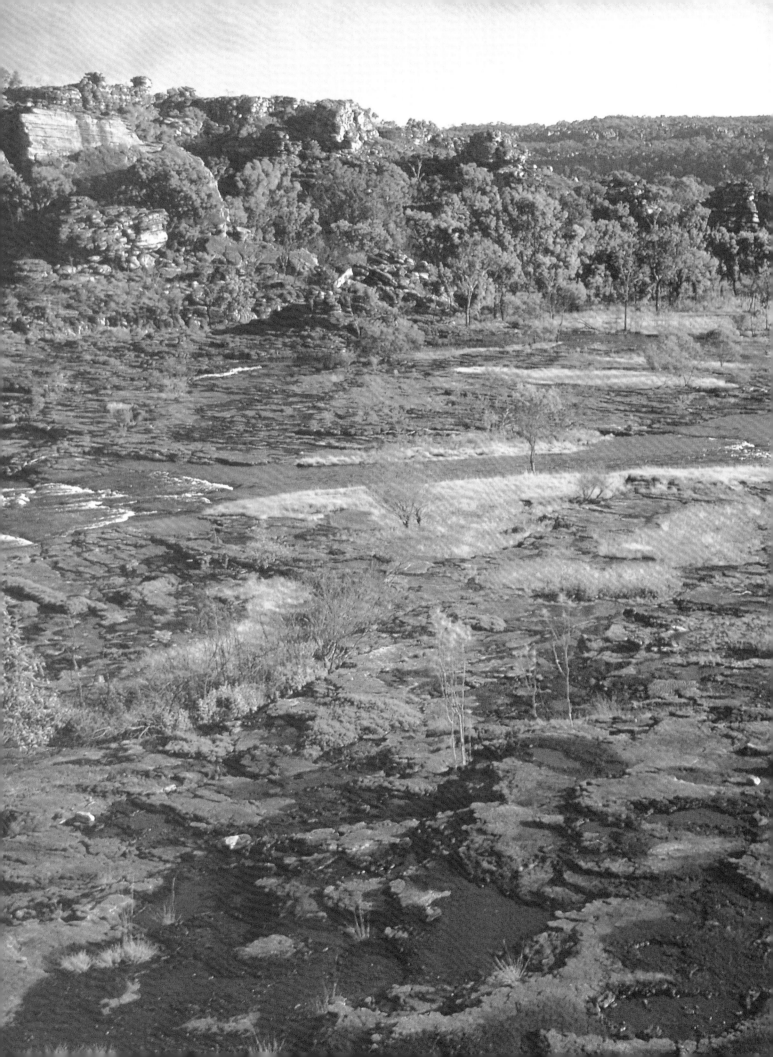

# Journey in Time

## The world's longest continuing art tradition

The 50,000-year story of the
Australian Aboriginal rock art
of Arnhem Land

George Chaloupka

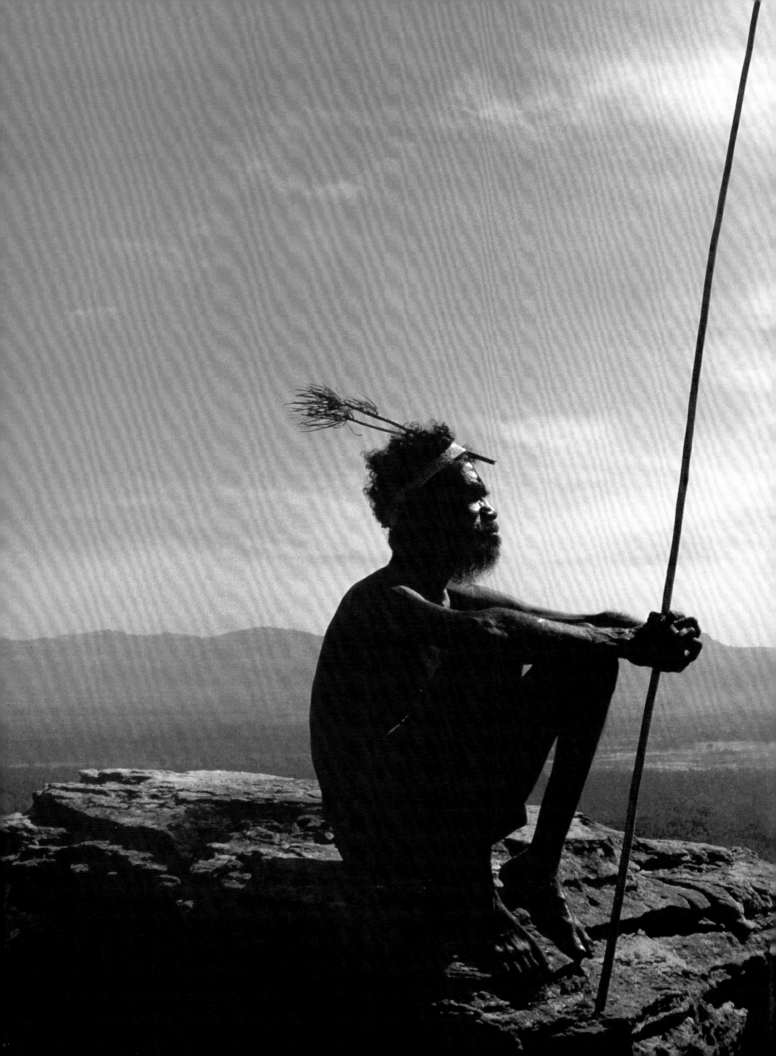

## Dedication

*Anege djurra arrbanbanimarnemarnbom nawu Nangila dja*
*Nawagadj Nabadmardi bogen, Kapirigi dja Namingum,*
*ganbengdayhge ba marrek arrbanbanibengngukme.*
*Arrbanwon nawu* bininj *wurdwurd gabandigadjung.*

This book we made for them, the two Badmardi Nangila and Nawagadj,
Kapirigi and Namingum, that it may remind us of them so we will never
forget them. We give it to those Aboriginal children who follow them.

*The content of this book is published with the permission of the members of the Gagudju Association Inc., traditional owners of the Kakadu National Park and other areas of western Arnhem Land.*

Published in 2023 by Reed New Holland Publishers
Sydney

Level 1, 178 Fox Valley Road, Wahroonga, NSW 2076, Australia

newhollandpublishers.com

First published in 1993 by Reed Books. Reprinted in 1997

First published in Australia in 1999 by Reed New Holland
Reprinted in 1999, 2010 by Reed New Holland

A record of this book is held at the National Library of Australia.

National Library of Australia Cataloguing-in-Publication Data:

Chaloupka, George.

Journey in time: the world's longest continuing art tradition: the 50,000-year story of the Australian Aboriginal rock art of Arnhem Land.

Bibliography. Includes index.

ISBN 9781760793630

1. Aborigines, Australia – Northern Territory – Arnhem Land – Art. 2. Rock paintings – Northern Territory – Arnhem Land. 3. Arnhem Land (N.T.) – Antiquities. I. Title.

759 01130994295

As the author has been most closely associated with the Gundjeihmi and the Mayali people, the terms and orthography developed to record their language is used throughout this book.

Managing Director: Fiona Schultz
Edited by Helen Grasswill
Editorial assistant: Pina Giuliani
Associate editor: Leila Henderson
Designer: Andrew Davies
Production Director: Arlene Gippert
Printed in China

10 9 8 7 6 5 4 3 2 1

Keep up with Reed New Holland
and New Holland Publishers

 ReedNewHolland
 @NewHollandPublishers and @ReedNewHolland

*Half-title page* The most beautiful sector of the Yuwunggayai shelter. To the left of the three vertical fish is a group of female figures. Two of the women are shown frontally, while the third, depicted in profile, has a decorated dilly bag hanging down her back. On the other side of the fish, in yellow and red, is a strange portrayal of a European. Further female figures are to the right, while higher up the wall is a bewhiskered didjeridu player.

*Title page* During the wet season the rugged plateau is coated with a soft green veneer. The streams draining the interior cascade down the rock platforms, eventually plunging over the escarpments as waterfalls.

*Dedication page* A traditional owner of the Badmardi clan's estate in Balawurru, the locus of his land. On the horizon rises Djarrwambi (Mt Gilruth), the highest point of the plateau.

*Opposite* One of the most striking and best preserved examples of the decorated hands motif. The hand has a diamond-shaped infill. Across the wrist is a hollow band representing a watch or a bangle, and the nails and joints are also indicated. The arm is longitudinally divided by lines, one half decorated with large dots and diamond shape designs, and the other remaining in solid colour. Location: Inagurdurwil.

# Author's note

*Journey in Time* describes and illustrates the outstanding body of rock art of the Arnhem Land Plateau. It documents the depth and complexity of this art tradition, as well as the aesthetic achievements of the people, its creators, who were for so many years denigrated and relegated to the periphery of human cultural development.

This book has had a long gestation, as I was first approached to produce a work on rock paintings some 20 years ago. But its beginning goes further back, to 1958, when, in the heartland of the region's rock art at the East Alligator River, I entered a rock shelter whose wall and ceiling were ablaze with multicoloured layers of painted images. Some were identifiable as representing the natural species that inhabited the riverine environment, others were of human figures and some, as I was to learn later, were beings from the Dreaming. In the stillness of the day I stood spellbound by their magic, captivated by their unique form and the brilliance of their execution. Although I happened to be in one of the richest rock art areas – where 10 years earlier C. P. Mountford, one of the pioneers of the study of Australian rock art, recorded numerous sites – in time I was to find that what was represented here formed only a fraction of the region's rock paintings. Thousands of art sites extend across and around the plateau, constituting a large and very important part of the totality of Australian Aboriginal rock art.

To discover what it all meant, who the artists were, and how this tradition fitted in the cultural sphere of the local populations, I sought out the traditional owners of each area where I was to search for rock art sites. I was privileged to meet many people of generous spirit and great strength of character, who accepted me as a friend. A number of these men and women possessed a deep knowledge of their traditions. These people were my closest companions for more than two decades. They taught me all that I know of this land, their society and its traditions: 'they grew me up' in knowledge, as they would express this learning process. I was taught to see the landscape, the shelters and the paintings through their eyes.

Many years later, when the future of a considerable and important part of their land was at stake, I was able to repay my debt. At the time, certain parties who wanted to exploit this region were denying the Aborigines' very existence. During an inquiry I, along with others, revealed some of their intimate knowledge concerning their land and Dreaming. This inquiry, after the passing of empowering Aboriginal Land Rights legislation, constituted the first Aboriginal land claim heard in Australia. Aboriginal attachment and prior ownership of the area in question was recognised. In the fullness of their spirit, the traditional owners then opened the land to the nation, and it is now known as Kakadu National Park.

Many of the people who took me through their land, and who during the long evenings spent around the campfire taught me the traditions of their Dreaming, have since passed away. But it is really only their bodily self that is gone; their spirit lives on. I see them often in the bush, for they now approach me in their other manifestations. I know that the dingo which dogged my footsteps over several days, and at night came to where I slept, is one of my friends. So, too, is the white-breasted sea eagle which flies to sit in a paperbark tree where I camp when visiting his land.

I am often asked at which university I studied, what courses I took, and if this was here in Australia, or in Czechoslovakia where I was born. Instead of formal studies, I am one of those who have learned about things and people by living, observing, caring and understanding. In this, I perhaps reflect the nature of my deceased friends.

George Chaloupka
Darwin 1993

7

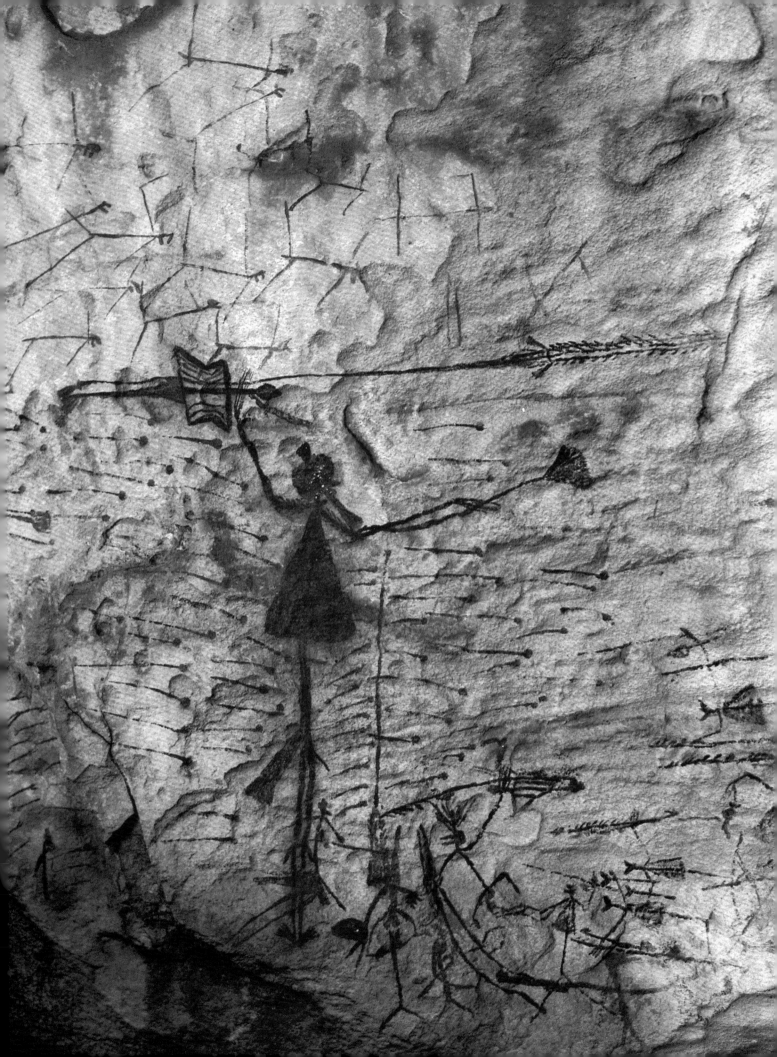

# Preface

BY PROFESSOR JOHN MULVANEY

The precipitous sandstone escarpment of Arnhem Land – and the enormous outliers and rock falls strewn near its base – houses one of the world's supreme art collections. The Kakadu region's World Heritage status is justified by its art treasury alone. For all Australian Aboriginal people it constitutes an even greater cultural inheritance, while many galleries still hold deep spiritual significance for the owners of that region.

This superbly illustrated book provides an opportunity for those who cannot travel to Kakadu to appreciate the richness, complexity and antiquity of its rock art; visitors would find it a memorable record of their time there. It is to be hoped that Australian school children of every ethnic background are given opportunities to view these illustrations. They constitute a salutary reminder that books on the origins of human culture concentrate unduly and incorrectly on Western Europe as the focus of prehistoric artistic talents.

Non-Aboriginal Australians have been slow to recognise the significance of Aboriginal art generally, and rock art in particular. It is worth reflecting that even a quarter of a century ago, Aboriginal art was exhibited only in museums. Artefacts were displayed there essentially as disparate objects from a *past* and lost culture. In contrast today, public art galleries display Aboriginal art as a *living* art form, for its aesthetic qualities. There is an extensive commercial market for both traditional and adaptive art forms and media, while Aboriginal art has achieved international recognition.

Because rock paintings must be viewed in the bush, chiefly in remote areas, that art form has permeated less into the non-Aboriginal consciousness. That is why George Chaloupka and a handful of other dedicated and enthusiastic workers, who have recorded innumerable galleries with their cameras, have performed such a vital service for future Australian culture.

Such was the meagre first European perception of rock art in this region that, in 1845, when Ludwig Leichhardt's party trudged and clambered through the escarpment, where paintings abounded, Leichhardt reported only that an expedition member noticed a red ochre drawing of a turtle. The hills at Oenpelli were visited in 1912 by the anthropologist Baldwin Spencer (with whom the term 'Kakadu' originated). His account of that experience was the first to emphasise the vast number of paintings. 'Up on the hillsides, among the rocks,' he reported in 1914, 'wherever there is an overhanging shelter, these drawings are certain to be found in the country of the Kakadu.'

Thereafter, the region reverted to its non-Aboriginal artistic limbo, until C. P. Mountford popularised its rock art in 1948. It was not until the 1960s, however, that Eric Brandl and Robert Edwards began to systematically survey and photograph galleries, working closely with Aboriginal people.

Across more than two decades George Chaloupka has concentrated tenaciously and with devotion upon recording sites, in collaboration with Aboriginal elders. The scale of his work is unsurpassed. All Australians are in his debt.

It is a sad reflection upon European perceptions of Aboriginal culture that its art was ignored or denigrated for decades. In the later nineteenth century, following the widespread acceptance of theories of unilinear social and physical evolution, the paintings were classed as the production of children. Where motifs or symbolism seemed too complex for child art, however, it was asserted that these were the work or inspiration of 'superior' foreign visitors. This rejection of the intellectual depth of Aboriginal art, or of the ability of artists to vividly recreate the Dreaming creation-time, should be repugnant today to all Australians. It denied the artistry, dignity and spirituality of indigenous society. Yet

The main subject of this composition, involving some 50 characters, is the standing male figure depicted in profile, wearing a cape and a bustle. He is shown holding a three-pronged multibarbed spear engaged in a decorated complex spearthrower. A goose-wing 'fan' is suspended on a long string from his upper arm. He is surrounded by a volley of some 40 'goose' spears. At his feet is a group of simple figures using the same type of spear and spearthrower, one of whom also wears a cape. The stick-like beings above, although appearing as horizontal figures, actually represent a group running towards the main figure. Location: Garrkkanj. Tallest figure 60 cm.

the tradition lingers. Egyptians, Indians, Malays and Middle Eastern peoples have been invoked as the originators of much Aboriginal art, while Erik Von Danniken attributed images in the Kimberley region of Western Australia to space men.

George Chaloupka's research sweeps aside this racist nonsense, demonstrating the quantity, quality and deep symbolism of these diverse art styles. The task of interpreting this corpus of art is even more daunting than the labour of recording it. It requires excellent judgement, because not only do these extensive, rough-hewn surfaces often contain many layers of superimposed motifs in different styles and pigments, but frequently water and wind have eroded them, termite and wasp nests obscure them, or buffalo and wild pigs have scuffed dust over them or rubbed against them.

The author offers an interpretation based upon the close observation of hundreds of sites. He infers a sequence of styles, techniques and dominant motifs, and concludes that there were several basic changes through time. Some, he believes, reflect the massive environmental fluctuations in the Alligator Rivers floodplain as the sea level rose following the last Ice Age and the present plains were formed. Other factors suggest varying cultural phenomena, such as technological change, different hunting techniques and changing ritual practices. Some paintings probably depict animals which are extinct today, the most common of such species being the Tasmanian tiger (thylacine).

This book by George Chaloupka is the most definitive presentation of the Arnhem Land Plateau region's rock art ever published. His chronology, stylistic interpretation and perhaps his identification of some artefacts and species of fauna may be challenged by future investigators. Such discussion is to be encouraged as an opportunity to build upon and modify his grand schema.

On such an immense canvas, Chaloupka's broad brush is an essential pioneering tool. Equally significantly, this book should provide great pleasure and inspiration for many people, while the sheer number, variety and quality of the photographs must assist the wider recognition of the creativity of Aboriginal culture, from ancestral times to the period of European contact.

Professor John Mulvaney
Canberra, 1993

*Above* A great artist at work, teaching a novice. Two stone palettes with delek, garlba and gunnodjbe pigments together with brushes and a sheet of bark are his basic tools and materials.

*Opposite* Fighting picks of a deeply hooked kind associated with human figures, the concluding motifs of the yam figures style. Three composite uniserially barbed spears form an integral part of this man's weapon complement. Location: Djidomdjud. Male figure 120 cm.

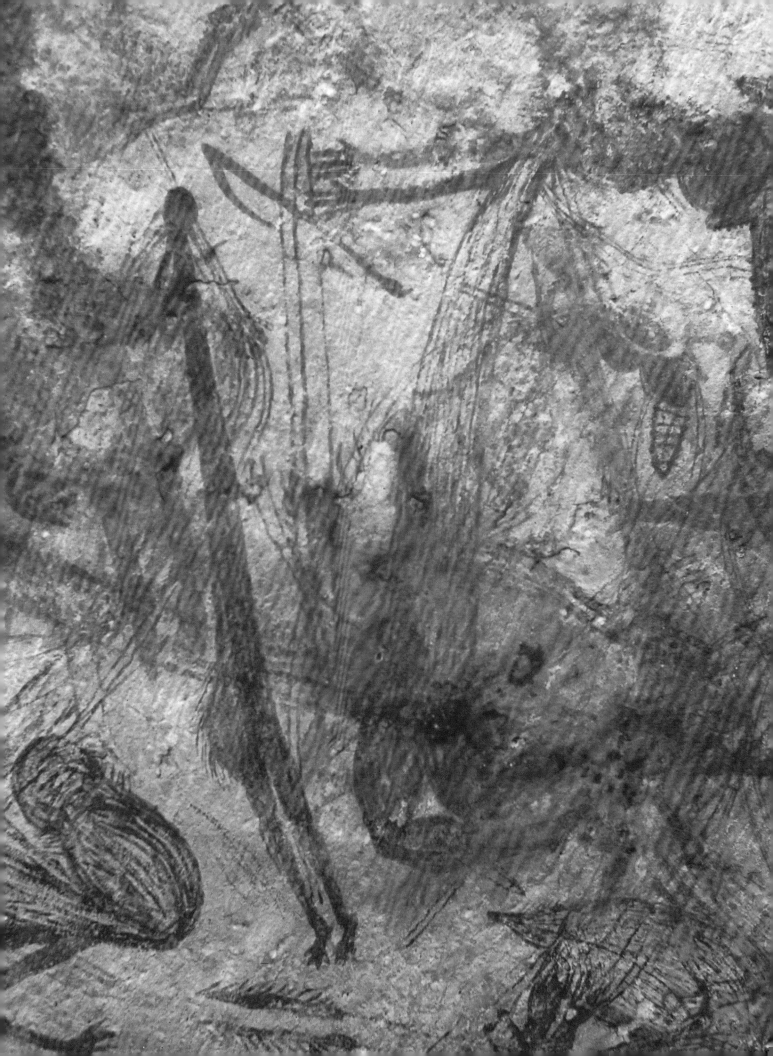

# Contents

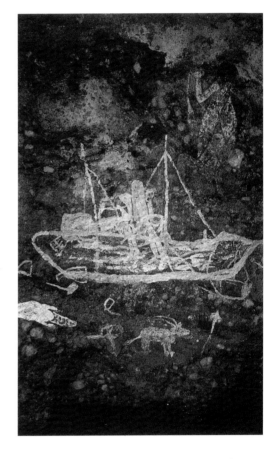

A steamship discharging its cargo is painted on the wall of a Wellington Range shelter. The steamship bears a striking resemblance to a boat photographed in the Darwin harbour c.1890 by Foelsche. Location: Mabuludu. Boat 137 cm.

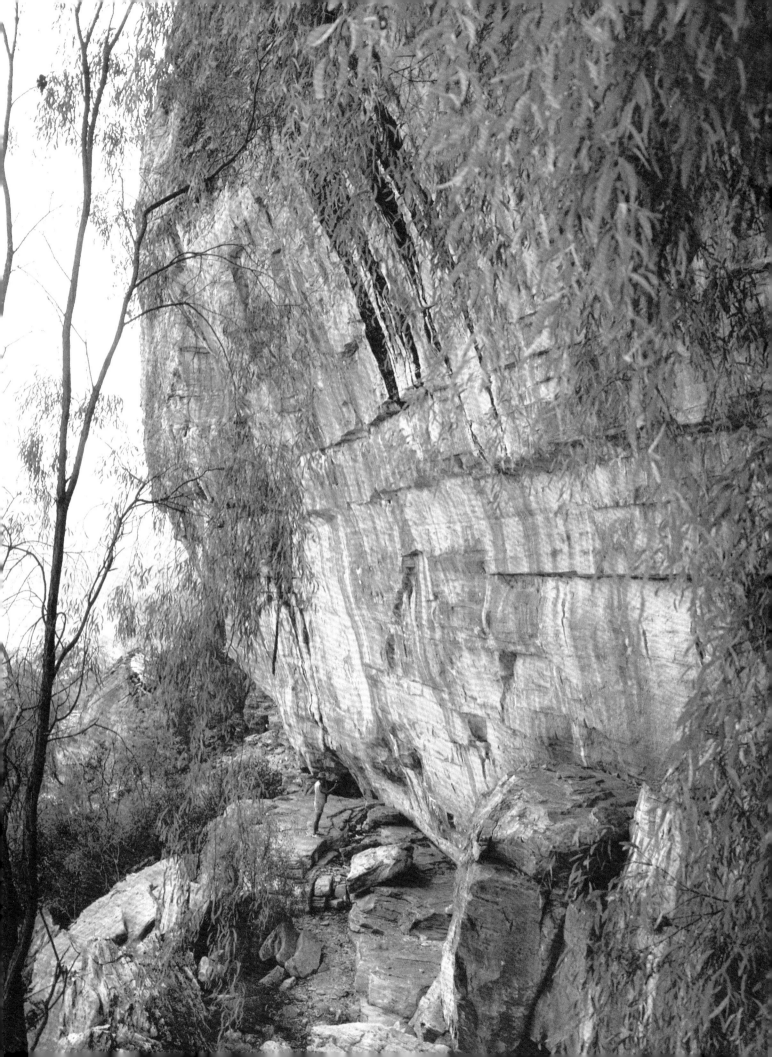

# Introduction

Homo sapiens from the very beginning was a creative and innovative being. In the habitation sites of the early hunters we find not only stone tools, bone fragments, and charcoal from their fires – items which tell us about their pursuits and evolving technologies – but also ornaments, used pieces of ochre, and engraved and sculpted objects that reveal the mode of their artistic endeavours. These occupational sites are in many instances deep caves or rock shelters protected by overhangs, their walls and ceilings frequently found ablaze with layers of multicoloured paintings, while obliquely falling light may reveal incised and engraved designs in its shadows.

The early art objects found in the habitation sites and the weathered rock art images executed on their walls bear witness to the aesthetic impulse locked within the mind of modern humans, and to a perhaps innate need to create. Art and language have an early and contemporaneous origin and followed an analogous form of development. They both embrace a wide variety of activities, art being expressed by means of visual symbols and language by verbal ones. The first sets of symbols used to communicate meanings developed into a symbolic universe, in which art, language, myth and religion were interwoven, forming a rich tapestry which encompasses all peoples of the world.

People of our time, infinitely curious about their past and inquiring about other cultures and societies, acknowledge the common origins of all humans, confirming that creativity has never been confined to a select human group or groups locked in space or time. This commonality of aesthetic endeavour is best reflected in the universality of rock art. As with all other human achievement, this art form had a concurrent beginning in a number of world centres. In Australia, it may have commenced as early as 50,000 years ago – it was

definitely in place 30,000 years ago – and has continued into recent times. Australian Aboriginal rock art, as practised in Arnhem Land, is the world's longest continuing art tradition, a heritage of the First Australians and a unique treasure of universal importance.

## A world perspective

In most parts of the world, painted or engraved rock art images are the most common, the most varied and also the most complex human artefacts. Whereas in the majority of excavated archaeological sites, stone tools, used pieces of ochre, bone remnants and traces of charcoal only partially reveal people's early pursuits and technologies, rock art documents in considerable detail the ephemeral objects of their material culture and portrays modes of human experience, behaviour and relationships. Consequently, a study of rock art can provide us with the missing chapters of our prehistory, as the representations of given subjects depict through time recognisable changes in the artist's physical, social and cultural environment. The realistic representations of human figures and their prey add flesh to the excavated bones, their hands hold artefacts that did not endure time, while the constructs of the imagination – symbols and signs – tell us about past modes of thought and beliefs. The painted images and symbols reflect the shifting experiences, dreams and fears of untold generations of humankind.

Rock paintings and rock engravings are located throughout the world, on every continent and even on the most far-flung Pacific islands, wherever one finds suitable shelters and rock formations. (See appendix, page 246.)

Although many countries have at least one well known rock art site, the art of Altamira and Lascaux – the two astounding art complexes of the European Franco-Cantabrian region – are perhaps the best known. Nevertheless, in all the continents, early discoveries were followed by countless others as those who succumbed to its lure continued to search and to study the art of indigenous peoples. Since then, many thousands of rock art sites have been discovered and the

The majority of dynamic figures style paintings are found in sites like this, situated high up the escarpment, or on the top of the plateau. Along the walls of this particular shelter 150 figures of the dynamic figures style have been identified amongst other paintings of the pre-estuarine period. The site was also a quarry, a source of stone for implements. Location: Djuwarr site complex.

Megaceros deer, a speared anthropomorph, ibex and aurochs are some of the paintings in Cougnac Cave, in the Lot region, France.

A rock with a deeply engraved herd of deer, one of many such sites in the high alpine valleys of Valcamonica, Italy.

findings have been described in hundreds of publications. However, the methical study of rock art in many countries is a recent phenomenon.

In Europe, though, the serious systematic study of rock art began in 1902 when Abbé Henri Breuil, then a young prehistorian, commenced his exploration of the Altamira cave in Spain. The published descriptions of his finds created a worldwide interest in the subject of rock art and led to many spectacular discoveries in other parts of the world. Through Breuil's efforts, and those of André Leroi-Gourhan and others, rock art studies became recognised as a respectable branch of archaeology.

The Altamira paintings had been discovered many years earlier, in 1879, by five-year-old Maria, daughter of Don Marcelino de Sautuola, a gentleman landowner and amateur archaeologist. Sautuola was at the time digging in the entrance to a deep cavern, searching for prehistoric tools, while his daughter explored its interior. After her eyes adjusted to the cavern's gloom, young Maria saw painted animal shapes moving across its undulating ceiling. She called to her father to come and see what she thought to be paintings of oxen. He was able to identify the animals as the bison of the European Ice Age, as he had seen stylistically similar figures in collections of Palaeolithic art objects. The following year Sautuola published a booklet on the discoveries, and later that year he took his findings and also copied images of the painted ceiling with its bison to the International Congress of Anthropology and Prehistoric Archaeology in

Lisbon, Portugal. He failed to convince the congress's learned participants that the paintings and engravings at Altamira were of the same age as the artefacts which he had excavated from the area's deposits. The stunning naturalism and the artistic qualities of the paintings were in divergence with the concepts of intellectual and physical abilities ascribed at the time to prehistoric peoples. And as this was the first painted cave to be discovered in Europe, its images were declared a modern forgery. It was only after the death of Sautuola, in 1901, when two further caves with paintings of a similar period were discovered in France, that the art of Altamira was accepted as the creation of Ice Age people. We now know that the paintings of bison in this cave are 14,000 years old. Since the discovery at Altamira, more than 200 other caves with art of Palaeolithic hunters have been recorded. At Lascaux, in France, the most spectacular of the European rock art sites was not discovered until 1940. Nevertheless, rock art has long occupied a leading position in studies of European prehistory.

It would be easier to name the countries where rock art has not as yet been found, than to list all of those where it has. In many parts of the world, examples of rock paintings and rock engravings had been noted long before the discovery at Altamira. Even in Europe, the knowledge of rock art images extends far into the past. In the mid-1400s, Pope Calixtus III, a native of the Valencia region of Spanish Levant, where many rock art sites are located, disallowed the use of rock shelters for worship if they contained paintings of horses on their

*Opposite above* A large fish and enigmatic abstract designs in black at La Pileta, Spain.

*Opposite below left* Traditional South-East Asian sailing era in the cavernous Swallow's Cave on Phi-Phi Island, Thailand.

*Opposite below right* Paintings of mainly human beings cover the sheer cliff face at Huashan, China.

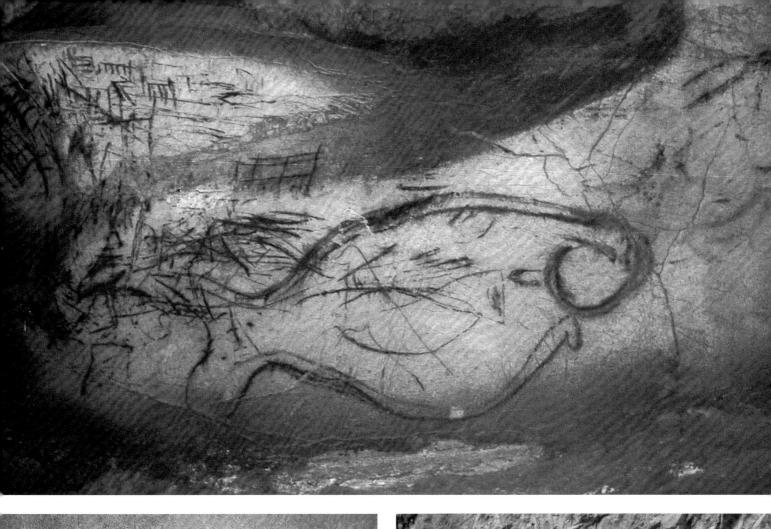

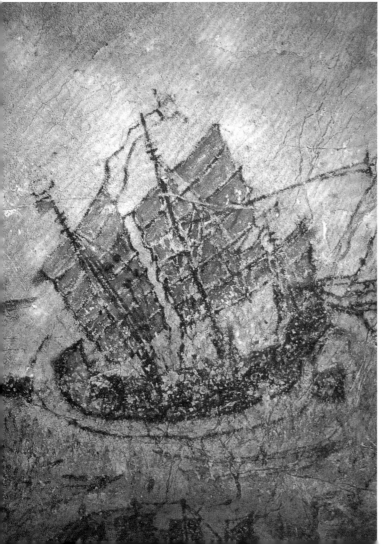

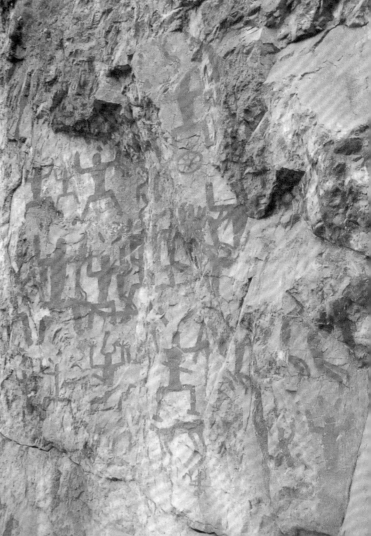

walls. A century and a half later, in 1598, Lope de Vega wrote a verse play in which he mentions *figuras de demonios*, 'images of devils', referring to rock paintings found at Las Batuecas in the province of Salamanca. The painted and engraved images, whose origins were not known, were attributed with the power and potency of evil spirits. In Russia, Christian monks carved symbolic crosses over ancient engraved figures found on boulders along the shores of Lake Onega, to exorcise spirits and exterminate their demonic influence. It is in China that the world's earliest record of rock art was made, more than 1400 years ago. A geographer of the Northern Wei dynasty (386–534 AD), Li Daoyuan, recorded in his book *Shui Jing Zhu (Notes on the System of Rivers)* that there were many painted cliffs in the Yinashan area of the Great Bend of the Yellow River in Inner Mongolia. This major rock art complex was rediscovered in 1976. Other ancient texts also contain references to rock art sites and are now studied by Chinese archaeologists to aid them in their rediscovery work. Major concentrations of rock art are found in a broad swathe across China, from the Xinjiang Uygur Autonomous Region to Yunnan and Guangxi on the South China Sea. Perhaps the best known and most important of the Chinese rock art sites is Huashan, known as Yilai ('Mountain of Flowers') to the local Zhuang people. The site is a 40-metre-high sheer cliff rising above the bend in the Zuo River. Its face is covered by 1300 human figures clustered in groups from 5 to 20 metres above ground level. (See appendix, page 246.)

But to discover the oldest tradition of rock art in the world, one must follow in the footsteps of the first settlers to come to the Australian continent, commencing our journey many thousands of years ago in South-East Asia. Early skeletal remains found in Australia suggest the existence of two distinct human forms, described according to the morphology of their skulls as 'robust' or 'gracile'. The robust people were probably the first migrants to reach our shores, and may have been descendants of the Solo Man whose remains have been found on the Indonesian island of Java. The more lightly built gracile people, later arrivals, are thought to have originated in southern China, a view supported by the recent discovery of human skeletal material in that country which bears remarkable similarities to some ancient Australian remains.

## Rock art in Australia

In Australia, as in other parts of the world, many rock art sites were recorded long before Europeans recognised the true origin of the rock art heritage. For a great number of years the Australian Aborigines, like the Ice Age hunters of other lands, were sometimes denied the authorship of many of their painted images and frequently not credited with due artistic skill.

The existence of Aboriginal rock art was known to Europeans two centuries ago. In the first months of the English settlement at Port Jackson in 1788, Governor Arthur Phillip organised and led a short expedition to assess the nature of the land surrounding Sydney's now famous harbour. During the course of this expedition his party found vast rock pavements covered with engravings of land animals, fish, human beings and some of their implements. The first European discovery of rock paintings occurred 15 years later in the Northern Territory, on 14 January 1803, when, while surveying the shores and islands of the Gulf of Carpentaria, British navigator and explorer Matthew Flinders landed on Chasm Island. There, he found a number of rock shelters with painted and stencilled motifs. He asked the ship's artist, William Westall, to record some of these images. Westall executed two watercolour sketches depicting subjects from two individual sites. They were the first documented recordings of Australian rock paintings. In describing the location and the rock paintings in his journal, Flinders created the first site report:

> In the deep sides of the chasms were deep holes or caverns undermining the cliffs; upon the walls of which I found rude drawings, made with charcoal and something like red paint upon the white ground of the rock. These drawings represented porpoises, turtle, kanguroos [sic], and a human hand; and Mr. Westall, who went afterwards to see them, found the representation of a kanguroo [sic], with a file of thirty-two persons following after it. The third person of the band was twice the height of the others, and held in his hand something resembling the waddy, or wooden sword of the natives of Port Jackson; and was probably intended to represent a chief. They could not, as with us, indicate superiority by clothing or ornament, since they wore none of any kind; and therefore, with the addition of a weapon, similar to the ancients, they seem to have made superiority of person the principal emblem of superior power, of which, indeed, power is usually a consequence in the very early stages of society.

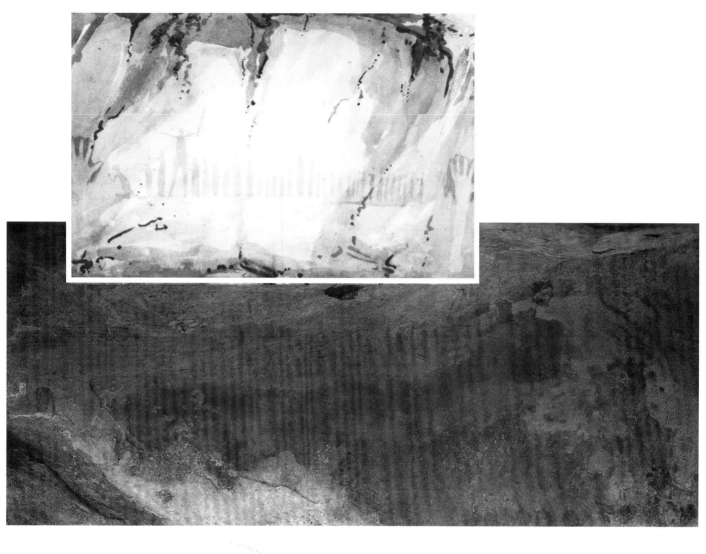

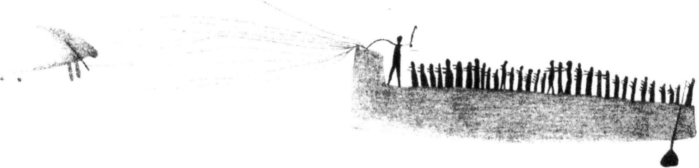

*Top* The first recording of Australian rock paintings, a watercolour sketch executed by William Westall during Matthew Flinders' visit to Chasm Island in 1803. National Library of Australia.

*Middle* A 1988 photograph of the Chasm Island paintings previously recorded by William Westall. It is probable that the paintings were already considerably weathered before their 1803 discovery, as the artist only partially recognised what was being represented.

*Bottom* Reconstruction of the original scene. The painting represents a large canoe carrying 34 people – men, women and children. The hunter standing in the bow holds aloft a spearthrower and in his other hand are 10 lines leading to a harpooned dugong.

This record describes the location of the paintings, identifies selected subjects, mentions the materials used in their execution, attempts an ethnographic interpretation, and generalises about their meaning. Locating these sites 185 years later, I found it necessary to reinterpret the subject in only one of Westall's sketches. The composition described by Flinders as representing 32 people following a kangaroo actually depicts 34 people – men, women and children – aboard a high prowed canoe, while the tall man standing in the forefront (not third along as noted by Westall) holds a spearthrower in one hand and 10 harpoon lines leading towards a dugong in the other.

There were many other early discoveries in other parts of Australia. In 1821 Allan Cunningham, accompanying Captain Phillip Parker King during one of his nautical explorations, found rock paintings on Clack Island, off the eastern coast of Cape York Peninsula. George Augustus Robinson came across a series of circular engravings on the north-west coast of Tasmania in 1833. But perhaps the most important of all the early discoveries was that of the Wandjina paintings, found in the Kimberley shelters by George Grey in 1838. These paintings are amongst the most fascinating and spectacular depictions of Dreaming beings in Australia and are without equal elsewhere in the world. They are said to represent the region's ancestral heroes, while the shelters in which they appear are the religious centres of the local clans.

The fortuitous commencement of rock art recording in the Northern Territory by Flinders and Westall was continued by the explorer Ludwig Leichhardt in 1845 when he noted in his journal that while making their way across the 'stone country' of the Arnhem Land Plateau, a member of his party saw a rock painting depicting a long-necked turtle. The location, as deduced from his journal, places this painting within the Kakadu National Park. A decade later, in 1856, the distinguished artist Thomas Baines accompanied Augustus Charles Gregory on his North Australian Exploring Expedition. While in the Victoria River District the party located several rock painting sites on Depot and Gordon creeks. Baines recorded these sites in watercolour sketches, in one instance using artistic licence to arrange subjects from two individual sites into a single, pleasing composition.

After the early discoveries in the north came further reports of rock art locations in the centre of the continent.

In 1894, during a scientific expedition organised by W. L. Horn, the anthropologist Dr E. C. Stirling recorded rock paintings in sites located around the base of Uluru (Ayers Rock). Since then, thousands of rock art sites have been recorded throughout Australia, more than 2000 of them in the Arnhem Land Plateau region alone.

The early accounts of Aboriginal rock art describe it as crude and colourless.

Later, with the recordings and descriptions of the Kimberley's Wandjina figures – large, multicoloured images executed with considerable skill and aesthetic sensibility – the critics were convinced that such paintings could not have been done by local Aborigines. After all, William Dampier, the well known British explorer and buccaneer, had earlier described the west coast inhabitants as the 'miserablest people in the world'. In the following decades a number of learned papers were written about the origin of the Wandjina paintings, the authors attributing them to some accidental visitors who were of a 'race distinct from and superior to the local populations', but on whom, during their stay, they unfortunately had 'little influence'. The only problem with these speculations was that the writers could not agree if the visitors were Chinese, Hindus, Malays, Phoenicians, Portuguese or Spaniards. More recently, this list of ludicrous attributions has been extended to include extraterrestrial visitors.

The early evaluations of the Australian rock art, and similarly biased comments about the nature and state of the artists, were based in the main on ethnocentrism and ignorance. In 1872 Charles Staniland Wake, in his first volume of the *Journal of the Anthropological Institute of Great Britain and Ireland*, summed up the perceived aesthetic value of Aboriginal rock paintings in the following statement: 'It will not be pretended that any of the native drawings furnish evidence of great artistic skill. They may occasionally exhibit certain amounts of crude vigour, but as a rule they may be classed with the production of children.'

Twenty-three years later J. Mathews, writing in the same journal, commented: '… the art of painting had been so little practised by the Aborigines in Australia that to say they were ignorant of it altogether would not be far from the truth.' How wrong these people were. They based their judgements on insufficient and second-hand data, in many instances brought in from regions where rock art was not

*Opposite* Many of the painted shelters are extensive galleries, with walls and ceilings covered with successive layers of paintings depicting motifs derived from the artists' physical, social and religious environment. Locations: Manaamnam (above); Inyalak (below).

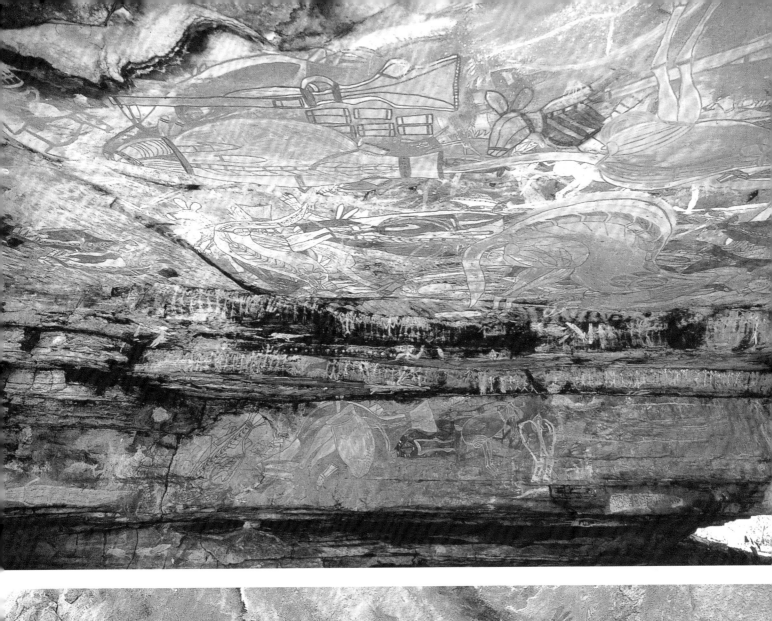
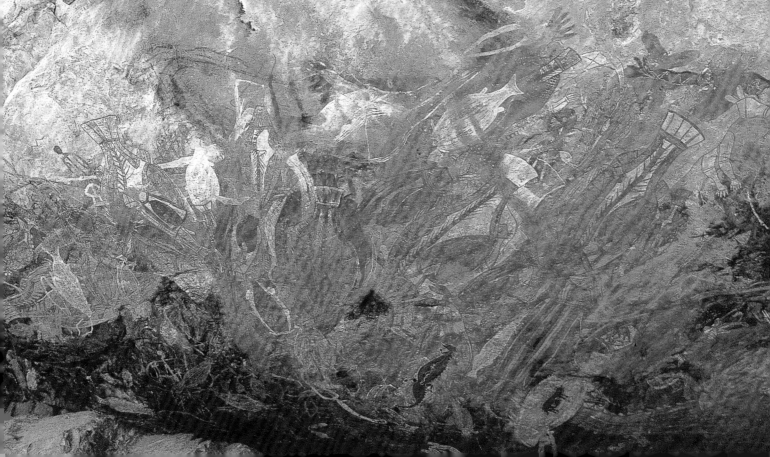

a dominant creative feature. In other cases the lack of skill attributed to the Aboriginal artists was actually that of the person copying their images. Nevertheless, these views were perpetuated over the years, though finally the great body of accolades Aboriginal art has since received in Australia and internationally has forced all but the most ignorant critics to recognise the aesthetic sense and creative ability of the artists.

The thousands of rock art images in their painted and engraved forms found across the continent are as diverse as the physical environments in which they are located. They record the achievements of the Aboriginal people, who developed their unique cultural forms and technological innovations in almost total isolation. Their art represents a major contribution to humankind's cultural heritage. It is acclaimed for its exposition of Australian Aboriginal 'history', as well as for its aesthetic merits, inventiveness and sophistication.

The major concentrations of rock art are situated in the tropical north. There, an almost unbroken arc of sites extends from the Pilbara and the Kimberley in Western Australia, through the Victoria River District and the Arnhem Land Plateau in the Northern Territory, and along the Gulf of Carpentaria and its islands to Cape York Peninsula in Queensland. The most complex and extensive body of Australian rock art within this arc is found in the galleries of the Arnhem Land Plateau.

## The Arnhem Land galleries

The Arnhem Land plateau is a vast sandstone natural edifice whose outliers and residuals extend across the adjoining lowlands to the Van Diemen Gulf and Arafura Sea. Its weathering rock formations have provided thousands of suitable rock shelters, while the rivers which originate in this rocky expanse and then meander through the resource-rich alluvial floodplains to the sea are the region's life stream. The Aboriginal groups whose traditional lands were in this area exploited not only this rich riverine environment, but also the adjacent floodplains, freshwater swamps and pockets of savannah, as do their descendants today. The availability of water, rich economic resources and suitable shelters made the 'stone country' an ideal area for settlement.

The region is a place of outstanding natural beauty as well as being of great historical, scientific and cultural significance. The high sandstone plateau abuts the adjacent lowlands with sheer escarpments, while the residuals and outliers that delineate its original extent rise starkly from the floodplains.

Rivers and creeks cut deep valleys and gorges along faults and joints in the massif, and other less entrenched streams cascade and plunge over the precipitous escarpment into deep pools below. The emergent rivers and creeks flow between paperbark-lined banks into lagoons and swamps, becoming meandering tidal rivers. The region has a variety of landscapes and habitats with an abundant diversity of plant and animal species, some of which are rare. Many are relict communities and populations, finding here their last Australian refuge.

The weathering of the plateau – and the retreat of the escarpment with rockfalls of massive boulders lodged in the talus slopes, the erosion along joints and bedding planes, roof-falls, and the spalling and weathering of less resistant strata – produced the caverns and overhangs which became the wet season refuges for the local Aboriginal inhabitants. For thousands of years they have decorated these shelters with paintings that record their changing environment and their world view. Some sites were also quarries and workshops where they fashioned stone tools, both for their own use and for trade. Other sites are the homes of their creator heroes and of the spirit people, as well as the spirit centres for many plants and animals.

Many of the rock shelters are extensive galleries, their walls and ceilings covered with layer upon layer of brilliant paintings. They are not galleries representing collections of individual art works, but rather a palimpsest of generations of work undertaken by successive artists who had the right to use these shelters. Some of the most recent paintings can be attributed to known individuals, but most are anonymous. In Aboriginal society, every person participated in all aspects of the culture. There were no special classes of creators or consumers. Although some individuals were recognised within their field to be more skilled than others, they all painted, danced, sang, told stories and fashioned their own weapons and implements.

The Arnhem Land Plateau rock art is the work of men. Women may have made an occasional hand stencil in the context of group activity, when all those present in a particular shelter left this mark of their visit. This masculine exclusivity of art creativity was considered by most observers to be the outcome of the division of labour under which women were said to be food collectors, while men were hunters who also concerned themselves with religious and related affairs. However, such strict allotment of responsibility was not the reality. What did exist was a complementary relationship between the sexes, in which the women's life was

# Dating rock art

In the past the origins of art were sought in the caves of Palaeolithic Europe. There, indirect evidence suggested that some rock art images may be 33,000 years old. This proposition was based on a sequence of stylistic changes seen in 'art mobilier' – portable objects with painted or engraved designs – recovered from radiocarbon-dated archaeological deposits. However, the well known paintings usually associated with the European Palaeolithic era, exemplified by those at Altamira and Lascaux, were executed much later, during the Magdalenian period of 17,000–12,000 years ago. But at those sites, as elsewhere in the world, the dating of rock art is in a state of flux. Recently Michel Lorblanchet, an eminent French researcher, has obtained a radiocarbon date from painted pigment in Cougnac cave which suggests that some images there may be 23,000 years old.

A dramatic development in rock art research occurred in Australia in 1988, when results from a complex process known as cation-ratio dating provided absolute dates for rock engravings found at the Karolta site, in the Olary province of South Australia, some 100 kilometres west of Broken Hill. Physical geographer Ronald Dorn and rock art researcher Margaret Nobbs collaborated to measure the age of the rock varnish which has developed over the engravings since their execution. It was revealed that the series of engravings subjected to analysis were produced between 16,100 to 31,400 years ago. After their results and the dating technique itself were questioned, Dorn and Nobbs carried out further sampling at this site using the time-tested radiocarbon method in conjunction with the previously used,

less reliable cation-ratio dating. The dates obtained from their research suggest that the rock engravings at Karolta and other sites in the Olary region were made over a long period of time, commencing before 36,000 years ago. Recently Dorn and Nobbs released dates of engravings from two other localities in that region extending the time of this art technique's commencement back to 42,000 years ago.

Engraving an image into a hard rock surface by pecking, pounding or abrading is a complex and skilful task, making it unlikely that these successfully dated engravings were the first creative expressions of a visual art form of the local group, or of others living elsewhere in Australia. Long before then, the storytellers and men of knowledge would have accompanied their discourses, as do Aboriginal narrators of today, by illustrating their tales with designs drawn with fingers or sticks in the sand or soil of their campsites. Others, who sought protection in the rock shelters from the inclement weather, may have originally used pieces of charcoal from their fires to outline the salient points of their stories with sketches on the walls and ceilings of overhangs. Perhaps it was not much later that they collected the coloured earth to use as pigments, or picked up a harder rock to engrave images into rock surfaces.

The dating of rock paintings is far more problematical, as in the past there were no physical means to determine their age. Until recently, direct dating by radiocarbon techniques has not been possible because the amount of pigment that would have to be removed for testing would be destructive and unacceptable. The only way the art

could be positively dated was to find separated fragments of the painted surface in occupational deposits, where they could be dated with the associated charcoal. Archaeologists recovered many pieces of used ochres from their excavations, but painted rock fragments eluded them. A new advance in radiocarbon techniques, requiring only minute samples of organic material which are then measured by accelerator mass spectrometry, is now being used to date paintings. The first rock paintings to be positively dated are from the Laura shelters on Cape York, east of Arnhem Land. They were executed 24,600 years ago.

Over the years, claims have been made by researchers proposing that their particular area of interest had the greatest number of rock art sites, or painted or engraved images, and that these were the oldest or the most important complexes in the world. Having considered the complexity, extent and apparent age of the art of Arnhem Land Plateau as inferred by the circumstantial evidence, I, too, made such statements. This served to draw attention to these treasures and their importance as a cultural heritage of universal value. Soon after the declaration of Kakadu National Park in 1981, the cultural and natural values of the region were assessed by an international committee, and Kakadu was inscribed on the World Heritage List, as the first Australian world heritage property.

Recent research, including the recording and dating of faceted pieces of ochre ground by an artist to prepare pigment, now supports the early evidence, suggesting that a painted shelter on the plateau, the 'stone country', with its rich resources and benign environment, was first occupied some 50,000 years ago.

Stencils of hands, fish and an acutely angled, boomerang-like weapon at Teluk Berau (MacCluer Gulf), Irian Jaya. (See Appendix, page 246.)

A procession of animals decorates the wall of a rock shelter near Raisen, in the state of Madhya Pradesh, India. (See Appendix, page 246.)

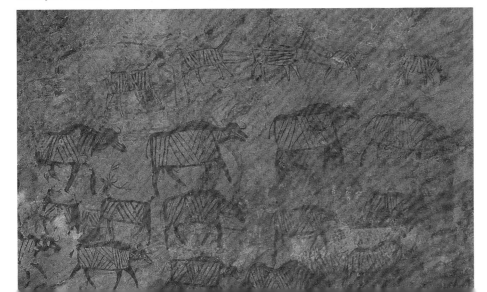

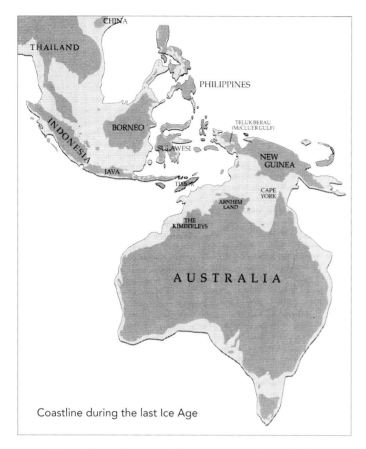

Coastline during the last Ice Age

as aesthetically and spiritually creative as that of the men. They had their own ceremonies and sometimes participated in the men's rituals. Their craft, too, extended far beyond utilitarian requirements. String bags and dilly bags in a variety of pleasing forms were exquisitely made and decorated. That the women didn't lack aesthetic drive and sense is best seen at present. Released from the necessity of providing the bulk of the food supply, they express their own interpretations of the Dreamings in bark paintings and in shimmering canvases and batiks at various locations including Arnhem Land, the Centre and other parts of the Northern Territory.

Rock art held an integral and significant place in the life of the society. The artist depicted the sought-after animal species, totemic kin, ancestral heroes and other mythic beings of the group's cosmogony, as well as himself and members of his group. The main subjects in most shelters are the economically important animals found in the immediate environment, although species living in other habitats may also be represented. The social range of each Aboriginal group extended over a vast area which included several different ecological zones, allowing the artist a familiarity with all of the region's animals and plants. In the weathered residuals bordering the floodplains and in sites along the rivers, paintings of estuarine fish and of saltwater crocodiles are superimposed upon animals that existed during earlier periods and which are

now extinct. Later, these images of the estuarine fauna were overpainted with others depicting magpie geese and other waterfowl of the more recently formed wetlands. Some of the most recent paintings portray Europeans who came here to hunt the water buffalo, which was introduced in the late 1820s. In shelters located around the plateau's margins, in the escarpment valleys and within the 'stone country', paintings depicting macropods predominate. There are representations of agile wallabies, antilopine wallaroos, the shy and seldom seen black wallaroos, the common rock wallaroo and rock possums, along with paintings of freshwater crocodiles and the fish of the freshwater streams and waterholes.

Both the mode of expression and the depicted subjects changed through time. A change in the rock art style may be a group's response to a social or symbolic need at a particular time, while the variation in motifs may reflect the environmental changes which have occurred since the last Ice Age. During this period some animals have become extinct, others have moved further into the interior, and new animal species have colonised the region.

Rock paintings within a site may vary in size, form and style of depiction. There are paintings of animals that are larger than life, as well as minute stylised creatures. Some species are drawn in a simple monochromatic outline, while others are complex multicoloured images that show both the subject's external form and its internal features. Many of the humans are depicted as solitary figures and were occasionally painted larger than life, but there are also detailed compositions of small, exquisitely drawn hunters arrested by the artist in their flights across the landscape.

At the commencement of my study of this region's rock art some 30 years ago, I sampled transects of sites along the plateau's western and northern escarpments and across the stony interior to its eastern margin. The purpose of this sampling was to identify the spatial extent of language and land-owning groups, and establish their membership, and also to get some idea of the spatial distribution of sites and rock art styles. The traditional owners of each area participated in the research by identifying depicted subjects, describing associated mythologies, and on occasions attributing authorship to some of the most recent paintings. Two special people, Kapirigi and Namingum, were my constant companions and friends.

In the first step of this study, the individual styles and style complexes – representing the varying artistic traditions – were identified. Often images in some styles were found

painted over images in other styles on the walls of a single shelter, so their order of superimposition was used to develop their chronological sequence. This work was followed by a detailed analysis of each style's contents, at which point it became obvious that certain subjects were present in one or more styles but absent in others. The reasons for the presence or absence of the individual subjects was then sought. The results of the inquiry provided the time indices used to divide the chronological sequence of styles into major periods and art phases.

The rock art of the Arnhem Land Plateau region, as reflected in the chronological sequence of its art styles, represents not only the world's longest continuing tradition of this art form, but also, in its detailed narrative compositions, the world's longest continuing record of human endeavour.

Culture is usually defined as the distinctive and complex systems developed by a group of human beings to adapt to their environment. Throughout the human occupation of Australia, Aboriginal populations successfully settled a continent of extreme climatic zones that extended from the tropical north to Tasmania, amongst the world's southernmost inhabited areas – which at the time of the Aborigines' arrival, some 23,000 years ago, was a land of glaciers. As the environment of each area changed over successive time periods, so did the adaptive strategies of the inhabitants. These changes in the cultural patterns of local populations and their successful adaptation to their evolving environment are graphically represented in the Arnhem Land region's rock art.

The rock art of Arnhem Land also reflects the complex and innovative nature of Aboriginal populations. Within the shelters, layer upon layer of colourful paintings depict the bounty of the environment, the strategies of hunting and collecting food, and the religious beings responsible for this plenitude. Spirits with whom the Aboriginal people of this region share the land, and the presence of invading cultures, are also recorded. Beneath the more recent strata of paintings lies an earlier sequence that extends far into the past, to a time when extinct animals roamed through the escarpment valleys and the adjoining savannah. Then the island of New Guinea along with Australia formed a large landmass, joined together by the Arafura plain of what is now the continental shelf. Subsequently, the seas at the end of the last Ice Age began to rise and swallow the coast. The huge Rainbow Snake, depicted as a sea monster by the coastal populations, devoured the land, giving the present-day shape to the northern coastline.

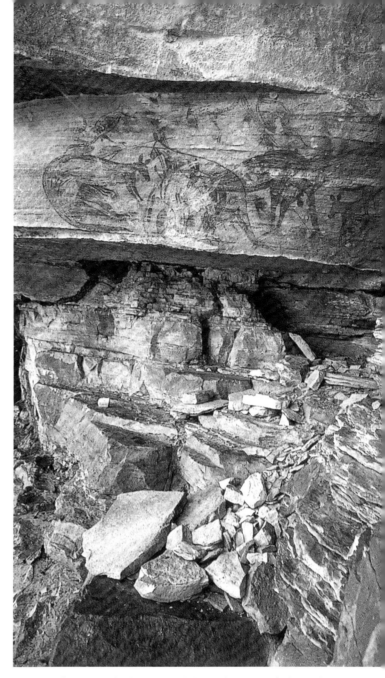

A frieze of macropods above a workshop where men fashioned stone implements. Represented are male and female forms of the common and black wallaroos (*Macropus robustus* and *M. bernardus*). The female macropod at left is depicted with a joey in her pouch. Location: Djuwarr site complex.

Then it pushed rocks aside as it made its way inland, where it entered, in a great variety of forms, the religious beliefs of Aboriginal Australia.

Some painted shelters lie within the protective arms of the Dreamings, and can be visited only by sanctioned members of the local groups. In other shelters, some of the paintings are said to be of non-human origin – paintings where the given being placed its own image on the shelter's wall, or those situated too high on a rock wall to have been executed from the floor of the shelter. These latter paintings may have been executed from constructed platforms, from trees which may have grown along the rock face or from ledges which

have since collapsed. To the local people they represent the works of the spirit people, whose magical powers enabled them to bring the rock surfaces down to within mortal reach and then raised them high again.

The rock paintings of the Arnhem Land Plateau represent only one of several superb art forms practised in the region. When living away from the 'stone country', people made homes from long sheets of bark and decorated the interiors with paintings of the same subjects which are found in rock shelters. Aesthetic expression permeated all aspects and activities of their lives. Children played with painted toys sculpted out of beeswax. Decorated message sticks were sent as invitations from clan to clan. Art was evident in ceremonies of a clan member's first achievement in hunting or gathering. As well, the bodily remains of the dead were placed in beautifully painted hollow logs during final mortuary rites. Indeed, art is integral even in the decoration of objects of everyday use: toys, dilly bags, spears, spearthrowers, mats and items of apparel.

During rituals, all the art forms were fused into a single dynamic expression of their culture. Bark shelters with paintings of ritual personages on their walls were often erected on ceremonial grounds. Alternatively, 'sacred shades' were constructed from leafy boughs to protect bark paintings with sacred designs that would be shown to the initiates. The shelters also housed sacred objects carved from wood, incised and decorated with intricately painted designs and multicoloured feathered strings, or constructed from wood, bark and string, painted and covered in bird down. It was in the bough shelters, too, that the bodies of novices were painted with sacred clan designs. During a ritual, the decorated participants moved over sculpted ground, their bodies taking on the forms of ancestral beings as they expressed their stories in song-poetry and dance.

Many of the rock shelters are silent and only occasionally visited now. But a number of whole clan groups have left the larger communities, originally government settlements or missions, and moved back to their traditional lands, where they have established outstations. There they have regained and now maintain their own cultural identity. Children again watch their fathers or relations painting designs that originate in rock art, though today the artists sustain the Dreamings on sheets of bark. The culture lives on; art's longest journey continues.

Two Europeans, explorer Ludwig Leichhardt and pioneering anthropologist Baldwin Spencer, made considerable contributions to world knowledge of the Aboriginal groups living along the north-western part of the plateau and the adjoining lowlands. A third, Paddy Cahill, was an agent of destiny for the majority of the plateau's populations.

In 1845 Ludwig Leichhardt entered the region towards the end of his journey of exploration from Moreton Bay in Queensland to the Victoria Settlement at Port Essington on the Cobourg Peninsula. It was an epic trek of more than 14 months. During the trip Leichhardt made keen observations of the fauna and flora, and collected plant specimens. Whenever possible, he and his party supplemented their meagre diet by eating bush foods. In his journal he left vivid descriptions of the region's landscape, and of his party's amicable encounters with local groups whom he referred to as 'my friends the Aborigines'.

In 1912 Baldwin Spencer spent several weeks at Oenpelli as a guest of Paddy Cahill, a former buffalo shooter turned cattle man. With the help of his host, who spoke the local language, Spencer recorded rituals, customs, mythology and aspects of the social organisation of the Gagudju and adjacent peoples. He also collected many items of their material culture: weapons, implements, ornaments, dilly bags and ceremonial objects. More than 200 bark paintings which he collected during his visit, or were collected on his behalf by Cahill, document this art form as it was practised before any European influence. These barks, now housed in the National Museum of Victoria, reveal a close relationship with the region's rock art. Spencer called the dominant local population 'Kakadu', and said that it: '… is one of a group, or nation of tribes inhabiting an unknown extent of country, including that drained by the Alligator rivers, Cobourg Peninsula and the coastal district as far west as Finke Bay. Its eastern extension is not known. For this reason I propose the name Kakadu, after that of the tribe of which we know most.' The name 'Kakadu' was subsequently widely used, both in popular and scientific literature. Because of this established use, it was selected as the name for the present-day World Heritage National Park. The name of this once-dominant group is now transcribed as 'Gagudju' or 'Kakudju'.

Paddy Cahill, the first buffalo shooter to enter the Alligator Rivers region, commenced operating in 1894. By then, buffalo covered the plains in their thousands. Hides were fetching good prices and, in time, other entrepreneurs followed his example. It was a labour-intensive industry, and soon the majority of at least the northern and western Aboriginal groups were involved in the enterprise.

In 1906 Cahill moved to Oenpelli and established a dairy cattle herd. Many of the Gagudju people who had worked for him during his buffalo shooting days on the East Alligator River plains accompanied him. Thus, most of the information recorded by Spencer during his visit was from the Gagudju perspective and not from that of the Mengerrdji, the traditional owners of Oenpelli. Later, Cahill sold the station to the federal government, though he remained for some time as manager. He left the region and the Territory in 1924.

In 1925 Oenpelli became a mission run by the Church Missionary Society. By then, most of the Mengerrdji and Gagudju inhabitants had passed away or lived further west in the 'buffalo country' and groups from the Gumadeer and Liverpool rivers were moving in.

In more recent times, research by several other Europeans has extended world knowledge of Aboriginal traditions, and of the prehistory of the western region. In the late 1940s Ronald and Catherine Berndt commenced their invaluable anthropological studies at Oenpelli and at Goulburn Island. In 1948 Charles Percy Mountford, leader of the Australian-American Scientific Expedition into Arnhem Land, undertook a detailed study of the rock art galleries centred around the East Alligator River and for the first time exposed the incredible heritage of this art form to the wider community. His pioneering work was continued by Eric Brandl between 1968 and 1974, and by Robert Edwards in 1965 and 1973.

The first archaeological work of major scientific importance commenced in 1964 with excavations by Carmel Schrire. Her field work revealed the considerable antiquity of human occupation in tropical Australia and established a basic chronology and stone tool sequence for the region. Subsequently, Harry Allen, Johann Kamminga and Rhys Jones filled in many of the details and corrected several anomalies evident in Schrire's pioneering work and expanded the archaeological knowledge of the area. Rhys Jones returned to the area in 1989 to re-excavate two shelters and to collect sand samples from levels previously dated by the carbon-14 technique. These samples were subject to thermo-luminescence testing by Bert Roberts. Thermo-luminescence is a dating technique previously used to date the sand sheets in the vicinity of the plateau. The outcome of this work has again pushed back the dates of Aboriginal entry into Australia. At the 50,000-year-old level, Jones' team recovered used pieces of red ochre as well as a large piece of unfragmented haematite brought in from some distant

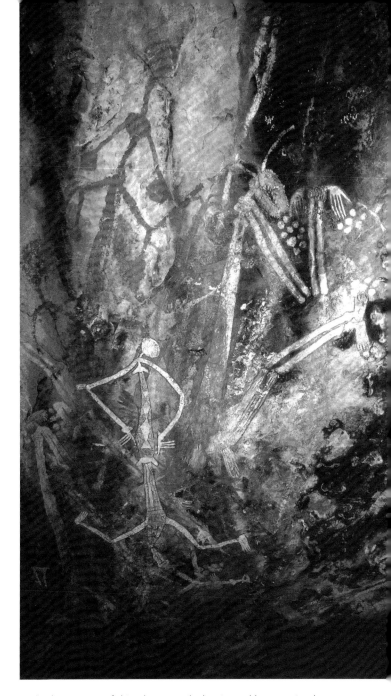

In the lower part of this photograph dominated by an animal-headed being is a composition in which a female, with her hands at the hip and her head thrown back, is seen positioned on an ornate penis. The phallus, with ridges and swellings, tapers to a thread-like limbless body with an animal head. Location: Mayingarril. Female figure 90 cm.

location. This level was some 2.5 metres below ground level, and the rock paintings which may have been executed with this pigment have been subsequently buried by sediment sheets that have accumulated over the intervening tens of thousands of years.

The Aboriginal rock art of Arnhem Land documents a 50,000-year – perhaps longer – journey through time, and celebrates an artistic tradition of excellence, exquisite beauty and unimagined significance to our understanding of the development of humankind.

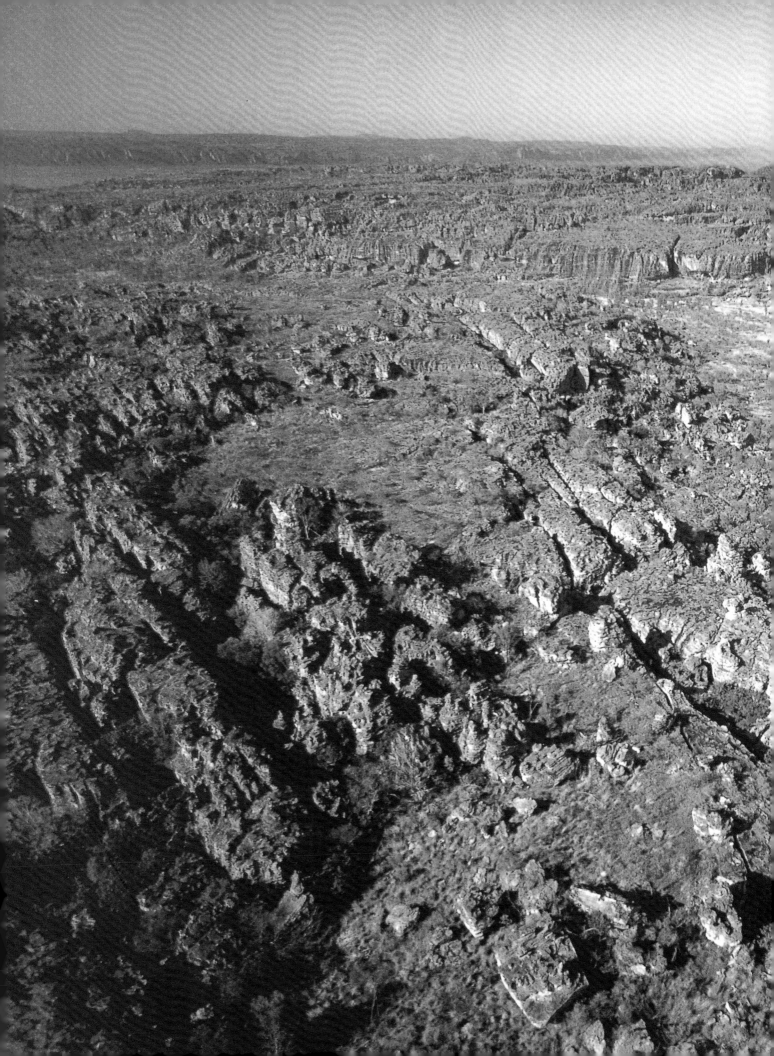

# Gubolk

THE LAND

The vast, mystical and visually impressive sandstone plateau known as the 'stone country', with its ochre-stained escarpments, is the dominating physical feature of Arnhem Land. It contrasts dramatically with the adjacent lowland plains and lush wetland areas, both geologically and ecologically. This duality of the landscape was graphically recorded in the journal of the explorer Ludwig Leichhardt, who with his party were the first Europeans to cross the plateau's forbidding interior and then descend on to the bountiful plains, traversing wide streams and making their way to the coast. Soon after they entered the plateau on its southern margins, where it gradually rises in a series of rolling hills, they reached a point where the true character of the land ahead of them became obvious.

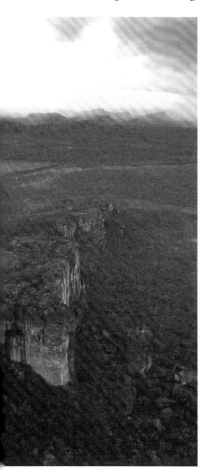

At the distance of four miles I came to a rocky creek going to the westward, which I followed. From one of the hills which bounded its narrow valley, I had a most disheartening, sickening view over a tremendously rocky country. A high land, composed of horizontal strata of sandstone, seemed to be literally hashed, leaving the remaining blocks in fantastic figures of every shape; and a green vegetation, crowding deceitfully within their fissures and gullies, and covering half of the difficulties which awaited us on our attempt to travel over it.

*11 November 1845*

That the party successfully navigated this maze of chasms, ravines and rocks is a tribute to the skill and the indomitable nature of their leader. After all, they were confronted with this seemingly impenetrable obstacle towards the end of their journey, after 14 months of hardship and privations.

To the Aboriginal people, however, the 'stone country' was not inhospitable. Occupied by a large number of clan groups speaking several languages, it had been their home for thousands of years.

Although there were no meetings between Aborigines and Leichhardt's party at this stage, the Europeans noted ample evidence of local activities. Old campfires, scorched carapaces of turtles, the remnants of meals, and wells dug in seemingly dry creek beds bore witness to Aboriginal occupancy. One member of the exploration party discovered a painting of a turtle in red ochre decorating the side of a residual rock outlier.

When, after many difficulties, the party reached the western edge of the plateau, they saw below them the magnificent valley and the many arms of the Jim Jim Creek which flows north to join the South Alligator River.

We stood with our whole train on the brink of a deep precipice, of perhaps 1800 feet descent, which seemed to extend far to the eastward. A large river, joined by many tributary creeks coming from east, south-east, south-west and west, meandered through the valley; which was bounded by high, though less precipitous ranges to the westward and south-west from our position; and other ranges rose to the northward.

*17 November 1845*

The party was located between the two major arms of the Jim Jim Creek, both of which plunge during the wet season over the edge of the escarpment as spectacular waterfalls – one set of falls is known now as the Jim Jim Falls, the other forms the Twin Falls. The explorers negotiated the plateau's precipitous brink for a further two days, seeking a safe route of descent for themselves, their horses and their last bullock.

*Previous spread* The other face of the 'stone country', the vast and dominating plateau fissured and scarred by 1600 million years of weathering. Here in this upland valley, are many protective overhangs which provided shelter and painting surfaces for the members of the local group.

*Above* The rain sets in and the parched land is again mantled in green. The wedge-shaped escarpment seen here is Djidbidjidbi, a sacred-dangerous site, while on the horizon Djalandjal Rock overlooks the plains.

*Opposite* The escarpment of the plateau rises starkly from the adjoining plain, which extends northwards towards the sea.

We had now a more extensive view of its eastern outline, and saw extending far to the right a perpendicular wall, cut by many narrow fissures, the outlet of as many gullies; the same wall continued to the left, but interrupted by a steep slope; to which we directed our steps, and after many windings succeeded in finding it. It was indeed very steep. Its higher part was composed of sandstone and conglomerate; but a coarse-grained granite, with much quartz and feldspar, but little mica and accidental hornblende, was below.

*19 November 1845*

Soon after their descent, Leichhardt's party came to a wide stream, where, looking back towards the gorge from which it emerged, they saw that:

The creek formed a fine waterfall of very great height, like a silver belt between rich green vegetation, behind which the bare mountain walls alone were visible.

*20 November 1845*

That night the party camped at the confluence of the two main arms of Jim Jim Creek. The next day they were visited

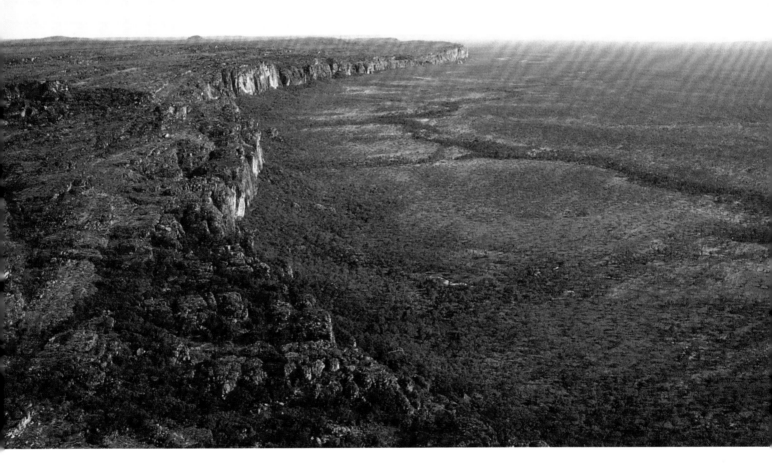

Leichhardt was not aware that the granite slope, the mineral structure of which he described in such detail, marked the beginning of a Dreaming journey across the plateau by Yamidj, one of the 'First People' and now manifested as the long horn grasshopper *(Caedicia* sp.), and of his companions who left round yams and red ochre in this locality. Today, the people whose territory Yamidj was then leaving call this place Gunnodjbedjahdjam, while those living on the southern slopes of the plateau, the creator's ultimate destination, know it as Yamidjgorrang.

here by a group of Aborigines, who presented the explorers with a gift of red ochre, which was judged a prized possession, a spear and a stone spearhead.

In the following two weeks, Aborigines guided Leichhardt's party across the swampy ground of the Jim Jim Creek and Nourlangie Creek wetlands. The Europeans went on to meet hundreds of Aboriginal people as they traversed the subcoastal plains between the South and East Alligator rivers. It is possible that the local populations had their numbers augmented by visitors from the wider region, including

Sunrise over Djarrwambi, Mt Gilruth, the plateau's highest point and the location of a number of important rock art sites.

The magic of the 'stone country' is best seen in the escarpment valleys, where the ancient rock faces tower over deep waterholes.

people from the plateau, who came to the lowlands at that time of the year to share in the bounty of the land.

Leichhardt was overwhelmed by the richness of this landscape. He describes the immense plains, the paperbark swamps, the waterholes covered with waterlilies and fringed by pandanus, the innumerable geese, ducks, brolgas, egrets and the many other birds that frequent the wetlands. He commented that no part of the continent they had passed since the commencement of their journey was so well provided with 'game' as this. Leichhardt was a keen and accurate observer, describing the 'goose' spears and spearthrowers that were skilfully used in hunting the,geese, the gathering of the spike rush corms and the burning of the land. He noted the party's surprise at finding in the middle of one swamp a camp of paperbark shelters, and also of their discovery of 'a noble fig tree' – a large banyan *(Ficus virens)* – which seemed to him to have been a favourite campsite for the last hundred years. This banyan site was Baneydja, where, during the later part of the year, when fat geese congregate in their hundreds of thousands on the diminishing swamps, the local groups held morak and djambarl ceremonies. In this time of plenty, they were joined by people from all parts of the plateau who came here to initiate their youths and to ensure, through ritual, the continuing procreation of animals and plants.

On reaching the East Alligator River, Leichhardt and his party had to follow the stream to its tidal reach, within the arms of the escarpment, before they were able to ford it. As they approached the plateau from the north it showed them its other, not so foreboding, face:

… after having tried in vain to pass at the foot of the rocky hills, we found a passage between the lagoons, and entered into a most beautiful valley, bounded on the west, east, and south by abrupt hills, ranges, and rocks rising abruptly out of an almost treeless plain clothed with the most luxuriant verdure, and diversified by large Nymphaea lagoons, and a belt of trees along the creek which meandered through it.

*6 December 1845*

The entries in Leichhardt's journal, although stressing the duality of the landscape, suggest that the Arnhem Land Plateau and the lowlands extending north to the coast are a vast mosaic of landforms and botanical communities creating a complex range of habitats.

Indeed, to the majority of visitors today, the plateau is one of the most remote and unique landscapes of Australia. It is an immense sandstone island almost surrounded by a sea of eucalypt-dominated tropical woodland. Only the north-western edge of the plateau and the outlying residuals extend into the flood plains. The 500 kilometres of plateau escarpment rise up to 300 metres above the adjacent lowlands. These escarpments are dissected by complex networks of chasms, ravines and gorges, and wide valleys penetrate deep into the interior of the plateau.

The genesis of the present landscape occurred sometime between about 1688 million and 1610 million years ago, in the middle Proterozoic era, when in an ancient sea or lake the sands and pebbles which now make up the 400-metre-thick Kombolgie formation of Carpentarian sandstone were being laid over older strata including volcanics, coarse and medium sediments, and metamorphic and granitic rocks. Throughout the eons that followed the deposition of the sandstones, they were repeatedly subjected to marked faulting, jointing, uplifting and relentless weathering. At one stage, the

*Opposite above* Wet season mist in the escarpment rocks brings a touch of magic to the rugged landscape.

*Opposite below* In between the plateau's deep chasms and gorges lie remnants of rainforest, home to unique fauna species.

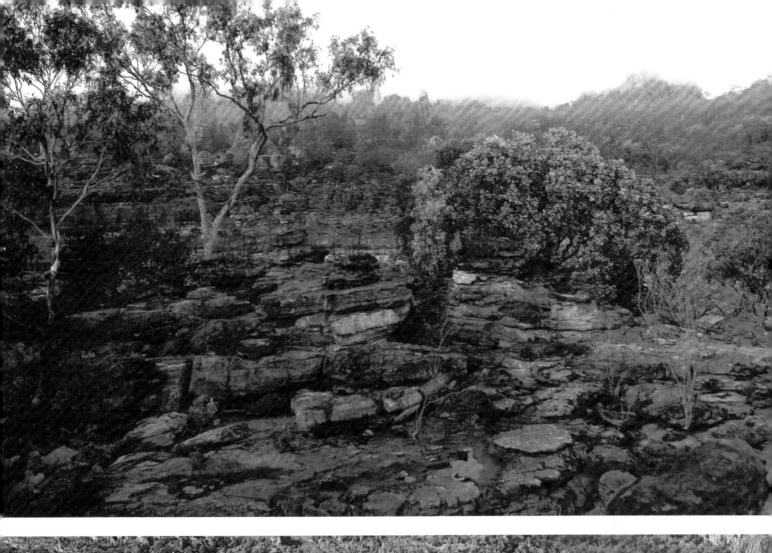

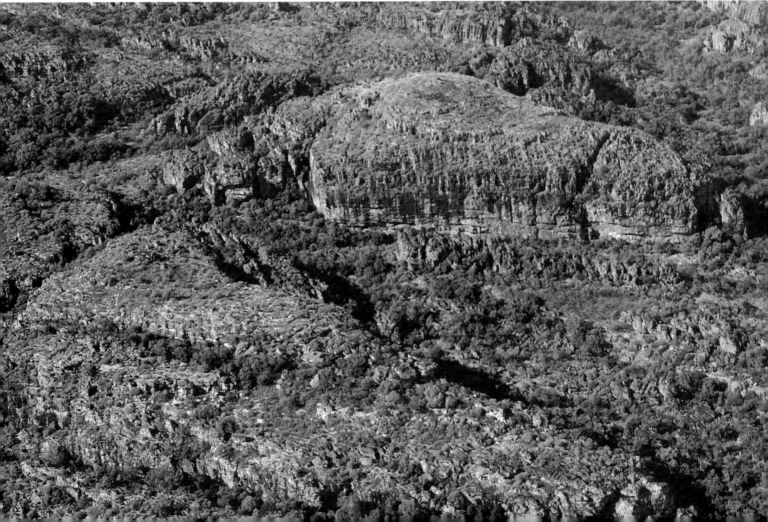

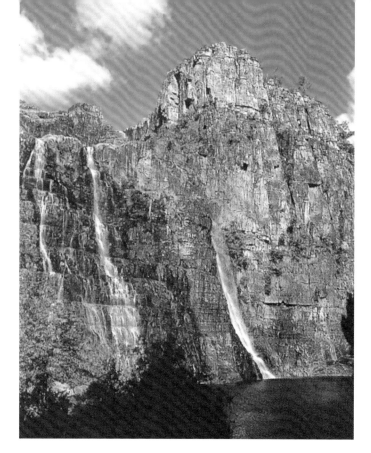

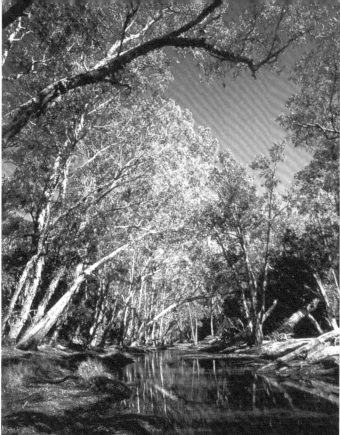

During the wet season hundreds or waterfalls cascade over the escarpment, but only a few continue to flow throughout the year.

Paperbark trees line the sandy banks of the escarpment streams, providing shade for the popular dry season camps.

escarpments of the plateau formed coastal cliffs, washed by tropical seas. Today, pebble beds and conglomerates can be seen at the base of the plateau, with the horizontally bedded sandstone lying above, prominent cross-bedding and fossil ripple-marks recording its origin as an ancient sea or lake bed. Minor bands of sedimentary rocks, such as siltstone, and basalts of volcanic origin are also present in this formation.

The exposed sandstone of the Kombolgie formation now forms the rugged, visually impressive Arnhem Land Plateau. Below are the sandy lowlands, which pass gently from the alluvial floodplains to the coastal and estuarine plains and the sea. The outliers of the plateau – seen now as residual rocks scattered across the plains, or as large massifs such as that of Nourlangie Rock-Mt Brockman and the Wellington Range complex – extend to within 10 kilometres of the coast and delineate the former extent of the plateau. In the south, the plateau today merges with hills that roll on to the inland plains.

Petrological investigations indicate that the rock types of the Kombolgie formation fall into two groups: orthoquartzites, which are generally stable as they still retain at least some of the original, interlocking silica matrix which cements the quartz grains together; and quartz sandstones, which are less stable as they have a matrix of koalinate, a clay mineral, and sericite, a mica, with small and variable but highly significant amounts of phosphates, sulphates and carbonates – such a matrix is liable to break down by hydration and solution processes. These two rock types may occur together, though usually the stable scarps of the plateau and its valleys contain orthoquartzites, whilst the residuals are quartz sandstone.

Weathering of the rocks, erosion along joints and bedding planes together with the leaching through the more soluble strata have produced spectacular and intricate patterns of relief – stone columns, labyrinths, crevices, ravines, caverns, tunnels, towers and boulder piles. In some places, huge blocks of stone have split from the escarpment cliffs and lie embedded in the scree and talus slopes that extend along their bases. Some such falls occurred within the living memory of local populations. There are people who refuse to sleep in the rock shelters, recalling tales of shaking ground, collapsing overhangs and large blocks of sandstone tumbling down the slopes. Massive slabs from painted ceilings now lie shattered on the floors of rock shelters, bearing mute witness to such events. The talus slopes merge with the adjacent lowlands where the weathered sandstone, decayed and disintegrating, becomes the alluvium of the sandy plains.

Over millions of years, rivers and creeks have etched deep gorges and carved out wide valleys throughout the plateau. In the north-western sector lie the catchments of the South and East Alligator rivers and their tributaries – the Jim Jim, Nourlangie, Deaf Adder, Magela and Cooper creeks

– all of which flow into Van Diemen Gulf. The Gumadeer, Liverpool, Mann, Cadell and Blyth rivers form the northern catchment area. In the south-eastern sector lie the headwaters of the Wilton, Mainoru, Flying Fox, Maiwok and Warehouse rivers, major tributaries of the Roper River which flows into the Gulf of Carpentaria. The south-western sector has the headwaters of the King, Katherine, Edith and Fergusson rivers, tributaries of the Daly River which flows into the Timor Sea.

Although the greater part of the wet season's rainfall over the plateau is instant run-off, the weathered sandstone nevertheless becomes saturated, discharging water to supply the escarpment's springs and providing the base flow in many of the streams. The effect of this aquifer ensures that some streams flow throughout the year.

There is no lack of water in the 'stone country' even during the hottest times of the year, for those who know where to look for it.

## Flora and fauna habitats

The plateau and its environs offer a complex range of habitats for the region's species. The tropical sea fringing the northern coast is the home of turtles, saltwater crocodiles, dugongs, dolphins, sharks, stingrays and many other types of marine fauna. The white sandy beaches provide nesting sites for turtles, a favourite food item of the coastal people. The Gagudju, Amurdak and Ngarduk families made their way across to Kardangarr (Field Island), an important sea turtle nesting place. There they hunted and gathered the eggs of the green *(Chelonia mydas)*, flatback *(Chelonia depressa)* and loggerhead *(Caretta caretta)* turtles. An early European visitor, Captain F. Carrington, visited Kardangarr in 1887. He noted the evidence of such activities and collected the remains of decorated bark shelters. On the walls of one of these shelters, amongst other paintings, was a depiction of a turtle. The Iwaidja, Maung and Margu people visited similar nesting sites along the coast of the Cobourg Peninsula.

The tides along this coast can rise and fall 8 metres, and the high tides of the dry season can send a rushing bore up the river estuaries. On the East Alligator River, the tidal influence extends past the residual rocks into the escarpment. High tides allow occasional sharks and stingrays to penetrate far inland. The coast and estuaries are fringed by mangrove communities which provide an important ecological niche. Amidst their aerial roots one can find the large, succulent mud crab *(Scylla serrata)*, a wide variety of shellfish and the spectacular black

and yellow mangrove monitor *(Varanus indicus)*. The crowns of the mangroves are host to colonies of black and little red flying foxes *(Pteropus alecto* and *P. scapulatus)*. Mangroves extending along the river estuaries provide rookeries for a number of bird species and a habitat for many song birds. Coastal mangrove forests are important breeding grounds for barramundi *(Lates calcarifer)* and other fish. The coast is also the niche of the saltwater crocodile *(Crocodylus porosus)*, though this mighty predator is equally at home in estuarine rivers or the freshwater streams, swamps and billabongs.

Behind the beach dunes and along the margins of the floodplains are pockets of monsoon rainforest, remnants of an era when the region was wetter and the rainfall more constant and more evenly distributed throughout the year. These small patches have survived the ensuing cycles of aridity, and are relics of the ancient Australian rainforests and of more recent tropical flora, including the representatives of the Indo-Malay regimes which, like the predecessors of the Aboriginal people, reached Australia during one of the periods of low sea level when the northern coast extended almost to Indonesia.

The banyan tree *(Ficus virens)*, now one of the dominant trees in the surviving rainforests, is one such newcomer. Aborigines of the region attribute its presence in their land to Warramurrunggundji, their creator, who brought it with her when she entered the land after crossing the sea from far to the north-west – an indication of their knowledge of its origin. Other trees within the rainforest include the milkwood *(Alstonia actinophylla)* and the kapok tree *(Bombax ceiba)*, both of which were used to make dugout canoes, the styptic tree *(Canarium australianum)*, and the yellow flame tree *(Peltophorum pterocarpum)* which when in bloom is densely covered with glowing golden flowers. A variety of shrubs and climbing plants form a thick understorey. In the dry season the isolated pockets of rainforest stand out like green islands in grasslands scorched bare by bushfires.

The rainforests are a permanent home to many animals. Their trees and shrubs are rich in seeds and fruits which attract Torres Strait pigeons *(Ducula spillarhoa)*, rose-crowned fruit doves *(Ptilinopus regina)*, emerald doves *(Chalcophaps indica)* and many other species of birds. Flying foxes, attracted by the fruit, roost in any tree that will bear their weight, such as those of the *Syzygium* and *Ficus* genera. Under the dense canopy the 'jungle fowl', or orange-footed scrub fowl *(Megapodius freycinet)*, makes its huge nest, while the brilliantly coloured rainbow pitta *(Pitta iris)* runs along the ground in search of insects. Because of the sheltered position

and more permanent water supply of the monsoon rainforest, its plant and animal communities are more diverse than those found in the rainforests of outliers on the plains.

Inland from the coast and flanking the major northern rivers and creeks are vast floodplains which extend beyond the residuals and outliers of the plateau, along the East Alligator River to the high escarpment. In the wet season, rushing floodwaters overflow into the estuaries and the whole area becomes a vast reservoir. Many animals are forced to seek higher ground. Sometimes the only refuge may be the branches of an overcrowded tree, and a common goanna *(Varanus panoptes)* of the floodplains may be seen sharing this abode with dusky rats *(Rattus colletti)* and with a variety of hungry venomous and non-venomous snakes.

At the peak of the wet, an inland sea of freshwater extends towards the coast. As the skies clear after several months of rainbearing clouds, the hot sun warms the water and nature explodes in growth. The wetlands become covered as far as the eye can see with aquatic growth, sedges, grasses and waterlilies – large white, pink and blue *Nymphaea* waterlilies, delicate yellow and white snowflake lilies *(Nymphoides hydrocharoides* and *N. indica)* and in deeper basins and billabongs the large red lotus lily *(Nelumbo nucifera).*

These are some of the most important tropical wetlands in the world, a refuge for waterbirds which were once widespread throughout Australia. The magpie geese *(Anseranus semi-almata)* at the height of the floods build their nests in the clumps of spike rushes *(Eleocharis* sp.). Later in the year, as the waters recede, the geese congregate in their hundreds of thousands in the drying swamps, where they feed and fatten on the new accessible spike rush corms. The waterholes are then an ornithologist's paradise. The jabiru *(Xenorhynchus asiaticus),* Australia's only stork, and the many egrets, ibises, spoonbills, herons and other waders stalk along the swampy fringes picking up morsels of fish and frogs. Cormorants, snake birds and pelicans harvest the abundant fish. As the floodplains dry out, the permanent basins, billabongs and creek channels, their margins lined with stands of paperbark trees and pandanus palms, re-emerge from the flood. Before the seasonal swamps dry out completely, the northern long-necked turtle *(Chelodina rugosa)* and the common short-necked turtle *(Emydura victoriae)* bury themselves deep in the mud to await the next wet season. When the ground is crazed by the heat of the incessant sun and the grasses are burnt yellow, the brolgas *(Grus rubicundus)* group together on the shimmering plains and perform their stately dances.

Then fires sweep across the plains. Not a trace remains of the plants: their seeds and bulbs, now baked in the mud, lie dormant to await the life-giving rains of the next wet season.

The rivers and the creeks are the lifeblood of the region. But, soon after the cessation of the wet season, the freshwater streams beyond the estuarine waters become chains of waterholes, pools and finally bare sandy creek beds. Their banks are lined with the water pandanus *(Pandanus aquaticus),* the screw-palm *(P. spiralis),* the tall paperbarks *(Melaleuca argentea, M. viridiflora* and *M. symphyocarpa)* and the freshwater mangrove *(Barringtonia acutangula).* In rock shelters in the vicinity of these streams are painted images of the important fish species and turtles hunted by the artists. The barramundi *(Lates calcarifer)* and the fork-tail catfish *(Arius leptaspis)* are the dominant subjects of shelters along the estuarine rivers and are frequently depicted in sites in the vicinity of the larger freshwater streams. In the upper reaches of the rivers and creeks, beyond the limit of the barramundi and catfish habitats, are saratoga *(Scleropages jardini),* black bream *(Hephaestus fuliginosus),* archer fish *(Toxotes* spp.), long tom *(Strongylura kreffti),* several species of eel-tail catfish *(Neosilurus* spp.), and a freshwater crayfish *(Macrobrachium* sp.), freshwater crocodiles *(Crocodylus johnstoni),* snapping turtles *(Elseya dentata),* the long-necked turtles *(Chelodina rugosa)* and pig-nosed turtles *(Carettochelys insculpta)* share this habitat. Both the woodlands and open tall forests are widespread about the plateau. They are botanically rich and diverse, their composition being controlled by factors such as soil type, terrain and the amount of inundation they are subjected to. The animals and birds which live in these environments are equally diverse. The dominant plants are eucalypts, of which the Darwin stringybark *(Eucalyptus tetrodonta)* and the Darwin woollybutt *(E. miniata)* are the most common of the 14 major species identified. The bark of the stringybark tree is still used by Aborigines today as the 'canvas' for bark paintings, and in the past it was also used to construct wet season shelters and canoes. Indeed, Arnhem Land is as famous for its bark paintings as it is for its rock art.

Low-lying areas which are subjected to some flooding feature white gums *(Eucalyptus alba* and *E. papuana),* paperbarks *(Melaleuca nervosa),* the swamp banksia *(Banksia dentata),* and the fern-leaved grevillea *(Grevillea pteridifolia)* with its long silver leaves and large orange blossoms. These areas form park-like settings in the dry season. Elsewhere, the fan palms *(Livistona humilis* and *L. inermis),* the yellow-blossomed kapok bush *(Cochlospermum fraseri),* the turkey

bush *(Calytrix extipulata)*, the billy-goat plum *(Planchonia careya)*, the green plum tree *(Buchanania obovata)* and two wattles *(Acacia oncinocarpa* and *A. dimidiata)* are common plants. In the southern hills, the tropical woodland is admixed with plants from the arid interior. Most of these plants blossom in the early dry season, a time of plenty for the nectar-seeking honeyeaters. Then follows a bounty for seed-eating birds. The spear grass *(Sorghum intrans)*, found throughout the lowlands, grows up to 4 metres in height, and when it seeds it provides food for many other birds and animals such as the grassland melomys *(Melomys burtoni)* and the northern brown bandicoot *(Isoodon macrourus)*.

The most prevalent macropod in the north of the Arnhem Land region is the agile wallaby *(Macropus agilis)*. Larger, and less common, is the antilopine wallaroo *(M. antilopinus)* which along with the rock wallaroo *(M. robustus)* played major creative roles during the Dreaming. The bandicoot *(Isoodon macrourus)*, the northern brushtail possum *(Trichosorus arnhemensis)*, the 'native cat' or spotted northern quoll *(Dasyurus hallacatus)*, the bright-eyed and brush-tailed phascogale *(Phascogale tapoatafa)* and a host of other small marsupials live throughout the woodland.

More than 270 species of birds – too numerous to list – inhabit the plateau region. They include many birds of prey, rare pigeons, colourful and noisy lorikeets, cockatoos, parrots and rosellas. The largest of the birds, the emu *(Dromaius novaehollandiae)* which is highly prized by Aboriginal hunters, is not common here. Among the smallest birds are finches and wrens, including the beautiful Gouldian finch *(Erythrura gouldiae)* and the white-throated grass wren *(Amytornis woodwardi)*, which are threatened with extinction.

There are also many reptiles. One of the largest snakes of the lowlands is the olive python *(Liasis olivaceus)*, which grows to a length of 4 metres. In all, six python species are found in the region, and they, along with other harmless snakes, are hunted and eaten by the Aboriginal inhabitants. Other snakes are mildly venomous and still others such as the death adder *(Acanthopis praelongus)*, the king brown snake *(Pseudechis australis)*, the western brown snake *(Pseudonaja nuchalis)* and the taipan *(Oxyuranus scutellatus)* are highly venomous and can be considered extremely dangerous.

The sand goanna *(Varanus gouldii)*, the largest of 15 goanna species in this region, is often depicted in rock paintings. Images of the well known frilled lizard *(Chlamydosaurus kingii)* are also found, as are paintings of the northern blue-tongued lizard *(Tiliqua scincoides)*. One of the most interesting

Early dry season morning mist hangs low over the East Alligator River plains at Namarrkananga, Cannon Hill.

lizards, which is unique to the region, is the swelled-head or chameleon dragon *(Chelosania brunnea)*.

Among the most unusual species in the 'stone country' are the shy black wallaroo *(Macropus bernardus)*, the banded fruit dove *(Ptilinopus cinctus)*, found in the tall trees of the escarpment gorges, and the spectacular Leichhardt grasshopper *(Petaida ephippigera)*. But these are only the better known species: hidden within the plateau, living in the sandstone scrub and woodland or in the rainforests of the moist gorges and ravines along the escarpments, are many other rare and unique species of animals and plants.

The common rock wallaroo *(Macropus robustus)*, often depicted in the rock shelters, lives in the escarpment along with two smaller macropods, the short-eared rock-wallaby *(Petrogale brachyotis)* and the little rock wallaby or nabarlek *(P. concinna)*. The escarpment is also the home of the rock ringtail possum *(Pseudocheirus dahli)*, which is equally at home among the rocks as it is in the trees.

The largest of all the snakes in the 'stone country' is the Oenpelli python *(Morelia oenpelliensis)*, which is unique to the area and was discovered by scientists only in the 1970s.

It is said to reach 7 metres in length and is both hunted and feared, as it reputedly kills large rock wallaroos and could harm people. It is often found coiled in the sheltered overhangs, as is the brown tree snake *(Boiga irregularis)* – which, despite its name, usually seeks refuge in the rocks. The hills and the escarpment are also the preferred home of the echidna or spiny anteater *(Tachyglossus aculeatus)*, a prized food of the Aboriginal population.

The northern and western margins of the plateau are dissected into complex networks of chasms and deep narrow gorges which lie between large areas of almost bare rock platforms. The heavy wet season rains wash rapidly over bare surfaces cascading down rocky slopes and forming spectacular waterfalls. Within the shaded gorges and ravines lie rainforests, while the rocky expanses and the gently sloping uplands are covered by sandstone scrub and woodland. The largest rainforest tree is the evergreen myrtaceous anbinik *(Allosyncarpia ternata)*, which dominates the slopes of sandstone gorges, but the plateau's rainforests also abound with a wide variety of trees, palms, vines, mosses, lichens, ferns and orchids. Although anbinik is a most striking tree, it is the sandstone pandanus *(Pandanus basedowii)*, with its many branching arms and long aerial roots, that symbolises the plateau.

There are many rare and delicate plants across the plateau's variable environment. Amongst them are at least eight grevillea species, with beautiful multihued blossoms, and several varieties of hibiscus. The sharp-needled porcupine grasses or spinifex *(Triodia* spp.) form dense hummocks between the rocks, and pads of 'resurrection' grass cover the rocky platforms. Like the woodland forest of the lowlands, the sandstone woodland is dominated by eucalypts, including stringybark and woollybutt. The scarlet gum *(Eucalyptus phoenicea)* grows on the stony foothills, as does the variable-barked bloodwood *(E. dichromophloia)* and many species of acacia, grevillea, melaleuca and boronia.

## Climate

The region's physical dichotomy of plateau and plain extends to its climatic regime, which is under the influence of two alternating monsoons. Strong north-west winds around November bring the reliable rainfall of the wet season, while south-easterly winds in April herald the long dry season. But while Europeans refer to this 'duality' of climate – wet and dry – to the Aborigines of this region, whose social and economic lives were closely governed by the dynamics of

the climatic changes, the seasonal pattern is more complex. They divide nagudji andjeuk (a year – literally 'one rain') into six seasons. These are: gunumeleng, the time of first storms; gudjeuk, the wet season proper; banggerreng, the last rains; yekke, the early dry season; wurrgeng, the cold weather time; and gurrung, the hot weather. Although these six periods can be approximated to the two-monthly periods of November–December, January–February, March–April May–June, July–August, September–October, the climatic pattern is ever-changing, with seasons varying in their duration and effect. The Aboriginal year does not start or end on a fixed date, but is a pulsating cycle of seasons unconstrained by a given number of days.

Gunumeleng, the first storms, is the time of hot and humid days when, after the clear skies of the previous seasons, clouds build up during the day, then afternoon showers moisten the parched land, and at night lightning plays around the horizon. This early rain is nagurl. It comes from the south-east, and eventually gives way to the more forceful rains of the wet season. Dinirdini, cicada larvae, come forth from their underground slumbers, climb up the tree trunks and shed their skins to emerge as adults. The air reverberates with their incessant drone. The grass begins to grow and soon the ground is mantled with green. It is then that the favourite fruits ripen. These include the green and black plums, andudjmi *(Buchanania obovata)* and angurndalh *(Vitex glabrata)*, and also the white and red apples, anboiberre *(Syzygium rubiginosum)*, andjolkbirro *(S. eucalyptoides* ssp. *bleeseri)* and angirribui *(S. suborbiculare)*. Along the creeks the air is heavy with the scent of the blossoming paperbark trees, now visited each evening by colonies of flying foxes. The first rains spread a layer of fresh water over waterholes, which until then are at their lowest levels, containing only anbogare ('old water'), exhausted of oxygen and nutrients. It is said that the rainwater makes the fish 'drunk', for they float to the surface and die. This also happens when the first localised ephemeral flows flush the creek beds and the small stagnating pools, bringing worrhgorl (turbid 'black water') into the larger waterholes. People then await gulng (the first flood wave). It brings the barramundi, which are carried by the fresh water out of the diminished waterholes where they have spent the dry season. As the first waves spill over the sandbanks, the fish are caught by hand. Later, when the waters swell, they are speared.

The anvil-shaped cumulo-nimbus clouds, with their billowing heads known as angodjbolebole, continue to build

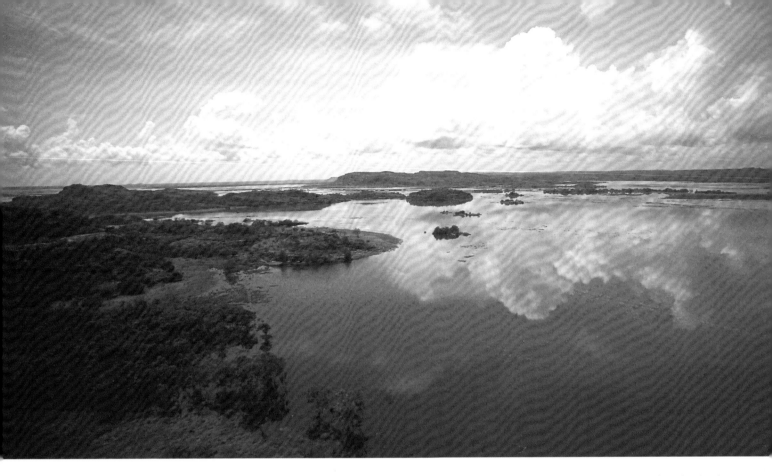

The sandstone plateau sheds the rain and channels it through its gorges to flood the surrounding plains. The residual rocks of the lowlands then become islands.

up, heralding the onset of gudjeuk, the season of heavy rains, violent thunderstorms and tropical cyclones. It is the nahbilil wind that goes to pick up bula (the cyclone) from one of its many Dreaming sites in the Jawoyn country. This gudjeuk season consists of five distinct rain periods identified by their intensity and direction of movement: balmarradja, gudjeuk, molendjerre, makkumbu and gerralkgen.

The first of these rain periods, balmarradja, is brought by the north-west monsoon, when strong winds and incessant rain frequently lash the land. It is the time of anboukwurd (the 'small flood'), when waterfalls cascade off the escarpment and creeks run full, flushing and filling the shrunken waterholes, swamps and marshes of the low-lying wetlands.

Gudjeuk rains can come from any direction and are accompanied by winds which uproot trees and by lightning strikes which can shatter trees and rocks. As the earth trembles with thunder and the sky is rent asunder by lightning, people in open areas bury their stone axes to avoid attracting the lightning bolts. They know that the thunder and the lightning are caused by Namarrgon, the Lightning Man, when he strikes at the clouds with his stone axes. They also fear cyclones, which may veer from their usual path along the northern coast and move inland, bringing heavy rain and destruction. The monsoonal rains provide the most

awesome spectacle. Run-off from the almost stark surfaces of the sandstone plateau pours over the precipitous escarpments in majestic waterfalls, then rages in torrents through the narrow gorges, moving huge boulders, tearing up trees along the watercourses and finally flooding the countryside. This is anboukgimuk (the high flood time). The waters spread across the floodplains, creating a freshwater inland sea that stretches from the escarpment to the coast, separated from the ocean by only a narrow strip of ragged ridges, the old beach lines. Only the high residual outlying rocks escape the inundation, becoming arks teeming with animals seeking refuge.

The rain and heat during this period produce a plant growth that is almost violent in its intensity. For the Aborigines it is a time when new fruits and root foods are ready to be collected. The major food items are garrbarda, the long yam (Dioscorea transversa), and anburre, the 'bush potato' (Stephania japonica). Favourite foods are the sweet fruits of the abundant shrubs and trees found in fertile areas throughout the Arnhem Land Plateau.

It is now, too, that the females of two species of rock wallaroos, djugerre and wolerrk, bear their young.

The gudjeuk rains are followed by molendjerre, the rains which come from the west.

The next set of rains, the makkumbu, again come from the

39

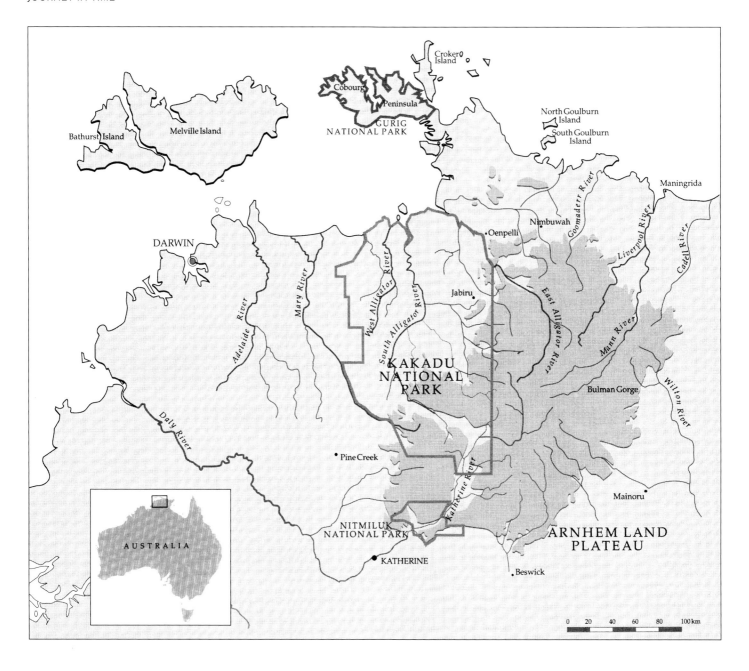

north-west. They are cold and incessant, lasting for days and deeply soaking the land. The accompanying winds push the high tides up the South and East Alligator rivers, lifting the level of water over the plains. Goannas, snakes and possums are forced to seek refuge in trees, where they are easily caught by hunters who pole their rafts through the wetlands. Towards the end of this period, when the seeds of the spear grass turn black, the magpie geese lay their eggs. This is danbuk (egg-gathering time).

Later, the gentle gerralkgen rains move in from the east. Then the ngalwalgarra wind comes and shakes the seeding heads off ngulubu, the spear grass, scattering the seeds and bending the grass towards the ground, to await banggerreng, the season of last storms.

It is cooler now, but still humid. Yamidj, the long horn grasshopper *(Caedicia* sp.), calls out that anginjdjek, the 'cheeky' round yams *(Dioscorea bulbifera)*, are ready to eat. When namadjalawolmi (the heavy 'knock 'em down' rains) come from the west they flatten the bending spear grass first in one direction, then return from the east and push the grass over in the opposite direction. The wet season is drawing to a close. Now, the south-easterly winds from the inland come twice. The first time they push the clouds to the north-west, stopping further rain. When they return a second time it is yekke, the early dry season. In the early morning, mists hang low over the plains and the waterholes – the work of duberrk, the land snail, moving slowly through the land. Karrd, a small spider, spins its gossamer threads between the blades of

the ground-spreading grasses. The webs are heavy with dew, which glistens like crystals in the early sun. Angomgorrk, the golden acacia (*Acacia latifolia*), andjalen, the woollybutt (*Eucalyptus miniata*), and andadjek, the orange-blossomed fern-leaved grevillea (*Grevillea pteridifolia*), begin to blossom. The grevillea flowers are heavy with nectar and stain the ground when they fall. Small, fringed, yellow and white snowflake lilies (*Nymphoides hydrocharoides* and *N. indica*) carpet the shallows of wetlands and freshwater billabongs, while large white, pink and blue waterlilies (*Nymphaea* spp.), spread across the deeper water, their seeds, stems and corms ready to be eaten.

Wurrgeng is the 'cold weather time'. The days are slightly cooler, with an average maximum daily temperature of 30 °C, while at night the temperature only seldom drops below 17 °C. The sky is clear, except for an occasional wispy cloud, and at night it is studded with brilliant stars, which previously only could be seen through the haze of humidity. The Milky Way is seen meandering across the sky, as the 'saltwater creek' of one legend. Eucalypts are in flower and dawn is alive with the songs of feeding honeyeaters. It is then that alwalngurru, the swelled-head dragon (*Chelosania brunnea*), is said to throw anbundjak (the sweet manna) on their leaves. Flying foxes give birth to their young, freshwater crocodiles lay their eggs and wild bees fill their hives with nectar. By now most of the creeks have stopped flowing, swamps are drying out and the waters of the wetlands have receded into a few permanent but ever-diminishing waterholes, covered with countless waterbirds. The magpie geese are fat and heavy, after feeding for weeks on the corms of angurladj, the spike rush (*Eleocharis dulcis*). It is 'goose time', when, in the past, people came to the wetlands to hunt not only the geese, but also nawarndak, the file snake (*Acrochordus arafurae*), and long-necked turtles. Ceremonies were held in the vicinity of 'goose camps', to ensure that the life-sustaining forces and the regenerating rains of the wet season would return. Before the annual cycle begins anew the days are windless and oppressively hot, with the average maximum temperature of 36 °C reducing only to 28 °C at night. The intense solar radiation dries and cracks the black soil floodplains. The land lies dormant awaiting the first rains.

The present-day landscape is very different from the way it was when the first humans reached the edges of the plateau some 50,000 years ago. At that time, the sea levels were much lower than they are now and Australia was connected by a broad plain to New Guinea. The climate was also different from the present regime, with rainfall, temperature and humidity being considerably lower than today.

In the north, the river valleys were slightly incised into gently sloping lowlands, while the bases of the escarpments and the floors of the valleys were only thinly covered with sandy sediments. As humans entered this environment with their fire-sticks, the frequency of fires increased dramatically. Burning of the vegetation extended into the escarpments and the plateau, causing increased erosion. Large quantities of sand were removed from the upper slopes and accumulated at the base of the escarpments, filling the floors of the rock shelters and spreading as sand sheets across the valleys. This increase of erosion commenced some time before the height of the last Ice Age, when glaciers and great ice sheets had captured so much water that the sea level was about 150 metres lower than at present and the nearest sea coast was some 250 kilometres to the north-west.

The most dramatic geomorphological and environmental change occurred at the end of the Ice Age when the seas rose rapidly, submerging the land and finally separating Australia from New Guinea. When the sea peaked, the broad shallow valleys and trenches of the South and East Alligator rivers and of Cooper Creek were filled with estuarine clays, creating broad salt marsh environments which extended to the escarpments of the plateau and its outliers. During this period of sea level change and increased sedimentation, between 6500 and 7000 years ago, mangrove forests – which usually fringe sheltered coasts and tidal estuaries – developed over these extensive swamps.

The rising seas were accompanied by a climatological change. The monsoonal rains, which were intensifying as the coast became ever closer, extended over the plateau, and increasingly violent rains were caused by the cyclonic depressions which then developed over the warm shallow seas. During the annual inundations, freshwater sediments were deposited over the brackish swamps. By 5500 years ago, this continuous process caused the retreat of the mangroves towards the coast and tidal estuaries. Silt-rich black soil plains formed over the swamps previously colonised by mangroves. Over the following 4000 years, the present-day landscape slowly evolved. Gradually the salt was leached from the muds, which were then invaded and stabilised by grasses. Sometime before 1400 years ago, the saltwater channels to the wetlands were choked off and they became the freshwater billabongs and paperbark swamps of today.

# Garrewakwani

## THE ANCESTRAL PAST

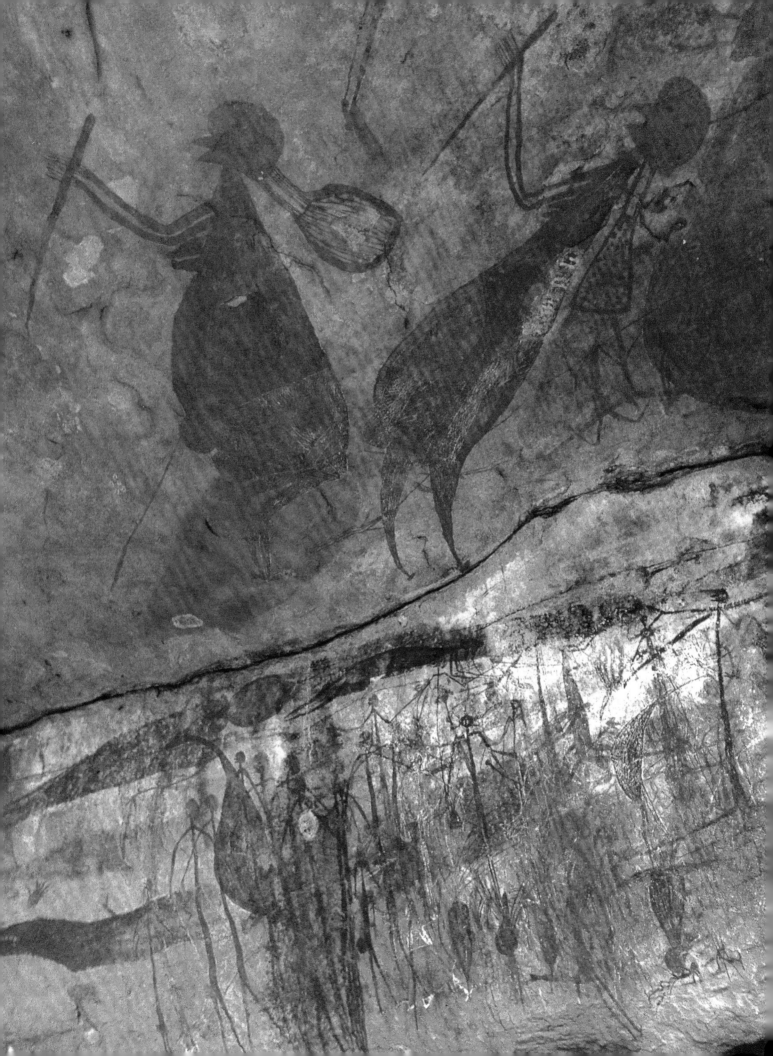

*A*strong and intimate bond exists between members of an Aboriginal group and their estate. The land is their 'book of Genesis', tangible evidence that the myths telling of the creation are true. The people believe that the natural features of their landscape and all that is living within it – including themselves, the bininj, their pattern of growth, the modes of behaviour and everything else now significant to them – were created by the mythic figures of their cosmogony, the Nayuhyunggi. These, the 'First People', existed during a period referred to as garrewakwani, the ancestral past, which is glossed in Aboriginal English as the 'Dreaming'. The creative activities of the First People and all the incidents which occurred during their passage through the land are vividly described in oral traditions of song-poetry, legend and ritual. There were many actors in these founding epics. Some remained human throughout their creative life, but most were protean figures, changing from human form to that of some natural species or vice versa.

Many of the Nayuhyunggi came with a specific intent. Some of them formed the land, planted foods and left people, or spirit children, behind, directing them as to what language they should speak. Others created animals, or conversely caused the people, or themselves, to change into animals, the predecessors of the present fauna. Still others taught how to prepare foods, set examples of moral conduct and instigated the various systems of social organisation. They also made laws and brought ceremonies – the rites of passage, and rituals intended to maintain and to renew the life of natural species, ensuring the continuation of their grand design. Inevitably, the action of one of them also brought the spectre of death to the world. Most of the mythic beings concluded their creative deeds during the Dreaming, but there are others, such as Almudj, the Rainbow Snake, and Namarrgon, the Lightning Man, as well as the many spirit people, some malevolent and others harmless although of mischievous character, who are present and active in the environment to this day.

At the completion of their creative activities, the Nayuhyunggi 'sat down' at the localities where their last acts took place or returned to one or other of the sites which mark their journeys. Here, they now remain as a living essence. Many of these beings placed themselves on the walls of the rock shelters, where they are today found as multicoloured paintings. Elsewhere, such sites are places marked by striking or unusual physical features a tor, a rocky outcrop, a deep waterhole or a permanent spring. The whole landscape is not only evidence of their past activities, but also of their current presence. The creative acts of these founding beings are commemorated in rituals, whereby they reappear as Dreamings and are reactivated by ceremony. They are sung and danced, and depicted in body designs, bark paintings and sculpted objects.

The myths about the major creator beings are known throughout the region, and even the minor characters, whose journeys and activities were of limited extent, are known to a wider group of people than the clan or language group in whose territory a specific incident may have occurred. This spreading of knowledge is due to the fact that people had social links far wider than just with their immediate neighbours. As they moved on their annual journeys through their social range, visiting relatives and attending rituals, connections were made with distant groups and transference and exchange of local lore occurred. There are some variations in the accounts of many of the characters, according to the local perspective. The detail of a particular myth will emphasise a set of activities that occurred in the estate of the particular language group or clan recalling it, and those activities that occurred elsewhere will be known only in abstract. Such abstract knowledge is only reluctantly talked about, as it is considered that rights to that knowledge, as with the land where the events took place, is the property of the specific local group. Similar variations in myths are observable in the form of the rock art images depicting ancestral beings, and also in the styles of their execution.

All the major mythological characters that were involved in the creative activities within this region are said to have come from the sea between Cobourg Peninsula and Goulburn Island or from Marrabibbi, the coastal area near the mouth of the Wildman River. Other characters are said to have emerged from the sea at Balpanarra, a coastal area to the east of Maningrida. The movement of these mythic figures was towards the resource-rich wetlands between the East and South Alligator rivers. From here, some moved across the sandstone plateau to its southern and western margins, or even beyond. These myths perhaps suggest that the people

*Previous spread* The second-longest Rainbow Snake so far recorded extends across a ripple-marked ceiling in the eastern sector of the plateau. Location: Malakandanjma. 650 cm.

*Opposite* Of all the paintings of women in the region's rock art, this depiction of the stout female on the left, with a dilly bag hanging down her back, is what Warramurrunggundji, according to the myth, may have looked like. Her partner carries a different type of dilly bag, and both carry short, sharp digging sticks. Location: Garrkkanj. Female at left 115 cm.

abstractly retain knowledge of their ancestral origin, or, together with introduced practices, they may express the influences of contact.

## Warramurrunggundji

The principal ancestor for most of the Aboriginal groups living in this region was the female Warramurrunggundji, who is attributed with the creation of bininj, the people, in a land which she had prepared for their reception. The main incidents of her creative acts are well known. She emerged from the Arafura Sea at Cobourg Peninsula and moved inland. During her journey she met a man called Wurragag, sent out spirit children to various localities, and planted vegetable foods. Most people also know the general location of her last camp, her Dreaming, where she remains in spirit to this day. The articulated detail of sections of this myth remains with particular local groups. For example, the Margu people of Croker Island retrace Warramurrunggundji's steps through their land until she reaches the mainland. From there they say 'it is another man's story'.

The myth about this creator was first reported to Europeans by Paul Foelsche, an inspector of police, in 1881. In this early version she was said to have come at a time when there was no water on the Earth. When she reached Port Essington on the Cobourg Peninsula, finding it a good country, she made a large fire. When this burnt down, the sea rose to its present level, while inland fresh water filled all the springs and waterholes. Warramurrunggundji then left there the first group of humans, gave them their language and name, and continued inland.

Baldwin Spencer recorded a detailed version of this myth during his visit to Oenpelli in 1912, where to the Gagudju she was known as Imbromebera while her consort's name was transcribed as Wuraka. He was told that when Imbromebera emerged out of the sea at Malay Bay she had a huge stomach containing many children. She wore a headring, from which hung dilly bags full of yams, and in her hand carried a large digging stick. She was to meet the man Wuraka, who came walking through the sea from the west. He was so tall that his head was well above the water. The land parted and two hills, Mt Bedwell and Mt Roe, rose as he came ashore. At the site where the two met, Imbromebera left spirit children, instructed them to speak Iwaidja, then planted yams and told them they were good to eat. She left another group of spirit children who were to speak Iwaidja further south. The

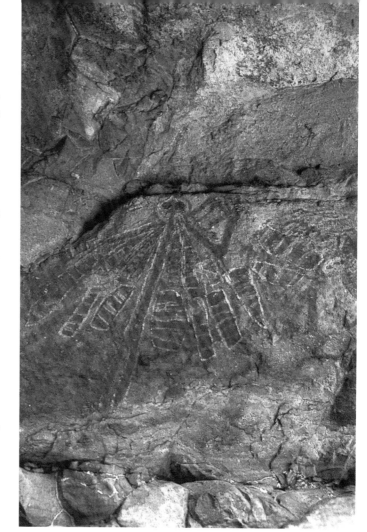

This painting of a female with 15 dilly bags suspended from her headring, although not possessing the huge stomach characteristic of the mythic being, was identified as Warramurrunggundji. Location: Inyalak. 40 cm.

ancestral pair continued on their journey until Wuraka 'sat down', saying that he was too tired and his penis too heavy to carry. He remains there to this day as a prominent landmark known to the local populations as Wurragag and in English as Tor Rock.

At Cooper Creek, north of Oenpelli, Imbromebera left more spirit children, who were to speak Amurdak. Turning west, she crossed the East Alligator River and at four localities planted yams. She then continued till she reached the South Alligator River plains, where she searched for a good camping site. At first she sat down in a pool of water, but on being attacked by leeches she moved to higher ground. From here, her last camp, she threw the seeds of bamboo in all directions and sent five pairs of men and women to different localities. She named their destinations, and instructed them to eat the yams, lilies, 'sugarbag' (bush honey) and other foods she had left there. Imbromebera also instructed them about the totems they were to give to their children. Each of the couples she'd sent out then had children, who, again in five pairs,

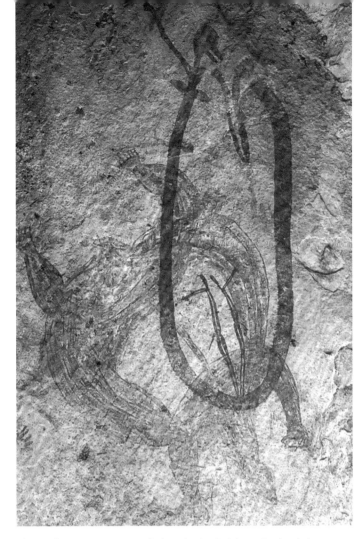

This early representation of Almudj, the Rainbow Snake, in its female form, is from the western side of the plateau, where the being first entered the escarpment. It is shown with one arm and one leg, as it has not, as yet, fully changed into its reptilian persona. Its body envelopes the two young men of the local myth. Location: Djuwarr site complex. Rainbow Snake 111 cm.

were directed to go to various parts of the country to inhabit locales already prepared by Imbromebera for their reception. At most of these localities she had previously left spirit children; where she had not, they were sent subsequently. Each group of spirit children was given a specific language to speak.

Spencer records that Imbromebera was recognised as the creator of all the people in the Alligator Rivers region and responsible for many features of the present landscape, which she then populated with animals and planted with vegetable foods. Although at a later period there were other mythical characters who took part in the continuing creation process, they were said to have derived all their powers from Imbromebera and were guided by her in everything they did.

In its basic structure, Spencer's version of the Warramurrunggundji myth has present day counterparts. There are some differences in views as to whether there was one or two Warramurrunggundji or whether she ever met

Wurragag. Her name suggests that there were two women, as in Iwaidja 'warra' is a plural prefix. The myths told about her today identify her point of origin as Manggadjarra (Makassar on the Indonesian island of Sulawesi), and describe in detail her travels through the land and all her activities. Sites mentioned in these accounts are known to the narrators of the myth. Many are Dreaming sites of animal and plant species and two are locations where, until very recently, rituals were enacted to commemorate her creative journey.

One of the myths told at present follows closely the version recorded by Spencer. Warramurrunggundji came out of the sea at Wamiriyi (Malay Bay) and met Wurragag at the Mangulwan waterhole where they made love. Some time after they'd left that place, Warramurrunggundji remembered that she left her digging stick behind. Returning, she found the digging stick firmly embedded in the ground, and, as she pulled it out, a spring welled up, overflowing into the waterhole. This spring now reminds the people of their union. When she rejoined Wurragag and was asked where she found the digging stick, she told him, 'At Mangulwan where we —', but before she could finish the sentence he put his hand over her mouth, admonishing her that such talk 'might spoil the future generations', as they were in a wrong relationship. Upset about his prudery, Warramurrunggundji left him. Although the Mayali-speaking clans know about Warramurrunggundji's creative activities, they attribute a similar incident to that described above to two protean beings, a man called Nabilil and his sister. This pair also came from the northern coast, Nabilil wearing a daberrk (a head ornament of white cockatoo's feathers) in his hair. On their last night together they slept on top of Burrunggui (Nourlangie Rock). Next day, as they were continuing on their journey, the sister looked back at the rock and exclaimed, 'Look, you have left your feather where we—', but before she could speak further, he too silenced her, warning her not to speak of their actions. Upset about his prudery, she climbed to the top of Burrunggui and threw the feather ornament down on to a lower ledge where it remains to this day. She then changed into Almudj, the Rainbow Snake, slid down the crevice and made her way to the nearby Dabul waterhole. From here she followed Balawurru (Deaf Adder Creek) into the 'stone country'. She left behind a female body made out of grass with a vulva moulded out of mud. Nabilil followed her, and finding the female figure tried to copulate with it. Realising that it was only a decoy he changed into ginga, a saltwater crocodile. He made his way to Balbbun in the Madalk clan's territory, where he stopped

for some time before going on to Golodjerayi shelter in the estate of the Wurnjgomgu clan. Here, a rock painting depicts his transformation from man into crocodile. Nabilil's further activities are described in the myths of the Jawoyn people. His sister, Almudj, the Rainbow Snake, became the awe-inspiring, eternal and essentially indestructible being of the people's cosmogony. To the Gundjeihmi and Mayali speakers she is Almudj, the Amurdak call her Aburrga, the Gunwinjgu say she is Ngalyod, and to the Jawoyn and the Ngalkbon people she is known as Borlung.

## Almudj

### THE RAINBOW SNAKE

Hidden in the rock shelters across the plateau are beautiful images of the Rainbow Snake, the being which holds such an important place in the local mythology and in ritual life. The origin, activities and oral traditions describing this being, in its male or female form, vary from group to group, as do the images that depict it. The earliest rock painting of a Rainbow Snake is perhaps more than 8000 years old, while the most recent was executed in 1965. The belief in the Rainbow Snake, a personification of fertility, increase (richness in propagation of plants and animals) and rain, is common throughout Australia. It is a creator of human beings, having life-giving powers that send conception spirits to all the waterholes. It is responsible for regenerating rains, and also for storms and floods when it acts as an agent of punishment against those who transgress the law or upset it in any way. It swallows

This Rainbow Snake has a crocodile-like head and ears shown in twisted perspective. A second serrated tail rises from the lower part of its body. Below is a long, wide-bodied snake. Location: Yirrwalatj. 235 cm.

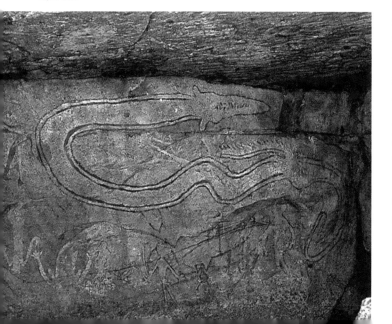

people in great floods and regurgitates their bones, which turn into stone, thus documenting such events. Rainbow Snakes can also enter a man and endow him with magical powers, or leave 'little rainbows', their progeny, within his body which will make him ail and die. As the regenerative and reproductive power in nature and human beings, it is the main character in the region's major rituals, ubarr, marrayin and kunapipi – the main aim of which is the procreation of humans, animals and plants along with the maintenance of seasonal cycles and social maturation of the participants.

A myth describing a conflict between the Rainbow Snake and Gulinj, the progenitor of the Gundjeihmi-speaking Badmardi clan, is illustrated within their estate by a painting on the ceiling of a shelter in Deaf Adder Creek. Another image relating to this myth is found far to the east on the Mann River, and similar subjects are depicted in recent bark paintings.

In the Gundjeihmi version, the following incident took place in the upper reaches of Balawurru (Deaf Adder Creek). Balawurru was the destination of Nabilil's sister after she left him and changed into Almudj, the Rainbow Snake. At that time Gulinj, who was then a man, lived there with his wife and children. When two of his sons were of appropriate age, he sent them to Jawoyn country to become 'young men' in an initiation ceremony. Returning home across the top of the 'stone country', the brothers killed a rock possum. While they were roasting this animal, one of its eyes burst in the heat of the fire making a sound that attracted the attention of Almudj. Shortly afterwards, Gulinj's sons heard a buzzing sound which they thought was made by nabiwo, the wild bees that make their nests in the ground. They were 'too hungry' for its dark sweet honey, and began to turn over the slabs of rock looking for the beehive. But from under every stone they overturned, water gushed out. It was then that they realised the sound was made by Almudj. They picked up their spears and started to look for this being. When they saw the Rainbow Snake's head rising up from the nearby waterhole, they threw spears at it, but it kept on coming nearer. In fear the boys ran towards the higher rocks, but the Rainbow Snake made a large waterhole which surrounded them and swallowed them up.

A large cloud rose above the waterhole, reflecting the colours of the Rainbow Snake's body. This was seen by Gulinj's wife who pointed it out to him, thinking that it was a bushfire. But Gulinj, when he saw the flashing colours, knew that it was not a fire. He told her that it is was the Rainbow

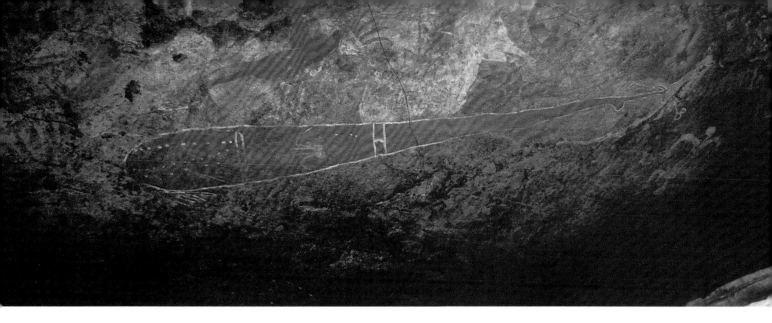

Snake who had swallowed their sons. He picked up his stone axe, sharpened it on a rock surface, placed a bent withy around it, tied it securely with a vine and cemented it in with beeswax. To test its sharpness, he cut down a tree. Satisfied with his weapon, he set off to look for the Rainbow Snake. He was then like Namarrgon, the Lightning Man. Lightning bolts flashed from his body and struck wildly out across the valley as he travelled. When he reached the waterhole where Almudj was sheltering, he killed the being with a bolt of lightning and pulled it out. Cutting open its stomach he released his sons. Afterwards, he dismembered the Rainbow Snake and threw the individual parts in different directions, naming the localities where they landed.

Some time after Gulinj and his sons had returned to their camp, the Rainbow Snake again swallowed the two young men, this time while they were swimming in a nearby creek. Again Gulinj went and killed the Rainbow Snake and rescued his sons. However, when it happened for the third time, after releasing his sons out of the Rainbow Snake's stomach, he said, 'I am Gulinj, the little bat, you are Almudj, you can go anywhere', which accounts for the presence of this indestructible being at so many localities.

One of the named localities where Gulinj threw a part of the Rainbow Snake's body is Mayawunj, the 'Dreaming Waters' on Nourlangie Creek, a large, deep waterhole in the Wilirrgu clan's estate. Originally, this was clean sandy ground, a popular campsite where people lived in shelters made from sheets of bark of the stringybark and paperbark trees. One day a young child, an orphan, was crying for food but nobody took any notice of it. Through the day and into the night the child cried incessantly for sweet food, only to be ignored. In the morning the cries were heard by the Rainbow Snake who lay in a swamp at Maddjurn bawodjmeng. The Rainbow Snake made its way to Mayawunj and drowned all the people who camped there. All that remains of their camp today is a small island, said to be the roof of one of their shelters. This Rainbow Snake was originally maddjurn, the black headed python *(Aspidites melanocephalus)*, shown

*Above* The Badmardi Almudj myth, depicted in a more recent painting of a Rainbow Snake at a site in the eastern sector of the plateau. Here it is portrayed with a short serrated tail, and with a body narrowing towards its animal head. Two eyes on long 'strings' extend from the head, while the two young boys whom it has swallowed are seen within its body. Location: Bonorlod. 300 cm.

*Below* The body of Almudj as painted by the region's artists has taken different forms over time, while still expressing the substance of the myth, particularly how this being repeatedly swallowed Gulinj's sons. Here, the Almudj myth is being painted on a sheet of bark by a Ngalkbon man.

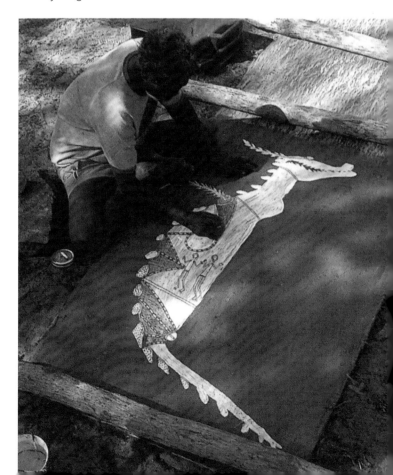

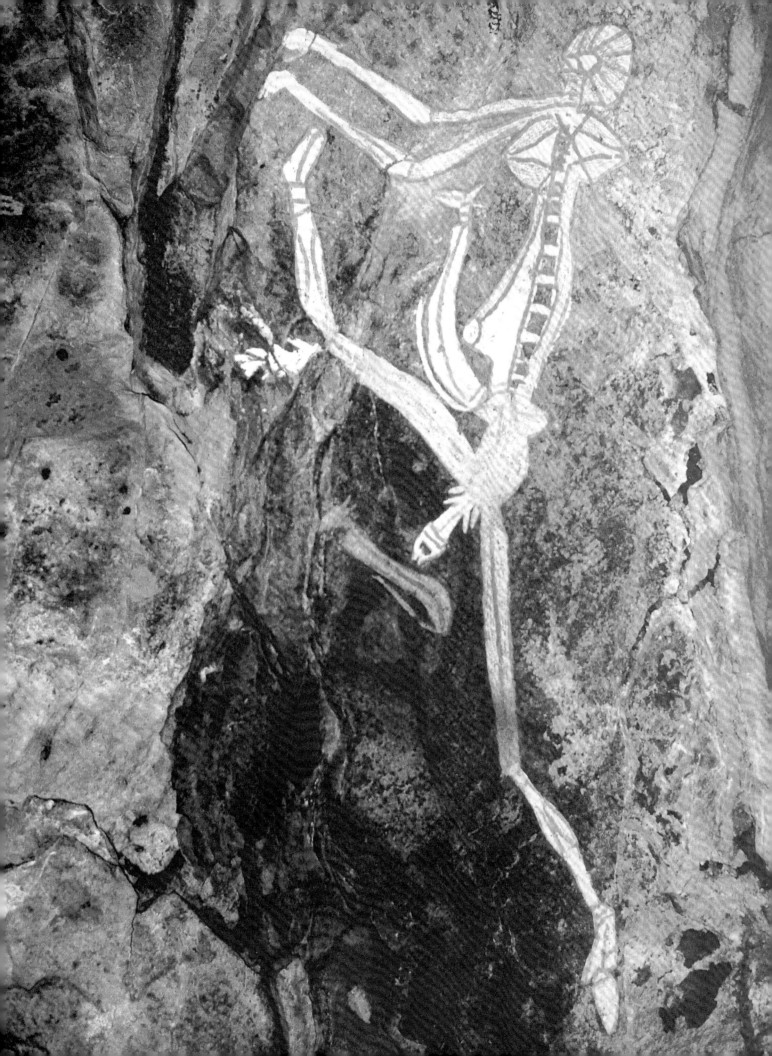

in rock paintings as a snake with four ears.

In Amurdak, Gagudju, Iwaidja and Maung mythology, the Rainbow Snake is a huge serpent which emerged out of the sea. On Goulburn Island, a site associated with this being is indicated by a pathway of rocks which it pushed aside as it crossed the island. In the modern Gagudju version, the Rainbow Snake – called Namardjedurr – came out of the sea at Mountnorris Bay, where, as she was crossing Wandalgayin (Valencia Island) she split it in half. From there, the Rainbow Snake followed Murgenella Creek inland to Walarra on the lower Cooper Creek, and then stopped at Madjigarral Creek. At that time, a large group of Amurdak people were camping further west at Warlawarla. As in the previous myth, a little child kept crying in their camp and this was heard by the Rainbow Snake. She pushed the end of her tail into the ground and 'stood up' to see where their camp was. When she pulled her tail from the ground, water rushed out, and this is now the large permanent spring called Miya in the Gamulkban clan's territory. From Miya, the Rainbow Snake went to Aburradmirrawu, near Bopo beach. It circled the ground there three or four times, making a large swamp. Again it heard the child crying. It was crying for lily root. There are three kinds of lily root: one is sour, the other two are sweet. To pacify the child – which, unlike in the previous myth, was not an orphan – its mother gave it a lily root. But the night was dark and she mistakenly gave the child the sour root instead of a sweet one. The child cried even louder. In the morning it was still crying. Suddenly, the wind rose and the people felt cold. They should have stopped the child from crying, because that Rainbow Snake was close to their camp then. The Rainbow Snake rushed in, coiled around the camp and at first swallowed the crying child. The people tried to flee, but the Rainbow Snake was so large that she swallowed them all, except for two men who escaped, and ran and hid in nearby rocks. They sat there frightened. Then a mosquito landed on one man's arm. He did not realise that he should have slapped it, as the Rainbow Snake cannot hear that sound. Instead, he pressed the mosquito against his body. The Rainbow Snake heard it squash, and came and swallowed them, too.

The Rainbow Snake then crossed the East Alligator River and was nearing Ginin, in the Bunidj clan's territory, where the Gagudju people were camped. The people could see in the distance a large number of birds of prey circling above a bright, glowing object and went to investigate what it was. As they got closer they could see the Rainbow Snake's bulging

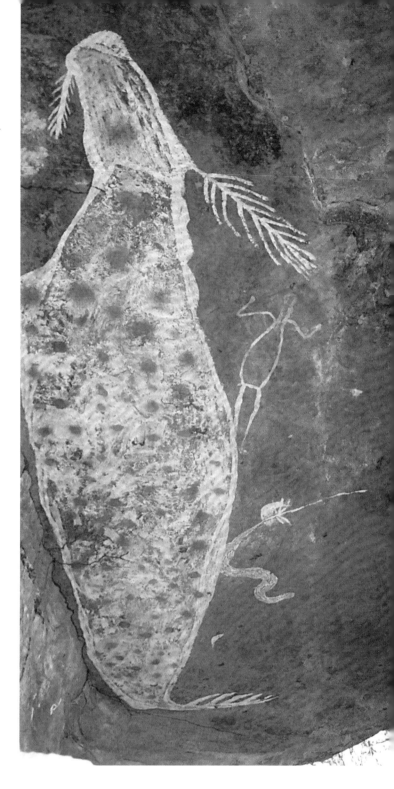

*Above* This Rainbow Snake from the eastern sector of the plateau is voluminous but it still retains its serrated tail. The head is earless and decorated with a feathered ornament, while another feather extends from its chin. The prominent bulge on its chest, glossed as the 'brisket' by informants, symbolises the opening in the body through which the Rainbow Snake swallows its victims. The red spots infilling the interior are another convention associating this being with an actual rainbow. Location: Dugulah djarrang. 450 cm.

*Below* A bisexual being depicted with one human and one macropod leg. Its body, with a prominent backbone, swells towards its navel. Attached to the stylised hips is a Rainbow Snake, while a second Rainbow Snake lies between the widely spread legs. A single namarnde plant is attached to one of the legs. Location: Anbadjawuminj. 160 cm.

51

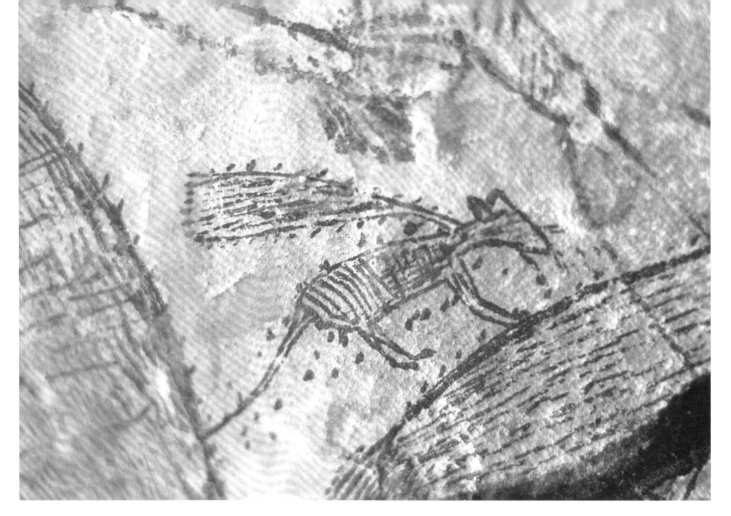

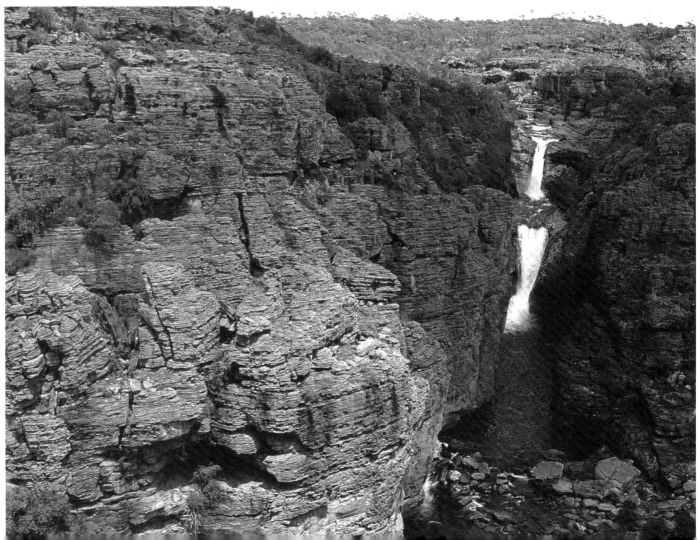

form and, guessing what had probably happened, they asked where it was that she swallowed all the people. They called the names of the localities where the different groups they knew usually camped. The Rainbow Snake did not make a sound until they mentioned the Amurdak people at Warlawarla. She then snorted assent. Angered, they killed the Rainbow Snake, spearing it from all sides with heavy stone-bladed spears. When they opened its stomach they found that all the people inside were dead. They then cut up the Rainbow Snake into small pieces and cooked and ate it. The Rainbow Snake was fat, and tasted better than dugong.

In a Rembarrnga myth, the Rainbow Snake is Yingana, the creator of all the people and animals. In the beginning, her body was heavy and pregnant with people. She first gave birth to Gorrogo, but he was lonely and wished for the other people to be released. So he killed Yingana, cut her open with a stone knife and freed them all. Later he changed into the blue-winged kookaburra *(Dacelo leachii)*. In another version, the first group that Yingana gave birth to were not people but composite beings, part-human and part-animal, or anthropomorphs with deformed bodies.

The northern Ngalkbon version identifies three men as spearing Yingana and releasing the people. These men were then transformed into the blue-winged kookaburra djigirridjdjigirridj, the willie wagtail *(Rhipidura leucophrys)* and the magpie lark *(Grallina cyanoleuca)*. The Gundjeihmi say that it was a friend of the Rainbow Snake, deudeu, now the dollar bird *(Eurystomus orientalis)*, who cut the hole in its chest with a stone blade. Water rushed out of its body and carried the Rainbow Snake's eggs to all the waterholes where this being is now found.

The Rainbow Snakes continue to have offspring. Some are born as manjdjurdurrk, the water python *(Liasis fuscus)*, which because of its iridescent skin is the being's 'shadow', or spirit, and is said to be the actual rainbow seen in the sky. Others are born as bolokko, the keelback snake *(Amphiesma mairii)*. During the period of the first storms, the Rainbow Snakes let some of these species out of the waterholes and keep the rest. The snakes which are released are not Dreaming, they are maih, food for the Aborigines.

*Opposite above* This diminutive thylacine *(Thylacinus cynocephalus)*, with a dilly bag is djanggerrk, an associate of the Rainbow Snake. Each Rainbow Snake is accompanied by a pair of these animals. Location: Landa. 12 cm.

*Opposite below* Rainbow Snakes reside in deep waterholes below waterfalls, which the Aborigines usually name after djanggerrk (one of the being's 'dogs'). At Mirbolo Waterfall, paintings that depict the animal after whom the waterfall was named and its mate, Gorrogorro, can be found in the high shelter seen in the rocks at lower left.

*Below* A representation of Mirbolol and its mate, Gorrogorro, in their anthropomorphic form. Location: Djuwarr site complex. Male figure 160 cm.

The simplest representations of Rainbow Snakes depict a snake with a macropod-like head. In the elaboration of the image, a serrated tail was borrowed from the crocodile's anatomy. The head may be decorated with a feathered ornament, and it may have prominent teeth, eyes attached to long 'strings', and long whiskers. The whiskers may be simply facial hair or may represent catfish barbels. It is said that the Rainbow Snake may use all of these features to hook and sweep the people into the opening in its chest. In the most recent representations the body has been expanded, remaining snake-like in name only. In some depictions the Rainbow Snake's body is outlined in more than one colour and may be further decorated with circular patches of pigment sprayed by mouth on to the rock surface. This patterning is said by some people to symbolise the snake's scales, though others say that it represents the iridescence of the Rainbow Snake's 'shadow' as seen in the spectrum of an actual rainbow. Similar decoration is used on representations of wallaroos and emus when they are depicted as associates of the Rainbow Snake in ritual activities.

Paintings of the Rainbow Snake with spotted infill are associated with ritual and are considered to be andjamun (sacred), whereas its other representations are secular images illustrating a narrative. Thus, there are ritual Rainbow Snakes and narrative Rainbow Snakes. The vast majority are the latter, narrative images.

The most complex depictions of Rainbow Snakes are found in the yam figures images, the earliest style in which this being is represented. The Rainbow Snake can also manifest itself as a human being – male, female or bisexual – or as a therianthrop, a person with some animal features. These 'humanised' Rainbow Snakes are sometimes depicted in rock art as giving birth to their progeny.

The Rainbow Snake usually resides in large, deep waterholes, and in all the pools below waterfalls, where its presence is signified by the spectrum created as the sun strikes the spray. It is most active during the wet season, when it brings the rains and its 'shadow' spans the sky. The light side of a rainbow's spectrum represents gandagidj, the male antilopine wallaroo, who brings the balmarradja rain from the coast, while the other side represents galkberd, the male common wallaroo, who is responsible for the gerralkgen rains which come in from the south-east. It is the galkberd who drowns young people – those whose facial hair has not started to grow, and those without cicatrices – as they attempt to swim rivers in flood.

The close association of the Rainbow Snake and the wallaroos is described in several Nagorrgho myths. In some versions, it is the Rainbow Snake who sends the two wallaroo species living in the waterhole back out on to the land for the people to hunt and eat.

It is said that the Rainbow Snakes have as their companions djanggerrk, described as 'dogs' but identified in rock paintings as the thylacine or Tasmanian tiger (*Thylacinus cynocephalus*). The cicatrices across an initiated person's chest are said to be similar to the dark stripes marking the rear part of this animal. When the people cross the flooded streams during the wet season, the djanggerrk swim alongside, protecting them from galkberd. Further protection against young people drowning is sought from the Rainbow Snake during the ubarr ritual. The ceremonial ground, which also represents the body of the serpent, is repeatedly stabbed with sticks, as the participants in the ritual symbolically threaten the Rainbow Snake not to harm their young.

Rainbow Snakes that live in the deep splash pools below the waterfalls have a pair of these dogs, a male and a female, as their associates. The locality itself is usually named after the male dog. At the head of the Djuwarr Gorge is the Mirbolol Waterfall. There, the two spirit dogs, Mirbolol and Gorrogorro, are painted in a shelter adjacent to the fall.

## *Nagorrgho*

After warramurrunggundji concluded her creative task, Nagorrgho and a group of protean beings accompanying or meeting him along his path brought the religious aspects of the region's culture and instituted the social systems used by people today. It was the period now described as the time when 'all that Dreaming was moving about', when the 'First People brought our culture'.

There is some divergence of views as to whether there were one, two or more Nagorrgho figures, and whether or not they were accompanied from the beginning by their wives or married them later. The northern myths relate how Nagorrgho emerged from the sea in Malay Bay and describe his journey as far as the Bulman waterhole in the Ngalkbon language group's territory. Other myths specify that he went further south to the Roper River, or even that he and his group continued to the land of the Djingili people in the region of the present-day township of Elliott.

The Croker Islanders say that there were two groups of these beings, each consisting of a man, his wife and his father.

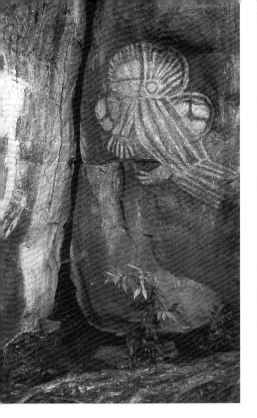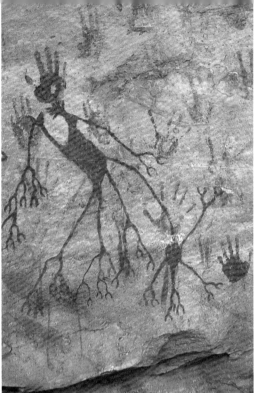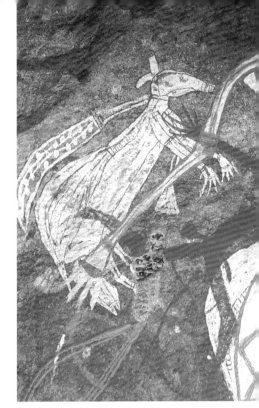

*Left* This owl-like creature represents Mandjawilbil, one of the creator beings, now the koel (*Eudynamys scolopacea*). It was this being who divided the people and their universe into two moieties and brought the marrayin ceremony to the many groups of the region. Location: Yuwunggayai. 85 cm.

*Middle* This many limbed and branching subject is Nadjurlum, the Dreaming of the destructive winds, glossed as 'whirlwind'. Location: Dangurrung. 23 cm.

*Right* Yok, the bandicoot (*Isoodon macrourus*), seen here with a dilly bag and exaggerated penis, was also once a human who participated in the activities of the Dreaming. Location: Namarrgon site complex. 52 cm.

They state that the Nagorrgho entered their island at Cape Croker, from where they made their way to Wurrudja (Grant Island). The two groups of Nagorrgho came separately and did not know of each other's existence until their first night on the island, when they saw each other's campfires. When they met the following morning, they talked Margu, the language of the two islands. They discussed the ceremonies which they were carrying in their dilly bags and their destinations.

On parting, one group of Nagorrgho went east to the Liverpool River, where the Gunavidji people of today, far from Cape Croker and Grant Island, retain the Margu 'feeling'. This Nagorrgho story is also given as the reason why the Gunavidji people, like the islanders, do not circumcise. The people from the south-eastern margin of the plateau identify Balpanarra in the Gunavidji estate as the site of origin for these creator beings.

The other group of Nagorrgho left for Arrambidj, on the mainland. Standing on the beach the man looked back and in the distance saw the outline of the island they had left. He was sad that he was leaving the island and also the Margu language, and sang 'Wurrudja ngawu ngawu' – 'I am leaving Grant Island' – a line which to the present day is still part of

the kunapipi song-cycle. Before continuing his journey, the man sent his father back to Croker Island where he was to remain and look after a dangerous Rainbow Snake site. Now speaking Iwaidja, the man and his wife went further inland.

In the Iwaidja version, the Nagorrgho were two men, father and son, who came out of the sea in Malay Bay, as had Warramurrunggundji before them. They brought with them short bamboo spears. The son looked back over the sea to where they had come from, hooked the spear in his spearthrower, and threw it. As it landed on Indjurrangan (McCluer Island), it embedded itself deeply in the soil. That is given as a reason why the bamboo now grows on that and no other island of the northern coast. The men 'carried' the kunapipi ritual with them. As they travelled through the land and came across different animal species or passed significant locations, they made songs about them which are now part of that ceremony. Eventually, they crossed the 'stone country' to where the Ngalkbon people live and gave them the kunapipi ceremony. They married Ngalkbon women of the right subsections, but, not too long after they were married, the father told his son that they should kill their wives. He said that the women wanted their ceremony, and if they did not

kill them first, they themselves would be killed. The location where they killed their wives is a dangerous site now, a deep spring of poisoned water. Afterwards, the father and son returned to Croker Island, where they remain to this day as a rock outcrop above a sandy beach. To the Margu people, this is a njunjuk (a dangerous site). When people hunt in that vicinity, they are careful not to throw blood from gutted fish or turtle into the sea, as this action could cause an intense storm to develop.

The Ngalkbon people say that Nagorrgho was a father with his son and their two wives, who came from Balpanarra, a coastal area to the east of Maningrida which is shared by the Djinang, Nakarra and Gunavidji people. After the Nagorrgho group passed through the Ngalkbon's estate, they went further south to the countries of the Warramumu, Djingili and Walbirri people. On their journey, the Nagorrgho carried a number of birrgala (boomerangs). As they walked through the land they threw the boomerangs to different parts of the country, thus creating large, deep waterholes as they landed.

In the Gundjeihmi version of this myth, the Nagorrgho was an old man who came into their land carrying large dilly bags made from gundirdde, a tall grass which grows in the 'stone country'. In these he carried the marrayin, morak and djambarl ceremonies which he gave to the local people, and also the kunapipi which he took across the plateau to the Roper River. He is said to have been accompanied by a number of associates, one of whom he left as djarrlung, the king brown snake *(Pseudechis australis)*, at Djidbidjidbi, now a sacred dangerous site in the Mirarr clan estate. It was marrawudi, the white-breasted sea eagle *(Haliaeetus leucogaster)*, one of his companions, who created the Mirarr group of people and impressed his will on the landscape, and who is now the Mirarr Dreaming. At the same time another member of Nagorrgho's group, nawurrkbil, the whistling kite *(Haliastur sphenurus)*, was responsible for the neighbouring Dadjbagu clan and its estate.

Gurrih, now the blue-tongued lizard *(Tiliqua scincoides intermedia)*, also accompanied Nagorrgho. When crossing the Yarranggulnja saddle, between what is now Mt Brockman and the Nourlangie Rock massif in the Godjgarndi-Warramal clan territory, Gurrih slipped and fell on his face, hurting his tongue. He looked back towards the passage, changed into a blue-tongued lizard and 'put himself' on the rock now called Gurrih birrangdoi (literally, 'blue-tongued lizard hurt his mouth'), which is one of his Dreaming sites. Later, he travelled across the country to the Bulman waterhole, calling out the names of the Dreamings which were to stop at the localities he was passing.

Meanwhile, Nagorrgho, continuing on his journey, came to Andjenjdjok gabuldi, a locality where a creek emerges out of the escarpment through a narrow gorge. There, at the base of the cliff, are engravings of animal and bird tracks so old and worn that they are said to have been executed by him. Further on, in Balawurru (the Deaf Adder Creek valley), Nagorrgho met a group of mythical figures who had come from Marrabibbi, the locality where the Wildman River enters the sea. They came to find out from him what was to be their role. There was Nadjamulu and Nadjamborro, now gandagidj and garndalbburru, the male and female antilopine wallaroos *(Macropus antilopinus)*. When narrating myths, the local Aboriginal people describe these macropods as the 'plains kangaroos'. Other mythical figures in the group were Wopal, now galawan, the Gould's goanna *(Varanus gouldii)*, and Mandjawilbil, the koel *(Eudynamys scolopacea)*, whom the people now call djowog. From the south-east, where the Rembarrnga and Ngalkbon groups live, came galkberd and wolerrk, the male and female common rock wallaroos *(Macropus robustus)*.

During their time together they talked about the ceremonies and what each of them was to do. Nadjamulu said that he and his mate were looking for the right places to leave the lorrkgon and ubarr ceremonies. They had already left ubarr at several sites along their journey. The location where they all met became the lorrkgon ceremonial ground, and two more ubarr sites were left in the Deaf Adder Creek valley. In one deep, well protected shelter, rock paintings record their passage through this valley: here, to commemorate their visit, the 'plains kangaroos put themselves' on its wall. From there Nadjamulu, carrying the two ceremonies, followed galkberd and wolerrk to the Wilton River Gorge, their place of origin, while Nadjamborro took the ceremonies to the Jawoyn people.

Mandjawilbil and Nadjamulu were also told by Nagorrgho how to structure Aboriginal society and establish social rules and order. Mandjawilbil divided the people and everything within their universe into two halves, the moieties, which Nadjamulu further subdivided into smaller social units. Later, Nagorrgho gave the marrayin ceremony to Mandjawilbil and asked him to take it back north to the Maung and Gunwinjgu people. In another version of this myth, Mandjawilbil is said to have actually stolen this ceremony and taken it to the Gunavidji speakers on the

Liverpool River. Nagorrgho then continued on his own, carrying the kunapipi south to the Roper River. At Wuymul, a waterhole filled by a large, deeply welling spring, the Nagorrgho planted pandanus palms, one for every person living around and across the Arnhem Land Plateau. Here they remain, grouped around the banks in clan and language units. The passage of Nagorrgho across the land is now reflected in the night sky as mayombolh (the Milky Way).

The Ngalkbon people say that a group of 'plains kangaroos', males with white cockatoo's feathers on their heads, came to their country from Madjawarr, a coastal site in Iwaidja country. One of the kangaroos separated from the rest of the group and followed Kungurul (the South Alligator River), to its watershed, planting a single bamboo at Pulpul, and then went on to Ngardluk (the Katherine River), and followed the stream down to where it leaves the 'stone country' through the spectacular Katherine Gorge. On its way, the actions of this gupu (as this species is called in Jawoyn) and those of garrkkanj, the brown falcon *(Falco berigora)*, created the dangerous hula sites located in that part of the Jawoyn land. In the Ngalkbon people's version of this myth, like that of the Gundjeihmi, the main group of kangaroos turned eastward into Deaf Adder Creek valley. The first lines of the lorrkgon song-cycle in the Ngalkbon ritual are: 'Balawurru barradad, Balawurru barradad, Balawurru, Balawurru barradad', commemorating the beginning of the journey of the 'plains kangaroos' across the plateau to Borlungbim, a large rock shelter near the source of the Wilton River in Ngalkbon country. At Borlungbim (literally, 'painting of a Rainbow Snake') they met a group of kangaroos who were making their way north. This band of kangaroos came from the coast near the mouth of the Roper River. They asked each other what language they spoke, discussed the 'business' they were carrying and the clan groups through whose estates they had travelled and named, and also asked about the social systems they had instructed people to follow. After parting, the band of 'plains kangaroos' that had journeyed from the northern coast now continued on to Gunjbuluk, situated on the shores of the Gulf of Carpentaria in the Ngalakan language group's country, which is now their Dreaming. Meanwhile, the kangaroos that had originated at Gunjbuluk crossed the plateau and the subcoastal plains and continued on to the tip of Cobourg Peninsula, where they became the Gunjbuluk Dreaming. Before leaving the Ngalkbon country, representatives of both groups left their images at Gugadubim (literally, 'painting of a male antilopine wallaroo'), commemorating their ubarr ceremony.

During their journey, the females of the group travelling south were continuously giving birth to young, which either moved into the countryside to become the 'plains kangaroos' of today or went into the waterholes and became Borlung (Rainbow Snakes). At Borlungbim, there is a painting of a large kangaroo with a feathered ornament on its head, superimposed by a painting of Borlung, the Rainbow Snake, emphasising their association. It is possible that this myth may account for the usual portrayal of the Rainbow Snake as a serpent with a kangaroo-like head. In one Ngalkbon version of this myth, the 'plains kangaroos' were actually accompanied on their journey by the Rainbow Snake, which travelled underground.

Garrewakwani, the ancestral past, continued after Warramurrunggundji, Almudj and Nagorrgho and his associates populated the landscape and introduced the 'law'. The time of Nayuhyunggi, the cosmogony, was not yet over. In the south-western margin of the plateau, a myth recalls the activities of Morkul-kau-luan, the Spear-grass Man.

## *Morkul-kau-luan*
### THE SPEAR-GRASS MAN

The Dagoman people say that the tall spear grass, which towards the end of the wet season may reach 4 metres in height, was brought to them by an ancestral being whom they call Morkul-kau-luan. They know what he looked like because his image gazes out over the countryside from where he placed himself on a slightly protected wall of a small residual rock.

Morkul-kau-luan is a very shy being who lives in the long grass, never venturing out into open spaces. He has a slightly stooped figure, a consequence of trying to move through the grass without being seen. When walking about he keeps his eyes partly closed to avoid the sharp twisting awns of the seeding spear grass and to keep out the sun's glare, which is too bright after a season in his subterranean home. Around his waist he wears the wide hairbelt that the Dagoman place on young boys during initiation ceremonies. His voice, a variable humming sound, can be heard during these ceremonies and also sometimes when the south-easterly winds shake the seeds out of the grass heads, piling them against obstacles ready for collecting. Only 'clever men', those gifted with special powers, can occasionally catch a glimpse of this being, with his long pointed nose, and distinguish him from the grass seed awns.

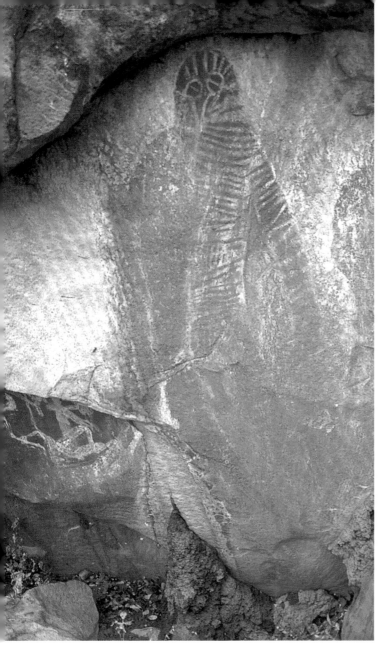

Morkul-kau-luan, an ancestral being who is credited with the introduction of the cereal producing sorghum species. The figure was executed first as a red silhouette, which then was outlined and had its features, the partly closed eyes and its long nose, detailed in white. The wide hairbelt is indicated by vertical lines, while the rest of the body with the exception of the phallus is decorated with white horizontal bars. Location: Bardugban. 175 cm.

During the bushfires of the dry season, Morkul-kau-luan seeks refuge in the deep limestone caverns found further to the south. He is known as a kind and generous character who helped those who were lost and hungry. The Dagoman say that he left his 'shade' (his portrait) so that the people would know that he always will be in the grass of the wet seasons, ready to look after them.

The spear grasses brought by Morkul-kau-luan are indigenous species of the *Sorghum* genus. In the Katherine area, where the painting of this ancestral being is situated, *S. intrans* and *S. plumosum* are the two most common species.

Although their seeds are small and enclosed in harsh glumes and long tough awns, Aborigines in the past harvested and cleaned them. The seeds were then ground, mixed with water into a dough, and cooked in hot coals. This original damper, known as morkul, was a popular food before the introduction of flour. Both the myth and the rock painting suggested to W. Arndt, a CSIRO agricultural officer who was the first researcher to record them, that this food was of considerable importance to the Dagoman people.

Not all of the Nayuhyunggi were benign creator beings. A number of the 'First People' remain as the fearful and punitive personages of the Aboriginal universe, their agents of destiny. Some punish only those who wilfully disturb their sites or transgress social dictums, others are the embodiment of evil – non-human, and unpredictable. Like all the other spirit people, these beings are visible only to the 'clever people' and to sorcerers. The details of their activities and behaviour, as well as the manner in which they are represented in rock paintings, vary from group to group. They were usually painted to illustrate a story or to substantiate a personal encounter with such a being.

## Namarrgon
### THE LIGHTNING MAN

Namarrgon, the lightning man, like so many of the 'First People', entered the land on the northern coast. He was accompanied by his wife, Barrginj, and their children. They came with the rising sea levels, increasing rainfall and tropical storm activity. The very first place where Namarrgon left some of his destructive essence was at Argalargal (Black Rock) on the Cobourg Peninsula. From there the family members made their way down the peninsula and then moved inland, looking for a good place to make their home.

Passing Marrkala and Guyuguyir, they rested for some time at Yirriyu, a stark and prominent rock where Namarrgon again left some of his potent force. Further south, they stopped at the Wugulumu waterhole near Nimbuwah, a place Namarrgon liked and which is said to be one of his Dreamings. During the dry season, one of his descendants leaves this waterhole and collects food in the surrounding monsoon rainforest, where the garnbanj, cabbage palms (*Carpentaria acuminata*), are plentiful. The people living in that area are warned that if they venture into this jungle environment, they are not to touch the cabbage palms, even

Namarrgon, the Lightning Man, reached Cobourg Peninsula and the plateau region with the first storms of the north-west monsoon, after the seas rose at the end of the last Ice Age.

Alyurr, the spectacular brilliant orange-red and blue grasshoppers (*Petasida ephippigera*), active at the beginning of the wet season, are Namarrgon's children.

though young palm hearts are a favourite bush food. Another of Namarrgon's Dreamings is at Ngugurrumu. In the nearby Gubalga shelter the members of the Madjawarr clan, in whose estate these two Dreaming sites are located, have depicted this being in a number of unusual forms.

Leaving Ngugurrumu, Namarrgon and his family followed the escarpment to the Liverpool River, where he left some more of his power. They then entered the 'stone country' and made their permanent home at Bolkngok in the estate of the Mayali-speaking Rol clan's estate, between the Mann and Liverpool rivers.

From Bolkngok, Namarrgon was to make one last journey. He walked across the plateau to its western edge and looked over the sheer walls of the escarpment. He took one of his eyes out and placed it high on a cliff face, where it stares in the north-westerly direction awaiting the next monsoon. His

*Left* Namarrgon, the Lightning Man, with the usual stone axes held in his hands and protruding from his head, and white marks within the lightning band suggesting accompanying rain. Location: Madjana. 99 cm.

*Middle* This partial figure of Namarrgon, the Lightning Man, from the Anbangbang shelter is an Australian example of a universal motif of the half-sided spirit being. Elsewhere, such representations are said to have been based on the belief that the right half of the body is of greater importance than the left. In this instance, the reason for the partial depiction of the Lightning Man's body is not known. Location: Anbangbang. 70 cm.

*Right* The largest depiction of Namarrgon yet located, associated here with a death adder and a short-necked turtle. Location: Madjana. 210 cm.

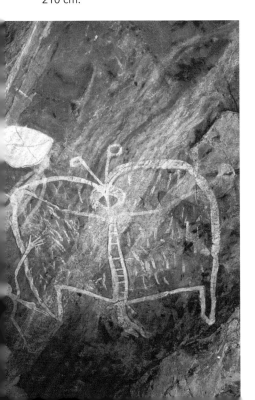
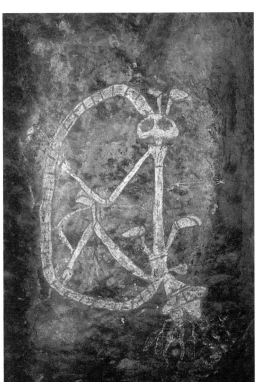
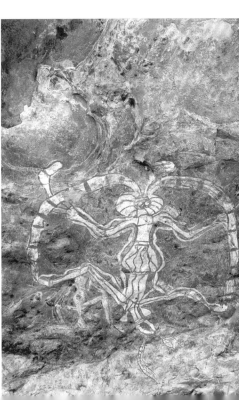

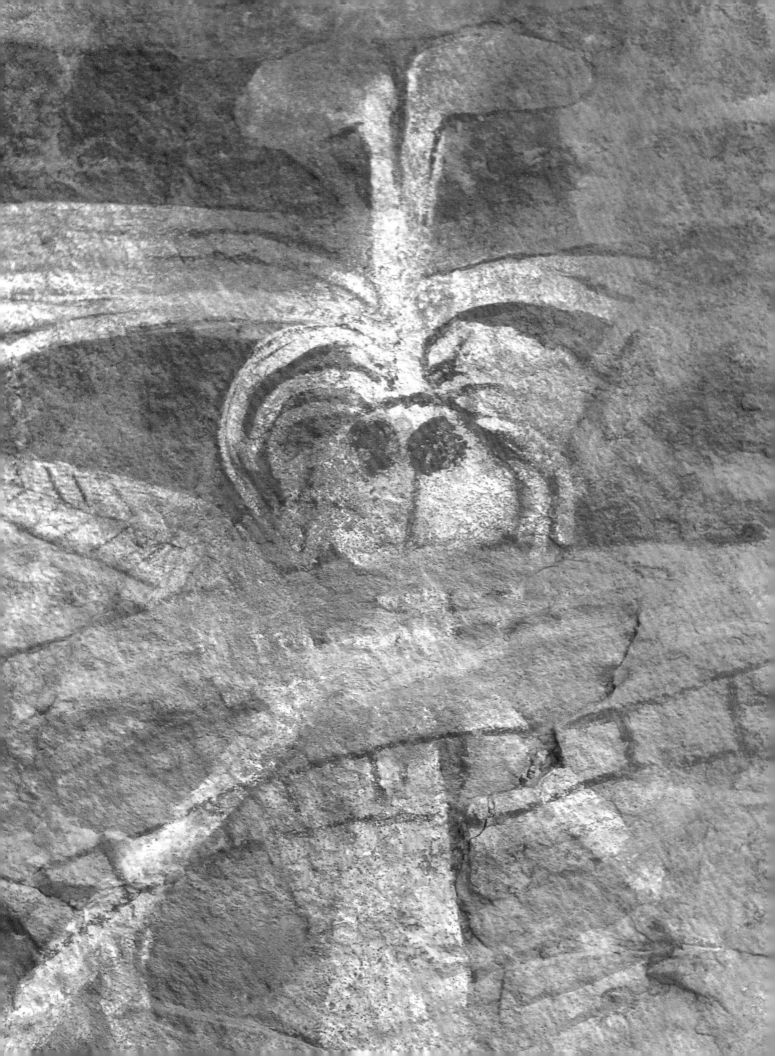

visit imbued that place with his spirit. Although he returned to his home at Bolkngok, Namarrgondjahdjam in the Godjgarndi clan's estate, which he visited, is, like all the other sites associated with him, a dangerous locality that should not be disturbed.

On his return to Bolkngok, Namarrgon sent his children to many parts of the plateau where they are now active during the wet season. They were at first djabbe, common grasshoppers, but Namarrgon changed them to alyurr, spectacular grasshoppers *(Petasida ephippigera)*. This insect was discovered for European science by Ludwig Leichhardt during his crossing of the plateau in 1845 and became known as 'Leichhardt's grasshopper'. It is a brilliant, bright orange-red and electric blue insect which emerges, mates and is most active during gunumeleng, the season of the first rains, when it can be found feeding on an aromatic perennial herb *(Pityrodia jamesii)*. As it feeds, it gains the strength needed for its activities during the forthcoming intense electrical storms.

In the rock paintings, Namarrgon is usually portrayed with stone axes protruding from his head, elbows and knees, though the axes may be attached to any part of his body. A striped band, replicating Alyurr's bent antennae, extends on each side of his body from head to toe, representing bamaihgeng (the lightning). The stone axes are used to split the dark clouds, when he shakes the earth with lightning and thunder. He is capable of causing widespread devastation by arriving with a storm, shattering and uprooting trees, and frightening both the Aboriginal people and the Mimi, who bury their own stone axes in order to not attract the fury of this being. Sometimes Namarrgon strikes and kills people. Young Nym, the son of Nym Djimongurr, one of the last rock painters, was struck by lightning at the East Alligator River in 1970. His death was attributed to a marrgidjbu (a 'sorcerer'), who has the power to call on Namarrgon to strike a person whom he wishes to kill. When executing a sorcerer's bidding, Namarrgon is known as Angarni.

The recorded myths about this being – as, perhaps, with those about all the other 'First People' – are only segments of a fuller story. Some of the rock art images found across the plateau depict Namarrgon in his usual male form, others show this being as a female, or even an animal-headed

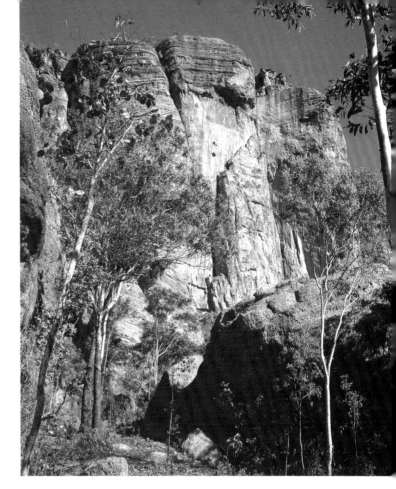

This is Namarrgondjahdjam, a prominent feature which commemorates Namarrgon's journey. He is said to have looked over the escarpment, leaving one of his eyes behind. This is now the circular hole seen high up in the cliff's face. In the past, children were warned not to throw stones up against the rock here, as such action could bring on the Lightning Man's wrath.

hermaphrodite, suggesting that many more details of the mythology existed in an earlier, more stable time.

## Namorrorddo

Namorrorddo, a malignant spirit, a ghostly, spectral figure, is another being that came from the northern coast, accompanied by a friend who is now gurrgurldanj, the mound-building scrub fowl *(Megapodius freycinet)*. They made their way to Balbbun, a prominent feature in the escarpment near Jim Jim Creek, which was the home of Algaihgo, a female mythic figure. The two males 'came on too strong for her', so she left the place and moved further into the plateau. Balbbun then became one of Namorrorddo's Dreaming locales.

Namorrorddo is usually portrayed in rock paintings as a very tall, thin and extremely elongated being with long slim arms and legs, and with claws instead of fingers and toes. It is not unusual to find images representing this being that are more than 8 metres long. He moves about only at night, when he may be seen for a split second rushing across the

*Opposite* Namarrgon is the second most commonly depicted ancestral being in the region's rock art, and is represented in a number of different forms. This staring creature with floppy hair and two stone axes sprouting out of his head is from the Yuwunggayai shelter.

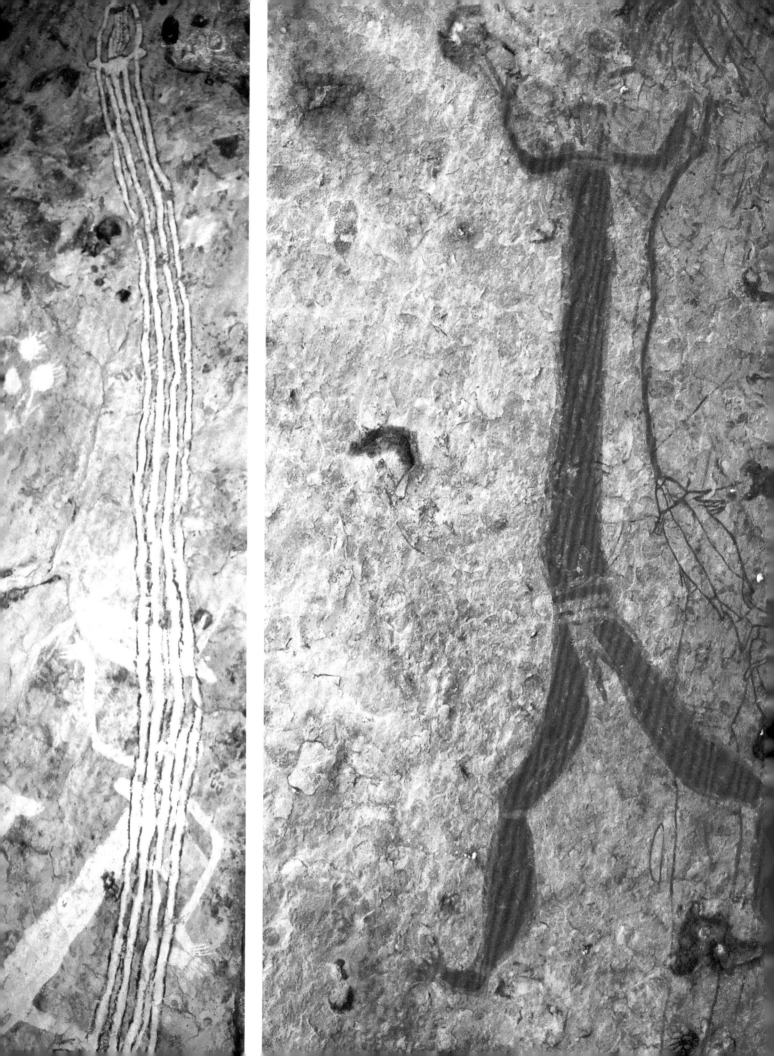

sky. When the people see the trail of a falling star they know that it is Namorrorddo going to a locality where somebody is dying. He is said to fly in search of sick people, waiting to rip open their chest, take away their 'breath' and carry away their heart. The brighter the star, the more important is the dying person. When a person dies during the day, their 'shadow' is taken away by birds who are said to be Namorrorddo, or who act on his behalf. They are garrkkanj, the brown falcon *(Falco berigora)*, marrawudi, the white-breasted sea eagle *(Haliaeetus leucogaster)*, and namaddol, the wedge-tailed eagle *(Aquila audax)*. Namorrorddo is also an agent of sorcerers and people who desire to cause others harm. Although he does not hurt healthy people himself, he carries with him bunbun, a string with which he strikes a victim, marking that person for the Rainbow Snake or for ginga, the estuarine crocodile, to kill.

To the Gagudju, Namorrorddo is known as Djunggalaya and is the subject of a specific local myth. In the past, Gagudju children were warned that if they saw a man dragging a line with lots of fish they should not steal any. When they asked why, they were told that fish is Djunggalaya's favourite food. As he catches the fish, he threads them on to a vine which he then pulls behind him as he returns to his camp. One day some boys saw him pulling the line of fish and, sneaking up, cut the vine in half. They took the stolen fish to the shelter where they camped with their families. When Djunggalaya realised what had happened he went and rolled a large rock, blocking the shelter's entrance and trapping all the people inside. Now a shallow overhang is all that remains of the once deep recess.

A painting of this being as he appears in the Gagudju myth is found on a ceiling of a shelter at Ubirr, though the incident which the tale describes occurred several kilometres to the north at Amarrkanangka (Cannon Hill). In 1956 Charles Mountford reproduced a photograph of this figure, which he was told represented Nabarakbia, a being who was always trying to steal the spirit of sick people, a practice associated with Namorrorddo's activities elsewhere in the region. It is possible that Nabarakbia was the name of this being in one of the now extinct local languages, perhaps Mengerrdji.

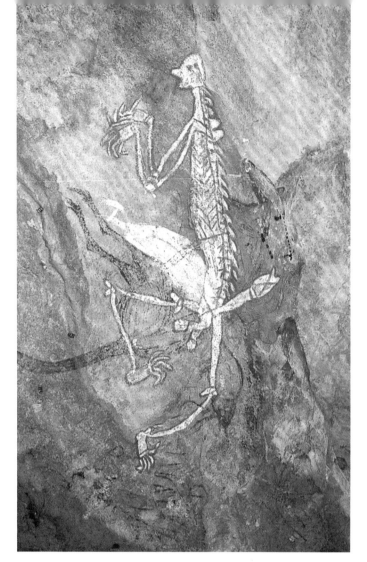

Namarnde is also used as a term for a corpse, depicted in rock art with an exposed backbone and protruding shoulder blades, suggesting a period of wasting or decomposition. Location: Djurlirri. 135 cm.

## Namarnde

The number of malevolent spirits living in the escarpment gave the plateau a menacing reputation. To people living outside this region it is 'devil-devil' country, best to be avoided. The most feared of these malignant spirits are Namarnde, the eaters of human flesh, who are frequently depicted in the rock paintings of the region. They are usually portrayed as male or female figures and occasionally as bisexual beings, with angarnbubbu, anbinjdjarrang and andjalwan – unidentified plants referred to as 'namarnde plants' – suspended from their elbows and knees or emerging from their mouth, penis or vulva. When one of these beings comes across a dead person, it takes one of the namarnde plants, puts the bulb

*Opposite left* Namorrorddo, a malignant spirit who steals the breath and soul of the dying, is usually depicted with elongated body, arms and legs. Location: Amurdak. 180 cm.

*Opposite right* In a Gagudju myth, Namorrorddo was known as Djunggalaya. He is represented here as a tall being dragging a line of fish. Charles Mountford recorded this painting as depicting Nabarakbia, a spirit with similar characteristics to Namorrorddo. Nabarakbia was perhaps the Mengerrdji name for this being. Location: Ubirr site complex. 220 cm.

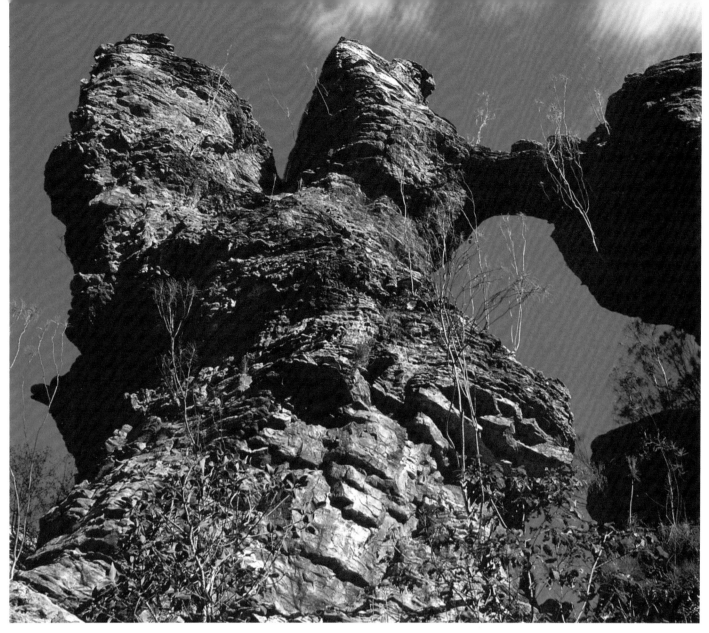

It is said that the Namarnde are born from the swellings on a tall, sparse shrub *(Platysace arnhemica)*, which grows on the steep faces of the escarpment.

in its mouth and, vibrating it, calls to attract all the other Namarnde to come and share in the feast. These harmful spirits are occasionally depicted carrying dilly bags into which they place the internal organs of the deceased, and sometimes they are portrayed with human bones hanging like pendants from their elbows and knees. 'Namarnde' is also a term used for a human ghost and a corpse, while the skeletal remains are called namarnde gunmurrung (literally, 'Namarnde's bones').

Namarnde are said to live in the many deep caverns and hollow trees found throughout the region. They leave their homes in the evening to wander about the land during the night, returning to their shelters in the early dawn.

The progenitor of all the Namarnde has his Dreaming at Anmaamnenemi, a cave in the entrance to Balawurru (Deaf Adder Creek valley), where the estates of the Badmardi and the Warramal clans meet. Later, he crossed the plateau and 'sat down' at Anmaamnurrkmi in the Jawoyn-speaking, Bagla clan estate. These sites and their immediate vicinities are considered dangerous and are to be avoided. The Namarnde living at these two locations call out to people, enticing them

*Opposite* One of the many great compositions found in the region's rock art. The undulating figures are on the ceiling of a sloping overhang and their perfect execution suggests the work of a master. The upper female figure with a hook-shaped head full of teeth and a protruding tongue holds a double string in her hands. Her body curves to the widespread legs and exposed vulva, which is in contact with the phallus of a male seen below her. The male holds a string bag in the hand of a disarticulated arm. The upper part of the body curves on to the lap of a female who is of a different colour from the other figures. She is shown headless, and also lacks hands, while her legs are joined to the body by tendons. The meaning behind this composition with sorcery overtones is not known. Charles Mountford identified this group as being Namarakain, malignant spirits of similar disposition to Namarnde. Location: Amarrkanangka. 105 cm.

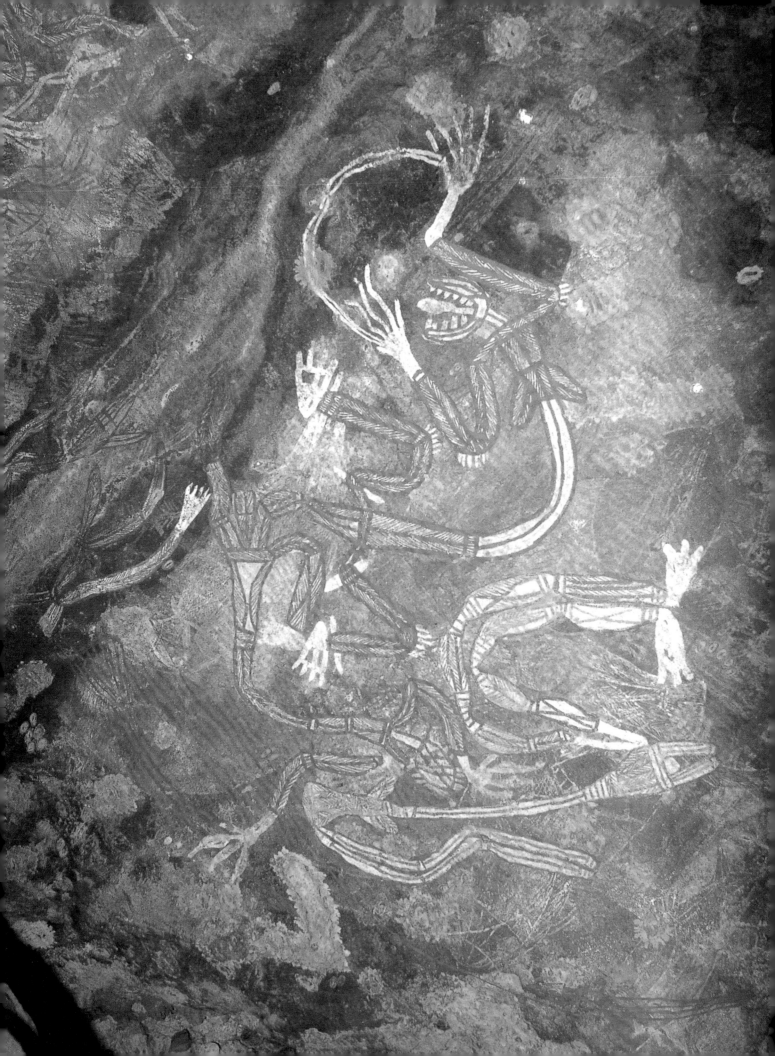

to come closer into the shelters, but, once inside, the caves close behind them. They also kidnap people and carry them into their caves.

Although their progenitor was one of the Nayuhyunggi, the Namarnde's spirits are now found within – and they are born from – the swellings of andjalkgardbam, a tall and sparse escarpment shrub *(Platysace arnhemica)*. Young women are warned not to go near such shrubs or they may give birth to a devil.

Other than human flesh, the Namarnde are said to eat the gum of anbidjanga *(Blepharocarya depauperata)* and anmarabula *(Terminalia carpentariae)* trees, and the tubers of anbonekinj, an unidentified plant which is said to have an unpleasant odour. Namarnde are invisible to ordinary people, but their presence in the environment is revealed during the first storm time, when their faeces may be found lying on the rocks of the plateau.

Algaihgo, a malignant female spirit, is depicted here as a four-armed figure. The feather-like decorations on her head may represent the flowers of the yellow bottlebrush tree *(Banksia dentata)*. Location: Nanguluwurr. 42 cm.

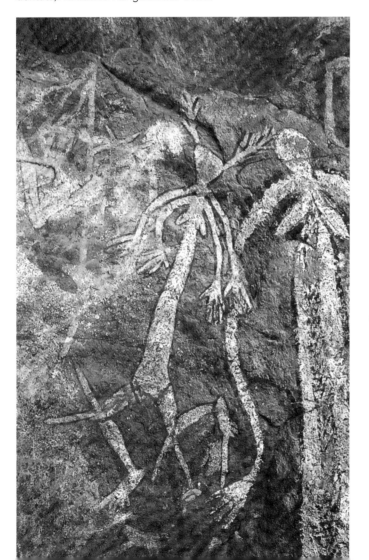

## Algaihgo

Algaihgo is a malevolent female spirit who burns and kills people: The only way to escape from her is to run towards white sandy ground or trees with white trunks – anbernbern, the white gum *(Eucalyptus papuana)*, or angomborloh *(E. dichromophloia)*. She calls these trees 'cousin' and, according to an avoidance relationship – a code of behaviour reflecting what is considered to be proper conduct between kin, usually either forbidding communication or limiting it to a special language – is not supposed to look at them. Algaihgo's favourite food is rock possum, which she hunts with a large pack of namanak and ngawu, red male and black female dingoes. She is an associate of Namarrgon, the Lightning Man. Her myth corroborates the belief that the origin of fires is due to lightning strikes.

Algaihgo was forced out of her original home at the base of the escarpment by Namorrorddo. She moved further into the 'stone country', where she made her Dreaming amongst a group of weathered residual rocks. This is andjamun, a dangerous place, not to be entered. Some years ago, during a survey of plateau sites, we inadvertently came across her Dreaming site. On returning to our helicopter we found that not only would it not start, but both the radio and the emergency beacon were also out of action. Kapirigi, my knowledgeable and constant companion who as a child had been lost for a week in the same area, attributed this malfunction of all instruments to our transgression of this site. After we walked out of the plateau, the search party found the abandoned helicopter burnt, reinforcing and confirming his belief that it was all Algaihgo's doing.

In rock paintings, Algaihgo may be portrayed with four arms, or with a head like a cone of guibuk, the yellow bottlebrush tree *(Banskia dentata)*, or with fire buds along her body which she uses to burn her victims.

It is said that this being planted the banksias throughout the region. Such an association between the plant and Algaihgo is given as the reason why its dry seed heads, used to carry fire between camps, smoulder for such a long time.

The 'stone country' is also inhabited by a number of spirit people who are said to have been created by Nagorrgho during his journey. In the beginning, they were bininj (ordinary people), but later they became Mimi, Nagidjgidj and Ngukdjarrang spirits. Although spirits, they continue to lead a life very much like that of the Aborigines. If not provoked, most of them remain shy and harmless, but at

times they may be mischievous. They are invisible to almost all ordinary humans except for nagurdangyi, the 'clever men', who can see them and communicate with at least some of them. Of the three groups of spirit people, the Mimi are both the best known and the most numerous.

## Mimi

The mimi are tall and slender like the djarngele, the fine-leafed fan palm *(Livistona inermis)*, growing in the escarpment, which is also their home. Their necks are so thin that they would break if the Mimi ventured out of their rock shelters in a strong wind. Even in a slight breeze the Mimi have to face into it, bracing themselves. They have remarkably keen eyesight and hearing. When the Mimi detect approaching Aborigines, they speak to or blow on to a rock which opens to admit them and then closes again. Their 'dogs' (or pets) are the many animals who live in their 'stone country' environment: djorrkgun, the rock possum *(Pseudocheirus dahli)*; badbong and nabarlek, the rock wallabies *(Petrogale brachyotis* and *P. concinna)*; barrk and djugerre, the male and female black wallaroo *(Macropus bernardus)*; nawarang, the rock python *(Morelia oenpelliensis)*; gowarrang, the echidna *(Tachyglossus aculeatus)*; and wayangbanjdji, a gecko *(Oedura sp.)*. The Mimi are very fond of their pets, but do hunt the 'wild' animals of these species, using andanj (a three-pronged multibarbed spear). They also eat the fruits of anmorre, the sandstone pandanus *(Pandanus basedowii)*, anburre, the 'bush potato' *(Adenia heterophylla)*, andidjgangu, the aroids *(Amorphophallus galbra* and *A. paeoniifolius)*, and the honey of nabiwo, the wild ground-nesting bees.

The Mimi taught the Aboriginal people many of their present-day skills. They showed them how to hunt, cut up and cook animals, and they composed songs and dances for their open ceremonies. They are also said to have been the first to paint representations of people and animals in the rock shelters, the Aborigines having learned this skill by copying some of the original Mimi designs. The red pigment the Mimi used was made from the menstrual blood of their cousins, mixed with the white of relic wasp nests which they scraped off the shelter's wall. As the majority of the early rock paintings were executed, or remain, as images in red, depicting subjects no longer portrayed or even present in their environment, and as they are in many instances situated beyond the reach of man's hand, the Aborigines consider that they were executed by the Mimi spirits. They say that the

The only definite representation of a Mimi spirit recorded. It depicts an elongated male figure holding a boomerang and associated with a large club-like object. The neck is long and thin, and is seen here broken – which occurs when these beings leave their shelter in windy conditions. Although the Mimi are the most numerous spirits existing in the environment, only a few paintings in rock art show this characteristic. Location: Inyalak. 45 cm.

Mimi can magically bring a rock wall down within the reach of their hands, paint on it, and then raise it again.

When the people move through the 'stone country' they call out to the Mimi, telling them who they are and where they come from or reminding them that they already know them as they have visited the locality in the past. Some members of the local groups have friendly relationships with these spirits: a recently deceased Gune man was kept company each night by a Mimi woman; a Mayali man of the Bolmo clan, an unerring spearman, has been given his skill by these spirits; while to a Jawoyn man, a renowned songmaker and dancer, they gave a cycle of songs, the well-known bungalen-bungalen, and showed him how to choreograph the performance. The Mimi also enter an artist's dreams to

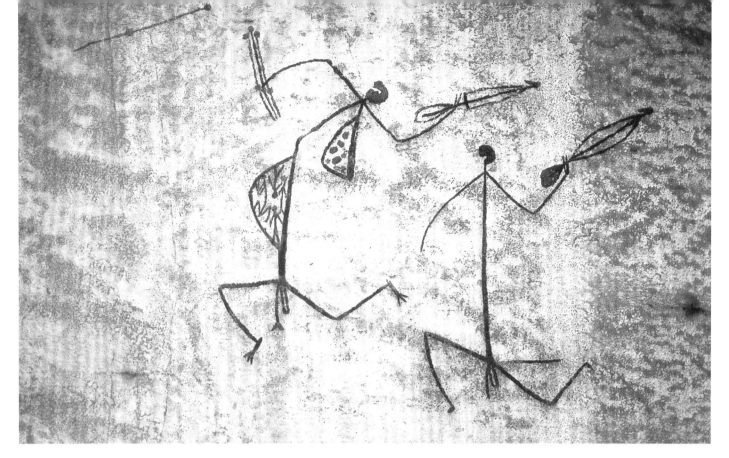

*Above* Two running male figures using short 'goose' spears. The first male has his one-line-thick body distended to a stomach, in which he carries four people. Charles Mountford was told that this was Andungun, one of the Namarnde spirits who kills and eats people. Location: Inyalak. 49 cm.

*Opposite* A long-necked turtle *(Chelodina rugosa)*, portrayed as a hunter, with a spear engaged in a spearthrower in one hand while in his other hand he holds a goose-wing 'fan'. Location: Namarrgon site complex. 53 cm.

tell him what to depict. Alternatively, the artist in his dream may see a Mimi executing a painting or be taken by a Mimi to look at an image which he then reproduces or reinterprets. These spirits are generally friendly to the people, although they may be mischievous. They get upset and seek retribution if somebody kills one of their pets. It is said that they yearn for human company and entice people to come and live with them. Young people are warned not to follow the Mimi because they would never come back.

One of the many stories about such encounters describes how a young man of the Djorrolam clan met a Mimi while hunting in the 'stone country'. The Mimi invited him to come and visit his cave, see all his pets, and meet his sisters who were young and had large, firm breasts. 'Garrirai' – 'we go' – said the keen young man. Soon they entered a large cave full of all the Mimi pets: black wallaroos, rock possums, rock pythons and others. At the back of the cave sat the two young girls, wearing only a djalbun (a string bustle) protecting their posterior. But as the young man walked towards them, the cave closed behind him. The Mimi then told him that he would have to stay with them forever. Later, after they had all eaten a meal of 'bush potato', they went to sleep. The young

man placed himself between the two sisters and first tried to make love to the one on the left, without success as she was 'closed', and then tried the other sister, again with 'no luck'. The Mimi were asleep, while he lay there wide awake and frightened. Some time later, he heard a sound. It was his father, who was a 'clever man', coming to his rescue. He opened the cave, killed the Mimi with a string made from anbornde, the banyan tree *(Ficus virens)*, and took his son back to their own camp.

Eventually the time of nayuhyunggi came to an end and the land was awaiting the people, who from then on would lead lives and tend the land and its resources according to the examples, strictures and warnings set for them by their mythical ancestral figures. They would make their own human choice as to whether to be brave and good or cowardly and evil, and whether to look after and care for each other or express their greed. Garrewakwani, the ancestral past, had ended. This era was followed by an indefinite period of time which bininj (the people) today call gorrogo mararrk ('long time ago', the remembered past), before their own time, which is known as bolkgime (the ongoing present).

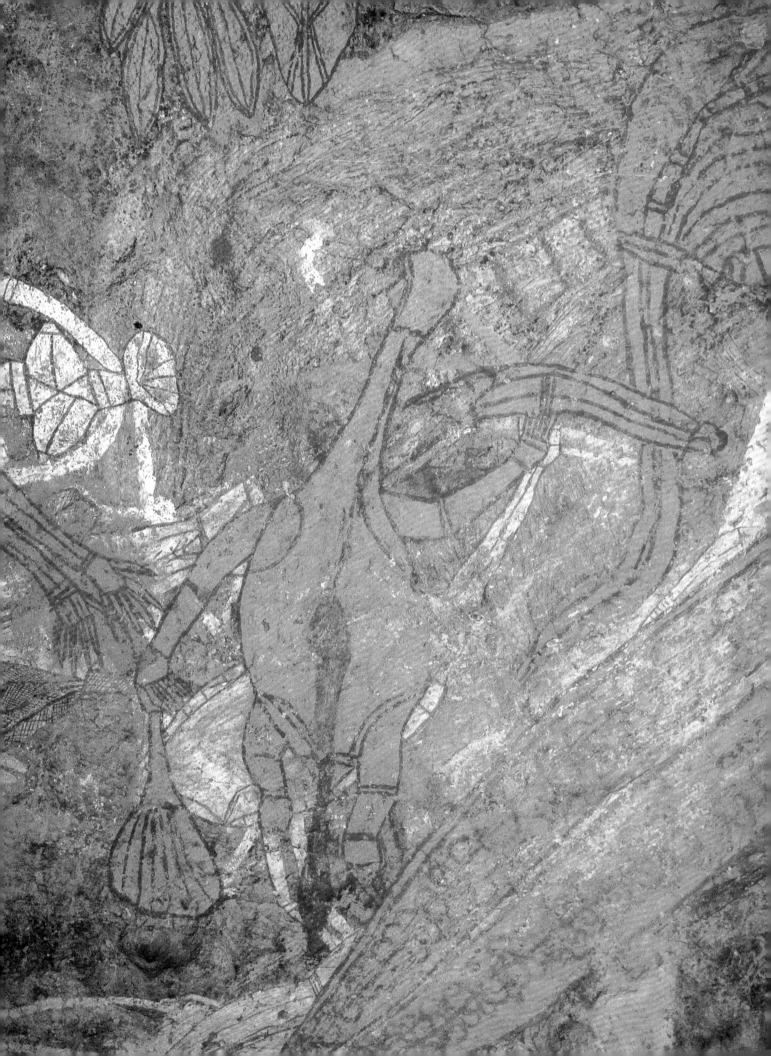

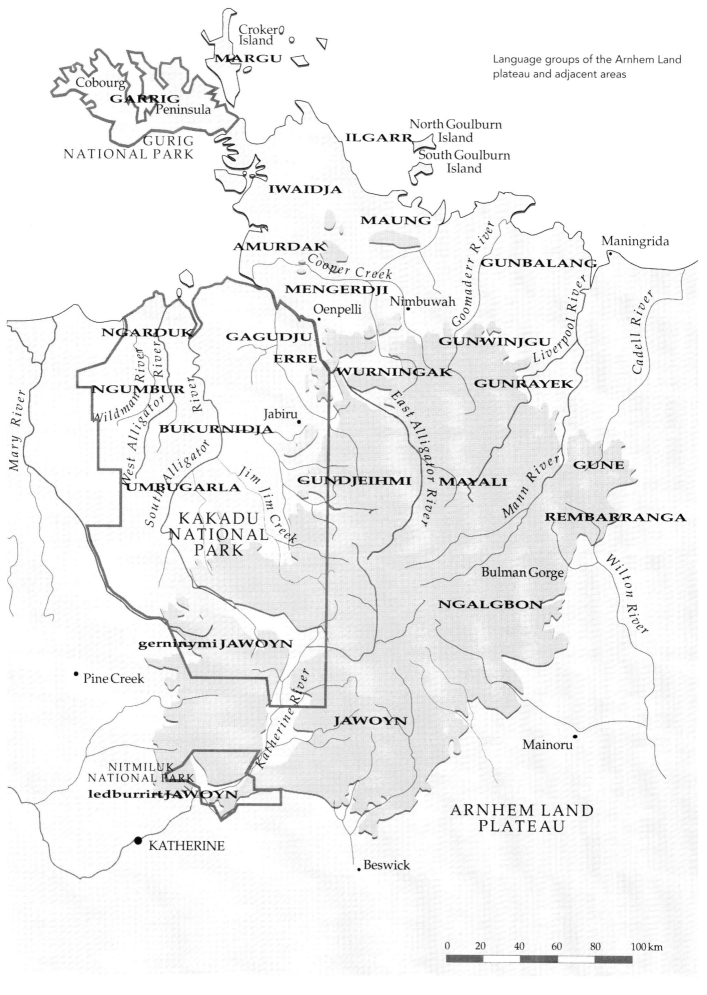

Language groups of the Arnhem Land plateau and adjacent areas

# Bininj

## THE PEOPLE

The people living around the Arnhem Land Plateau form a cultural group with close social and religious ties. The ordering of social relations is based on a model that divides the humans – as well as the known universe with its natural and supernatural phenomena and events – into two halves, or moieties. These moieties are exogamous, so a member of one moiety must pair with an individual of the opposite moiety. The moieties are further subdivided into phratries, or section and subsection systems, each division of which is associated with a specific set of totemic identities or elements.

Totemism is a worldwide sociological phenomenon, an intricate system used to structure the society and the universe, and one in which people are subdivided into units whose members consider each other kin. Each unit has its own totem or set of totems selected from the natural and supernatural environment. In most instances, these totems are animals or plants with which a group of people, as a social unit, feel a bond of kinship. In Australia, this system reached a high degree of specialisation and development. Totemism is the central feature of Aboriginal religious life, which is based on a philosophy that regards humans, nature and land as one.

In the plateau region, this philosophy is expressed as a symbolic association between the social groups and the flora and fauna, other natural phenomena and their ancestral and spirit counterparts. This association is best reflected in the language use of a neuter prefix, 'gun', the function of which is to characterise body parts, features of the landscape and also various cultural constructs – languages, clans and customs. All of the 'First People' and everything they created in the universe is somebody's totem. Aborigines call this concept djang; in English it is called the 'Dreaming'. Gadjangdi are the locus of these Dreamings, the sites where their spirit or essence remains to this day. Many of the rock paintings reflect this symbolic association of humans and their totemic ancestors. A set of Dreaming sites associated with one or the other of the two moieties delineates the extent of a clan's estate.

### Language groups

In Australia, at the time of the first settlement, there were about 200 distinct Aboriginal languages. Most of these languages, along with the people who spoke them, are now extinct. Such was the destiny of several language groups living on the 'buffalo plains' adjoining the north-western margins of the plateau, but in the Arnhem Land region itself most of the languages survive, although the number of speakers for each of them varies.

Languages used by the people living in the plateau region were given to them by the principal ancestor, Warramurrunggundji, during her creation journey from the Cobourg Peninsula to what are now the Kakadu wetlands, and by Namangeminj, another of the very early 'First People'. Namangeminj completed the task by throwing spears into

the country from a high point of the plateau in the vicinity of Jim Jim Falls, while calling out the names of the languages the people who lived in each direction were to speak. It was Namangeminj who also instituted the rite of circumcision in some parts of the region. In this act he threw four spears in the four cardinal directions. Spears that were aimed to the west and the north embedded deeply into the ground, their shafts trembling. The spears that he threw to the east and the south broke on impact and it is the boys in these two regions who are now circumcised during their initiation.

A language group is, in most instances, associated with a more or less contiguous area of land, though all of the languages have several variants. Each clan and even smaller groups can have their own recognisable dialects, as well as a secret language of the law men, and an avoidance or 'mother-in-law' language used to communicate with that kin. There are also complex sign languages used in both hunting and ceremonial situations when speech is forbidden. Aboriginal people are generally multilingual, speaking two or more languages. The mother traditionally came from an adjacent or even a remote language group, and a child spent considerable time in her estate learning first her tongue before becoming fluent in the language of the father. They may later have adopted the language of another group in whose land they had lived, or that of people with whom they had developed other close ties. So it may happen, even today, that when one asks to what 'tribe' (language group) a person belongs, the answer may be the language they now use to converse in their current place of residence, and not that of their birth. However, identity remains with the language and the estate of the father, even if the person lives on somebody else's land and uses some other tongue.

At the time of the first European contact, the Arnhem Land Plateau region and the adjacent coastal lowlands were populated by members of some 20 language groups. The most densely settled areas were in the north, along the coast and the estuarine rivers. These were the lands of the Ngumbur, Umbugarla, Bukurnidja, Ngarduk and Gagudju people between the Wildman and the lower East Alligator rivers. Across the East Alligator River, around the residuals and outliers of the Wellington Range, extending from just north of Oenpelli towards the coast, is the land of the Amurdak, Iwaidja and the Maung people. The Oenpelli area is the traditional land of the Mengerrdji group. To the south, the land of the Erre and Wurningak speakers centres on the East Alligator River and extends into the plateau.

Their neighbours are the Gundjeihmi, whose estates abutts those of the Mayali- and Jawoyn-speaking peoples. Further to the east, along the northern escarpment, are territories of the Gunwinjgu-speaking clans (sometimes written as 'Gunwinggu' or 'Kunwinjku'). The western clans speak the Gundangyohmi dialect, glossed as a 'light' Gunwinjgu, while the 'proper' version of that language is said to be spoken around the Gumadeer River. To the north-west of Nimbuwah, a local clan spoke the Gundangburrddjin gaberrk dialect. Where the Liverpool and the Mann rivers leave the 'stone country', the people speak Gunrayek, a dialect more akin to Mayali than to Gunwinjgu. At the eastern margin of the plateau, the Cadell River clans say they speak Gune, but acknowledge some Dangbon (Ngalkbon) influence. To the south are the Ngalkbon proper, whose neighbours are the Rembarrnga in the east and the Jawoyn in the west.

Each of these socio-linguistic groups is identified with a discrete area of land, the size of which is, in most instances, directly commensurate with its physical nature and resource availability. The language units with the smallest range are those situated where the seasonally flooded plains bordering the estuarine rivers meet the residuals and outliers of the plateau. Their members exploited the estuarine fauna, the waterfowl, their eggs and the vegetable foods of the wetlands, as well as the plants of the monsoon forest and the macropods of the higher country. The paintings in the rock shelters of the Amurdak, Erre, Mengerrdji, Wurningak and Gagudju groups reflect, in the diversity of the animal species, the munificence of their land. The Bukurnidja, Umbugarla, Ngarduk, Ngumbur, Iwaidja and Maung, neighbouring the previous groups, occupied slightly larger areas of open land. Those groups whose land extends into the plateau, the Gunwinjgu, Gundjeihmi and Mayali, and from the southern side of the 'stone country', the Ngalkbon and Jawoyn, occupy still larger areas with scarcer, more scattered resources, and in the past concentrated their activities mainly along the valleys that dissect the plateau.

The members of each group have close kin ties as well as intimate historical and ceremonial relationships with one or more of the neighbouring groups and often with other more distant language units. Being an exogamous society, the people marry not only outside of their moiety and clan but usually into a different language group. The Gagudju ties are with the neighbouring Erre and Ngarduk people, and extend across the East Alligator River to the Amurdak and the Iwaidja peoples, and then north to the coastal and island Ilgarr,

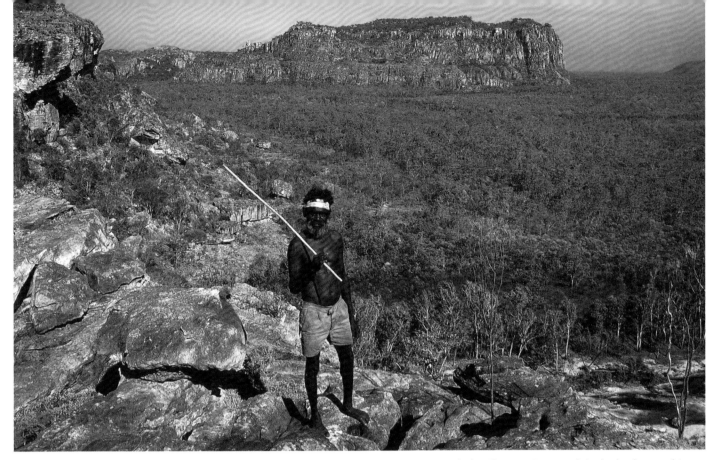

Kapirigi, standing on the top of the plateau above his favourite camp at the Djuwarr waterhole. The prominent rock in the background is Nawlabila. At its base is a shelter of that name used by Aboriginal people for some 30,000 years.

Garrig and Margu groups. The Gundjeihmi connections are not only with the people of the adjacent lowlands, but also in the opposite direction with other nawardegen, or 'stone country' people, the Mayali, Jawoyn and Ngalkbon, with whom they have ties through the mutually shared culture heroes who passed through their estates. The Gundjeihmi called the people who lived around the floodplains and wetlands gungarrigen (westerners – 'garri' meaning 'west'; or 'people from the sundown'), or naganjdjigen (lowlanders – 'ganjdji' meaning 'low'), as they lived downstream from them on the plains. 'They drink our water,' they said of them.

Some language groups were known to their neighbours by other names. The Mayali and the eastern Gunwinjgu referred to the Ngarduk and Gagudju people, jointly known as the Minjdjarra, also as gunbarrgid (the 'distant ones'). The Gagudju called the Amurdak speakers Waraydjbag, and they in turn called the Gagudju speakers Awur. The Gagudju also had a name for the three dialects spoken immediately to the south of their territory. To them the Erre, Mengerrdji and Wurningak were the Gimbiyu people, whom Baldwin Spencer referred to as Geimbio. The Ngalkbon are referred to by the Mayali and Gundjeihmi as the Daban people, speaking the Dangbon language, while other groups know them as Dalabon. The Jawoyn language, with three dialects, extends over a large area of the plateau and southern hills. The Jawoyn

proper is spoken in the south, the ledburrirt Jawoyn is used from Katherine towards Pine Creek, while its gerninymi or ('fine') version was spoken in the upper South Alligator valley and the surrounding plateau.

Gundjeihmi, Gunwinjgu, Mayali and those languages spoken in the Liverpool-Mann rivers area are all allied dialects. Although there are some differences in grammar and vocabulary, they are mutually comprehensible. It is in the estates of the clans speaking these languages that the majority of the Arnhem Land Plateau rock art sites are located.

When, in November 1845, Ludwig Leichhardt and his party traversed the land between the South and the East Alligator rivers, they met hundreds of healthy Aborigines, exploiting the bounty of the drying wetlands. To the north of Oenpelli, on Cooper Creek, they met other large groups of people, and also encountered their first buffalo.

Fifty years later, Europeans began moving into the region to commercially exploit the vast, rapidly increasing buffalo herds. By then, these herds were destroying the fragile ecosystems that had sustained the Aboriginal people for thousands of years. Within another 50 years, the European incursions took their toll on the region's Aboriginal populations. In some areas, only remnant populations of the language and clan groups that originally occupied this coastal land still survives today. Some language groups are completely extinct. There is

no person now who speaks Ngarduk, Bukurnidja, Ngumbur or Gurnbudj. Only three people remain who are to a degree conversant in Gagudju, the language after which the Kakadu National Park is named. The person with most knowledge of that language is not a member of the Gagudju group.

## Clans

Each of the plateau's language groups consists usually of several named gunmogurrgurr, clans of patrilineal descent which are the basic unit of social organisation. Children, regardless of their place of birth, are members of their father's clan. A clan is formed of two or more family groups who share an area of land, the extent of which is delineated by a set of Dreaming sites. The name of a clan is used in referring to the group, to any of its members and to their estate. Although several clans share the same name, and in some instances have contiguous areas of land, they are separate entities, differentiated by their moiety affiliation or membership of a different language group. When being referred to, they are usually identified by a 'big name' of the country in which their estate is situated. A number of Bolmo clans extend across the plateau: Bolmo of Mikginj, Bolmo of the Malgawo country and Bolmo of Gimbat. In another example, six language groups share the clan name Mirarr. Each of these clans belongs to one or other of the two moieties, depending on the moiety affiliation of the Dreamings located within their estates.

Clan members have the responsibility to physically protect, and ritually look after, the Dreaming sites within their estate. They may also share responsibility for sites located in adjacent or even in more distant clan territories. Some of the Dreaming localities in their traditional land are also 'increase centres' for animals or plants: appropriate ritual ensures the population increase of such animals and plants, not only within an estate but also throughout the wider region. In some instances, the species for which people are ritually responsible may not even exist in their own environment.

In the past, clans were further subdivided into smaller, named units. When identifying these units, their names were prefixed with the word 'gunwok', which in its ordinary sense means language. In several known examples, the name is used to denote a group of people, occasionally members of a single family, living in a particular area of a clan's estate. In the example from the Gundjeihmi-speaking Badmardi clan, whose traditional land extends along the escarpment valley of Deaf Adder Creek, the estate was divided between gunwok Agodedjon, consisting of two families occupying the lower part of the valley, and gunwok Wuluwulubidi, an extended family living in its upper reaches. It is possible that the term 'gunwok' in this instance may be identifying the dialects used by these smaller groupings. Studies have noted linguistic differences occurring even between families of the same clan. The physical

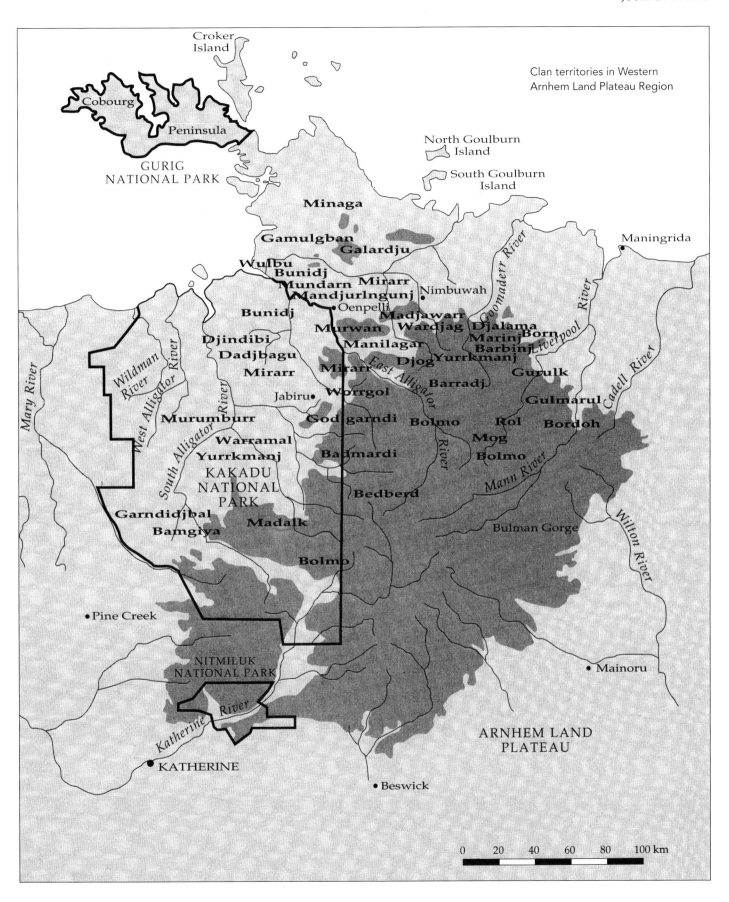

Clan territories in Western
Arnhem Land Plateau Region

*Opposite* This composition may represent a camp scene. To the right of centre is a reclining female with a child lying close to her, while other figures are depicted carrying out various activities. Location: Garrkkanj. Female figure 15 cm.

land of the clan's estate is known by a 'big name', usually that of a prominent locality. The Badmardi clan's land is known as Balawurru, their name for Deaf Adder Creek. In the past it was also known by its yiwurrumul name, Nadjalaminj. The concept behind this yiwurrumul affiliation is usually not expressed or is said to be too difficult to explain. This name was used in ritual invocations and was called out when danger threatened. It is still used by the old people when somebody sneezes, so that the person's spirit, if ejected by the sneeze, would know where to return to.

## Social units

Traditionally, the basic structure of the plateau's populations consisted of social units based upon patrilineal and matrilineal descent. The membership of language and land-owning groups was, and still remains, patrilineal, while the location within moieties, the two halves into which everything was divided, and their subdivisions, or phratries, was matrilineal. At present, patrilineal moieties and an associated subsection system introduced sometime in the recent past are the commonly used identifiers of social affiliation, although most people know their place within the matrilineal moiety divisions.

The matrilineal moieties, mardgu and ngarradjgu, divide the social universe into two halves. Children inherit their mother's moiety and marry partners of the opposite moiety. Under this system of social ordering, the clan's moiety affiliation, given by the set of Dreamings delineating its estate, is constant, while that of its traditional owners changes every generation. The moities are subdivided into six smaller units, the matrilineal phratries known as gundjungunj. They are: the yarriwurrgan and yarrigarngurrk of the mardgu moiety, and the yarriyarninj and nawalganj of the ngarradjgu moiety, and the yarriburrik and andjarrabuma divisions which are represented in both moieties.

Matrimoieties and their phratries were also used to classify animals and plants. Although the artist could use subjects from both moieties, some preferred to select their motifs from the totemic set with which they were associated through these social groupings. The people recall that it was Nagorrgho and the protean beings accompanying him who instituted the social structure of their society. Nagorrgho divided the people and their universe into the two moieties, while their subdivisions and their representative symbols were established by his companions. The origin of the yarriwurrgan

subdivision, with gabo, the green ant, as its chief symbol, is attributed to Ngarradj, now the sulphur-crested cockatoo, while yarrigarngurrk, with gunwarde (stone) as its sign, was established by Duruk, the 'dog'. However, this 'dog' was not the dingo, nor the domestic dog introduced later by Europeans which is also called by this name, but some other dog-like creature, mythological or now extinct. Yarriyarninj, whose chief sign is gundung (the sun) was instituted by Almudj, the Rainbow Snake, while yarriburrik, represented in both moieties with gunak (fire) as its symbol, was brought by namaddol, the wedge-tailed eagle. The andjarrabuma division, whose chief sign is gukku (water), is also represented in both moieties. Its ngarradjgu division was created by Gulinj, the Flying Fox Man, who fought with the Rainbow Snake, while its mardgu moiety counterpart was established by Namarrgon, the Lightning Man. The nawalganj division, with nabiwo, the ground nesting wild bee, as its symbol, was created by Nadjurlum (the 'whirlwind').

Each of the phratries was divided into four sections: nabininj goyek, nabininj garri, nabininj gakbi and nabininj bulgai, of which only the first two are associated with totemic signs. In these designations, the word nabininj denotes a person. Nabininj goyek is represented with a large, hard, heavy or hot subject, while the nabininj garri sign denotes a small, fragile, cool, fine or soft item.

This last social identifier – the division of the phratries into four – tells us from which part of the plateau a person's mother originates and documents their rights to her country. It also underlies the notion that the people of the plateau region are indeed a social and cultural unit and illustrates how, in addition to primary rights in their father's land, the people also have close spiritual ties with their mother's estate. In this division, the plateau has been divided into: goyek, the eastern sector; garri, the western sector; bulgai, the central part of the region; and gakbi, the northern part extending to the coast.

This unity of the region's population is physically demonstrated by the thick stands of pandanus (*pandanus spiralis*), the screw-palm, growing around the Wuymul waterhole on the southern margin of the plateau. At the head of the waterhole is a large spring welling crystal clear water. Above this are white gum trees embodying powerful beings. It is an important ritual area. The pandanus trees represent the people standing there in their clan and language groups.

## MATRILINEAL PHRATRIES AND THEIR ASSOCIATED 'SIGNS':

### YARRIWURRGAN

gabo, green ant

    *nabininj goyek:*  WARDJARRARG, large green ant

    *nabininj garri:*  GARRNGGILEL, small green ant, lives in pandanus

### YARRIGARNGURRK

gunwarde, stone

    *nabininj goyek:*  BIRDURRK, orthoquartzite, used for lauk, stone blade

    *nabininj garri:*  BELEMBERL, quartz

### YARRIYARNINJ

gundung, sun

    *nabininj goyek:*  GARRAWADJDJI, funnel web spider representing andungbahbang, hot sun

    *nabininj garri:*  KARRD, small grass spider, representing andungbolabola, cool sun manifested in the dew-laden web spreading through grass in the early dry season

### YARRIBURRIK

gunak, fire

    *nabininj goyek:*  DONGGORLMIRRIMIRRI, hot coal from the ironwood tree

    *nabininj garri:*  DJANGGOGO, fine ash from fire-stick

### ANDJARRABUMA

gukku, water

    *nabininj goyek:*  GERRALKGEN, gentle rain from the east

    *nabininj garri:*  BALMARRADJA, heavy monsoonal rain

### NAWALGANJ

nabiwo, ground-nesting native bee

    *nabininj goyek:*  BIRDIRAYEK, hard beeswax

    *nabininj garri:*  BIRDIGELH, soft beeswax

The patrilineal moieties duwa and yirridjdja were introduced in the near past. Together with a later subsection system, they have become the common identifiers of social affiliation. In this ordering the children follow their father's moiety. This patrimoiety-based classification system is said to have originated in eastern Arnhem Land and then spread westward, replacing the indigenous matrilineally-based systems.

Subsections, glossed as 'skins' by Aboriginal people, identify the present kinship relations, ceremonial groupings and marriage classes. The subsection system is indirectly matrilineal, as a child's subsection is derived from the mother though it is different from hers. It is thus compatible with both the matrilineal and the patrilineal systems.

## PATRILINEAL MOIETIES AND THEIR SUBSECTIONS:

| DUWA | YIRRIDJDJA |
|---|---|
| nangarridj | nangila |
| nabulanj | nawagadj |
| nawamud | nabangardi |
| nagamarrang | nagodjog |

The prefix 'na' denotes the male terminology, while 'al' represents the female form.

# Gunbim

## THE ROCK ART

*Rock art is no longer only an archaeological artefact –
its study is also concerned with the
human spirit, mind and soul.*

Rock paintings and rock engravings are a valuable component of the archaeological record. Until the notion of cognitive archaeology (the study of past ways of thought) was introduced, the prehistory of Australia was principally based on the study of human remains and stone implements. Rock art, in many areas the most obvious and most common artefact, was generally ignored. Now this art form is being used to discover the patterns of past cultures and lifestyles and to interpret and record the processes of cultural change.

From the European perspective, a number of commentators have viewed Australian stone tool traditions – with the exception of the remarkably ancient edge-ground stone axes of Arnhem Land and the exquisitely fashioned Kimberley points of Western Australia – as uninspiring. The stone artefacts have been described as crude and colourless, and their simplicity was used to support the erroneous notion that the Aboriginal people were human relics from the most backward part of the Pleistocene world.

There are two broad traditions represented in Australian stone tool technology. The first and earlier tradition of steep-edged flakes and cores was accompanied in Arnhem Land by edge-ground stone axes. The second and more recent small tool tradition consists of microliths, adzes and unifacial and bifacial spearpoints that date from about 6000 years ago. As these two traditions are found across Australia, their distribution does not indicate very much about the spatial extent of the particular social groups which used them and tells us virtually nothing of the non-material aspects of those cultures. The tools reflect such standard forms and processes of fabrication that the only factor which could delimit their spatial occurrence is the nature of the raw material utilised.

Weapons and implements manufactured out of wood, notably boomerangs, fighting sticks, shields and spears, as well as many objects of religious significance, are usually more varied and can be successfully correlated with both major cultural areas and smaller discrete cultural units. They are distinct both in their general form and in their modes of decoration. Unfortunately, however, items fashioned out of organic materials usually do not survive for very long in occupational deposits, so our knowledge of them is severely restricted by the passage of time.

The evidence of past cultures – previously sought by prehistorians exclusively in the form of items recovered from occupational deposits – is present in thousands of painted shelters as well as on engraved boulders and rock pavements throughout Australia. Rock art images in their painted and engraved forms are, indeed, the most common providers of information and are found in infinite variations. The styles of their execution are the typologies and their superimpositions may be regarded as stratigraphical units in the history of local groups, while the symbolic representations are rich sources of cognitive information. The rock art motifs depict the people's daily pursuits, the technologies used, ephemeral objects of their material culture, and aspects of their world view. The multiformity and complexity of expressed concepts and forms does not suggest a backwater of humanity, but, on the contrary, a dynamic society which from the very beginning stood at the forefront of human cultural development.

It is possible that rock art was disregarded by mainstream archaeologists because of its seemingly unruly nature. The multitude of complex images, too difficult to reduce into manipulative typologies, and the motifs that do not easily disclose their meanings and for which there may be several alternative explanations were left to the few enthusiasts. In the 1970s, however, the bone and stone period of Australian archaeology was extended to embrace the study of rock art, adding some flesh to the subject while the cognitive branch of the discipline now considers the artist's mind. At present, rock art studies are an increasingly popular subject within university prehistory departments. However, the term 'art', as used in describing the images found within the vast body of Australian rock art, many of which are complex and accomplished compositions, is being questioned. Clearly, aesthetic sensibility that allows a human being to create works of artistic merit did not commence only with the first expression and then lexical definition of that word. The term 'art' was first used in the English language only 300 years

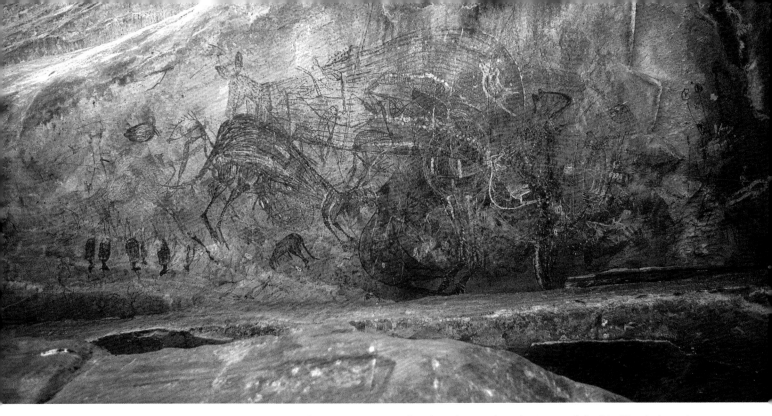

The ceiling of this deep overhang displays a number of superimpositions of early rock art styles. This is one of the Mt Gilruth sites, the highest point of the plateau. Location: Djorrwambi.

before ships from European nations sailed into South-East Asia and discovered Australia. Here, as indeed elsewhere in the world, the rock art tradition began tens of thousands of years earlier, at the dawn of creative time. Artistic activity and aesthetic sense is not the prerogative of any one people, it is a universal phenomenon, common to all humanity.

Propitiously, it is not only archaeologists who study rock art. Anthropologists, art historians, psychologists and students of comparative religion consider it from different perspectives. Rock art is no longer only an archaeological artefact, its study is also concerned with the human spirit, mind and soul. There is more to be learned from a rock painting than its typological form and spatial distribution may suggest.

## Antiquity of the rock art

The temporal aspects of the rock art sequence are based on the evidence of early human settlement of Australia and on the variations in sea level that have occurred since the period of first occupation. It is generally accepted that the colonisation was from the north, and that it occurred when the sea levels were much lower. During the last Ice Age, vast amounts of the world's water were trapped in massive ice caps, and the sea level in the South-East Asian and Australian region was perhaps 150 metres lower than at present. A wide continental shelf and the Arafura plain landbridge connected Australia

to New Guinea and extended to within 100 kilometres of Timor. Although Timor was then only joined to the island of Roti, further west the exposed Sunda connected the many islands of the Indonesian and Philippine archipelagos to the Asian continent. The sea level change which occurred 160,000 years ago, because of its gradual fall and rise, may well have provided the most suitable conditions for human migration. During the following glacial maxima about 55,000 years ago, the fall and rise of the sea was more rapid. It is, however, this later date which is currently given as the time of the initial colonisation of Australia. After crossing to the shores of greater Australia, the first dispersal of people would have been along the coast and inland via existing river systems. The settlement of the north would have been quite rapid as the colonists did not have to adapt to a completely strange environment. They had the necessary skills to exploit the marine ecosystems, the produce of the littoral zone replicated the environment of their place of origin, while on the coast and in the hinterland they would have found many familiar edible plants. Only the rich and varied marsupial and avian fauna would have been totally alien.

The catchment areas of the present-day Alligator rivers and adjacent streams would have been among the earliest settled regions. Recent datings of occupational deposits in Kakadu show that settlement began at least 50,000 years ago, though it may have begun even earlier than that.

The variations in sea level during the last glacial maxima

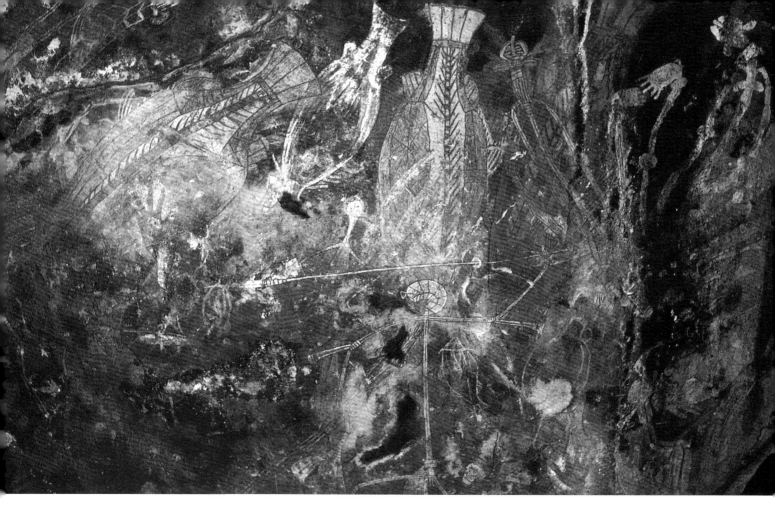

Superimpositions of the most recent paintings – colourful and large images of the popular fish subjects, a sorcery figure and man the hunter. White hand stencils at the centre bottom and on one of the barramundi were made in the 1930s. Location: Garrkkanj.

are of primary importance in dating the region's rock art sequence. The dramatic environmental changes, the accompanying introduction or demise of animal and floristic species, Aboriginal adoptive strategies and inevitable cultural changes are reflected in rock art.

The magnitude of the Arnhem Land Plateau rock art itself, and the complex and ever-changing sequence of styles, suggests an early commencement and a long period of development. Shelters where painted ceilings now lay in slabs on their floors, together with paintings found high up on the cliff faces in situations precluding the construction of platforms, indicate the previous presence of rock ledges which facilitated their execution, and consequently point to their antiquity. Within the chronological sequence the relative age of paintings of the same style is suggested by their differential weathering. In places where they are found superimposed upon one other on well protected rock surfaces, one design may appear as just a faint stain in the rock surface, the subsequent image is more prominent, while the most recent paintings, although weathered, survive in some detail.

Another indication of the antiquity of rock art is the presence of multilayered siliceous skins which have formed over many of the paintings. These skins, which began as soluble silicas within the rock matrix, have permeated through the pigment and evaporated at the surface, bonding the pigment to the rock. It has been suggested that these skins formed during the period of aridity that accompanied the last Ice Age, but a technique to establish when these layers of silica were formed is needed, so we can date the region's art with a greater degree of reliability.

The most important evidence indicating the early commencement of artistic expression in this region is the presence of used pieces of ochre that have been recovered during excavations of sites with dated Pleistocene deposits.

The first two sites of this antiquity to be excavated were the rock shelters Malangangerr and Nawamoyn situated in the vicinity of the East Alligator River, in the northern sector of what is now the Kakadu National Park. This work was carried out by Carmel Schrire in 1965. In both shelters, used pieces of ochre were found throughout the deposits. It is interesting to note that at Malangangerr the greatest density of ochreous materials lay in the lowest excavated level. This horizon was dated as extending from 22,000 to 18,000 years ago. The deposits at Nawamoyn revealed similar concentrations of

pigments in the earliest phase of the shelter's occupation. If we accept that these pigments were used to satisfy aesthetic need, they are not only indicative of an early commencement of art traditions at these shelters, but also suggest that this was a period of intense creativity.

Used pieces of ochre were also found in a number of sites archaeologically tested during the Alligator Rivers Fact Finding Study by Harry Allen and Johann Kamminga in 1973. From the sandy deposits of the Malakunanya II site at Djawumbu in the northern sector of Kakadu National Park, Kamminga recovered an 18,000-year-old grindstone impregnated with red ochre – an artist's palette. It is the earliest evidence documenting how pigments were prepared and confirmed the sophisticated use of the many coloured pieces of ochre found throughout the deposits of all the excavated shelters.

A more recent archaeological investigation of the Nawlabila shelter in the Deaf Adder Creek valley by Rhys Jones in 1981 confirmed the results from previous excavations. Among the materials recovered from this site were numerous pieces of ochre and soft iron ores suitable for use as pigments. The iron ore, pieces of haematite and other high-grade ochres were definite artefacts showing facets created while preparing the pigments. In this deposit, the red ochre was found to a depth of 1.65 metres, yellow ochre down to 1 metre, while the last piece of haematite was recovered from a depth of 2.37 metres. As this depth was below the last radiocarbon sample, the dating obtained by extrapolation from an age/depth curve suggests that the lowest find of the red pigment is in the order of 25,000–30,000 years old. This dating is of an age comparable with the oldest evidence at Lake Mungo in New South Wales and with evidence from elsewhere in the world for the early sophisticated use of red ochre in rock art.

The date for the commencement of pigment preparation and use was vastly extended in 1989 when Rhys Jones, assisted by Mike Smith and Bert Roberts, excavated a trench adjacent to Kamminga's original test pit at the Malakunanya II site. Jones and Roberts had previously sample tested this site in 1988. The sandy deposits taken in that year were subjected to thermo-luminescence dating analysis, the results of which suggested that they may be of far greater antiquity than previously thought. The 1989 excavation confirmed that this was so. Material recovered from a depth of 2.5 metres consisted of stone tools, blades, a large 1 kilogram piece of haematite brought in from some distant place, and also smaller pieces of this mineral with sides faceted from use.

Thermo-luminescence dates suggest the sands associated with these finds are 50,000 years old, indicating that the grindstone excavated by Kamminga is far older than previously thought. It is possible that when other previously excavated sites are subjected to this form of dating they may also be found to be of a considerably greater antiquity.

Although it cannot be demonstrated that the pigments prepared from the pieces of recovered ochre were used to paint designs on the walls of the shelters in which they were found, any possible alternative uses to which they may have been put could not account for the vast quantities of ochre present. The only common alternative use of the pigment within the confines of a shelter, as documented by recollections of local Aborigines, was the decoration of objects of material culture. Ochre and white pigments were used to decorate spears, spearthrowers, fighting sticks and dilly bags. But as well as pigments, various clear and coloured plant saps and gums were also used for this purpose, some of them actually being preferred as they provided a good non-slip surface. Another possible use of the recovered ochres would have been the decoration of human bodies for ritual purposes, and for smearing on human skeletal remains before their secondary interment. However, such activity was usually carried out on ceremonial grounds, away from habitation sites. Many of the ritual items such as the sculpted objects of the marrayin ceremony and the hollow logs used in the ubarr and the lorrkgon rituals were highly decorated with pigments. These objects, as with ritual body decoration, were prepared in sacred places, far away from occupational shelters and accidental discovery. Men also used to daub themselves with pigment to suppress their body odour before setting off on a hunt. For this purpose they used white pigment from clay deposits found along the route.

On the available evidence, it is reasonable to assume that the ochres and other pigments found in the occupational deposits were used in the preparation of paints for the specific purpose of executing an image (by painting, imprinting or stencilling) on the walls or ceilings of the shelters in which they were found.

Considerable age is also suggested by paintings representing species of the long-extinct Australian megafauna.

Of lesser antiquity are the numerous rock painting representations of the thylacine or Tasmanian tiger (*Thylacinus cynocephalus*) which confirm this animal's former presence in the north of the continent. Although the thylacine survived in Tasmania until the 1930s, its extinction on the Australian

This art site, situated halfway up the escarpment and of difficult access, is one of the few shelters where the paintings of the early styles have not been superimposed by the more recent images. Location: Djuwarr site complex.

mainland is thought to have occurred some 4000 years ago. That Tasmanian devils *(Sarcophilus harrisii)* also once roamed the escarpments of Arnhem Land is documented in rock art and in archaeological investigations. A *Sarcophilus* mandible more than 3000 years old was recovered from a shelter in the vicinity of the East Alligator River.

We do know some of the minimum dates for the rock art of this region. Analysis of carbon and organic salts forming the light brown, multilayered coatings of whewellite (carbon-bearing compound hydrated calcium oxalate) found over some paintings, carried out by Alan Watchman in 1989, established that they were executed at least 8000 years ago.

Some of the contact paintings of such objects as boats and aeroplanes can be dated historically. The most recent painting to be executed for a traditional reason rather than at the request of a non-Aboriginal person was painted in 1972. It is possible that, in the not too distant future, conceptual innovations in the dating of pigments from painted surfaces will establish beyond doubt the early commencement of rock art in Arnhem Land, the Kimberley and adjacent northern regions.

## The painted shelters

Most of the paintings in Arnhem Land are found on vertical and sloping walls and on ceilings of shelters used as occupational sites. A wide range of such shelters, varying in size and shape from spacious lofty overhangs to small recesses and low caverns suitable for habitation during different weather conditions, are located throughout the plateau and its erosional outliers. Some sites are formed by tumbled rocks balancing on one another, or are located beneath wide overhanging rock platforms. Others are long shelters running along the walls of narrow gorges above the talus and scree slopes. They are found at the base of residual rocks or overhanging cliff faces and at every level of the escarpment, as well as on the top of the plateau. There are rock promontories extending into the plains, on which the sites are clusters of residuals weathered into fantastic shapes. Others become islands during the wet season: in the past, as the waters receded, people would have been attracted to these places to exploit the fish of adjoining waterholes.

Many of the elevated sites in the residuals scattered along the edges of the floodplains were occupied throughout the year, as people sought refuge from the mosquitoes. Baldwin Spencer records how every evening during his stay at Oenpelli in 1912, a line of people carrying smouldering fire-sticks made their way across the plain and then up the steep slope to the summit of Inyalak Hill. Such shelters with virtually year-long occupation were the most lavishly painted.

But the artist was not restricted in terms of where to paint. Unexpected images are hidden in unusual places, some of which are extremely difficult to access. There are paintings high up on vertical rock faces and on ceilings of deep overhangs many metres above our reach. It is possible that some of these images were executed from trees which once grew along the shelter's rim or from platforms constructed to gain access to a preferred rock surface. Images on the sides of chasms and above rocky floors where vegetation could not get a foothold would have been painted from rock ledges which have subsequently fallen away. As well, on the wall of deep shelters recessed into the sheer cliffs of the escarpment, 50 or more metres above the ground and with no possible access at present, binoculars reveal the presence of painted and stencilled images.

In many instances, it seems the artist made a conscious attempt to place an image in a difficult position so that it would appear not to have been made by a human. People now point out such paintings and say that they have been made by spirits who have powers to move the rocks at will, or alternatively that they are representations of ancestral beings, their Dreaming, where they placed themselves at the end of their creation era.

# Delek, gundulk, bimno
## PIGMENTS, BRUSHES AND TECHNIQUES

Ochres have been used for ritual and decorative purposes by Aboriginal Australians for tens of thousands of years. Red ochre was scattered over a corpse buried at Lake Mungo in New South Wales some 30,000 years ago. As the ochre used does not occur naturally in the area, it must have been brought in from a considerable distance away. In the plateau region, used pieces of haematite and a grindstone impregnated with red ochre, recovered from the Malakunanya II site in Kakadu National Park, document the commencement of pigment use some 50,000 years ago.

Most Aboriginal groups throughout Australia recognise and have names for four basic colours: white, yellow, red and black. The people of the Arnhem Land Plateau expanded and elaborated on this list, identifying and using additional tints of basic colours and introducing an exotic colourant to their art.

The colours used in this region are: delek (white), a term also used as a generic name for all the colours of the Aboriginal spectrum; garlba (yellow); bandja (deep yellow ochre); gunnodjbe (red ochre); marnarr (haematite – a red with a purple tint); ganbulang and yamidj (pink); gunnjirrge (black); and blu (which is the gloss for 'blue' pigment introduced in the form of washing blue or 'blue bag' obtained in the laundries of mission stations).

The usual sources of white are clays of the kaolin type, but gypsum, burnt selenite, calcite and the rare mineral huntite (calcium magnesium carbonate) were also used. The numerous shades of yellow and brown are derived usually from limonite, a hydrated iron oxide.

Pigments of the red spectrum are found in a variety of forms and hues throughout the region. The best reds are the fine-grained iron oxides, especially the purple-tinted haematite, of ore-grade quality. Others were obtained from laterites, ferruginous sandstone and deposits of iron oxide stained clays. Red could also be produced by burning yellow ochre.

The black pigments in rock paintings are prepared from either charcoal or manganese oxide. Although any piece of charcoal could be used, some painters preferred the results obtained from soft coals produced from the thick, cork-like bark of anbadderre, the nut tree (*Terminalia grandiflora*).

The pigments are collected wherever they are found exposed on the surface or in the beds or on the banks of streams. Some deposits were also mined. Although ochres and white clay can be found throughout the plateau region, the finest quality materials are usually associated with important locales and they were prized and traded over considerable distances. Their suitability is judged by their purity, consistency, opacity and texture.

In European terms, all of these pigments have certain geochemical properties and their origin can be explained in scientific terms. Aborigines, however, believe that these qualities, like all the other aspects of their universe, have their origins in the Dreaming. The locations of the best sources of each of the pigments are centres of religious significance, their Dreaming sites. Pigments from these localities are sought-after and prized, as it is believed that they are also imbued with the mythical power of the creator beings. Only pigments with such associations should be used in painting the body decorations required in the mortuary ceremonies and other rituals of the area. Ochres from the Dreaming sites are said to have been used exclusively in rock paintings of the important mythological and totemic figures, although the traditional owners of estates where they are found also used these pigments in secular designs.

Pigment materials found as smaller deposits, or individual finds in localities which are not permeated with the Dreaming essence, were left by the 'First People' or are the evidence of the continuing presence in the land of certain mythological beings. The nodules of the white pigment, huntite, are said to be the faeces of the Rainbow Snake.

There are three white pigment Dreaming sites in the north-western part of the Arnhem Land Plateau region. The first is located at Gundjilhdjil, in the vicinity of the Kanarra shelter in the Worrgol clan's estate, and the second is at Wamanyi, on the coast, in the land of the Iwaidja-speaking Mandjarrwalwal group. The third and most prized white pigment comes from Madjarngalgun, along the Gumadeer River near Maburinj, in the Warddjak clan's estate. It is scooped 'like flour' from the ground, mixed with water and formed into large egg-shaped cakes, which when dry are traded across the plateau. This fine pigment was left here, and at other localities, by Gawoyag, now gandagidj, the male antilopine wallaroo, during his creative travels across the land.

In Kakadu, white pigment is also found at Bukbukluk, the Dreaming locality of the pheasant coucal in the Garndidjbal estate, as well as at Gornbuluk, near Barramundi Creek in Yurrkmanj territory, and in the vicinity of Barrkmarlam (Jim Jim Falls) in the land of the Madalk clan, where it is found associated with a yellow ochre. At this last site, the wet pigment on extraction from the ground was made into a 'damper' and left to dry for several days until hard. Before use, pieces of this material were crushed and mixed with water, or left to soak in paperbark containers.

The best source of yellow ochre in the western part of the plateau was at its Dreaming locality, Garlba gadidjam, situated on the eastern side of the Mt Brockman massif, in the Godjgarndi clan's estate. It was also mined from the clay deposits and banks

A collection of pigments, brushes and gundjinem (paperbark containers in which some of the pigments are prepared).

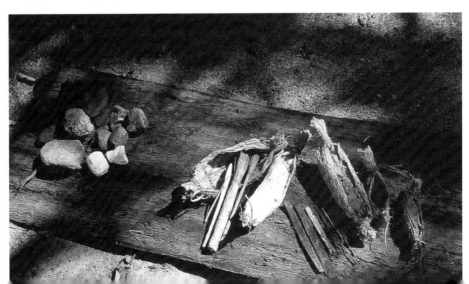

of a small tributary of Nourlangie Creek and in the Deaf Adder Creek valley. The yellow ochre was brought to this side of the plateau by Narlangak, a Ngalkbon-speaking man, now the frilled lizard. He is also credited with being the creator of haematite. Both colours can be seen on the belly of this lizard and are said to be the remnants of his original body painting. The yellow pigment from the Garlba gadidjam locality can be 'cooked' or burned, to produce red ochre.

Gunnodjbe is the most widely used of all red ochres. Its Dreaming and source is Gunnodjbedjahdjam, situated in the vicinity of Jim Jim Falls. Yamidj, now present in the environment as the long horn grasshopper (*Caedicia* sp.), calls to people towards the end of the wet season that anginjdjek, the 'cheeky' round yams, are ready to be dug out and eaten. During the creative period of the Dreaming, Yamidj accompanied by a group of women walked through the land planting these yams. Occasionally, when one of them made a hole with her digging stick, water would pour from the ground before she could plant a yam. The women would then know that the place was andjamun, a sacred abode of the Rainbow Snake, and they would move on to find another locality suitable for planting the yams. The circular stone arrangements in the vicinity of Gunnodjbedjahdjam represent the last holes Yamidj dug with her digging stick before she entered the escarpment to carry yams to people living across the plateau. It was at this place, as they made their way to the top of the escarpment, that some of the women accompanying Yamidj menstruated. Their menstrual blood seeped deep into the ground, and this now is the source of a highly valued red ochre. When Ludwig Leichhardt and his party descended from the plateau along the same route, they met a group of the local people who gave them a present of this red ochre. The explorer noted in his journal that the Aborigines seemed to value it highly.

At Gunnodjbedjahdjam, the soft mineral was dug out with digging sticks and taken to Wirridjeng (or Wirriwirrmi), a nearby shelter, where the ochre was crushed and sifted through open-meshed dilly bags, the coarser particles being discarded. The fine pigment was then mixed with water in paperbark containers, turned out and kneaded like a 'damper'. When the blocks were reasonably firm they were left to dry in the sun. My friend Kapirigi recalled that his father would make 20 or more blocks at a time. He would take a few for his own use, or to give away or trade across

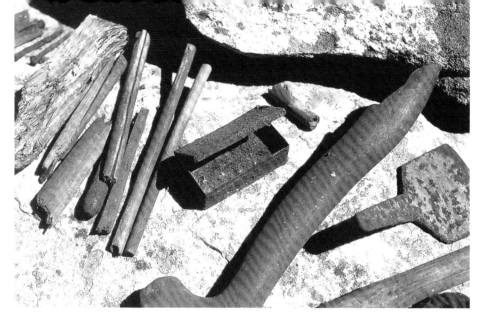

The exotic blue pigment ('washing blue') was brought from a distant place, perhaps Darwin or Pine Creek, in this now rusty tin matchbox found cached with other treasured possessions in a rock shelter.

the plateau, and the others he would cache to collect the next time they passed the locality. Such caches of good pigments are said to have been common.

A small deposit of a red ochre of this 'fine' quality is also found outside a small gorge on a tributary of Barramundi Creek. Another locality associated with this ochre is Barradjaluk, a hill further to the south of the same creek. It is the Dreaming site of Barradja, the blue-winged kookaburra, who brought the red ochre there. As well, this ochre is found in the Wirnmiyurr swamp of the Magela Creek wetlands, at Gunnodjbebaborroy.

Marnarr is haematite, a high quality iron ore which produces a rich purple-red pigment. Some samples, the Aborigines say, 'have eyes', referring to the small specular scales within its structure that glisten when the pigment is held in the sun. Haematite is easily identified as it has a distinctive red streak when scratched. There are several important sources of this ore in the region.

In Kakadu, haematite is found at Gunmadj, a location along the track to the Jim Jim Falls. The name marnarr is said to derive from that of garnamarr, the red-tailed black cockatoo. The Dreaming site for this pigment is a deep cave-like recess situated several metres above ground level in the sheer wall of the escarpment. It was in this shelter that, during the Dreaming, the red-tailed black cockatoo attempted to make love to two sisters who were accompanying him on his journey. They refused to have anything to do with him, so once they had fallen asleep he left the shelter and removed the sapling by which they had gained access to the cavern. To escape

captivity, the sisters transformed themselves into brolgas and flew away. The pink patch on that bird's head is the colour of ganbulang, a pigment of that tint, and this pigment shares with marnarr the Dreaming location of Gunmadj cave.

Another version of the origin of marnarr says it was brought to the western margin of the plateau by Narlangak, the frilled lizard. At a locality now called Narlangak bogeranj, in the Worrgol clan's estate, he met Bukbuk, the pheasant coucal, who asked him for some red ochre in order to paint himself. Narlangak hid the pigment under his little finger and then showed the palm of his hand to Bukbuk, saying that he did not have any. (This action explains the configuration of this lizard's forefoot). Bukbuk, angered by this meanness, took the pigment out of Narlangak's hand and threw it away. The pigment landed at Gumatj and became the red ochre deposit in that locality. Although marnarr is the Ngalkbon word for red ochres generally, the Gundjeihmi, recalling its origin, use the term specifically for haematite.

Bandja, a dark yellow ochre, is found as deeply stained clay in the banks of creeks. It was seldom used in rock art, although frequently used for body painting in certain rituals. Aboriginal people describe it as being of the same colour as the pelt of agile wallabies and antilopine wallaroos.

Black pigment was usually prepared from charcoal, though there are paintings which were executed with manganese oxide. The origin of charcoal lies in the first fire lit by the Mimi people to clean the land. These spirits later taught the people how to make fire and use it. The Dreaming place of charcoal black is

located in two estates situated in the central plateau region. Charcoal along with other fire symbols are totems in matrilineal moieties. The Dreaming of the mardgu moiety charcoal is in the Warddjak clan's country, while that of the ngarradjgu moiety is in the land of the Bolmo clan.

Blu stands for blue, and in particular for Reckitt's Bag Blue. Its 'Dreaming' should be Oenpelli, as that was perhaps the most likely source of the 'washing blue' used in a number of rock paintings. In 1912 Baldwin Spencer, visiting Oenpelli, commented disparagingly about the popularity of this exotic pigment with Aboriginal people in other parts of Australia, and expressed hope that it would never reach this region. He made this comment after watching women making a dilly bag using strips of coloured calico or wool instead of the beautifully made string and feather ornaments usually employed in decorating these bags. Despite Spencer's wish, Reckitt's Blue did find its way into the artists' dilly bags, and occasional paintings made using this pigment are found across the plateau. The 'washing blue' became readily available some time after 1925, when Oenpelli was taken over by the Church Missionary Society, though some was brought earlier from Darwin or Pine Creek. Most of the 'blue paintings' were done in the 1930s, and the most recent ones were executed in the early 1960s. A recent study, initiated in the Kakadu National Park to identify and describe the physical and chemical properties of pigments used during the contact period, revealed that materials of European origin were used alongside the traditional pigments in several shelters. This development is most noticeable at the Nourlangie Rock sites, where the most recent paintings were executed in the early 1960s, reputedly on the behest of tourist operators whose camps may have been the source of such material. The sampled pigments were dominated by carbonate minerals, a feature not observed elsewhere in the park. The most common pigment type was identified as a mixture of dolomite and the clay mineral montmorillomite, and it was used both as a white pigment and as a base for coloured tints. This mixture is clearly not a naturally occurring pigment as its particle size is uniform and very small, indicating a grinding process.

The small number of named colours does not indicate the actual range of hues that are found in the region's rock art. The set of four original colours is extended because pigments of red and yellow ochres vary in purity and intensity, the scale of shades reflecting their mineral composition. The red pigment spectrum ranges from pink through brilliant hues of orange-red and red to red-browns and purples. The yellows vary from lightly stained pipeclay to deep yellow and yellow-orange and dark yellow ochre. The scale of hues is then further extended by the optical mixes of colours seen when viewing hatchings of different pigments placed on a contrasting background and over each other. The scale of shades and of colours also varies as the result of differential weathering of the pigments, some remaining only as stains in the rock surface.

There are also tints achieved by mixing white with a colour agent, as well as intermixtures of other colours, producing a range of hues. For example, when black is mixed with yellow ochre the product is an olive green. Many of the lighter tints are created unintentionally when the white pigment, applied to an earlier surface to form the base silhouette for a new painting, becomes stained as the underlying layers of old paint mix and homogenise with the new. The degree of intermixing varies in intensity depending on the technique used to apply the fresh pigment. When a brush with long soft fibres such as andad, made from the aerial roots of andjimdjim, the river pandanus, was used, the intermixing of pigments was minimal. If, however, brushes with short, stiff bristles such as those made from strips of bark from anrebel, the stringybark tree, were used, the staining of the new base by pigments from the underlying design was quite considerable. In some areas, after the death of an artist, rock paintings known to have been executed by him were obliterated by spraying water or applying pigment and smudging it with the hand, intermixing all the ochres used in his work, and any previous paintings over which it may have been superimposed. Although the tradition of effacement was not practised in the western and northern sectors of this plateau, on many occasions an artist preparing to execute a painting on a wall or ceiling covered with multiple superimpositions of previous designs would prepare the surface for his painting by smearing the previous paintings and blending the pigments into a coloured slurry. This practice of smearing previous paintings can be observed at the Main Gallery at Ubirr.

Pigments were prepared in several ways. The hard minerals such as haematite were ground in water on a flat slab of rock or on a shelter's rock floor. Used pieces of this pigment, displaying flat, striated facets, have been found throughout the occupational deposits of all archaeologically tested shelters. The at least 18,000-year-old (possibly much older) red-ochre-impregnated grindstone recovered from the Malakunanya II site documents the early commencement of this technique of pigment preparation. Such stone palettes are found in many sites, as are stained rock ledges, some showing traces where excess wet paint overflowed, running down the sides. The softer ochre and clay materials were dissolved in gundjinem, boat-shaped containers made of paperbark. These 'paint pots' varied in size, depending on the amount of pigment required for a given design.

There is no evidence of the use of organic binders in the rock art. In the past, there have been many suggestions that binding agents such as blood, fat, orchid juice or resinous gums may have been employed, but this is not supported by the statements of the people who witnessed the traditional execution of rock paintings. However, a range of organic substances were used in preparing both the ground and the pigment for decorating weapons and implements, ceremonial objects,

Paintings in which blue pigment was used are found across the plateau, although they are most prevalent in the Oenpelli area. Location: Garrkkanj. 27 cm.

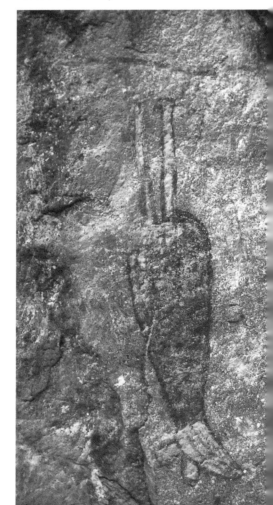

the human body and, more recently, bark paintings. The best known of these binders is the juice of the paperbark orchid (Dendrobium canaliculatum). Before use, the stem of this orchid was lightly roasted, cut open and rubbed over the surface that was to be decorated. In other areas, the latex-like sap of the milkwood tree (Alstonia actinophylla) was used as a pigment binder and also rubbed on to digging sticks, providing them with a non-slip grip. The red sap of the wild peach tree (Terminalia carpentariae) was used to stain spears, spearthrowers and digging sticks before further painted decoration was applied. The resinous gums of wattle trees, such as andjoh (Acacia difficilis), were used to impregnate and protect wooden artefacts as well as being used as binding agents.

The prepared pigment was applied to the rock surface in several ways: by fingers, by the full hand, by various brushes, by spraying from the mouth, or by imprinting an ochre-impregnated object. Occasionally, pieces of dry pigments were used as 'crayons' to draw designs on to the rock. In the Arnhem Land Plateau region, pigments were only very seldom applied by the fingers, and the direct use of the hand in painting was limited to the preparation of the surface for a new painting. The majority of images were painted with a variety of brushes.

The general name for all brushes is gundulk, though this term also applies specifically to finer ones made from sedge grasses. The finest of these brushes are called djiddudjiddu and are made from anyilk, the Cyperus sedges. They are used for fine subdivisions and to lay down rarrk (fine hatchings). The stem of the grass is chewed for the first 3 centimetres of its length, until it separates into individual fibres. Following this, a number of filaments are cut off until the desired thickness is achieved. It is possible to produce a brush of only a single fibre. Other fine brushes are cut out of the pandanus leaf. Fine lines are also made by brushes fashioned from feathers, especially those of the white egret, brolga and magpie goose. Medium-sized brushes are made from the bark of anbiyarrng, the cotton tree (Cochlospermum gregorii). Wider brushes are called angurlah, ('skin'), and are made from the inner bark of anrebel, the Darwin stringybark (Eucalyptus tetrodonta). They vary in width from 1 to 3 centimetres, have very short, stiff bristles and are used to apply large areas of pigment. Andad is a thick tapering brush made from the aerial root of andjimdjim, the water pandanus (Pandanus aquaticus),

and is ideal for applying large areas of paint as it holds a considerable amount of pigment and in application does not tend to intermix underlying colours.

Rarrk is a term for all fine decorative detail, found usually in the paintings of the X-ray convention. It includes parallel line hatching and crosshatching, as well as the parallel zigzag lines, herringbone and other delicate fine-line infill. The thick outlines and subdivisions of these decorative areas are glossed wunggal ('roads' or 'tracks'), or gunbodmemurrung ('backbones'). Internal hatching formed by thicker lines is identified as belonging to the ngarradjgu or duwa moiety, while the very delicate lines, the mandjawurrk rarrk, are associated with the mardgu or yirridjdja moiety. Both rarrk and wunggal are said to be derived from the reticulate and parallel venation seen in the leaves of plants.

Pigment sprayed from the mouth was mainly used when making stencils. In this region, stencils are predominantly of human hands and boomerangs. During the more recent period, patches of pigment were sprayed to decorate painted motifs, usually representations of the more powerful beings of the Aboriginal cosmogony. Such marks were also occasionally arranged in horizontal lines forming a non-figurative design. Unlike the backgrounds or bases prepared for the Wandjina figures in the Kimberley shelters, spraying to prepare bases for painted designs was a rarely used technique in Arnhem Land.

Imprints were generally made by placing a hand in a wet pigment and then pressing it against the rock wall, leaving a 'print' of its surface. Similarly, various objects, such as bunches of grass, were wetted in pigment and struck against the rock. Other imprints and paint splatters were made by hurling wet pigment-soaked objects against the rock surface. Two or more of these techniques of application may have been used in executing the one painting, which may have been embellished by the addition of beeswax pellets.

A preference for certain colours or colour combinations can be identified not only as a group expression, but also at the individual artist's level.

There are also noticeable colour biases found between sites, even those in close proximity to each other. The colours used by members of the Godjgarndi clan to execute painted images in rock shelters help to identify the extent of their estate. Their colour preference, as seen in the more recent paintings, was for the yellow

A painting of a hunter figure on a partially exfoliated surface documents how deeply into the rock matrix the prepared haematite pigment can penetrate. Location: Birradak. 25 cm.

and red pigments. As garlba (yellow ochre) has its Dreaming within the Godjgarndi's traditional land, it is perhaps only natural that they would choose this pigment before any other. Also, by burning garlba, a bright red pigment is created, so it is understandable that a combination of these two colours would be used in many of their designs.

An early awareness of and preference for colour contrast is evident in the selection of light coloured walls for designs executed in red pigment and darker backgrounds for paintings in white, and the contrast was increased by the use of more than one colour when constructing a painting and by superimposing colours. Most of the paintings of the earlier period were first painted in red, and then decorated in white or yellow. This colour selection was very judicious, as pigments made from iron oxides or haematite are long-lasting, some even penetrating rock surfaces to a depth of several millimetres. In contrast, the white and yellow are fugitive pigments, weathering at a much faster rate than reds and easily removed by the mechanical attrition rendered by wind and water.

That many of the images which remain now as red monochrome were originally executed in more than one pigment is documented by

paintings found in plateau shelters with deep overhangs and a relative absence of moisture and excessive air movement. In sites where such a favourable microclimate extends along the painted surfaces, paintings of styles which elsewhere appear only as red monochromes are found to have been also executed in white or yellow, or in a combination of the three pigments. Thus, many of the figures which now remain as red silhouettes originally may have been – indeed, most probably were – far more elaborate.

The order of colour application in constructing a painting was reversed during the estuarine and later periods. In these periods, the base silhouette depicting the given subject was applied in white pigment and details were added in reds, yellows and occasionally in black, and more recently in the introduced blue pigment. Although designs with yellow and red bases are also found during these periods, they constituted only a minor convention.

The white base of the paintings creates a high visual contrast for pigments applied over it. When decorative hatching was introduced, it helped to create shimmering optical mixes of previously unattainable qualities. The disadvantage of this sequence of colour use is that the paintings, if not well protected, are subject to rapid weathering. As most white pigments are of coarser particles than reds, they do not penetrate into the rock matrix but remain on its surface. Some whites also are of poor opacity and were usually applied in a much thicker layer than the reds. Being mostly clay-based, the white minerals are the most fugitive pigments. In many shelters where rain directly falls on, or water flows over, a painted surface, designs executed on a white base have washed away, revealing earlier paintings in red. Only where a red pigment used to outline and decorate such a painting has successfully penetrated the white base, to stain the rock surface, do we find traces of lines which indicate its former existence.

In contrast to paintings of the early styles, which were mainly line constructs, paintings of the more recent periods were executed as decorated silhouettes. In instances where the two traditions appear superimposed, the later one usually almost completely covers the earlier one. When the consequences of this, altogether with the fugitive nature of some pigments, is taken into consideration, it becomes clear that many of the paintings that once existed in these shelters have been lost to us. Furthermore, we will never know what the designs that remain as red stains originally looked like. Consequently, any statistical analysis concerning painted subjects or colour use must be viewed with scepticism, unless dealing only with the most recent horizon of the rock art.

From the available evidence it appears that the most popular colour schemes in the early styles were red, followed by red enhanced by white, and then white on its own. The colour contrast preference changed in the later periods to red over white. In the elaboration of the colour use, combinations such as two reds (red ochre and haematite) and white, or white, red and yellow, or red and yellow were used. At least 16 colour combinations were used in the most recent period. The most widely used pigments, in order of preference, were reds, white and yellows, with black pigment being only occasionally used.

The casual paintings of the latest phase of the region's rock art were executed in stained clay slurries, usually off-white in colour. These slurries were not used because they were the preferred medium, but because they were easily available everywhere.

## *Aboriginal view of the rock art*

The rock art of the Arnhem Land plateau reflects the basic cultural homogeneity of the people who live around and across this sandstone feature. That this cultural bond existed in the past is documented in the spatial range of earlier art styles and motifs. This overall impression, however, does not deny that in the more recent paintings, and indeed from the very beginning of this art tradition, there are recognisable stylistic variations in different subregions. Such regional differences are also common in ceremonies, cosmologies and mythic systems.

Aboriginal people view their rock art heritage from a different perspective from that of observers from other cultures. Their general term for a painting, a picture or an image, gunbim, has a noun class prefix – 'gun' – in common with parts of the body, landscape terms and various cultural constructs, demonstrating clearly the close and special relationship between human beings, their land and their Dreamings. They say that ancestral beings, the 'First People', taught their forbears how to paint.

The people of Arnhem Land subdivide the body of rock art in their region into five categories:

1. Mimi bim
2. bim gurrmerrinj
3. bim banemeng
4. bawarde garruy
5. 'rubbish' paintings

**1. Mimi bim** – paintings believed by local groups to have been executed by the ancestral Mimi, some of the 'First People', but not their present-day kin, the mischievous spirits of the 'stone country' environment. Aborigines are said to have acquired their artistic skills by being taught by the Mimi or by copying their paintings. Many of the human and spirit beings and some representations of animals of the pre-estuarine period styles are placed into this category.

**2. bim gurrmerrinj** – paintings of ancestral beings, malevolent spirits and dangerous creatures. It is claimed that these subjects placed their own images on the rock. The term bim gurrmerrinj is translated as 'turn oneself into a rock painting' or 'paint oneself on to the landscape'. These images are not viewed as simple representations of given beings, but as their actual bodies. Paintings of this category

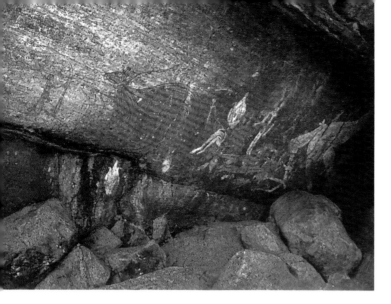

My colleague, on sighting the paintings in this shelter, exclaimed: 'This is the "proper" garlba from Garlba gadidjam.' Location: Namarrgon site complex.

can be divided into three sub-groups, according to the sites where they appear, which have varying restrictions of access, behaviour and knowledge of the associated meanings:

**(a)** images of ancestral beings – a generalised group including the Rainbow Snake – many of which are found in occupational shelters where they may be seen by women, children and uninitiated males, but to whom their inner meaning is not revealed;

**(b)** representations of ritual importance and sacred designs, the knowledge of their meanings and access rights to such sites being restricted to initiated men; and

**(c)** paintings of dangerous creatures such as djurrang, the taipan *(Oxyuranus scutellatus)*, the images being the species' potential increase centres: these sites are accessible only to the most senior men, who ensure that the paintings are not disturbed or damaged as any interference could cause the increase of these harmful species.

**3. bim banemeng** – the secular paintings of the more recent periods, executed in the contemporary stylistic conventions and depicting known subjects. The individual motifs of this category may have been executed with different intent at different times. An animal species, for example, may represent a totemic ancestor, a portent of fatherhood or a good meal. This category embraces bim bawabon (sorcery paintings), images which were usually painted in occupational shelters and were meant to be seen, and also gunbirdi bim (beeswax designs).

**4. bim bawarde garruy** – rock engravings (literally, 'rock dug') are so termed when depicting subjects other than animal or human feet, in which case they are described as gunbok (tracks). Their origin is said to fall into the ancestral past, being attributed to either Nagorrgho or Namarrgon.

**5. 'rubbish' paintings** are crudely executed paintings usually painted with white slurry, the casual art of the chronological sequence.

## Non-Aboriginal sequence of the rock art

Non-Aboriginal views of the region's rock art may be constrained by the methodologies used. In the past, this complex body of rock art – in which a number of styles are evident, even after only a perfunctory survey – was reduced to two all-encompassing art phases. The diverse painted images were classified as being of either the Mimi style or the X-ray style. Later, the Mimi phase was subdivided into 'early' and 'late' periods, and the X-ray paintings were classed into 'incipient', 'simple', 'standard' and 'complex' types.

In this book, the term Mimi is not used as an identifier of a stylistic phase of rock art and it is important to note that its previous usage in texts has not been consistent. The term has been applied to paintings of human and mythological beings, as well as to animal subjects depicted in various styles, ranging in time from the commencement of this art form to the most recent period. This is in contradiction to the view of Aboriginal people, who identify representations of subjects with which they are not familiar, unusual types of weapons and implements, extinct animals, and images of styles and techniques not used in the ethnographic present as being done by the Mimi spirits.

The chronological sequence of the Arnhem Land Plateau rock art presented in this book is based on the study of some 2000 rock art sites. At the commencement of the study, the identification of rock art styles was seen as the basic and most important tool for ordering this immense and varied body of art. After some time, a number of styles with paintings of specific forms, constant elements and overall aesthetic quality of expression were identified. These divergent and distinct styles were then structured with other forms of rock art, by their order of superimposition, into a chronological sequence. Clear superimpositions of all styles, confirming this sequence, were recorded at many sites. This work was followed by detailed analysis of each style's content, during which it was noted that certain subjects were present in two or more styles, but absent in others. In the quest for the answers as to why this had occurred, the climatological, geomorphological, archaeological and historical data, along with the zoological and botanical evidence, were sought and considered. The styles were then divided into art periods and phases, and positioned between time indices indicated by the study. The

outcome is a rock art sequence of four main periods: the pre-estuarine, estuarine, freshwater and contact.

Logical, descriptive and meaningful terms are used to describe the styles, periods and phases of this rock art sequence. The periods were given names which reflect environmental or other changes, while styles were named after the most obvious aspect of the given group of paintings. As art expression is considered to be an integral and significant aspect of the society that produced it, any changes in rock art styles represent responses to social or symbolic needs at different times and perhaps by unrelated groups.

Within this sequence considerable stylistic diversity is evident in the broadly defined art complexes which are found at the beginning of the rock art sequence, represented by the large naturalistic figures at the commencement of the pre-estuarine period, and at the other end of the sequence in the multiplicity of expression accompanying the paintings of the X-ray convention of the late estuarine, freshwater and contact periods. But even in the well defined styles – such as those of the dynamic figures, the elegant Mountford figures and the simple figures with boomerangs – the depiction of human beings and animals changed through time in its form of expression. This variation is understandable as no art style, however conservative its creator or society, ever remains static. In the dynamic figures style this continuing development is evident not only in the size of the figures but also in their typology. In some examples, the arms and boomerangs are one-line thick, while in others the musculature of the limbs and the form of the weapons are shown. Figures may be sketched in by an array of fluid strokes or alternatively the parts of the body may be outlined by thicker continuous lines. Some figures are completely formed of dotted outlines or pointillistic silhouettes. The body mass or surfaces may be suggested by dotted or barred infill, by stroked infill following its contours, or by a combination of these techniques.

## CHRONOLOGY OF THE ARNHEM LAND PLATEAU ROCK ART

| Period | Phase | Style/technique | Major or identifying elements |
|---|---|---|---|
| *Pre-estuarine* | 50,000 years ago<br>From this date, haematite and red and yellow ochres were used to prepare pigment | | |
| | | *Object imprints* | **Hand prints; imprints of grass and thrown objects** |
| | **20,000 years ago** **Naturalistic** | *Large naturalistic figures* | **Extinct megafauna; thylacine; Tasmanian** |
| | | *complex* | **devil; terrestrial animals; rock python; freshwater crocodile; human beings; earliest *X-ray* paintings** |
| | | *Dynamic figures* | **Human beings in complex apparel; anthropomorphs; zoomorphs; terrestrial animals; freshwater fish; stencils: hand of 3MF convention, boomerangs; one-piece multibarbed spears; detailed compositions** |

| Period | | Phase | Style/technique | Major or identifying elements |
|--------|--|-------|-----------------|-------------------------------|
| | | Stylisation | *Post-dynamic figures* | Human beings in headdresses, pubic aprons and bustles; macropods; lizards; fighting pick/hooked stick introduced |
| | | Schematisation | *Simple figures with boomerangs* | Human beings in headdresses, pubic aprons and bustles; conflict; fighting pick; single- and multiple-pronged barbed composite spears; possible spearthrower |
| | | Stylisation | *Mountford figures* | Human beings (many elongated); spearthrower |
| | | Naturalistic symbolism | *Yam figures* | Anthropomorphised yams; phytomorphised animals; Rainbow Snake; ibis; egret; short-necked turtle; flying fox; long-arm prawn; segmented circle symbol |
| *Estuarine* | 8000 years ago | Naturalistic | *Early estuarine complex* | Estuarine fish: barramundi, mullet, catfish; saltwater crocodile; variety of spearthrowers |
| | **4000 years ago** | | *Beeswax designs* | Human beings; anthropomorphs; non-figurative designs |
| | | Intellectual Realism and contemporaneous naturalism | *X-ray complex* | Lighning man; stone-tipped spear; X-ray paintings of animals and humans with detailed and decorative features |
| *Freshwater* | 1500 years ago | | | Hook-headed human beings; magpie geese; water lilies; 'goose' spears; goose-wing 'fan'; didjeridu; complex spearthrower |
| *Contact* | 300 years ago | | | Makassan and European subjects; introduced animals; sorcery paintings; decorated hands |
| | **Ethnographic present** | | *Casual paintings* | |

# Pre-Estuarine Period

The commencement of this period, when the initial stirrings of aesthetic sensibility were transposed into visual expressions by the first questing individuals, is literally covered by the sands of time. If we accept the validity of the most recent dating of occupational remains, it began at the plateau's northern margins at least 50,000 years ago. Amidst the fascinating cultural items recovered at the Malakunanya II shelter in Kakadu National Park were a large block of haematite, several ground pieces of this material that had been used in preparing pigment, as well as several types of red and yellow ochre. Paintings which may have been executed using these pigments are buried by the sands that have accumulated against the wall of the shelter over the following tens of thousands of years of Aboriginal occupation.

It is possible that the first rock art images within the wider region may have been executed before this time on the now submerged rock features that formed the landscapes of the continental shelf extending westward towards the sea and on the Arafura plain then joining Australia to New Guinea. The first colonising humans, after making their way across the deep Timor Gap, the last water barrier, and establishing themselves on the coast, went on to occupy this larger continent. Some groups followed the coastline north towards New Guinea and became the progenitors of the Papuan populations, while others ventured along the coast south and then followed the continental rivers inland. One such band followed the 'Alligator' River (which included the present Adelaide, Mary, Wildman and the three Alligator rivers as tributaries) to the margins of the Arnhem Land Plateau, and found the Malakunanya II shelter.

During the pre-estuarine period, the local groups were subjected to a number of dramatic environmental changes. At first, the climate of northern Australia was substantially more arid than it is today, with rainfall perhaps less than half of that at present. The 'Alligator' River region and the Arafura plain – the landbridge north to New Guinea – had an open savannah vegetation with forested river margins, a regime and a floral community similar to that now found several hundred kilometres inland on the Barkly Tableland.

The region's rainfall has substantially increased with the rising sea levels. By 30,000 years ago, when the sea peaked, the nearest coastline for the plateau populations was a small bay between the present-day Melville Island and Cobourg Peninsula. The people living there at the time were, perhaps, like the groups living on the Cobourg Peninsula at present, an integral part of the Arnhem Land Plateau cultural block with close social, economic and ritual ties. As they moved out to recolonise the emerging land during the last Ice Age, somewhere on the vast Arafura plain, they may have met with the 'Papuans', who expanded southward from the lowlands of New Guinea. The sea began to rise again, after reaching its lowest level some 20,000 years ago, and, as the waters invaded the continental shelf and submerged the Arafura plain, the populations were forced to retreat. At first this sea rise was quite rapid, but about 10,000 years ago it slowed considerably. Aboriginal groups by then had lived for many thousands of years alongside the 'Papuans' – indeed, for a far longer period of time than has passed since the sea parted them again. During this period of contact, the Aborigines would have developed close social and cultural ties with their northern neighbours, and it is more than likely that they adopted and brought back with them some of the northerners' cultural traits.

The pre-estuarine period of rock art was formerly thought to have commenced 20,000 years ago, at the height of the last Ice Age, and perhaps as far back as 35,000 ago. The early commencement of this art form was then, as now, based on dates of used pieces of ochre recovered from the lowest levels of archaeological excavations and on the presence of paintings depicting the long extinct megafauna. However, the most recent dates for the settlement of this region considerably extend the commencement of aesthetic activity, rock art tradition and the beginning of the pre-estuarine period to at least 50,000 years ago.

As its name suggests, the pre-estuarine period of the region's art ends with the rise of the sea after the last Ice Age and the

development of an estuarine environment along the north-western margins of the plateau. This incredible span of time – from at least 50,000 to about 8000 years ago – introduces many challenges in the study of the multiplicity of stylistic forms and techniques of the rock art of this earliest period. Throughout its duration the artists depicted human beings, emphasised terrestrial animals and freshwater fish, recorded changes in weapons and implements, documented the mode of dress and decoration of human figures and portrayed aspects of their spiritual life with beings of cosmogony. They also experimented with depictions of subjects' internal features and at a very early stage developed the X-ray concept of quite complex forms. During this period, the rock art sequence consists of a number of art phases, styles, motifs and techniques of image-making:

1. *Object imprints*
2. *Large naturalistic figures complex*
3. *Dynamic figures*
4. *Post-dynamic figures*
5. *Simple figures with boomerangs*
6. *Mountford figures*
7. *Yam figures*

## Object imprints

It is not possible to identify with any degree of confidence whether the first rock art images were the imprinted marks or the figurative forms. From my observations, however, it seems that the earliest recognisable images are the hand prints, grass prints and imprints of thrown objects. Red ochre of varying hues, from bright orange to dark brown, has been used in their execution. Some of the hand prints are almost black.

Hand prints are generally found superimposed by all the other motifs and styles. They are the first and the most common subject in this stylistic grouping. They were made by placing the hand into a wet pigment and then pressing it against the rock surface. The hand prints are usually made in some numbers and are arranged into compositional groups. In some sites they are found in several discrete layers, superposed and differentially weathered, suggesting that this form of expression was used over a considerable period of time. The stencilling technique was perhaps first used towards the end of this period, as occasionally impressions of hands are found

within their stencilled form. However, it is also possible that these stencils may have been made at a later date.

The grass imprints are considered to be contemporaneous with hand prints. They are usually located on vertical rock surfaces, high above the reach of a human's hand. They were made by immersing the heads and stalks of grasses in wet pigment and striking them against the rock surface. A wide range of grass-like plants were imprinted in numerous shelters across the western and northern margins of the plateau. Although most of these imprints are weathered, it is probable that examples clear enough for taxonomic identification will be located sometime in the future. The grass prints were made at a time when cereals probably formed an important part of the staple diet of the local populations. As most of the general subjects depicted in the rock art of this region reflect the economies of local environments, the grass prints would have been made in the shelters of lowland residual formations and along the margins of the escarpment adjoining the plains. These sites were later also favoured by the populations of the estuarine and subsequent periods, and it is possible that only those grass imprints which were made high up on the walls where they would not be overpainted by other images survive. However, usually their placement a considerable distance above ground level has been deliberately chosen, as is seen in other shelters where they appear above other early images of this period or where they are the only subject represented.

Another contemporaneous practice was that of creating images and marks by throwing ochre-impregnated objects against the walls and ceilings of shelters, leaving mostly unidentifiable imprints. They are found up to 8 metres above ground level. Initially, it seemed that some of the curvilinear images were uncoordinated brush strokes, made by a brush attached to a long flexible stick. The artist would have had little control over directional movement, which could account for what looked like doodles found on some ceilings. Later, several clear examples from a well protected shelter documented that at least some such images were imprints of skeins of bush or hair string, as even their individual loops and their twined nature were distinctly impressed. Imprints of more solid objects are also found, some surrounded by radiating splashes of pigment forced out by the impact. These objects may have been compressed pieces of paperbark or similar material immersed in pigment and hurled against the rock surface. But many

*Opposite* Detail of a ceiling, showing a painting of a tree with yam 'strings' extending from two of its branches. On the left is a being with a snake-like body and a yam head placed above open arms. In the centre is a one-armed anthropomorph shown with hair along its back. Location: Maddjurnai. Tree 100 cm.

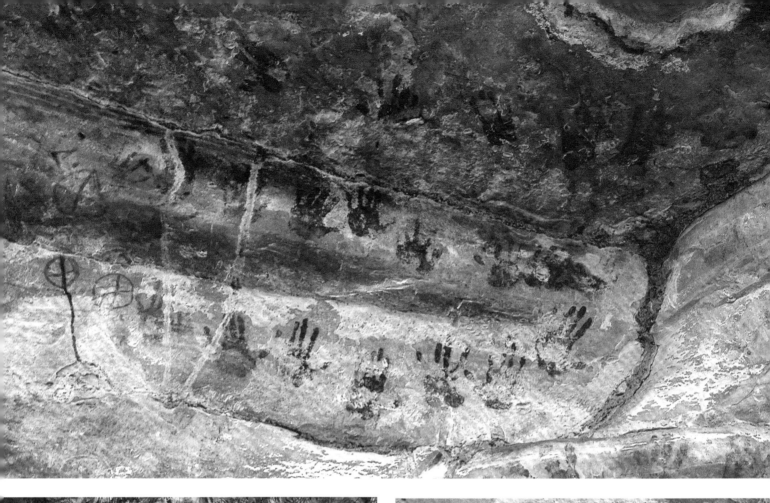

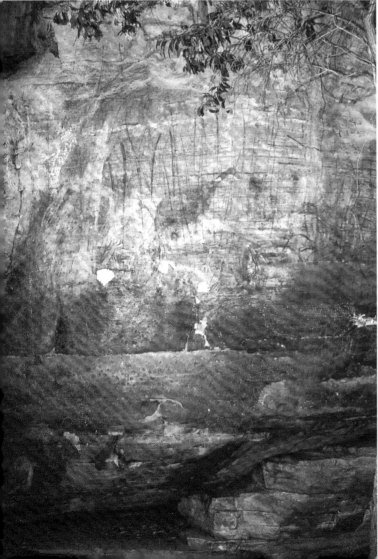

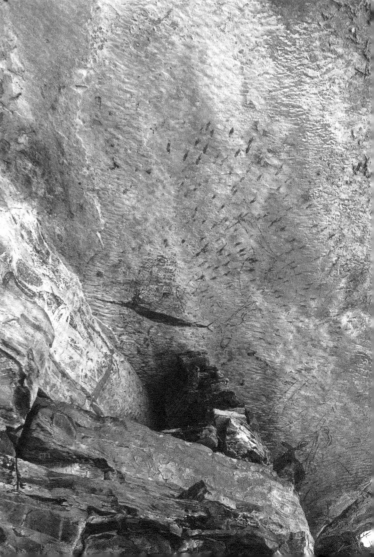

other imprints remain as enigmatic images whose identity and purpose may never be known. Imprints of animal tails are found in a number of shelters across the plateau, but are most common in its eastern sector.

## Large naturalistic figures complex

This stylistic complex consists of paintings depicting animal species and human beings executed in the naturalistic mode of expression. The individual representations are quite large, and often larger than life-size. The name of this vast corpus of images reflects the obvious difference in size when compared with the small, delicate figures of the following style. The term should be regarded as generic, because in this complex, which extends over a period of many thousands of years, subjects have been depicted in a number of divergent stylistic forms. The exact placement of each of the stylistic variants within this body of art has not yet been established. There are several difficulties in unravelling its secrets. Many of these early paintings are badly weathered, remaining only as stains of varying hues in the rock surface, while others are superposed by numerous layers of more recent paintings with only a tantalising glimpse of part of the design showing through as evidence of their presence. Even in the deep and well protected shelters in the plateau and escarpment, where most of the paintings of this stylistic complex are found, it is not always a simple process to establish the order in which they have been executed as the wall or ceiling may be a mass of superimposed designs in red. It is only where two lines of contrasting hues cross, or where one of the lines is enhanced by pigment of a different colour, that the order of superimposition is quite clear.

What is most surprising is that the first paintings represented in this stylistic complex are not tentative and undefined collections of lines gradually evolving into a recognisable image, but that from the very beginning all the figures are confidently drawn indicating a long development of such tactile skills. Paintings of animals and human beings depicted with their internal organs first appear in this stylistic complex.

## Large naturalistic animals

Faunal species are the main subjects of this period. The animals are usually drawn in broad, free-flowing outlines and are textured or filled in with contour lines, stipples, patches and occasionally ochre wash. Sometimes, darker wash has been used to accentuate certain parts of the body, like the lower legs in macropods. Most animals are depicted in profile, but there are several examples of an oblique orientation where they are portrayed in a three-quarter view. The animals are identifiable, as the artist depicted those details most characteristic of the species concerned. For example, the head shape, ear shape, vibrissae, length of forelimbs, general body form, and shape and size of the feet and tail are the distinguishing features used in portraying macropods, the most numerous subject of this period. The depicted species are identified as the antilopine wallaroo (*Macropus antilopinus*), the black wallaroo (*M. bernardus*), the common rock wallaroo (*M. robustus*) and the agile wallaby (*M. agilis*). Other represented animals are the rock possum (*Pseudocheirus dahli*), the northern brown bandicoot (*Isoodon macrourus*), the echidna (*Tachyglossus aculeatus*), the rock python (*Morelia oenpelliensis*) and the freshwater crocodile (*Crocodylus johnstoni*).

However, a number of representations are not recognised by Aboriginal people as belonging to the present-day fauna of the region. One such animal frequently depicted is the now extinct thylacine (*Thylacinus cynocephalus*). Others are the numbat (*Myrmecobius fasciatus*) and the Tasmanian devil (*Sarcophilus harrisii*), still found in other parts of Australia. There are also paintings of four animals that may represent the extinct megafaunal species: the long-beaked echidna (*Zaglossus* sp.), the marsupial lion (*Thylacoleo carnifex*), the single-toed macropods (Sthenurinae) and a large diprotodontid (Palorchestidae).

*Opposite above* Hand prints were originally executed in many different shades of red ochre, ranging from bright orange to dark brown. Some pigments may have changed colour as they oxidised or as their composition altered due to the effects of hydration.

*Opposite left* In a number of shelters, imprints of grass extend from just above the reach of a human hand to 7 metres above ground level. Location: Birradak.

*Opposite righ* Imprints of animal tails are found in a number of shelters across the plateau. The most extensive panel featuring this motif is on the ceiling of a 20-metre-high overhang. The imprints were made from a ledge which has since partially collapsed. Location: Mandjedjgadjang.

*Left* A site dominated by on expressive painting depicting the large rock python *(Morelia oenpelliensis)*, common to this area. The snake was painted over earlier images of macropods. On the ledge below is a rockfall which has been dislodged from the painted wall. Location: Maddjurnai. Snake 260 cm.

*Middle left* A larger than life-size painting of the female common wallaroo with a joey in its pouch. Location: Burrunggui site complex. 165 cm.

*Middle right* In this shelter a freshwater crocodile *(Crocodylus johnstoni)* and the adjoining stylised white and red macropod are found superimposed over a number of earlier paintings of macropods, some of which are larger than life. Freshwater crocodiles inhabit the plateau's streams, but are found there today only in their pygmy form. As in this and other plateau shelters, they are depicted by paintings up to 5 metres long – the artists may have been portraying the Dreaming representations of this species. This shelter, with three large representations of freshwater crocodiles, was identified as the freshwater crocodile Dreaming. Location: Dangurrung. Crocodile 340 cm.

*Bottom left* In this accomplished painting a macropod is depicted with an alimentary canal, an early X-ray feature. It bears some resemblance to the short-eared rock wallaby *(Petrogale brachyotis)*, except for its hind legs which end in bird-like feet. Location: Inagurdurwill. 110 cm.

*Bottom right* Most of the early images of animals and human beings are drawn in broad, free-flowing outlines, with the body mass suggested by contour lines or textured with broken lines or stipples. This technique of structuring an image enables us to see 'through' the superimposed paintings and to identify the sequence in which they have been executed. In this example, the four consecutive paintings of common wallaroos were eventually overlaid by a macropod with some of the features of an agile wallaby but with an elongated body. Location: Inagurdurwil. Agile wallaby 120 cm.

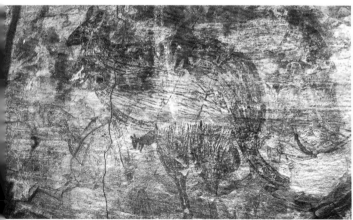

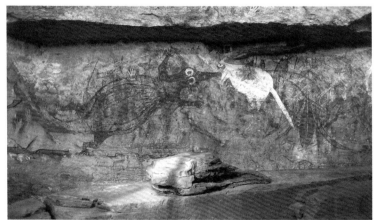

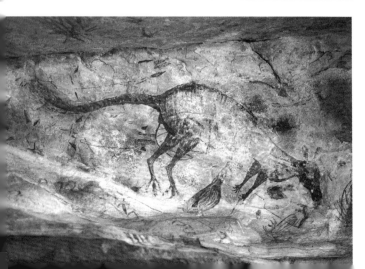

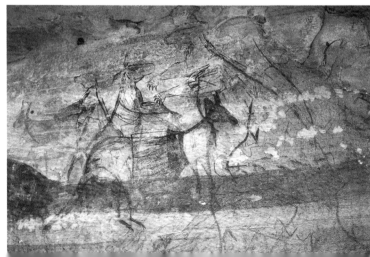

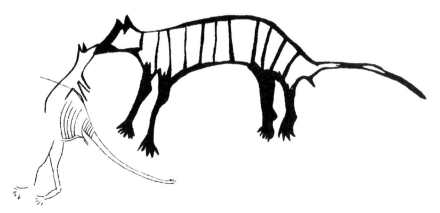

# Thylacine

The first evidence that the rock art of the Arnhem Land Plateau may be of some antiquity came with the discovery by Eric Brandl in 1972 of painted images of the thylacine. Some of these representations are in considerable anatomical detail, leaving no doubt that this animal once roamed the environs of the escarpment and hunted throughout the rocky maze of the plateau. Many other depictions of thylacines, in a number of stylistic forms, have subsequently been located.

The thylacine, popularly known as the Tasmanian tiger, was the largest carnivorous marsupial of recent times. Its scientific name, *Thylacinus cynocephalus*, describes its general appearance – a pouched dog with a wolf's head, whose mighty jaws could gape 120 degrees. It was indeed wolf-like, with short legs and a long, stiff tail resembling that of a kangaroo. The males, more solidly built than the females, weighed as much as 35 kilograms, measured up to nearly 2 metres, and were 60 centimetres high at the shoulder. The average weight was about 25 kilograms. Both sexes shared the thylacine's most distinctive features and the source of its popular name – a series of 15 to 20 black to dark brown stripes running across the back from the shoulders to the base of the tail.

The fossil record shows that thylacines were once common throughout Australia and New Guinea, but disappeared from the mainland some 2000 years ago. Their extinction was most likely due to climatic changes and competition from the dingo, a more efficient carnivore. The dingo, however, never reached Tasmania, and there the thylacine continued to survive until the coming of the European settlers and the establishment of their sheep farms.

As thylacines killed sheep, the early settlers considered them to be a threat to their prosperity. In 1835, the Van Diemen's Land Company introduced a bounty on this animal, which was later augmented by a government bounty. By the end of last century, at least 3000 thylacines had been killed. The animal was becoming quite rare, but continued to be hunted to the point of extinction. The last thylacine was shot on a farm in Tasmania's north-west in 1930, while the last captive animal died in the Hobart Zoo in 1936. Since then, many sightings of this species have been reported but not substantiated, and it is unlikely that the thylacine survives.

In the rock paintings of the Arnhem Land Plateau, thylacines appear in a number of rock art styles of the pre-estuarine period, including that of the yam figures which concludes this period. The thylacines are depicted as elongated dog-like animals with a long tapering tail, a series of vertical stripes and marsupial genitalia. In males, the penis is posterior to the scrotum and directed backwards where it projects from beneath the tail. That the female had a backward-opening pouch with four nipples is depicted in a painting of this animal with four young feeding pups. The most detailed and anatomically accurate images were executed by the artists of the dynamic figures style. Paintings depicting this animal vary in size from a 12-centimetre diminutive representation to a 250-centimetre-long, larger than life-size image.

That the thylacine was hunted and eaten by the Aborigines is also depicted in the rock art. In one weathered image, a male dynamic figure is seen carrying a striped animal by the neck, and in another image, on his shoulders. A painting in the post-dynamic figures style depicts a hunter throwing himself at a dog-like animal, perhaps a thylacine, to grasp it by the tail.

As well as paintings of thylacines, there are also representations of other dog-like animals, some of which may represent the marsupial lion (*Thylacoleo*). One painting has been thus tentatively identified. Others may be early representations of dingoes, before this animal was adopted by people as a pet. Only rarely are dingoes found depicted in the more recent periods. There are also paintings of one-toed kangaroos and their tracks, which may represent the extinct short-faced kangaroo of the genus *Sthenurus*, as the extant macropods and their tracks are shown in the three-toed schema. However, it is possible that the artist may have simply omitted to depict the animal's side toes. The humans who entered the Australia of this giant marsupial perhaps contributed to or caused its extinction.

Also present in this horizon of rock art are paintings of large birds, which still await reliable identification.

Detail of a thylacine feeding its young, and its superimposition by a more realistic and detailed, but now badly weathered, painting of the same species in the dynamic figures style (the rear, back legs and tail are painted over the young). This latter representation is similar to a painting located some 60 kilometres to the south (above) and may have been executed by the same artist. The ochre used by the artist at both locations was of a fugitive nature and paintings at these sites remain as stains only. Location (left): Dangurrung. Adult thylacine 122 cm. Location (above), Djarwambi. Thylacine 62 cm.

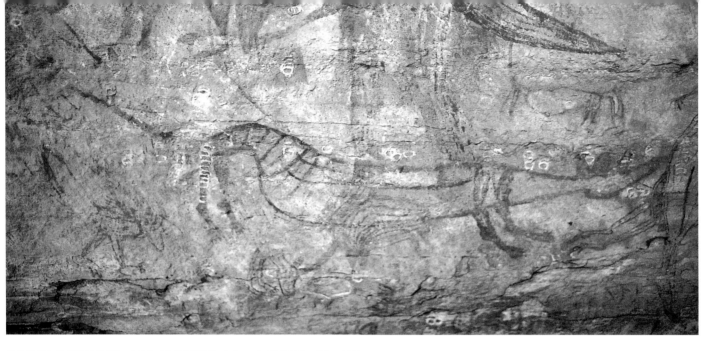

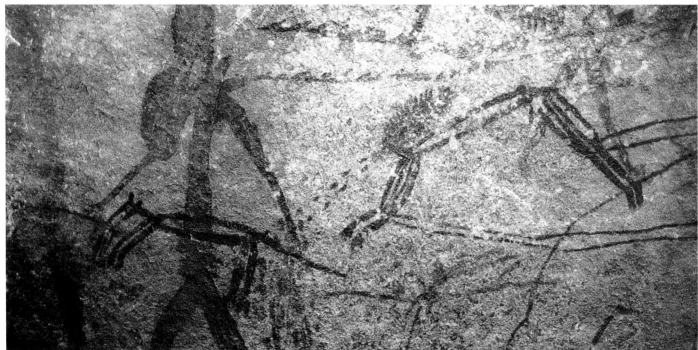

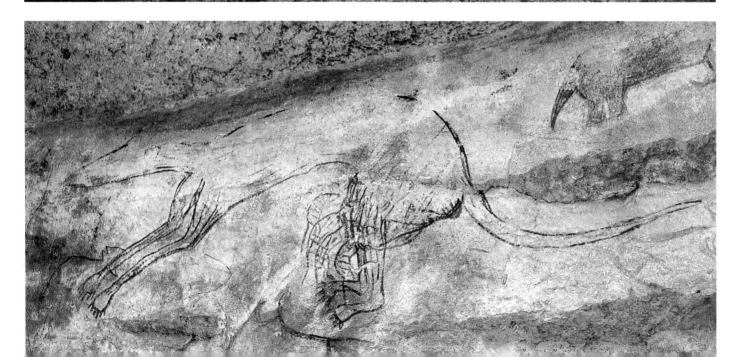

## Tasmanian devil

The Tasmanian Devil *(Sarcophilus harrisii)* is another animal that once lived in this part of now-tropical Australia. It was hunted by the Aborigines, an activity portrayed in rock art. The animal's former presence was first documented during the excavation of an occupational deposit situated in a cavernous shelter formed in a Barribarri residual in the northern sector of Kakadu. Skeletal remains of a Tasmanian devil were recovered from the base of this deposit and found to be 3100 years old. The species appears to have been less frequently depicted in rock art than was the thylacine. It is most commonly represented in the large naturalistic animals stylistic complex and in the dynamic figures style, while in one example it has been executed in a simple early X-ray form.

*Left* This composition of a Tasmanian devil being followed by a hunter figure holding a boomerang, poised to strike, suggests that the people of the dynamic figures style period hunted this animal. Location: Bolkngok. Tasmanian devil 60 cm.

*Below* One of the best portrayals of a Tasmanian devil is this painting executed in the dynamic figures style. Location: Wongewongen. 80 cm.

*Opposite top* A depiction of a thylacine as an extremely elongated 'sausage-like' animal, perhaps suggesting that the artist of the period was a whimsical 'cartoonist'. Location: Dangurrung. 138 cm.

*Opposite middle* Several rock painting compositions suggest that thylacines were hunted. In this example, a man wearing a large headdress has launched himself at the animal to grab it by the tail. The double row of dashes emanating from his mouth towards the thylacine is perhaps an exclamation of success. Location: Guliyambi. Thylacine 21 cm.

*Opposite bottom* Painting of a female thylacine with four feeding young. Although its backward opening pouch has four nipples, European records describing this animal indicate that only two or three young were reared. This painting, an earlier record, suggests that occasionally four young were reared. Location: Golbon. 165 cm.

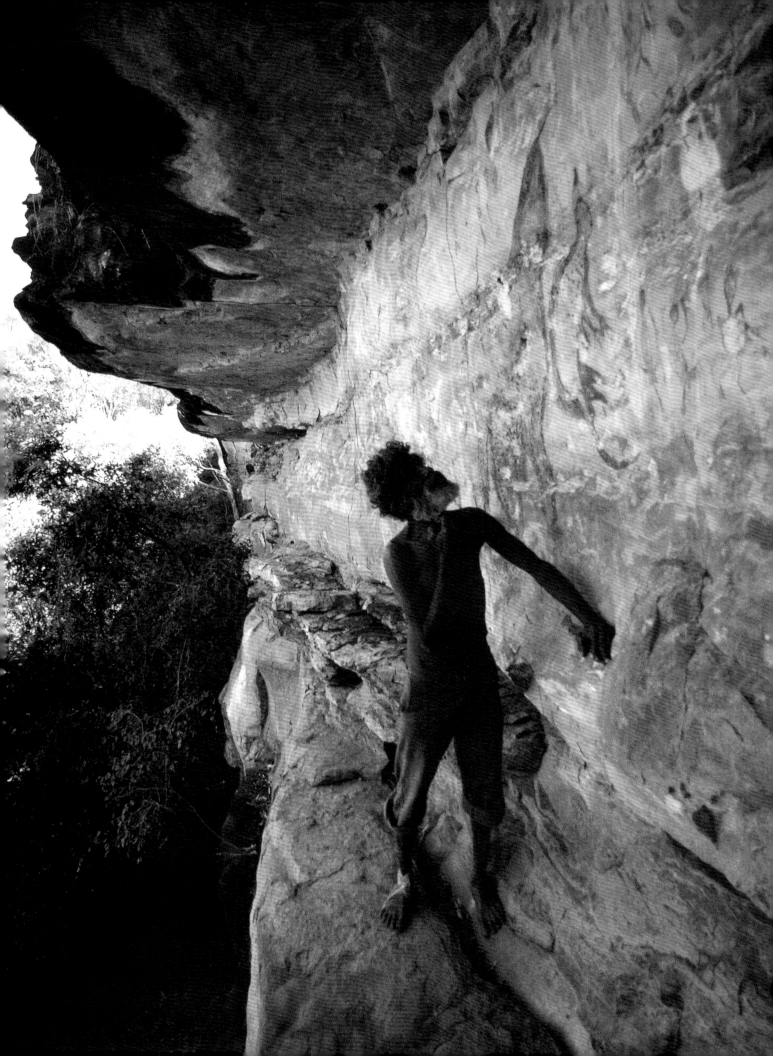

## Zaglossus

### THE LONG-BEAKED ECHIDNA

Many clear representations of echidnas are found in the large naturalistic figures complex as 'well as in various other styles of the pre-estuarine period. Although there is considerable variability in their form, the artists did portray their identifying features in some detail. On examination of these representations, it can be seen that two types of animals have been illustrated. One type is portrayed with a long, narrow tapering and downcurved head, long legs and a ventrally directed tail. The other form has a clearly delineated head with a well defined, straight or slightly upturned beak, squat body and tail directed posteriorly in line with its beak. The former strongly resembles the living *Zaglossus bruijnii*, today found only in highland New Guinea, while the latter type can be recognised as *Tachyglossus aculeatus*, present in the local environment.

*Zaglossus*, the long-beaked echidna, was widespread in Australia during the late Pleistocene and is associated with the extinct marsupial megafauna. If this species became extinct in the plateau region at the same time as it did elsewhere on this continent, paintings depicting its form could be at least 15,000 years old. The time of extinction of the megafaunal elements can perhaps be determined by considering their functional morphology and the habitat which they required for survival. For example, *Zaglossus bruijnii*, surviving in Papua New Guinea, feeds on earthworms of the soft humus layers of the montane forests. Similar ground environments may have existed in the Arnhem Land Plateau region before the retreat of the sandstone rainforests, of which remnants are now found only in small protected areas of the plateau. This retreat was marked by massive erosion and sediment transport, which began to fill the occupational rock shelters at the base of the escarpment and its surroundings with sand from some 25,000 years ago.

The long-beaked echidna which became extinct some 15,000 years ago is represented here by a detailed painting. Location: Golbon, 45 cm.

## The 'Palorchestes' painting

In July 1977, my friend Kapirigi and I followed the Deaf Adder Creek to its watershed, examining the southern walls of the scarps lining its valley on our way upstream and the northern walls on our return. On the last morning of this 10-day trek we came to a small, densely wooded pocket in the escarpment, where through crowns of tall trees we glimpsed a cliff with a shadow cast over its face by an overhang, suggesting a possible rock art site.

Although tired, the curiosity drove us on up the short talus slope which terminated at a vertical wall. Looking up we saw a high, narrow ledge and above it a painted wall dominated by an animal 'out of the Dreaming'. That is how Kapirigi described this painting, as the image did not resemble any indigenous or introduced animal that he knew. On the same wall were other paintings of that bygone era, but I could identify those as thylacines and Tasmanian devils. The large, extraordinary painting of the unidentified mammal was depicted in some detail, a long tongue protruding from its mouth as if feeding on some herbage and two breast-like projections extending from its chest. We found a way to reach the ledge and Kapirigi cautiously made his way along the painted wall. The remnants of the shelf on which the artist stood to paint these images were now the rocks in the talus slope. I had to climb down and use a telescopic lens from the slope below the site to photograph the strange animal.

For a number of years, the creature in the photographs remained unidentified. It was not until Peter Murray, a distinguished palaeontologist, joined Darwin's Museum of Arts and Sciences a few years later that it was given a name. The animal in the photograph bore a close resemblance to his reconstruction of the extinct genus *Palorchestes*.

*Palorchestes* was a large marsupial which became extinct some 18,000 years ago. The animal is known only from fragmentary cranial, dental, foot and other remains. At least three palaeontologists have made reconstructions of this animal. They agree that *Palorchestes* was a moderately to heavily built browsing animal with a short tapir-like trunk. Its remains indicate

*Opposite and above* A large painting of what may represent a *Palorchestes*, an extinct tapir-like marsupial, and its young. The features depicted by the artist are those that palaeontologists use to describe this extinct browsing animal: a short tapir-like trunk, short robust limbs equipped with long claws, and a well developed tail. The projections extending below its body may represent a shoulder mane or long, shaggy hair. It is located on a long wall above a very narrow ledge. To Kapirigi (pictured), this was an animal out of the Dreaming. Location: Wongewongen. 235 cm.

that the limbs were robust and probably fairly short, with long claws, and that it had a well developed tail. The morphology of the jaws indicates that the animal had a slender, probably long tongue and a trunk-like upper lip, similar to selective browsing animals such as giraffes. These are the very features which are represented in the rock painting.

The 'Palorchestes' painting depicts a large, 235-centimetre-long animal. Although parts of it are considerably weathered, with areas of pigment missing due to spalling of the rock surface, overall it is clearly identifiable. The animal in the painting is short-legged and has steeply inclined hindquarters terminating in a heavy tail. The claws on the forepaws are long and curved. The neck is short, the head proportionately small, with a long, slender tongue protruding from its mouth. Two breast-like projections are the most puzzling feature, as they are also depicted on an adjoining, smaller painting of a similar animal, perhaps its pouch-young with which it forms a composition. It is possible that these projections represent a long shoulder mane or shaggy, long hair. A stipple pattern sometimes used in paintings to indicate hair is evident in the depiction of this animal and its young. Concentrations of dots in both the main and the adjoining paintings as well as a series of lines along the back suggest the presence of long, coarse hair.

## Large naturalistic human figures

The human body in the large naturalistic figures art complex has been depicted in many different stylistic forms. Most of these disparate figures have not been recorded in numbers that would allow for their classification into stylistic groupings. At present, only one type of human figure displaying constant elements, form and quality of expression has been identified as a distinct group. As these figures are the most numerous representations with a pan-plateau distribution, they typify the human form in this body of art.

In this distinctive stylistic group the male is the main subject, the female being seldom depicted. The majority of human figures are individual representations. Where more than one such image is found in a shelter, this does not necessarily represent a composition but is likely to be a later addition adjoining or superimposing the original figure. However, one definite composition depicting a human couple has been recorded.

A typical figure is depicted with the head in profile, detailing its facial features and the shape of the cranium. The arms are held open and outstretched, or, in some horizontal figures, hanging down at right angles to the body. Although the upper part of the body is depicted frontally, the lower part is slightly turned aside, showing a slightly swelling abdomen and penis, and, on the opposite side, the buttocks. The legs are bent at the knees, with the feet pointing down. Both the

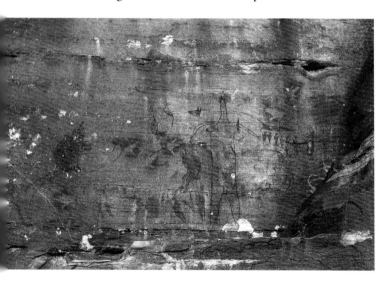

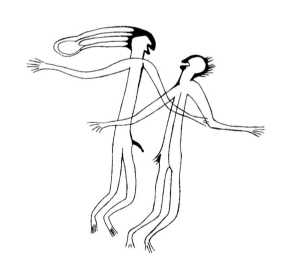

*Above left* During the long period of the large naturalistic figures art complex, the human body was also executed in many other stylistic forms. In this example, the female is depicted frontally, with her body and breasts emphasised, while her arms appear to have been added as an afterthought. The long pointed head, with two eyes as its only feature, is shown with the hair standing on end. Location: Dangurrung. 190 cm.

*Above right* The male-female relationship expressed in most stylistic conventions was also depicted during the large naturalistic figures art complex. The figures, the male wearing a long headdress, face each other with their arms outstretched. Their facial features are emphasised, bringing attention to the upper part of the body, while the genitals and pubic hair are of only secondary interest.

*Opposite* This painting of a male figure typifies the only stylistic convention of representing the human person which forms a coherent body of expression within this complex. The male is shown with his head to the side, with opened arms and his body partially twisted, revealing a slightly distended abdomen and rounded buttocks. His legs are bent at the knees, and both the feet and the hands with their toes and fingers are carefully detailed. Location: Bonorlod. 110 cm.

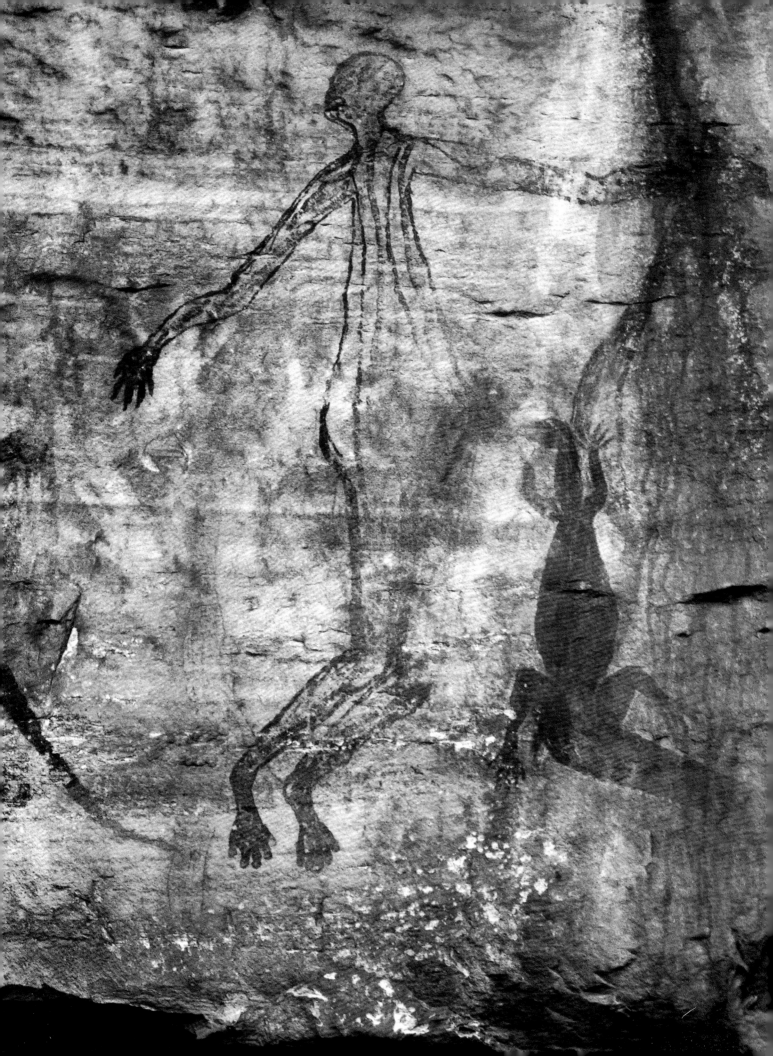

hands and the feet are detailed and executed with great care, and as such are the stylistic element typifying these figures. Most of the figures have an unearthly aura about them, appearing as if floating in space. So far, they have not been found engaged in any activities or associated with weapons or implements.

A number of concepts and conventions usually associated with the more recent periods can be seen to have early origins. Paintings with detailed X-ray features, and not just simple life-lines or hollow-bodied structures, as well as the dismembered body motif are form concepts first introduced in paintings of this distinctive stylistic group.

*Left* The earliest known painting exhibiting X-ray features is from the large naturalistic figures art complex. In this painting, the artist depicts a male in profile with extended arms and slightly bent legs. The figure has detailed hands and feet, opened mouth, and the torso is infilled with internal organs. Location: Liverpool River. 105 cm.

*Right* A male figure, holding a spearthrower and throwing sticks above his head. He has a hollow torso in which the vertebrae have been indicated. Location: Gunbilngmurrung. 30 cm.

## Early X-ray paintings

Paintings with some X-ray features were made throughout the whole rock art sequence. The term X-ray is used to describe paintings of subjects in which one or more of the internal organs or other features are depicted. Hollow-bodied images, sometimes described as 'incipient X-ray', are not included in this category except when a simple 'life-line' – an abstracted backbone, circulatory system or alimentary canal – is indicated. The reason for this exclusion is that the body cavity, usually a rectangular hollow, may have originally been filled in or decorated with a fugitive pigment, which has subsequently weathered away. One would not deny, though, that in some instances it may have actually represented the body cavity. Paintings from this period – and others from the following period before the development of the complex, colourful and detailed descriptive and decorative forms – which display their subjects' internal features are referred to as being of the early X-ray convention. A cognitive stimulus for this concept was perhaps the inception of a 'clever man' in the social hierarchy of the local groups. Such a person is

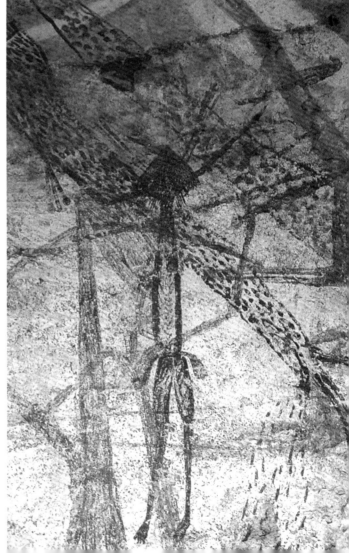

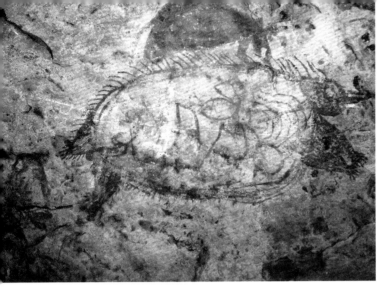

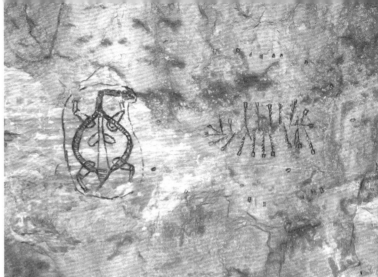

*Left* A painting of an echidna (*Tachyglossus acuelatus*), with a detailed X-ray depiction of its internal organs. Location: Maddjurnai. 45 cm.

*Right* A long-necked turtle in its subterranean home. As the swamps dry out, turtles bury themselves deep in the mud where they hibernate until the next wet season. This animal has been depicted with a wide alimentary canal and lungs, and with legs extending into its shell. Location: Mikginj. 15 cm.

said to have extraordinary powers which enable him to see through subjects.

The majority of the early X-ray paintings are monochromatic red, but like so many of the other images of this period it is possible that at least some may have also been enhanced by a secondary, fugitive colour. It was previously thought that there was a linear development from a hollow-bodied subject, to which a basic life-line was added as a next step of elaboration, and then a representation with detailed anatomical features evolved. This simple developmental progression is not what has actually occurred. In fact, the level of complexity of the X-ray paintings parallels the variation seen in the depictions of human figures throughout the sequence – from the naturalistic art phase, through stylisation and schematisation, to be expressed again in realistic forms. Detailed representations of internal organs in the earlier complex were reduced to simple life-lines and then were elaborated again with the addition of more and detailed internal structures. The most frequently depicted subjects are human beings, macropods, turtles, echidnas, fish and lizards, although a number of other species including a Tasmanian devil have been represented. Examples of early X-ray paintings are found at sites around the plateau. Simple forms of X-ray convention are also found elsewhere in Australia and in other parts of the world. But it is only in paintings of this region that during the following periods X-ray was developed into complex, detailed representations expressed in multicoloured and exquisitely decorated images.

## Dynamic figures

The most vital and exciting paintings of the region's long rock art sequence are those of the dynamic figures style. Strictly speaking, the figures are drawings and not paintings as they were sketched with fine brushes and not infilled with pigment. The style is typified by mostly small drawings of human figures, anthropomorphs, animals and composite beings in expressive movement, arranged into narrative compositions. Many of the individual figures, and the complex and detailed compositions, are masterpieces of innovative concepts and of outstanding aesthetic quality, embodying the artists' existential experiences and describing the world around them and their relationships with others. Paintings of the dynamic figures style, although present in some sites investigated by Charles Mountford, were first described by Eric Brandl in 1973.

The artist of this stylistic period placed overwhelming emphasis on human figures, depicting them in spirited action during their economic and socio-cultural activities. The style's icon is a running figure with widespread legs, the man with his weapons and prey, the female with her digging stick and dilly bag. In depicting these figures, the artist has translated the intensity of physical motion into pictorial dynamics. It is this aspect of the paintings which is reflected in the style's name.

Representations of this style have been recorded in 350 rock shelters, over an area extending from the residuals of the Wellington Range, near Aurari Bay, 180 kilometres south to Birdie Creek, and from its westernmost occurrence to the Cadell River, 200 kilometres east. The majority of recorded sites with these figures are in the north-western sector of the plateau. The temporal range of the dynamic figures style extended, as is evident from the number of superimpositions and their variable states of weathering, over a very long period of time. Of all the subsequent styles, only paintings executed

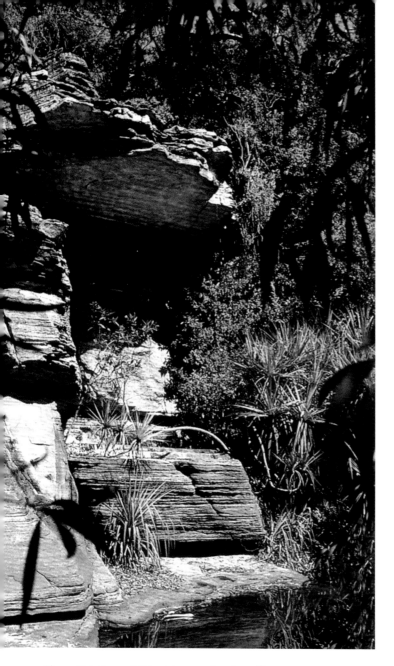

*Above* Paintings of this style are often found in narrow escarpment gorges, on rocks that extend over streams. One figure is located on the 7-metre-high ceiling of this overhang and must have been executed from a since-collapsed ledge. Location: Djuwarr site complex.

*Opposite* Depicted on this ceiling is a stunning male figure holding a boomerang above his head. In the other hand he holds two spears and an additional boomerang. He wears a headdress, armlets, wristlets and a hairbelt. His body is surrounded by dashes. Location: Djuwarr site complex. 120 cm.

in the descriptive X-ray convention have a comparable spatial and perhaps temporal distribution, but they have more noticeable stylistic variations.

The dynamic figures style may at first seem to be a homogenous body of art, but several well defined subgroups can be identified. The earliest representations, which bear many features that typify this style, are considerably larger than the classical dynamics – the figures which express the

maximum visual movement. In a third phase, the bodies of the male figures become stockier and their arms lose their musculature, becoming one-line thick. The latest figures are pointillistic, with dotted outlines or bodies fully constructed of dots. That the stylistic variations observed do not relate to individual artists or a distinct group, but rather to a different time period, is suggested by their spatial distribution.

The majority of figures which survive to this day are those that were executed in red pigments. However, that other colours were also used during this period can be seen in a number of elevated and well protected shelters, where figures are also represented in white, yellow and combinations of colours. It should be emphasised that perhaps only a fraction of figures once present at a given site still survive. Many others have weathered away, or are covered by more recent paintings.

The human male predominates as a subject, but females, animal-headed beings, a variety of other anthropomorphs, animals and zoomorphs are also depicted. The animals are mainly macropods, and of these the representations of the northern black wallaroo *(Macropus bernardus)* predominate, suggesting the artists' domain. Other animals commonly depicted are emus *(Dromaius novaehollandiae)*, echidnas *(Tachyglossus* sp.), rock possums *(Pseudocheirus dahli)* and thylacines *(Thylacinus cynocephalus)*. Three representations of Tasmanian devils *(Sarcophilus harrisii)* and one of a numbat *(Myrmecobius fasciatus)* have also been recorded. Snakes and lizards are uncommon in this style: to date only three images are known – a rock python *(Morelia oenpelliensis)*, an unidentified snake and a major skink *(Egernia frerei)*. Other animals portrayed are the long-necked turtle *(Chelodina rugosa)* and several varieties of birds and freshwater fish.

The typical male figure wears an elaborate headdress and a hairbelt to which is attached a pubic apron to cover the genital area and a flowing bustle which hangs over the buttocks. In some instances, only one or the other of these articles of dress are present. The penis is only occasionally depicted, but when it is there the context of the composition is usually of an explicitly sexual nature. Although almost all of the males are depicted wearing complex head gear, individuals lacking this item may in some compositions represent neophytes. The headdresses, pubic aprons and bustles appear in a wide variety of forms and sizes, and are constructed from a range of materials in varying techniques and complexity. Although the terms used here, pubic apron and bustle, do not quite satisfactorily describe the particular items of dress worn,

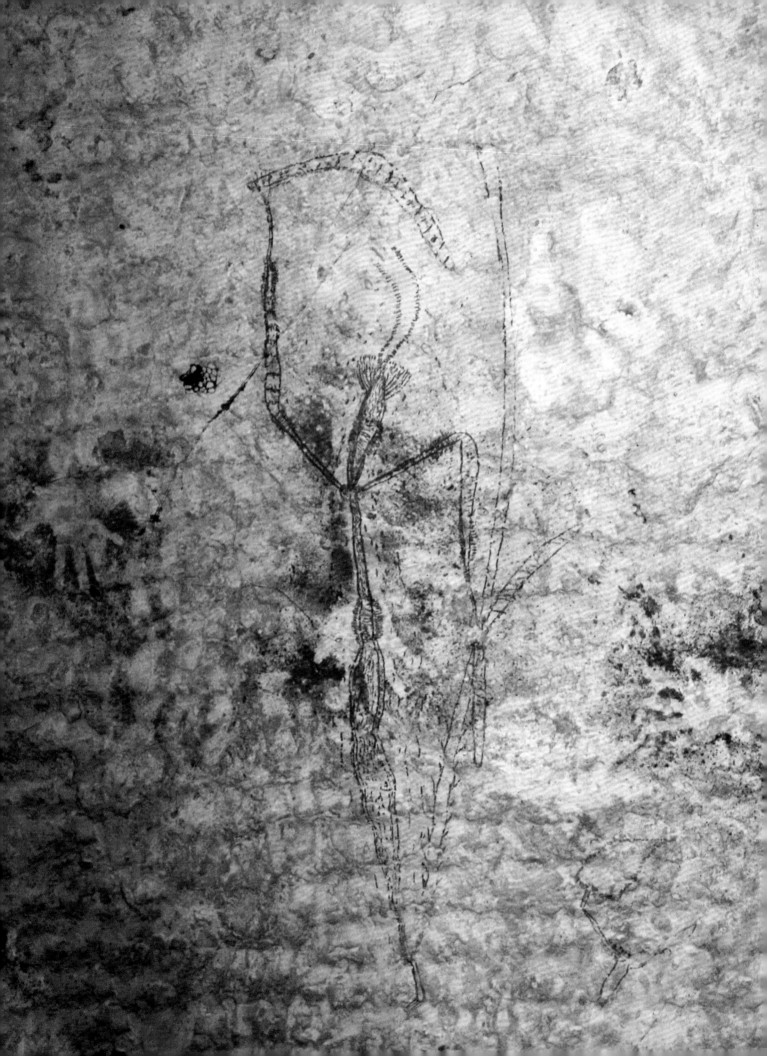

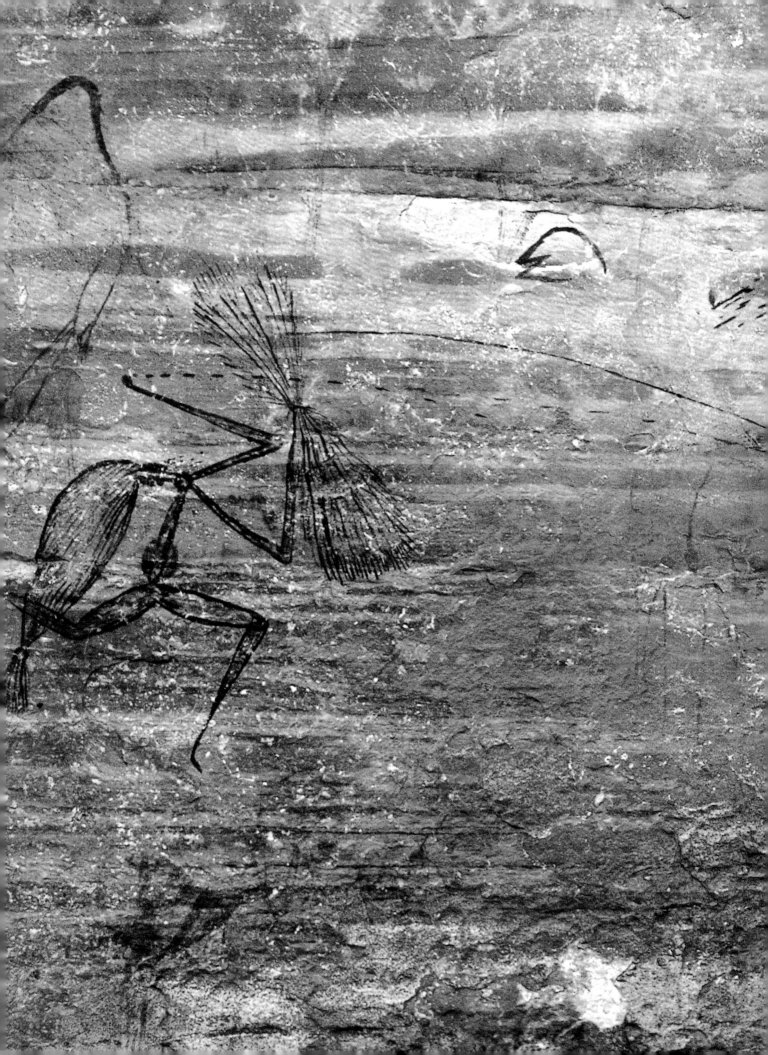

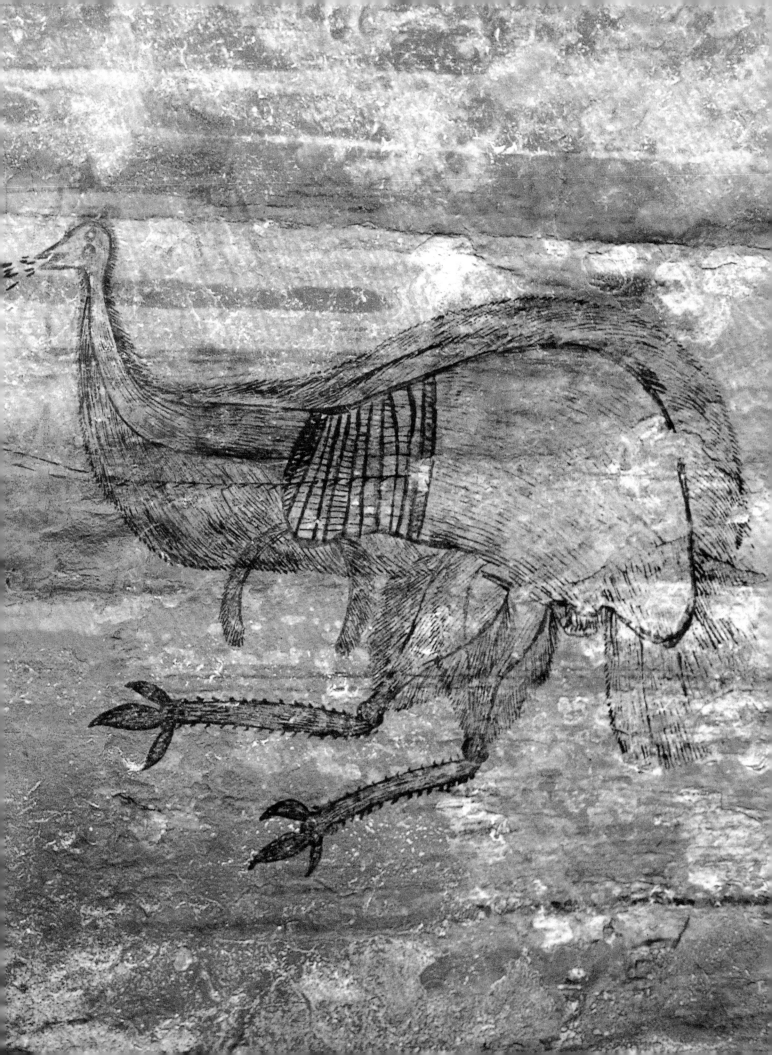

they are the most appropriate terms available. Only a small number of the aprons recorded could be described as pubic fringes or tassels. The term 'skirt', which was used at one stage, is inappropriate as it is apparent in many of the paintings showing this form of dress that it may either be folded over or tucked into the hairbelt or suspended from it.

In complexity and variety these three items of apparently everyday forms of dress have no current Australian counterpart, although in some areas headdresses continue to be made for ritual occasions. The large headdresses were possibly made by inserting the hair into a cone of paperbark bound with string or by binding braided hair with fibre or cane. Decorations and extensions of the hairpiece, made from cane and prepared pandanus leaves, have also been recorded in the Asmat region of Irian Jaya. The long, netted and fringed aprons and bustles, the knotted string, woven and tasselled pubic fringes, as well as the pads of leaves, grass or feathers beneath bustles are very similar to the traditional dress worn by adult males there and elsewhere in New Guinea.

Other decoration includes necklets, pendants, armlets, tassels and leg ornaments. Weapons consist of barbed, single-piece wooden spears, a variety of boomerang and club types, hafted stone axes and sticks. Dilly bags and string bags of varying sizes are worn over the shoulder, hanging from the neck or carried in the hand. The boomerangs used by these hunters also occur as stencils at some sites, documenting their actual dimensions and forms. In a number of instances the boomerangs are placed in a compositional context, along with hand stencils of both the open-hand and the three middle fingers closed convention (3MF). In the latter stencil mode the three middle fingers are held tightly together, while the thumb and the little finger are extended. Both types of hand stencil were also used as integral components of the figurative compositions of this style. Although the open-hand stencil continues to be used throughout subsequent styles and periods, the 3MF stencil is unique to the art of this period. Stencils of spears, dilly bags, necklets and a hafted stone axe have also been recorded.

The female of this style, with one exception, wears no apparel and has no apparent bodily decoration. Her usual implements are a digging stick and a dilly bag, although in several instances she is portrayed carrying spears and fire-sticks. In one example, a stone axe is being carried. Female bodies are more naturalistically portrayed than those of their male counterparts. There seems to be a total absence of children.

The animal-headed beings are frequently depicted participating with humans in a variety of activities. Although the shape of their bodies varies from those of male figures, they also wear hairbelts and aprons or bustles and carry spears and boomerangs. Often they are shown to have a long penis and large testicles, and in several paintings they bear a close resemblance to a flying fox *(Pteropus alecto)*, also called the fruit bat, a species on which these figures are apparently modelled. There are other anthropomorphic representations which at present cannot be classified into specific groups. The animal-headed beings and the anthropomorphs form the first concrete evidence of mythogenesis in rock art.

Some of the human and anthropoid figures and their weapons, as well as some of the animals and their associated tracks, are surrounded by dashes or splatters, and similar marks emanate from their mouths. These signs are probably perceptual cues that depict non-material phenomena of the artist's sensory experience. Such phenomena include sound, speed, smell, force, velocity and anxiety. In the case of animal tracks, they may represent their freshness. In the subsequent styles such symbols occur rarely and only serve to depict human voices. The different phenomena that may be symbolised by dashes are well illustrated in a composition depicting a hunter spearing an emu. The hunter, concealed behind a bundle of grass held in his hand, has successfully stalked and speared the bird. In portraying this action the artist suggested the power or speed of the arm thrust, the movement of the spear in its projectile path, loud cries or blood emission from the emu and the hunter's exclamation of success. Elsewhere in the world, symbols denoting human

*Previous spread* The most accomplished example of this style, a masterpiece of world art, is the 'Emu hunt' composition. In this painting a male figure wearing a long tasselled headdress and a hairbelt hides behind a hand-held bunch of grass as he stalks and spears an emu. The hurled spear pierces the emu in the chest. The force with which he threw the spear, or its trajectory, is indicated by the dashes that extend from his still upraised arm, along the spear and into the bird's body. The dashes that emanate from the hunter's mouth may represent an exclamation of success, while those that come from the emu's beak may be a call of pain or perhaps blood emission. This composition was executed by a master draughtsman, sketched with a brush and red pigment in confident and expressive lines. The emu is painted in considerable detail, with the long soft plumage and even the vestigial wings depicted. In composing this narrative scene, the artist first painted the hunter and then commenced to sketch in the emu, starting at the head. Realising that there was not enough room to include the spear, he repositioned the emu. Location: Dangurrung. Height of emu 93 cm.

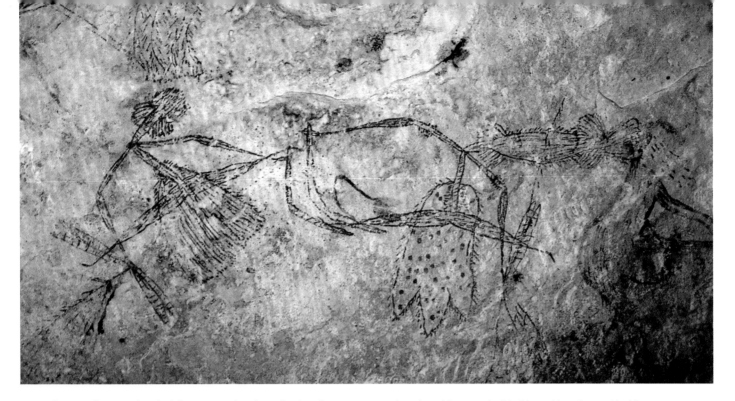

Two adjoining figures, closely following each other. The first figure wears a short headdress and wide fringed bustle, and holds two boomerangs and an object which may be a pubic apron. The second figure, whose long headdress overlies a macropod painting, has armlets and a tripartite bustle. Location: Djuwarr site complex. Figure at right, leg span 55 cm.

voice appear in Aztec codices of the fifteenth and sixteenth centuries. These glyphs are usually in the form of a down-curved tongue placed in front of a person's face.

In one study during which 1600 representations of this style from 241 sites were considered, 1165 (72%) were found to be males, 77 (5%) females, 44 (3%) animal-headed beings, 69 (4%) other anthropomorphs, 213 (13%) animal species and seven (0.5%) zoomorphs. Animal and human tracks, trees and enigmatic signs are some of the other subjects represented. At 28 (11%) sites these figures are associated with the hand stencils of the 3MF convention. At 59 (26%) sites they were found overlying earlier designs. The majority of all paintings were executed in red pigment but at six sites they were also represented in white pigment, at three in yellow and at two they were in red and white bichrome.

The majority of figures are arranged in 324 compositions. However, many rock surfaces on which the remaining 368 individual figures or their traces are located are badly weathered, preventing identification of any associations, so it is possible that the number of compositions may have been even greater.

Of the 1165 male figures, only 30 (1.9%) were found to be lacking a headdress. Clearly an important part of the art, headdresses vary in length and elaboration, many being decorated with other items. In 156 instances such articles are tassels, in 33 strings, in 14 feathers and in eight wooden pins. In two examples a flying fox is depicted sitting on the hunters'

headdresses, symbolising perhaps their totemic affiliation. It is only in the figures which are without a headdress that the head, albeit in the most rudimentary and stylised form, is clearly seen. In most other instances the head disappears within the headdress, Only 14 (0.8%) of the male figures are depicted with a penis, while 16 figures are shown with a nose pin. Some men are depicted associated with, carrying or wearing dilly bags. These dilly bags vary in size, but have been grouped into categories of 14 large and 27 small.

After headdresses, hairbelts are the most common form of male apparel. They are present on 633 figures in the sample. From the belts are suspended pubic aprons and bustles of varied shapes and length. In the past, these items have been described as 'skirts' and divided into 'front' and 'rear'. Now, described as pubic aprons and bustles, they are grouped as long, short and tripartite forms. Of the pubic aprons, 73 are long, 39 are short and 12 are tripartite, while 20 bustles are long, 16 are short and seven are three-cornered. In some instances it is difficult to establish if the represented covering is frontal or rear.

Necklace-type ornaments are found on 274 individuals and neck pendants on 22. Some of them are depicted in detail, identifying the material from which they were constructed. Decorative armbands are found on the upper arms of 103 figures and on the forearms of 11, while nine have wristbands. Only two figures have bands on their calves.

Nineteen of the figures appear to have knobbed arms, but,

 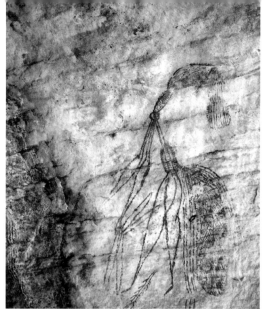 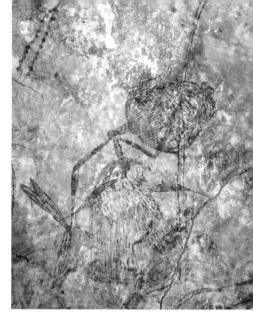

*Left* One of the most detailed figures of this style. A male – wearing a neck pendant, circular necklet, a large headdress, hairbelt and detailed tasselled pubic apron – is seen running along a vine and dislodging its leaves, which can be seen falling to the ground.

*Middle* One of the most exquisite and accomplished portrayals of a male figure, especially when the rough rock surface on which it is painted is taken into consideration. The walking male figure with well proportioned lower arms and muscular legs is shown wearing a tasselled headdress and a long bustle on which side strings flank a central, plume-like panel, attached to a wide hairbelt. The male is shown holding two boomerangs in one hand, and the other hand is situated in an area of waterwash which threatens this figure. Location: Djuwarr site complex. 60 cm.

*Right* A dominant painting from a group of 20 dynamic figures is depicted wearing a large wide headdress and a long, wide, fringed pubic apron, and carrying boomerangs and spears. Location: Burrunggui site complex. Height 46 cm.

as these are depicted as welts and not separate additions to the arms, they may represent raised cicatrices. Fourteen of the male figures are depicted with dashes in front of their bodies, while 16 have such marks along the body.

The weapon complement of the male figures consists of boomerangs and simple multibarbed spears. The boomerang, in its many forms, is the dominant weapon carried by 499 figures, while 339 carry spears. Stone axes are seen used in only two paintings. Stick-like objects of varying length are held by 23 males. Dilly bags are carried by 15, plants by nine, pubic aprons or bustles by eight, long feathers by three, a frond by one, and objects that cannot be identified are in the hands of 26 figures. Several figures are also seen carrying animals – three carry birds, two carry thylacines and one carries a turtle.

The figures are depicted in various stances. The majority of male figures, 708 (44%), are depicted running, 183 (11%) standing, 100 (6%) walking, 31 (2%) lying, 23 (1.4%) kneeling, 17 (1.1%) bending, seven (0.5%) sitting, and one squatting. Two males are seen carrying their companions.

Although it is at times difficult to identify the depicted activity, the compositions that have been recognised are represented in their order of magnitude: hunting, fighting man-to-man, other scenes of conflict, ceremonial activities, tracking animals, throwing spears or boomerangs, and copulation.

Of the 77 female figures, 24 are shown with stylised hair and four (all at the one site and interacting in a composition) with long plaits. Only one of the female figures is depicted wearing what may be a headdress. (More recently, a painting of a female with a hairbelt around her waist has been recorded.) The female icon is a running woman with a dilly bag and carrying a digging stick. The dilly bag is seen carried down the back by 20 figures, off the shoulder by 11, and from the neck by nine figures. In two compositions the dilly bags are lying on the ground. Digging sticks are carried by 21 women, fire-sticks by six, spears by three and dilly bags by two.

Aborigines identify a female's age by the size of depicted breasts and the shape of the body. According to this method of determining age, 49 portrayals of females have medium-sized breasts and are considered young women, 22 are depicted with large breasts and are perhaps older women, while 10 small-breasted figures may represent pubescent girls.

Forty-three women are depicted running (15 of them have dilly bags), 20 are standing, nine are lying down and seven are sitting. There are also individual figures kneeling or squatting, and one figure pierced by spears is bleeding and being watched by an animal-headed being.

Among the 44 animal-headed beings, seven are depicted with prominent penises, 11 wear hairbelts, six wear pubic aprons or bustles and two are shown with dilly bags. These beings also carry weapons: 14 are shown with spears, 12 with

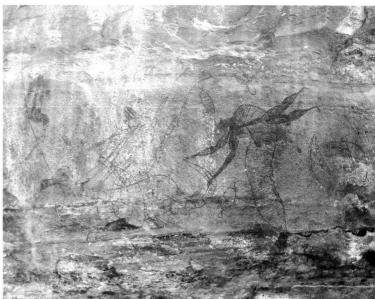

*Above* This narrative scene suggests that a strategy in hunting macropods was to surprise the animals when they were preoccupied, in this case drinking from a waterhole. A male with an extremely large, long and tasselled headdress leaps at a macropod and grasps it by the tail. The freshwater fish, the eel-tail catfish and the spangled and banded grunters, that surround the hunter and his prey identify the location as a dry season pool in a stream bed. Location: Dangurrung. Length of headdress 40 cm.

*Middle* When viewing some of the compositions, one can almost hear the sounds of the depicted action. The hurrying man, the first of a group of male figures in front, holds an angled boomerang in one hand and perhaps a bunched-up pubic apron and a spear in the other. Above him is another running male, wearing a large and detailed tripartite bustle, and there is another at the top-centre. This male and the other figures in the centre are superimposed by more recent designs. Immediately behind them is a well-executed figure in a headdress and bustle, carrying a large bird in one hand and a spear in the other. Below lies a prostrate man with a spear through the back. It has been thrown, perhaps, by one of the two smaller figures behind him. Location: Nawurlandja. Speared man 30 cm.

*Below* A male figure carrying boomerangs and spears wears a headdress, a neck ornament of tassels and long strings and armlets, while short tassels are attached to his thick hairbelt. On his arm sits a bird with outstretched wings and head pointing anxiously forward. Among the few pigment marks are dashes along both the male's torso and the bird's body. The question is, was this bird the man's totem or an accessory in a hunt?

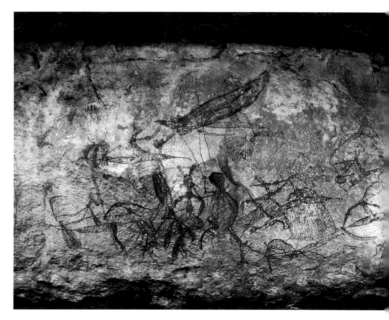

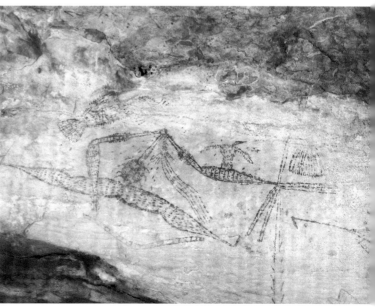

boomerangs, four with stick-like objects, and one holds a stone axe. Seven of these figures have dashes emanating from their mouths, and two have dashes along the body. They are seen participating in ceremonial, conflict and hunting activities.

The other types of anthropomorphs have varying body shapes, some quite amorphous. Of the 69 figures in this grouping, two are depicted with breasts and one with a penis. Fifteen of them carry spears, 11 carry boomerangs and three carry sticks. Four of the figures have dashes emerging from the

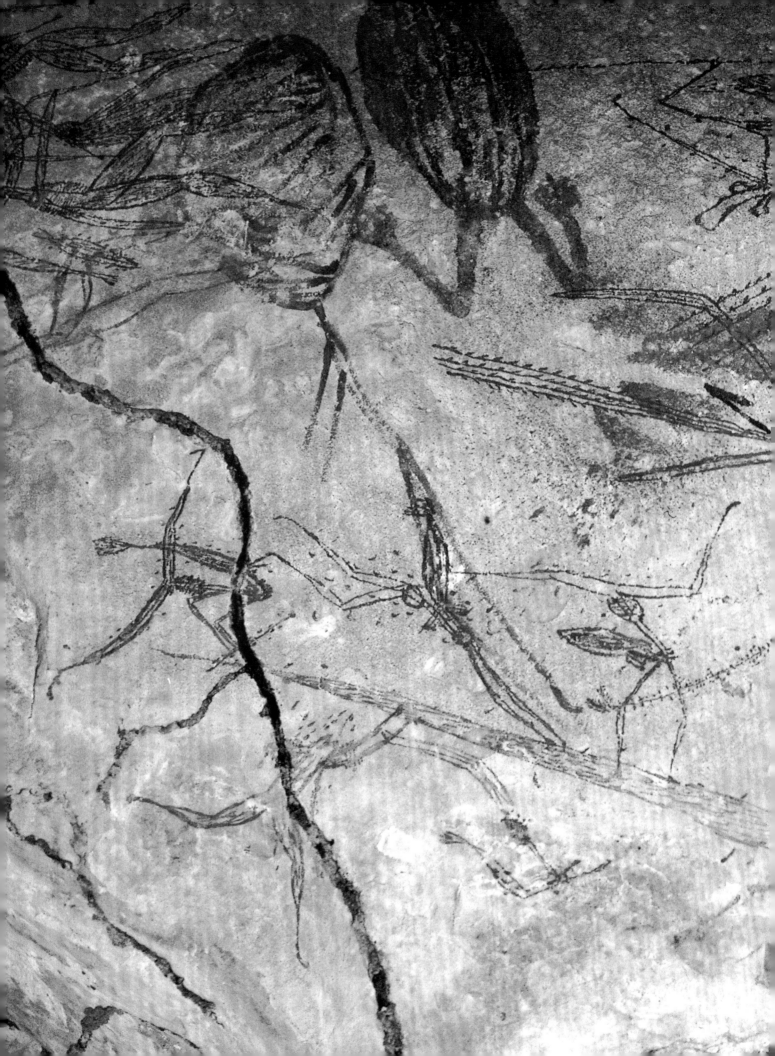

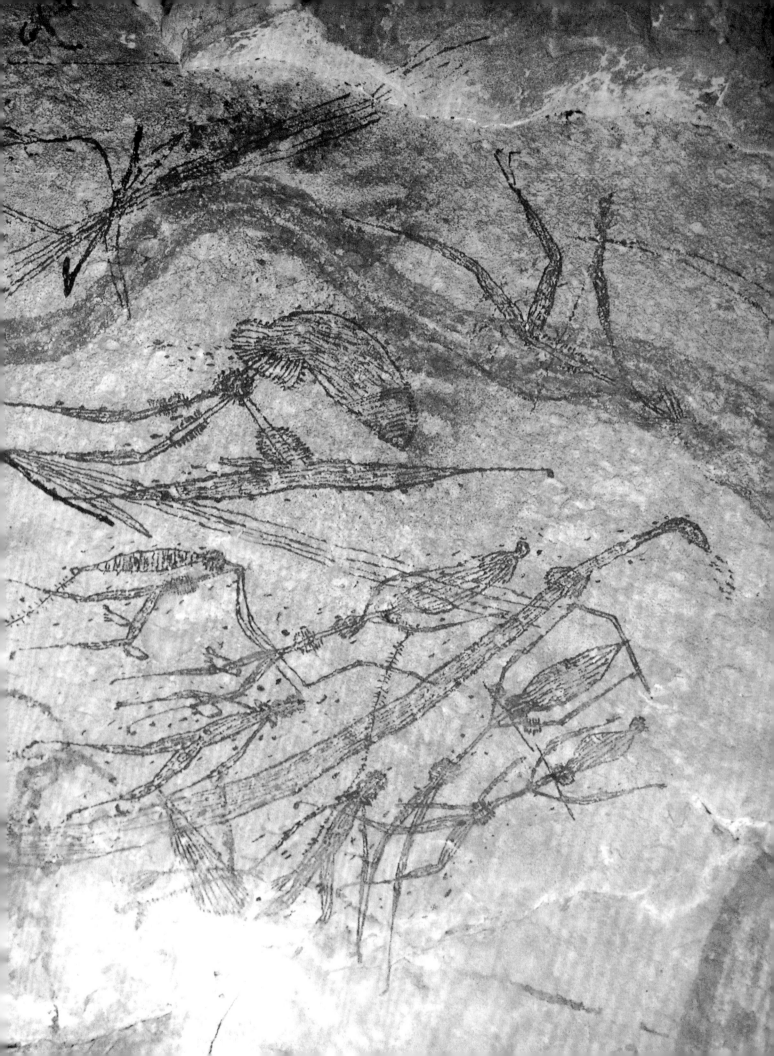

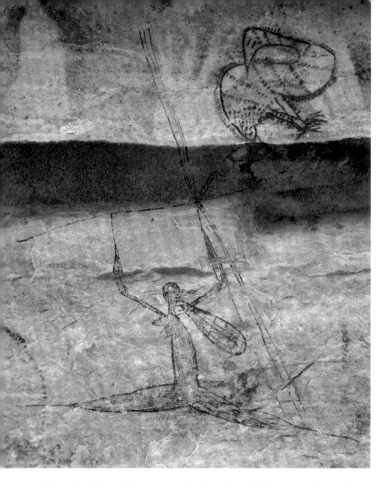

*Above* In this painting, a running female with her netted bag slung from her head is seen holding one spear as if ready to hurl it and carrying three others in her other hand. This is a rare figure, as throughout the rock art sequence only a handful of women are depicted with spears.

*Previous spread* One of the most exquisite and complex compositions depicting a group of human beings – eight men and three women – trying to capture and kill a large rock python (*Morelia oenpelliensis*). These snakes reputedly grow to a length of 7 metres and can kill and swallow large rock wallaroos. In this narrative scene, the snake as it commenced to shed its skin (shown as a bunched up roll below its head) was surprised by a group of eight men and three women. Some figures are seen striking it with sticks and boomerangs, while others try to hold it. Four human tracks are included in this composition. Dashes emanate from the snake's mouth and dots surround each human. Two of the male figures at the snake's head are depicted with long nose-pins. Above this composition is a running male and an animal-headed being, each holding a number of spears and boomerangs, as well as a weapon kit to which a later artist has added a hooked stick which may represent a fighting pick or a spearthrower. Dashes coming out of their mouths perhaps suggest audible communication, while those around the bodies and legs suggest motion or speed. Location: Landa. Snake 83 cm.

mouth, while two others are dashed around the body. They do not appear as active as previous figures; 12 are standing, 10 are running, six are walking, four are sitting and one is depicted carrying a thylacine. Most of them are participating in activities with human and animal-headed beings. In one instance an anthropomorph is shown being captured by two male figures.

Animals form an important segment of this dynamic style, with 213 representations depicting a number of species. Most numerous are macropods, depicted 94 times, the majority species being rock wallaroos. Freshwater fish are seen in 51 representations, thylacines in 20 and echidnas in 10. There are seven emus, some as large as life-size, and six birds of other species. Four snakes, three Tasmanian devils, two turtles, a black-footed tree rat and a numbat are also amongst the represented species.

The animals are depicted being tracked, cornered in rocky lairs, hunted, and carried as game. Some animals are shown speared or struck by a boomerang, while one macropod is seen grabbed at the tail by a leaping hunter. In one scene a man is prodding an echidna in its hide with a stick, while another echidna is portrayed poking its beak into a termite nest. There are also two groups of scavenging animals, perhaps thylacines, one group of which is devouring a macropod and the other a human being. Some animals were also considered to have other worldly roles as seen in a diminutive painting of a thylacine carrying a dilly bag down its back. In the ethnographic present such animals are said to be carrying rituals in their bags. Artists of the dynamic figures style were not only accomplished draughtsmen, but also innovators who, in complex compositions, anticipated concepts not achieved elsewhere in the world for many thousands of years. They portrayed themselves as confident and successful occupants of their physical environment.

The dynamic figures style does, however, have an equivalent in the Bradshaw figures of the Kimberley, in Western Australia. Close similarities in weapons, apparel and decorations worn by the male figures are apparent in these two rock art bodies. But they do vary in their mode of execution, the Bradshaw figures being depicted as silhouettes with only a suggestion of movement given by their slightly bent knees, whereas the dynamic figures are highly expressive. Nevertheless, the close correspondence between the two art bodies may indicate social interaction in the past. Such contact would have occurred on the Arafura plain before the two groups parted to colonise their respective territories. Unanswered questions which will have some bearing on the dating of the dynamic style are: at which point in time did the two groups part (was it as the sea began to rise at the end of last Ice Age, or later), and were they the people who recolonised the Arafura plain when the sea receded, returning to their original estates with ideas of contact?

*Above* Nowhere else is the fragility of the rock art heritage better shown than at this site, where a remnant of an ancient wall threatens to collapse at any moment. On its fractured face is a line of at least eight men and women, standing or walking with overlapping limbs. The females each have a long single plait, at the end of which three strands of hair are clearly depicted. Below, at left, are two prone males lying between grass/fire symbols. The larger male wears a headdress and a hairbelt, and his arm encircles a smaller male whose legs lie across the former's thighs. The smaller figure is one of a handful of males in this style depicted without a headdress, suggesting that he may be an uninitiated youth. This relationship of a mature adult with an adolescent may perhaps depict the initiator and the initiant, or a protector with an injured or sick and ailing friend. Location: Djawumbu-Madjawarrnja. Central female 22 cm.

*Below* Each composition tells a story, though some are expressing concepts not yet understood. This scene depicts a prostrate woman with her body pierced by four spears. The tops of the spears are surrounded by dashes, which may signify bleeding wounds. Her hair is stylised, and she is portrayed with one arm crossing her face, while in the other hand she clutches a spear. Her breasts are large and her vulva is depicted in detail with rounded pubis and outer labia. Between her splayed legs sits an animal-headed being holding a spear across its lap. His head, body, penis and testicles are similar to that of a flying fox, and may be based on the morphology of this bat. Location: Djuwarr site complex. Female 50 cm.

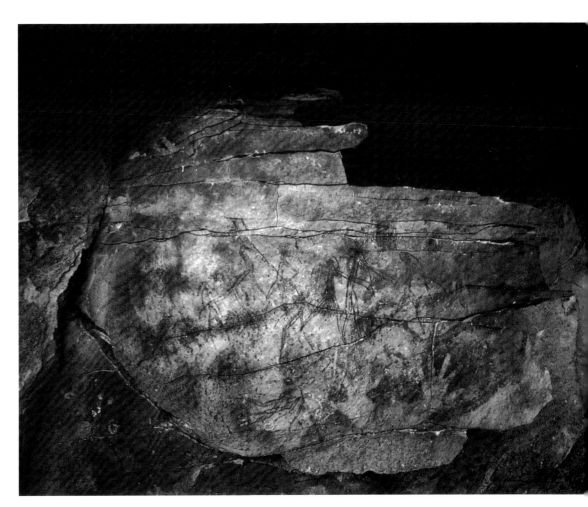

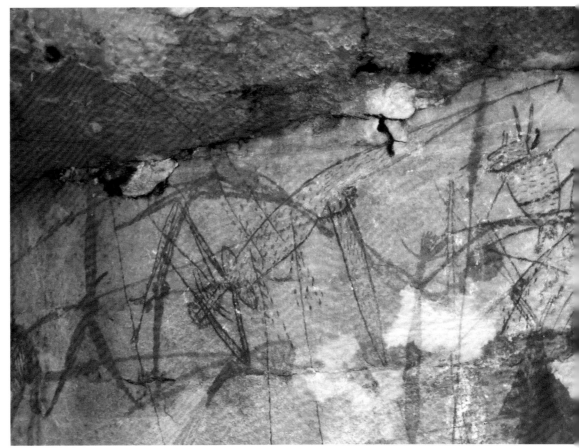

# Garramalk

## STONE AXES

The earliest identifiable stone axes are found in the paintings of the dynamic figures style. Both men and women used stone axes in many of their daily tasks. These axes were basically wood-cutting implements and their major function was opening 'sugarbag', the hive of the wild bees found in hollow trees. 'Angung garriyawan' – 'we go look for sugarbag' – would be the signal for men or women to pick up the stone axes and the tightly twined dilly bags in which they would bring back the contents of the wild bees' nest.

Stone axe heads were usually made from bifacially flaked ovate pieces of stone with lenticular cross-section. Occasionally they were further refined by 'pecking', before being ground on both surfaces at one end to form a smooth, convex cutting edge. These heads were then hafted in a withy. Some of the axe heads have grooves which would have helped in hafting. Grooved examples were first excavated by Carmel Schrire in 1965 at the Malangangerr site in the vicinity of the East Alligator River and were dated back to 23,000 years ago. Edge-ground axes of similar antiquity have since been discovered in Japan.

More recent datings suggest that the origin of stone axes in the Arnhem Land Plateau region may be considerably earlier than previously thought.

The most common stone used for the axe heads around the northern and western margins of the plateau is the Oenpelli porphyritic dolerite, which outcrops in many places throughout the Alligator Rivers region. These implements – also referred to as stone hatchets, having a small mass and a short handle – were used with one hand only.

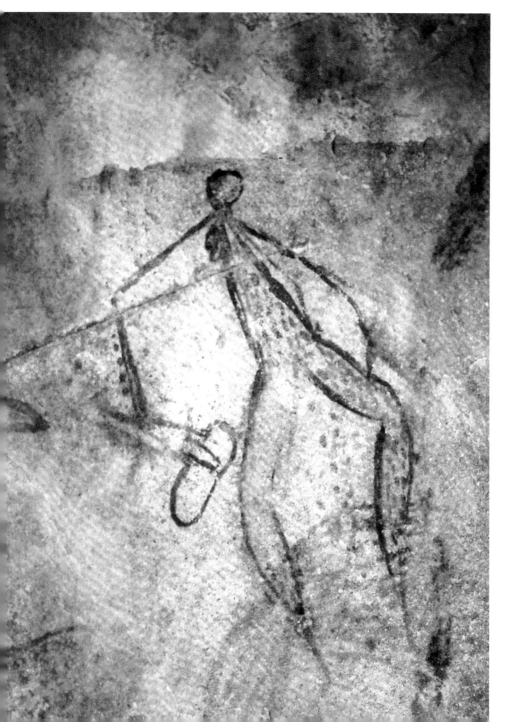

*Left* That women also used stone axes, even in the distant past, is documented by this female executed in the dynamic figures style. She is depicted holding an axe with a large head hafted in a bent withy. Location: Burrunggui site complex. 23 cm.

*Opposite above* That the dynamic figures images were also executed in yellow and white pigment, and in combinations of these with red, can be seen where these images survive in well-protected shelters. Here a walking male executed in yellow ochre is seen wearing a headdress, a hairbelt with a long apron and a tasselled bag with a closed top hanging from his neck. He is carrying a spear, as is the small male figure running behind him. Location: Liverpool River. Walking male 48 cm.

*Opposite below* This white male figure may fall within the post-dynamic figures style, as he is shown holding a fighting pick in addition to boomerangs which are expressed as one-line thick. However, it is possible that the two styles may have, at least in some regions, coexisted for some time. Location: Dangurrung. 42 cm.

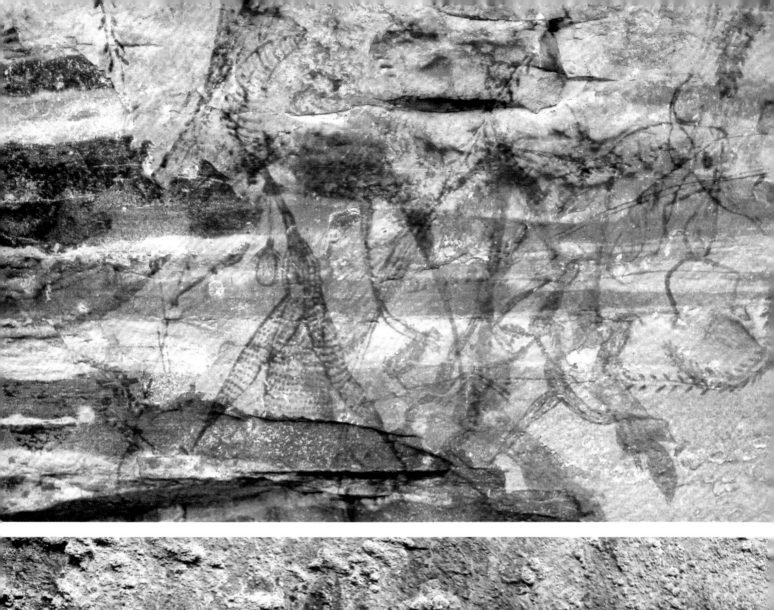
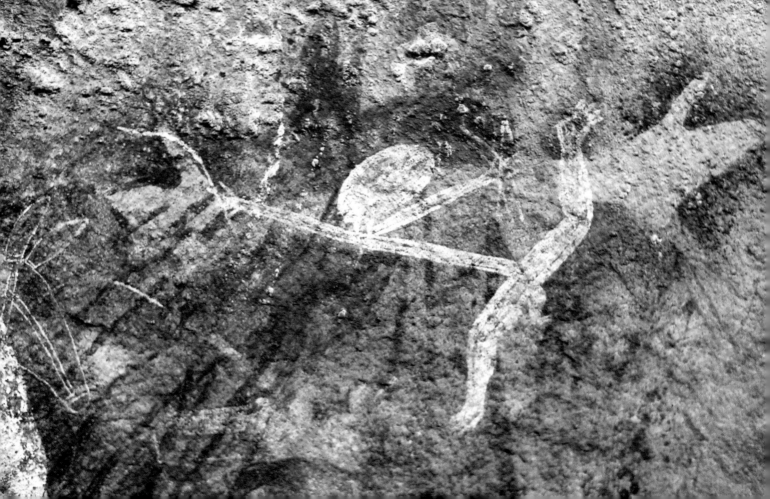

# Birrgala

## BOOMERANGS

Boomerangs, especially the returning type, are recognised as distinctly Australian weapons, although at the time of European contact they were not manufactured in Arnhem Land, Cape York, the northern Kimberley or along the border regions of South Australia and Western Australia. Elsewhere in the world, boomerang-shaped non-returning weapons were used by the ancient Egyptians, the Zuni Indians of Arizona and by several tribal groups in India.

The absence of this weapon and the boomerang-like objects from the area to the north of Katherine and Roper River, the location of the Arnhem Land Plateau, was noted by several early investigators. The only documented examples found in this region were used as clapsticks during ceremonies. These items were usually acquired by trade from the Victoria River District.

Boomerangs or their remnants have also not been found in any of the archaeological excavations carried out in this region. This, of course, is understandable, given not only the nature of the acidic soils and the alternating of wet and dry seasons, but also the presence of termites. This physical regime would rapidly destroy all the artefacts made of wood, bone and plant material that may have been left behind in the shelters. In most deposits more than a thousand years old, only mute stone tools remain to help us reconstruct the history of their makers.

The earliest stone tools of the so-called 'core tool and scraper tradition' were the pebble choppers, 'horsehoof' cores, steep-edged and notched scrapers, and other larger stone tool items. In Arnhem Land, edge-ground stone hatchets were a part of this tool kit. One of the primary uses of these tools was no doubt the manufacture of wooden objects. What some of these weapons and implements were, we can learn from their images depicted in the rock art of the region. Many of them

were not only depicted by the artist in painted scenes of hunting and combat, in which there is always the possibility of misrepresentation by a slip of a brush or excessive use of artistic licence, but those objects that were suited to the use of the technique were stencilled, recording faithfully their original shape and size. Some of the boomerangs depicted by artists of the dynamic figures style show interior marks suggesting that they were also decorated, possibly by engraving or by painting.

Boomerangs, boomerang-like throwing sticks and clubs – all of a wide range of shapes and sizes – were used in the Arnhem Land Plateau region during the pre-estuarine period and are recorded in the rock art by stencils and paintings. They vary from symmetrical, slightly curved objects to markedly asymmetrical form, with one long limb set perpendicular to a shorter second limb. When placed in a series, many of these weapon forms merge one into another so the transition from simple club forms to the large complex hook-shaped boomerangs is clear. In size, they are similar to other weapons of this type found elsewhere in Australia. That they were made during this period in the Kimberley of Western Australia is also documented in rock paintings: the Bradshaw figures are depicted with these weapons.

The early origin of the Australian boomerang was also revealed by an excavation in a peat bog, carried out by Roger Leubbers in the Wyrie Swamp of South Australia. At this site, boomerangs and other wooden implements, along with the stone tools used in their making, were recovered from what was, some 10,000 years ago, a camp on the shores of a shallow swamp. Subsequent drowning of the site preserved the wooden artefacts. Nine boomerangs were recovered, three of them complete, and all were of the returning type, displaying in their curvature and lateral torque the classic properties of this implement. Replicas of these artefacts were made and tested, demonstrating conclusively that they were indeed of the returning type. A digging stick, pointed stakes and one simple and two barbed spears were also recovered. The simple multibarbed spear and a variety of boomerangs and boomerang-like objects are weapons associated with the dynamic, post-dynamic and simple figures with boomerangs styles of the pre-estuarine sequence of the Arnhem Land Plateau. Their presence in these styles suggests that the origin of boomerangs pre-dates the 10,000-year-old date of the Wyrie Swamp discovery by perhaps 6000 years.

The development of this most sophisticated object from a curved stick, probably noticed by an early hunter to rotate more freely than a straight one, was perhaps thousands of years in the making. It would have been some considerable time before another hunter found that by flattening and thinning this crude weapon the resistance to its flight was reduced even further, increasing its efficiency. As a final step, what was perhaps an incidental or natural twist in the timber causing the weapon to plane upwards was noticed, studied, imitated and developed into the light aerodynamically-sound returning boomerang.

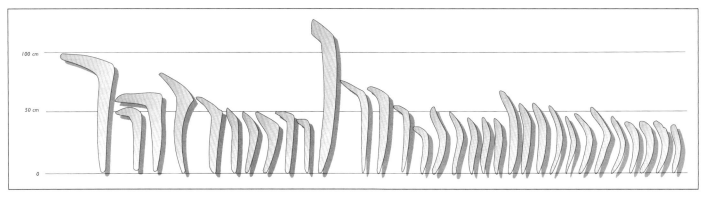

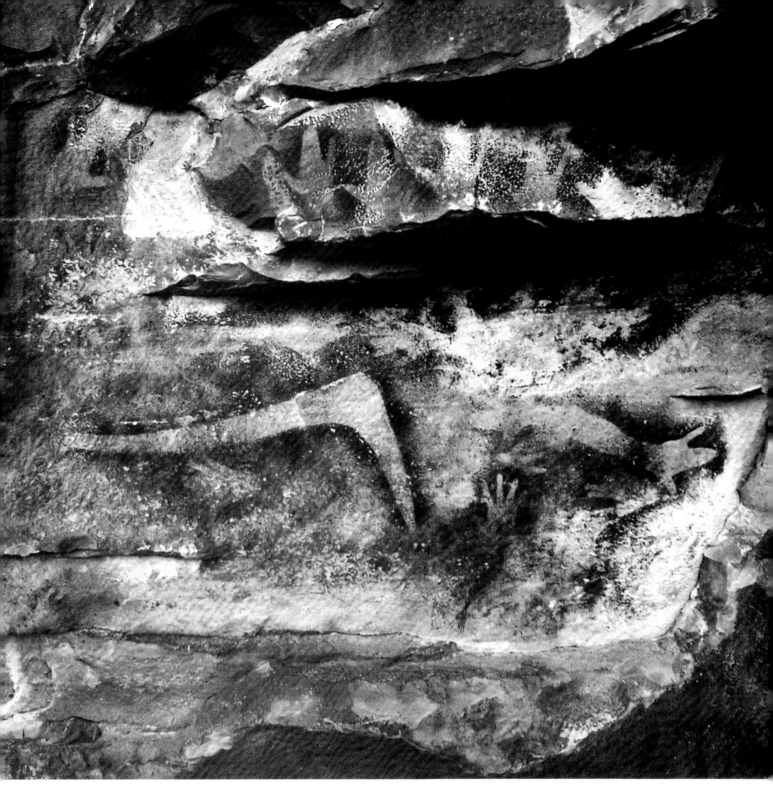

*Above* Stencils of two large hook-shaped boomerangs, associated with open hand, hand and arm stencils of the three middle fingers closed convention. Location: Djawumbu-Madjawarrnja. Weapon at right 117 cm.

*Opposite* BOOMERANGS OF THE PRE-ESTUARINE PERIOD

An array of stencilled boomerangs and boomerang-like objects arranged on the basis of general similarities. In this sequence, all the more prominent Australian forms of this weapon can be identified. Astonishingly all the weapons found in historical times to be unique to different parts of the continent were present during the pre-estuarine period in Arnhem Land. That they also occurred over the now submerged landbridge to New Guinea is documented in the rock art of the tiny Chasm Island in the Gulf of Carpentaria, where there are perhaps more boomerang stencils than in the plateau region. Stencils recorded in Teluk Berau (MacCluer Gulf) in Irian Jaya suggest a common origin for this weapon.

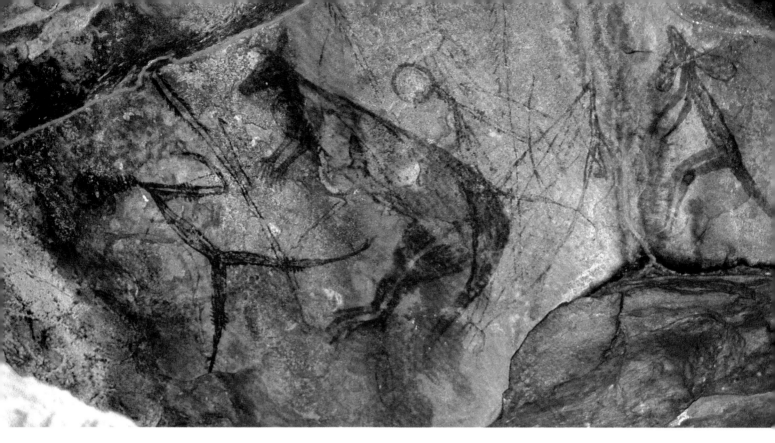

## Post-dynamic figures

The post-dynamic figures, as the name suggests, have certain features in common with the previous dynamic figures style. Initially, they closely resembled dynamic figures, but became progressively stylised, losing much of the animation of the earlier style and finally appearing as frontally-oriented, static silhouettes. Although their representations have been located in all parts of the plateau, they are not as numerous as the dynamic figures and their range of motifs is restricted.

The male figures wear large headdresses, which, although not executed in the same detail as in the previous style, nevertheless have lost none of their complexity. They also wear hairbelts, but pubic aprons or bustles are seldom seen. However, the range of weapons depicted in the previous style – the boomerangs and one-piece multibarbed spears – is extended by the inclusion of the fighting pick.

The female is again only a minor subject, usually portrayed with her digging stick, although in one instance an angry artist depicted a woman pierced by four spears. The limited

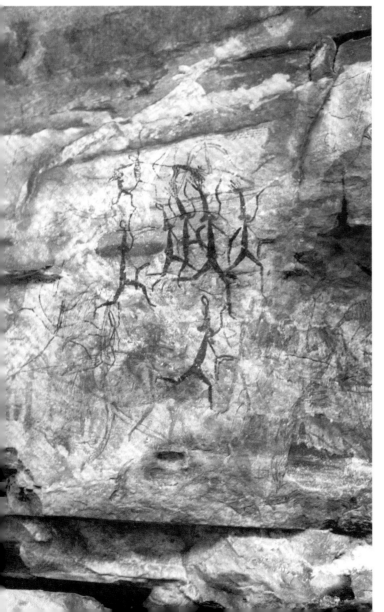

*Above* A hunter and his weapons, from the commencement of the post-dynamic figures style, though a close resemblance to the dynamic figures is evident. The male wears a headdress, as well as arm and leg ornaments. The arms are short and lack the elongation and musculature seen in the majority of paintings of the earlier style. The hunter's weapons consist of two one-piece, barbed spears and a fighting pick. Location: Gubarra. Male 42 cm.

*Left* A group of running male figures holding boomerangs. They are of the post-dynamic figures style and superpose earlier dynamic figures. Location: Kumanem. Lower figure 21 cm.

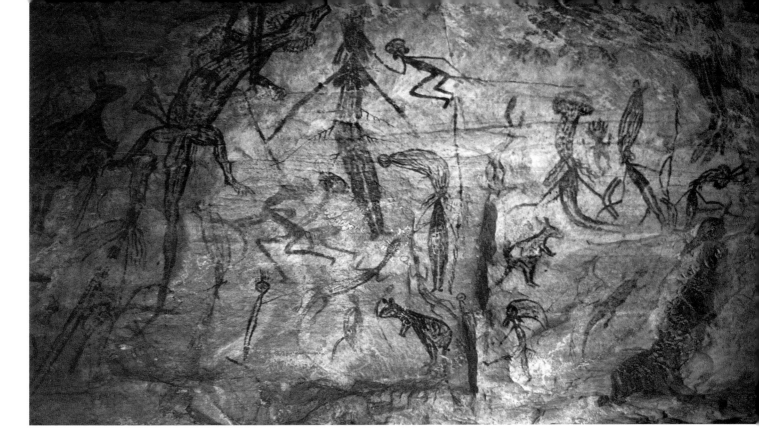

range of figure motifs does not include animal-headed beings or other anthropomorphs, and there are few animal representations. Animals, apart from one painting of a fish (a saratoga with outlined scales), are restricted to macropods and lizards.

All the known paintings of this style were executed, or remain as images, in a variety of red pigments. At least one of the stylistic variations is of a pan-plateau distribution. In this variation the figures are shown in tall headdresses with dotted outlines. They are arranged into compositions which include a cross-like symbol. One example from the Cadell River on the eastern margin of the plateau has figures that appear to be randomly positioned and are depicted in a variety of stances. In another example, on the western side of the plateau, an active group of skilfully executed figures of various sizes is cramped into a small triangular ceiling with the figures overlapping each other and superimposed upon earlier images of the same stylistic convention. Although in this latter instance differential weathering suggests that this style was practised for some considerable period of time, its relatively smaller number of representations and reduced range of motifs compared with the previous dynamic figures style suggest that perhaps it was only a transitory stage in the continuing schematisation of the human figures.

*Above* In this composition the artist has depicted a number of human beings and several types of animals. The most dominant painting is that of a frilled lizard (*Chlamydosaurus kingii*), depicted adjacent to a macropod. In the centre is a female figure with four spears in her body, while immediately next to her is another speared person, a suffering male who seems to be trying to pull a spear out of his rear. Further along and below are other male figures in large headdresses, holding boomerangs and spears. Two small macropods and two lizards, as well as weathered traces of other images, are also present. Location: Maddjurnai. Frilled lizard 86 cm.

*Below* A group of male figures with feathered ornaments in their headdresses. Two men hold curved boomerangs, while one is associated with a fighting pick. Location: Maddjurnai. Central figure with boomerang 64 cm.

*Below left* A composition of human beings associated with a macropad and a blue-tongued lizard (*Tiliqua multifasciata*). The male figures are identified by their headdresses and weapons, while the female in this stylistic variation is recognised by her long dishevelled hair. The small figure with the rounded head, at centre-left, may perhaps be a child. Adjacent is a couple holding hands. The squatting male has a subincised penis, a ritual operation not carried out in this region in the ethnographic present. Location: Bokul. Lizard 22 cm.

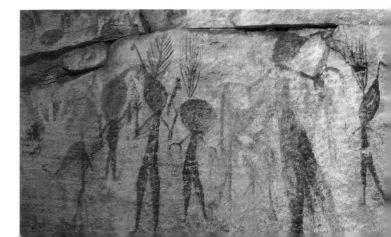

## Simple figures with boomerangs

In this style, the human form, considerably stylised in the previous period, is further schematised to become, in time, a one-line-thick, stick-like figure, the width of the body line being determined by the thickness of the brushes used. To differentiate between the stick figures of this style and any other similar forms, they have been named simple figures with boomerangs (SFB) – this weapon is not present in the body of art pre-dating the dynamic figures style, nor is it associated with humans in the art of subsequent periods.

Even at this point of abstraction, figures are still shown wearing headdresses, pubic aprons and bustles, indicating a continuation of tradition. Although many of the headdresses are of elaborate forms, decorated with feathers, tassels and pins, the pubic aprons and bustles lack the length and complexity found in those worn by the males of the dynamic figures style. However, some males are shown wearing armlets and neck bands, both of which may be ornamented by long tassels.

The male figure and his weapons dominate the paintings of this style, females and animals being again minority motifs. The most important innovation which occurred during this period, evident in the rock art, was the development of numerous spear types and other implements. As well, the paintings record the development of hafting. A composite spear made with a multibarbed head attached to a light wood shaft now appears. Before the style's demise, three- and even four-pronged multibarbed spears were being used.

However, despite the importance of the spears, it is the fighting pick, in several different forms, together with the boomerangs which are the dominant weapons in the

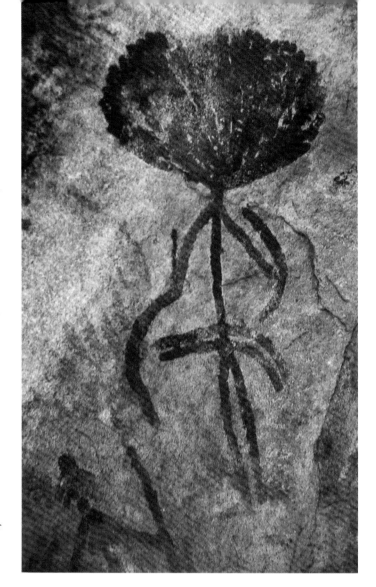

*Above* A male figure holds a boomerang in each hand, while two additional ones are stuck in his notional hairbelt. Location: Maddjurnai. 28 cm.

*Below* Many of the compositions of the simple figures with boomerangs style depict scenes of conflict. The antagonists, armed usually with fighting picks and boomerangs, engage in hand-to-hand combat. One such extensive combat scene occurs on this wall below weathered paintings of a thylacine, a macropod and two tall human beings. The small fighting figures were superimposed by later paintings in white, of which only faint traces remain. Location: Dangurrung. Figure at far left 43 cm.

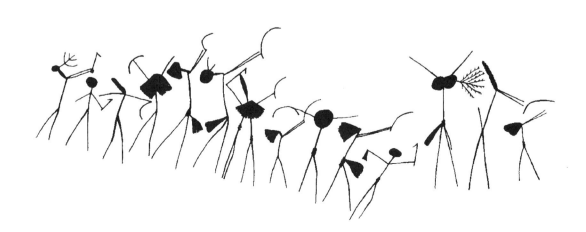

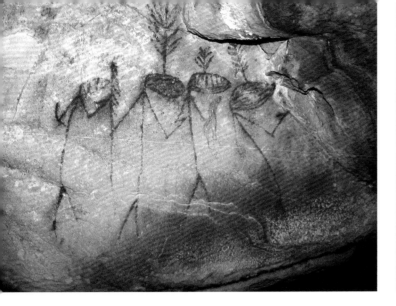

A composition of four male figures, three of whom have headdresses further decorated by feathered ornaments. The first carries a boomerang and a fighting pick, the second has a spear and a fighting pick, and the fourth also has a fighting pick. Location: Gubarra. 27 cm.

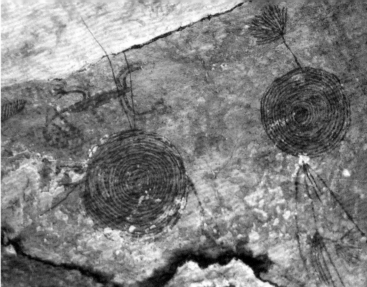

One stylistic variation of these simple figures, with a pan-plateau range, is a simple stick-like figure with a large headdress formed of concentric circles. In this example from the plateau's eastern margin, two such figures were executed on a ceiling of a low overhang. They have a feathered decoration in their headdresses and carry fringe-like objects. Location: Malakandanjma. Figure at right 55 cm.

many scenes of conflict depicted in this style. The use of the fighting pick in hand-to-hand combat is unambiguous. Although this weapon is often depicted as only a hooked stick, in several examples it is seen engaged to spears. It was perhaps some time after the invention of the spearthrower that lighter composite spears came to be made. Although composite spears and hooked sticks, which may have been used as spearthrowers, are seen in this style, it is in the later Mountford figures that the spear engaged in a spearthrower and ready to launch is first seen.

Some of the figures in this simple figures with boomerangs style seem to be crudely executed, which could be attributed to a lack of skill reflecting perhaps the movement of populations at this time as a consequence of rising sea levels. The majority, however, exhibit a virtuosity and subtlety in their execution that suggests that the region's consummate artists were perhaps adopting new aesthetic principles. Several examples show simple stick-like figures spearing exquisite macropods. In some instances these simple hunter figures are added to earlier paintings, creating new compositions. Although most of these figures are comparatively simple, as suggested by their name, they are nevertheless very skilfully executed paintings.

Several stylistic conventions are noticeable in these figures. At least two have a pan-plateau distribution. The most distinct of these shows the stick-like body topped by a large head or headdresses formed of closely drawn concentric circles. These figures are holding fighting picks and feather-like objects and are associated with multibarbed spears. The spears, like the figures' bodies, are expressed as a single line and it cannot be determined if composite rather than single-pieced spears are being depicted. In the other widely distributed stylistic variation, a pair of figures is depicted with their heads in profile, facing each other, separated by their weapons.

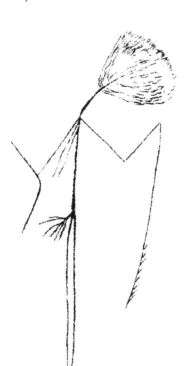

Some of the simple figures are executed in a series of thin brush strokes with the headdress remaining as the most elaborate subject, suggesting that this item of apparel signified a man's status. The man with the tassels off his neck is holding a boomerang in one hand and a spear engaged in a spearthrower in the other. Location: Maddjurnai. 52 cm.

127

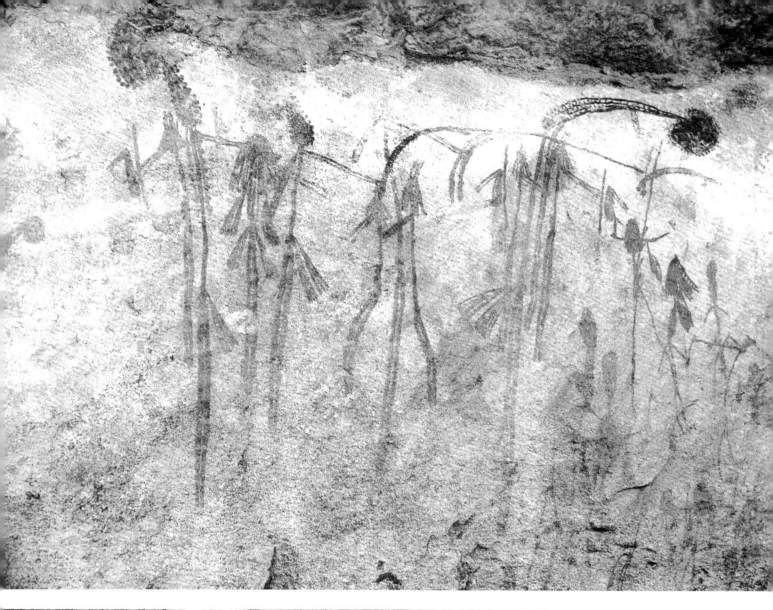

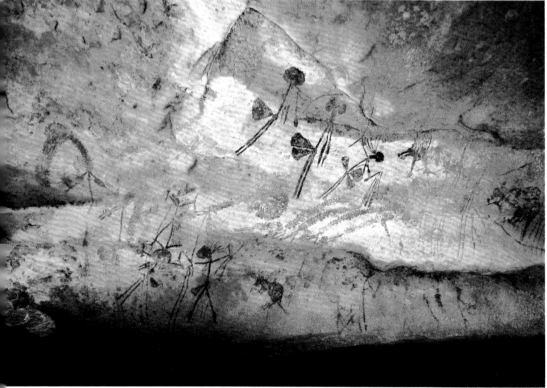

*Above* In this composition the elongated figures with their long and elaborate headdresses, tassels and pubic aprons and bustles are associated with several smaller and less complex figures. The composition may represent conflict as the participants hold in their extended arms boomerangs, fighting sticks and short-handled objects which may be fighting picks. Location: Maddjurnai. Tallest figure 85 cm.

*Left* Two generations of these simple figures are found on the wall of this shelter. The elongated figures with tall, elaborate headdresses were supplanted by shorter figures with wide, rounded headgear. The latter figures wear one, two and even three pubic aprons or bustles, and are depicted as if in conflict with boomerangs and fighting picks in their raised arms. Location: Dangurrung. Upper figure 28 cm.

## Fighting picks

An important and distinctive item of material culture, the fighting pick was added to the weapon complement during the transitional phase between the dynamic and post-dynamic figures styles. In the art of this period, the weapon was depicted as consisting of a long cleft stick with a triangular blade. In many of the examples from the following simple figures with boomerangs style this weapon is drawn, as the style's name suggests, in the most rudimentary form, as a construct of two lines of varying length, joined at divergent angles. Some of the human beings of this style are also stick-like figures, while the weapons they hold appear to be only 'hooked' sticks.

It is possible that the first examples of this weapon were fashioned from any suitable pieces of wood, such as a forking branch or a shaped tree root, or from a sapling whose root end was utilised for the pick's head. Indeed, the root end of saplings are known to have been used to manufacture wooden fighting picks and hooked boomerangs elsewhere in Australia. The best examples of such pick-like weapons are the so-called lioniles made by tribal groups in Victoria. A similar but simple form of this weapon continues to be made in central Arnhem Land today. Another form of this weapon was made from one piece of wood, with a heavy beaked hook being carved out of the solid, so that it was basically a hooked club. This artefact was used as an offensive weapon, and is depicted as such in the compositions of the simple figures with boomerangs, where it is frequently depicted being used by men in hand-to-hand combat.

In many of the paintings the nature of the blade or point of the weapon cannot be established. However, there are clear examples where the blade is depicted in a form other than two lines meeting at variable angles, suggesting that it had a sharp point intended for piercing. Because of its documented use as a fighting weapon, and given its piercing property, the examples depicted in the simple figures with boomerangs style are classified as fighting picks rather than 'hooked' sticks, as the latter term does not accurately describe their functional attributes. This does not mean that this implement may not have had other uses for which the name 'hooked' stick could be appropriate. One of these is its possible use as a spearthrower, suggested in several paintings in which this implement is shown to be hooked into the butt end of a spear.

Other examples of this weapon depicted in the simple figures with boomerangs style appear to be composite implements with stone blades inserted into a solid handle. The elongated triangular blade depicted with its median ridge, a typical attribute of flaked stone tools, is clearly shown.

In later examples, the long-bladed stone fighting picks are depicted clearly hafted in a bent withy handle.

*Above* The first fighting picks appear at the watershed between the dynamic and post-dynamic figures styles. Here, a male figure in a large headdress and arm and leg ornaments is seen holding a boomerang. The associated spears are of the single-piece multibarbed type, while the fighting pick has a sharply pointed head. Location: Gubarra. Male figure 42 cm.

*Below* A group of men attacking a large snake, perhaps nawarang, the rock python (*Morelia oenpelliensis*), with wooden fighting picks, two of which are decorated with tassels. Location: Mikginj. Snake 35 cm.

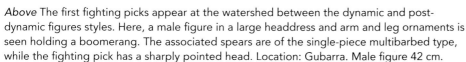

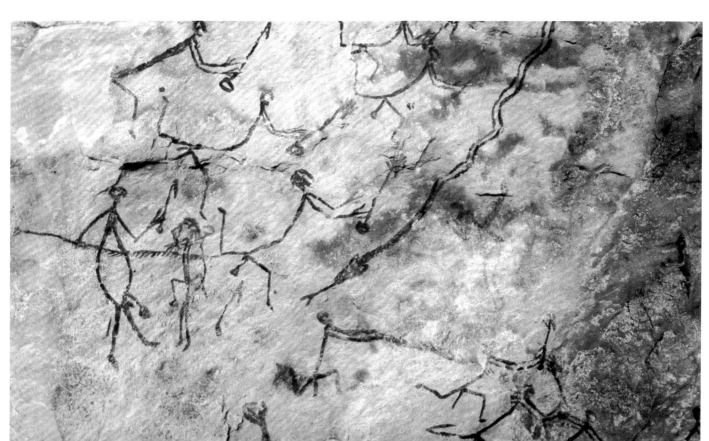

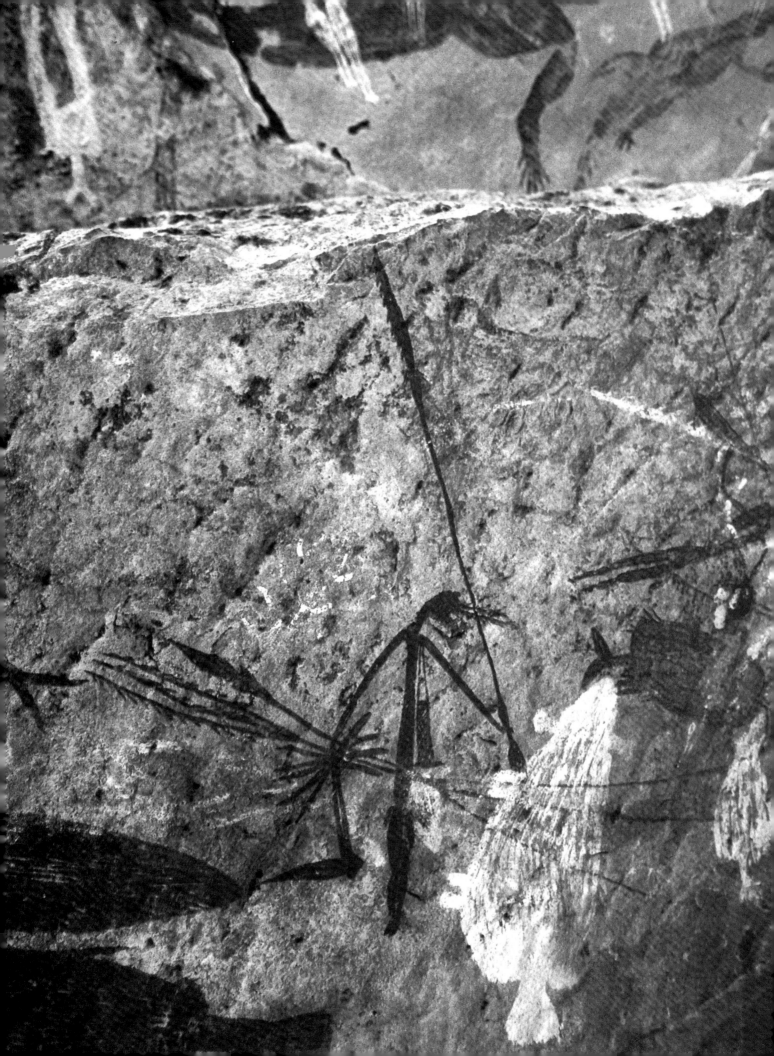

## Mountford figures

Paintings of this style portray human figures with flowing, sensuously elongated bodies which are usually depicted in exaggerated movement. They are named after Charles Percy Mountford, a pioneer of Australian rock art research, in recognition of his life-time devotion to this subject and to Aboriginal culture in general. 'Monty', as he was known to his friends, was the leader of the 1948 American-Australian expedition to Arnhem Land. It was on this expedition that he first recorded these graceful images and brought the incredible riches of the region's rock art to world notice.

Mountford described these paintings of human beings as the most sensuous figures in Australian rock art. Their inherent movement and posture reminded him of the South African Bushmen paintings and of depictions of human beings found in the rock art of the Spanish Levant. He considered a composition of four running women – which through his work became famous worldwide, and typifies the art of this region – to be one of the most spirited and beautiful examples of Aboriginal art in existence.

The predominant motif and perhaps the only subject of this style is the human figure with associated weapons and implements. The vast majority of figures represent males, though female figures occur more frequently here than they did in the previous three styles. Both male and female figures are usually shown in full flight, with elongated S-shaped bodies flexed over widespread legs. They are usually depicted in groups, streaking through a notional landscape or running diagonally down the wall. Occasionally, they are inverted and appear as if falling through space.

Females painted in this style have sensuous bodies with well developed breasts. In some very elongated figures the breast is reduced in size, without losing balance or sensuousness – and actually increasing the aura of mystique associated with them. These figures wear no item of dress, nor do they have any decoration. They do not have dilly bags, an item of material culture which along with a digging stick symbolises the female gender in other styles. Only in one example does a female appear to be holding a digging stick, while in another a woman extends her hand to a boomerang.

The males are depicted in more active poses than are

*Above* Two male hunters from the body of the Mountford figures. They are depicted in elaborate headdresses, with an armlet on the throwing arm and a small attachment at the waist which may represent a pubic fringe. Each hunter is holding a weapon, perhaps an acutely curved, weighted boomerang or a club with a handle of flexible nature. These weapons are similar to the formidable stone-headed clubs used by the Papuan groups along the southern coast of New Guinea. They were constructed by inserting a wooden handle into a round hole made in the stone and then securing it with wooden wedges or strips of leather or rattan. In this composition, the hands and the link connecting the rounded knob to the weapon were executed in white or some other fugitive colour of which no trace remains. The weapons were drawn across this secondary pigment, as is documented by the gap in the first weapon and also in the second one where the red pigment fills in the spaces between the fingers. Location: Garrkkanj. 30 cm.

the women, many with their arms thrown above the head as if casting a boomerang or a spear. It is possible that the weapons, like the missing parts of the anatomy in many of the figures, were executed in fugitive pigments and have since weathered away. The actual weapons are only occasionally shown. Most of the known examples are boomerangs, one of which is depicted with a bulbous end as if it was weighted. Other paintings show the figures with spears engaged in spearthrowers. Some of these spears are simple, in one-piece and unbarbed. Perhaps the spearheads were also painted in now vanished fugitive pigments. Other spears are composite multibarbed types or have long-hafted simple points.

The Mountford figures appear in a number of stylistic variations. The differences involve not only the colours used

*Opposite* A male figure in a feathered headdress is depicted with a string bag hanging from his shoulder, and with a variety of weapons including a long-bladed fighting pick hafted in a bent withy. The composite spears held in his hand are of two types – the three-pronged uniserially barbed one with its barbs pointing outwards, and the composite headed variety with one long and two shorter side blades. Four throwing sticks tapering towards the distal end have a winged head. In the other hand he holds a spear hooked into a spearthrower. Location: Gunbilngmurrung. Overall 25 cm.

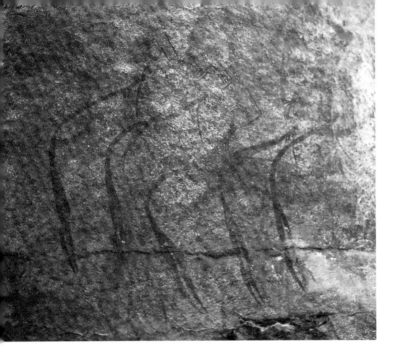

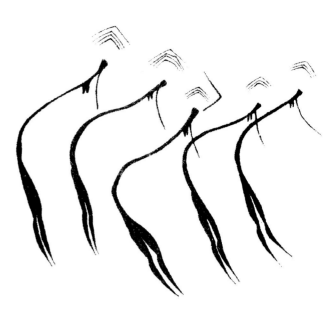

in their execution, but also the forms that the figures took through time – they vary in size, degree of elongation, relative width of the body, and internal decoration used. Most of the figures were executed as silhouettes in red, with heads and headdresses in a secondary pigment. Some of the bodies and headgear were outlined in red and then infilled with a wash of a lighter colour, while the interior of other outlined bodies was closely hatched. When not portrayed in spirited action, these figures assume graceful postures that often form rhythmic designs. However, even in those paintings which depict still figures, the shape of the elongated body or the position of the arms continues to express latent movement.

The artist of this style depicted the male figure with muscular legs, a prominent penis and wearing a headdress. In many instances the figures appear to be headless, because their heads and headdresses were executed in impermanent

*Above* A composition of five graceful, elongated female figures with small breasts and one with an arm raised above the stylised hair. Their heads, painted in some other pigment, have weathered away. This composition may represent a dance performance. Location: Inyalak. Height 42 cm.

(or fugitive) pigments and have weathered away. Part of the body, in particular the extremities, which have been executed in such colours are also missing, leaving gaps between the extended arm and the weapon the hand was clasping. The headdresses are of a variety of shapes and are adorned with feathers and other objects. These items are identifiable in paintings where they have been outlined and decorated in more permanent pigments. In other figures, only traces of such outlines remain to suggest what the headdresses may have looked like.

Although these figures are occasionally found as single representations, in most cases they are arranged into aesthetically pleasing compositions. Some compositions are quite complex, consisting of many interacting figures and varying themes that are not readily interpreted. Figures are also found superimposed on others and differentially weathered, suggesting a considerable time period for the duration of this style. The spatial range of the Mountford figures, however, is very limited, extending from the Inyalak Hill overlooking Oenpelli, along the Inagurdurwil sites and across the East Alligator River to Ubirr, Cannon Hill and

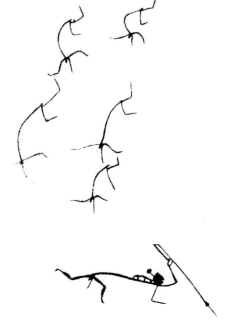

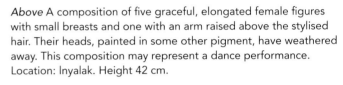

*Left* When depicted with their weapons, the early male figures of this style usually carry boomerangs. In the later stylistic variation they are depicted with spears engaged on spearthrowers. In this example, the hunter with a feather ornament decorating his headdress has a dilly bag down his back, while in his hand he holds a spearthrower engaged to a spear with a long, possibly wooden point. Location: Ubirr site complex. Length of figure 24 cm.

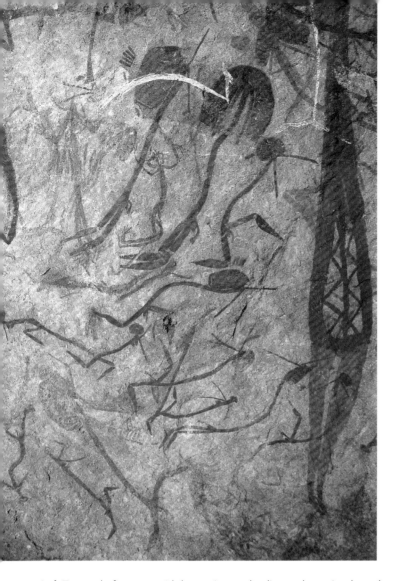
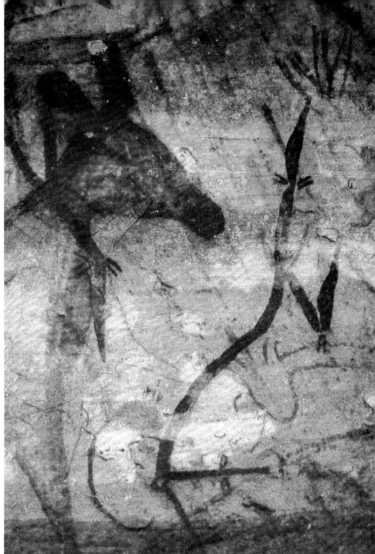

*Left* Two male figures – with long, sinuous bodies and wearing large headdresses – are depicted flanking an anthropomorphic figure, while the smaller male figures are perhaps associated with three female figures below. Location: Inyalak. Central top figure 30 cm.

*Right* Many of the Mountford figures are depicted running diagonally down a rock wall, or, as in this instance, are inverted. This elongated male figure has a rounded headdress and tasselled knee ornaments. Location: Inagurdurwil. Height 60 cm.

through Ngarradj wardedjobkeng, the passageways cut in the escarpment by Ngarradj, later the sulphur-crested cockatoo, to a Ginga wardelirrhmeng site where, in the Dreaming, Ginga, the saltwater crocodile, clawed his way to the top of the plateau, a distance of 25 kilometres. This territory is associated at present with people of the Mengerrdji and Erre language groups.

What is most surprising about this style is that although its extent is centred on the East Alligator River, there seem to be no representations of animal or fish subjects. The area would have been comparatively resource-rich, even during this pre-estuarine period, with no lack of faunal subjects. Yet, the artists, rather than drawing subjects from their physical or spiritual environment, focused on themselves and their society. It is perhaps their self-confidence which is expressed in these elongated, sensuous and spirited figures.

*Overleaf* Some of the most accomplished paintings of the Mountford figures style are found on this wall, where at least two generations of these figures superimpose earlier designs. The superimposed fish were executed in two or more colours, of which only the dark red ovoid and hook-shaped sections remain. A number of male figures with headdresses of varying complexity are seen vigorously interacting above a fringed net, held up by two simple bare-headed figures, perhaps adolescents. This composition of male figures with a net is superimposed over earlier figures in the same style, but which are painted in at least two different conventions. Some are full silhouettes, while others are executed with a dark outline infilled with a lighter wash. There is also an unusually tall figure painted in this stylistic mode. The headdresses of the more recent figures were originally more complex than they appear at present. Executed in more than one colour, the parts which were painted in fugitive pigments have weathered away. These headdresses, except for the two at left in which a second red ochre was used, remain as outlines only, with feathers and other ornaments seemingly floating in space. Similarly, the hands which held the boomerangs used in this scene of conflict were painted in an impermanent pigment and have now vanished. Location: Inagurdurwil. Fringed net 165 cm.

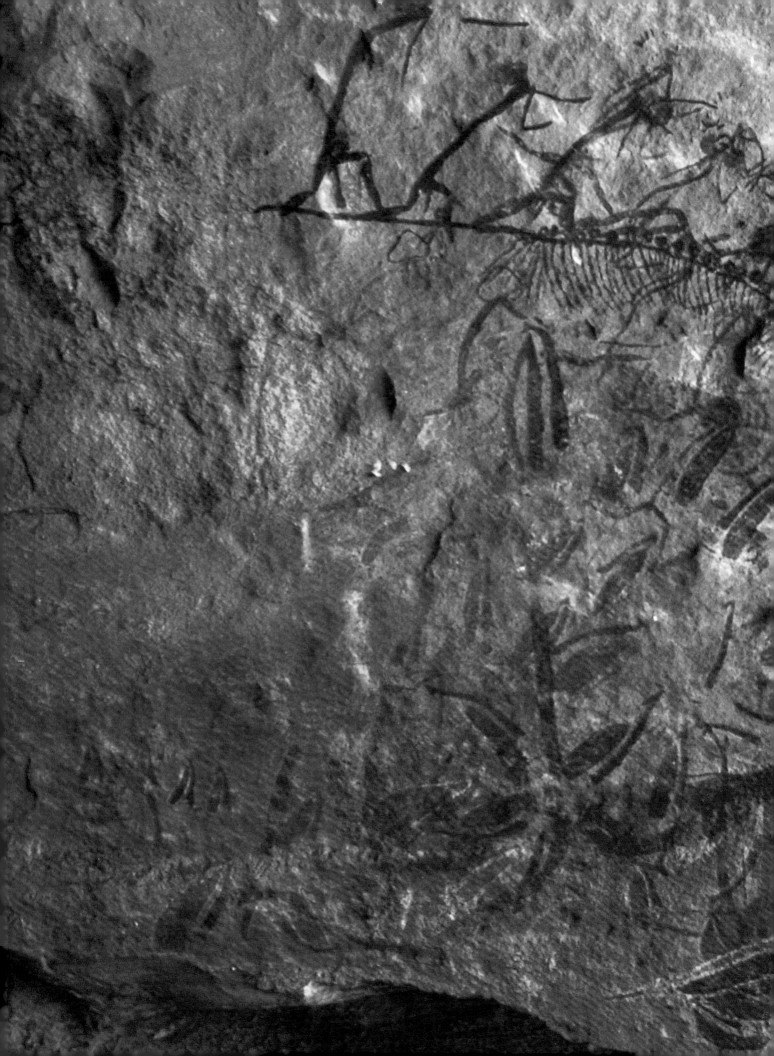

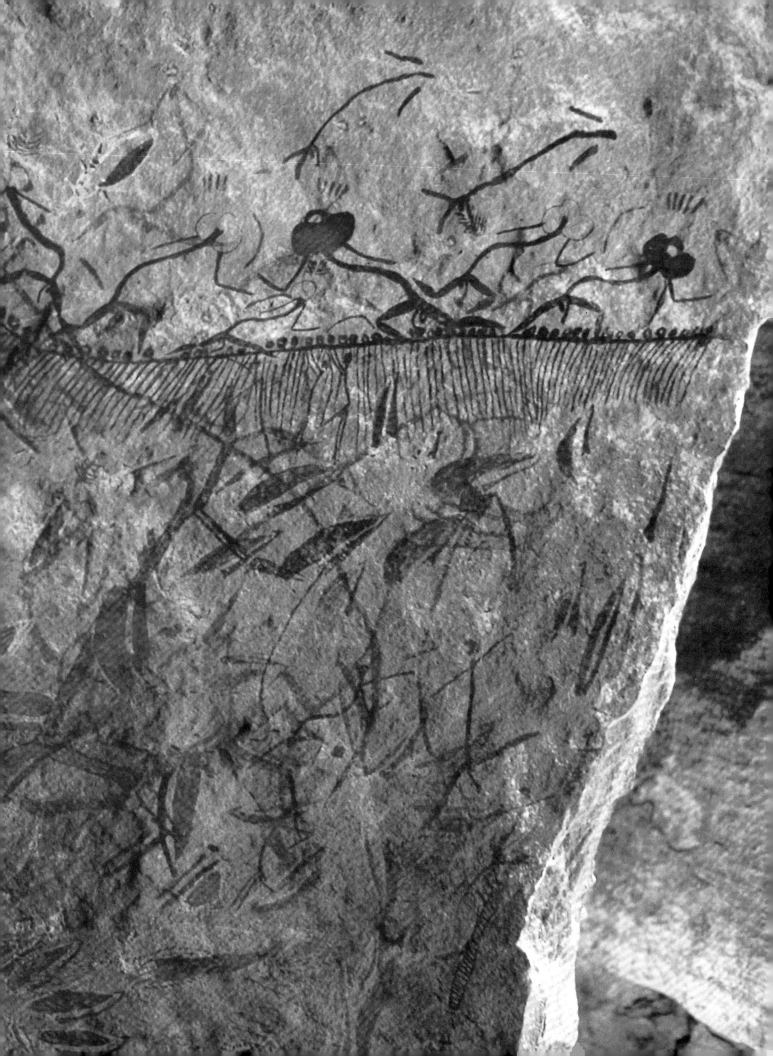

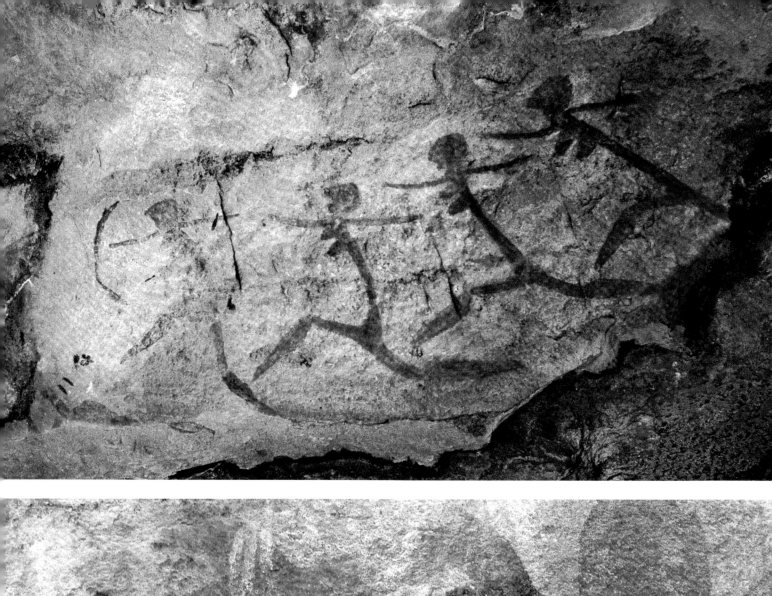
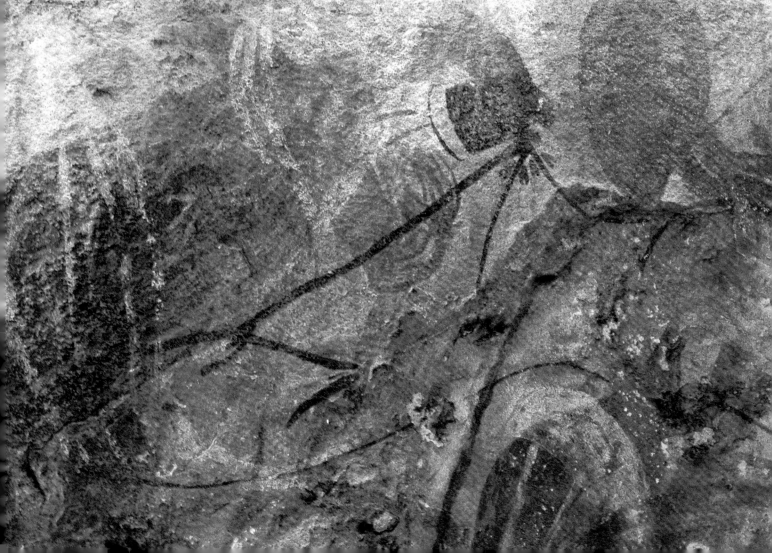

## Yam figures

Paintings of the yam figures style of the Arnhem Land Plateau are the most enigmatic images found in rock art anywhere in the world. These figures in their earliest form are simple images of yams, but as the style developed they represented, in symbolic naturalism, human and animal beings. In most instances the artist synthesised the intrinsic properties of a yam species with an ideoform of a specific or imaginary animal. Such images were associated with several distinctive motifs. The evolution of representations of human beings in this style can be seen in many paintings, from the outward shape of a yam tuber 'body' through to the complex image of a man associated with weapons and animals. Aboriginal people identify two yam forms on which these paintings are based – anginjdjek, the round yam *(Dioscorea bulbifera)*, and garrbarda, the long yam *(D. transversa)*.

Botanically, these yams are monocotyledonous Angiosperms. They were amongst the earliest flowering plants to evolve and have achieved worldwide distribution. The genus to which they belong, *Dioscorea*, originated in what is now South-East Asia, and the species found in Australia's tropical north are closely related to those of that region. However, the term 'yam' is often incorrectly applied to other tropical and sub-tropical root and tuber crops, and to aroids, a family of plants easily identified by the distinctive inflorescence of a cylindrical mass of flowers enclosed by a leafy sheath, such as those of the *Amorphophallus* species, none of which are connected with the yam figures painting style.

*Dioscorea* grow in regions that have a distinct wet and dry seasonal climatic division and where the annual rainfall is about 120 centimetres. The plant is dormant during the dry season, commencing an intensively active growth cycle when the wet season comes around. It sends out long twining vines which twist through the undergrowth and climb over trees, then die away at the end of the growing season. The flowers are dioecious, male and female usually being found on totally separate growths. After fertilisation, female flowers mature to become dry-winged capsules containing seeds that will be dispersed by the wind.

The yam tubers consist mainly of water, carbohydrate

The round yams, as can be seen from this example dug up by Kapirigi, grow to 20 cm in diameter. In their season, they are an important food item.

(in the form of starch) and some protein. They also contain nutritionally significant amounts of vitamin C and some of the B group vitamins. One of the important properties of these tubers is that they can be stored for considerable periods, which enabled people to transport and transplant them wherever they ventured. This portability accounts for *Dioscorea's* presence today throughout the Pacific region. The Australian species, growing prolifically in the plateau region, were collected and brought to ceremonial gatherings to feed the participants.

The anginjdjek tuber, an annual, has nodules and hairy rootlets on its surface, and a knobbed 'head' from which the stem of the vine sprouts. The Aborigines use a digging stick

*Opposite above* This group of four running female figures become world famous when it appeared in a UNESCO publication in 1949. Location: Inyalak. Height 21 cm.

*Opposite below* This variant of the style is executed in a dark brown, almost black pigment. The head in profile shows an open, gaping mouth. The man wears a string of neck pendants and holds a boomerang. An interesting and important element of the composition is the ground line shown below him. This is a landscape feature very seldom seen in the region's rock art. Location: Ubirr site complex. Height 30 cm.

On a weathered ceiling is a lizard-like creature with a yam head and slightly serrated body and tail. Tendril lines lead from its rear, along both sides of the body to above its front limbs, where they terminate in yams. Location: Karngbanalar. 116 cm.

to harvest the plant, pushing down into the soil along the dried stem to reach the tuber. On pulling it out, the knobbed head is broken off and replanted to ensure regeneration. This yam contains toxic alkaloids which must be removed prior to consumption. As the alkaloids are water soluble and easily removed by leaching, the tuber is sliced, placed in a dilly bag and left overnight in running water, hence its common names of 'water yam' or 'cheeky yam'. In later periods the artists, well aware of these poisonous properties, mixed anginjdjek with their pigments when executing sorcery paintings to enhance the potency of their images.

The basic motif of this style is a knobbed yam tuber with raised nodules and a number of stylised tendrils, vine or rootlets, though in later examples it is seen to have evolved into phytomorphic beings and finally human form. The body, in the earliest images, is thin and root-like, and in one known painting it is still attached to a leaf form. As the style developed, the body was split to form legs, and two of a number of long tendrils or vines were reduced to become arms. The upper part of the body, like the yam-like head, is surfaced with nodules on one or both sides. Alternatively, the body may be serrated. It is not until the final stages of this style, when the yam figures attain their fully human form, that they are sexually differentiated. The male figure is usually associated with both composite single-pronged and multipronged spears and a deeply hooked fighting pick. The dismembered body motif found in the previous

large naturalistic figures complex and seen in a number of examples in the most recent horizon of art is also represented in this stylistic complex.

Yam physiognomy is imposed on images of animals, zoomorphs, and the Rainbow Snake, too. Most of the fauna associated with the yam figures are species which, like the plant itself, are associated directly or indirectly with aquatic environments. They include long-arm prawns, freshwater crayfish, freshwater fish, ibises and egrets, flying foxes, freshwater crocodiles, short-necked turtles, frogs and snakes. However, paintings of a sulphur-crested cockatoo, a blue-tongued lizard, an echidna, an emu, a centipede and macropods have also been recorded. These species are arranged – with the yam figures, yam 'strings', barred lines, and occasionally tree forms – into complex compositions. In many instances the abstract symbol of a segmented circle is associated with such compositions.

Yam 'strings' are single or multiple lines of varying complexity, forked at one or both ends. The lines appear to be knotted or to have small nodules immediately above their split ends. When forked at only one end, the line is shorter and the distal end is knobbed. The 'yam strings' are a common motif and may be intertwined or extended across disparate figures, tying them into a uniform composition.

'Barred lines' are a rather obscure motif. They usually appear as three or more parallel lines of varying length, with a cross bar at one end. Some are constructed of more or less straight lines, while others have a fringe of wavy lines attached to a concave or convex top bar. Occasionally, the crossed line is extended and leads to yam tubers.

The tree form is an unusual subject, seen only in two examples of the previous dynamic figures style. Two multibranched trees with thick trunks and roots, and associated with segmented circles, as well as several other shrub-like forms have been recorded.

It is in the yam figures style that the Rainbow Snake is represented for the first time in the rock art of the region. The Rainbow Snake is depicted as a composite being with a macropod-like head, a snake's body and, in most instances, a serrated crocodile's tail. Although there are several simple forms of this being, the majority are complex representations. These latter dominate the compositions of this period and are the style's main motif. The myths associated with the Rainbow Snake – the major cosmological being celebrated in rituals of this region – are still an important part of the Aboriginal people's lives today. Thus the representations of

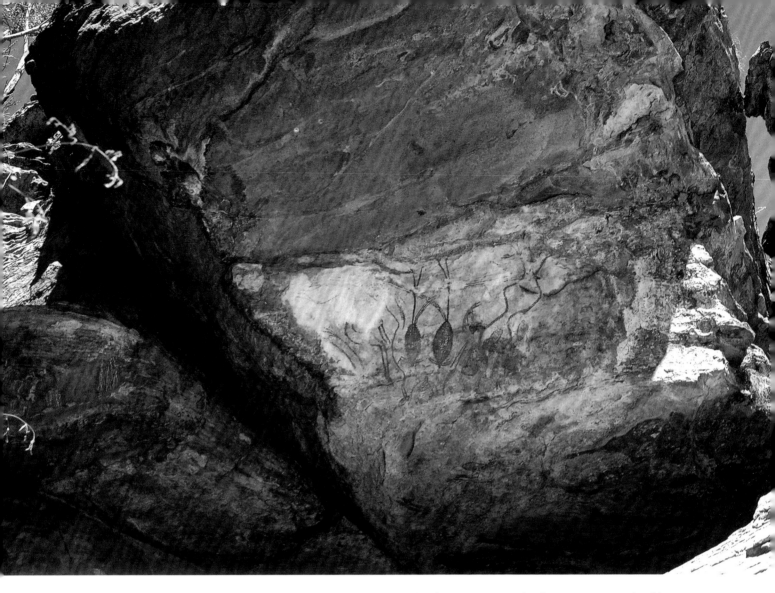

In this composition, two inverted yam figures with long tendrils crossing each other are associated with yam 'strings', stylised long-arm prawns and other unidentified motifs. Location: Gubarra. Yam figure at right 56 cm.

the Rainbow Snake in this early art style, and in all subsequent ones, documents the longest continuing religious tradition known in the world.

The conceptual change from the naturalism and the schematisation of the previous styles to the symbolism expressed in the yam figures perhaps reflects change in the artists' psychological environment. Such change in their world view together with the introduction of new mythologies may have been due to population movements that commenced sometime during the periods of the three previous styles. The effects of the rising sea on human migration and land settlement at the end of the last Ice Age could have been quite considerable. As the sea devoured large segments of the coast, the people would have had to adapt to a not only shrinking, but changing environment and adopt a conciliatory philosophy towards groups on whose land they were encroaching. It was perhaps the rapidly rising sea which was the ideational basis for the Rainbow Snake belief: in the

majority of northern myths this being is associated with rain and floods, and in coastal variations the serpent emerges from the sea and swallows or drowns people.

The wild yams would have formed an important food resource for early humans in many other tropical and subtropical regions. In at least two areas of the world, Western Africa and New Guinea, cultures based on the cultivation of yams developed and continue to survive today. In these areas, yams traditionally not only provide the major staple food, but ritual and magico-religious practices accompany almost every aspect of their cultivation. Neither the commencement of this yam cultivation nor the use of the wild *Dioscorea* species is documented in archaeological evidence. The only known direct evidence of the antiquity of such a culture is found in the yam figures rock paintings in the Arnhem Land Plateau which are dated as at least 8000 years old.

Many localities in the plateau region are virtually 'yam gardens', having been cultivated and attended by members

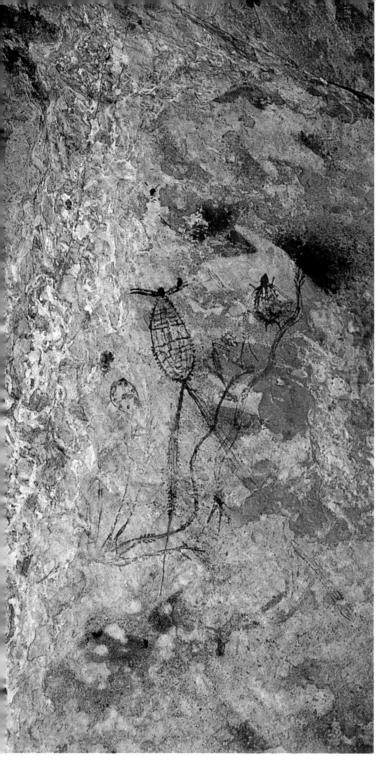

The basic designs in the yam figures style are yam 'strings', or vines – lines of varying complexity forked at one or both ends – and a yam figure – a knob-topped yam tuber representing the round yam (Dioscorea bulbifera). The head or tuber, with the 'eyes' represented as nodes around its circumference, and stylised roots or tendrils, all attached to a simple vertical body structure, make up the basic form of this style. In this composition, painted on a ceiling of a high overhang, three yam 'strings' and a yam figure are associated with a short-necked turtle, a circular design and other unidentifiable motifs. The circular design with the central mark and a number of dots along its inner margin may be the predecessor of the segmented circle motif associated with the figures of this style throughout the rest of the period. Location: Djuwarr site complex. Yam figure 65 cm.

of the local groups through the ages. Here the yams grow prolifically, spurred on not just by replanting the yam 'heads' (the sprouting tops) so they will propagate again, but also by enlarging the base stock by bringing in heads found during their journeys across areas not currently used by some other group. It was perhaps the transplanting of yam tops in this way, sometime long ago, that led people to first realise they could raise this plant, possibly with a perceived attendant magic power.

Aborigines say the yams were brought to the Arnhem Land Plateau region by their great ancestor, Warramurrunggundji, thereby assuming the plant's South-East Asian origin. After emerging out of the sea, Warramurrunggundji moved inland, scattering yams from her dilly bags at five different localities where they began to grow. The future propagation of the yams was accepted as the duty of the local groups, who initiated rituals to ensure the survival and proliferation of the species. The importance of yams to Aboriginal societies today is seen in the part they play in socio-religious events. In the plateau region and on Bathurst and Melville islands, a number of rituals associated with round yams are perhaps the relicts of the regional 'civilisation of the yam'. This cultural period commenced with the appearance of paintings in which the mystery and magic of these yams is expressed in many symbolic forms that today are impossible to fully explain.

Baldwin Spencer was the first non-Aboriginal person to record yam ceremonies in this northern region. In 1911 he was on Melville Island, where he witnessed the kulama ritual based on the round yam (Dioscorea bulbifera). Although kulama is usually described as an initiation ceremony, it was, at least at that time, also an increase ritual, not only for the round yam but also for the long yam (D. transversa) and all other edible tubers. Spencer records that while round yams were being ritually prepared for the initiates, the men repeatedly sung a refrain which was translated as 'yams, you are our fathers'. From Spencer's description it seems that here, as in the plateau region, it was the presence of harmful toxins in the yams, necessitating lengthy preparation before they could be eaten, that made the Aborigines consider this round species to be a superior kind of yam, endowed with powerful properties which the long yams and other tubers do not possess.

The following year Spencer was at Oenpelli visiting Paddy Cahill, whose knowledge of local language was of assistance in documenting the role of the round yam in several regional ceremonies. Two of these rituals had to do with the removal of

food restrictions. In the first, jamba *(djambarl)*, all the foods that were forbidden to adolescents, including kulori (the round yam), were described in a song-cycle. Then followed a kulori ritual in which the actual food taboos previously imposed on the youths were removed. At the conclusion of this ritual, the initiates became 'yam men'.

Spencer also recorded decorated stone and wooden objects which represented yams in marrayin ceremonies, as well as a body-art design featuring a representation of a yam. This latter yam design was painted on the back of a ritual participant and bears close resemblance to the elongated yam heads in the paintings of the yam figures style.

When Ronald and Catherine Berndt visited Oenpelli in the late 1940s they recorded a Gunwinjgu version of angindjek, a Gundjeihmi ceremony held between the ubarr and marrayin rituals. Ubarr was the first in a sequence of initiatory rites during which novices were told not to eat certain foods. The restriction included barramundi and fork-tail catfish, a number of reptiles and birds, and any bitter or dangerous foods such as the round yam. The novices had to participate in three ubarr rites before the taboos were repealed by the angindjek ceremony. During this latter ritual the participants' bodies were decorated with stylised representations of angindjek, the round yam. The primary purpose of this rite, like that of the Gagudju's kulori, was to terminate food restrictions associated with this yam.

In the past, when the stems of the round yam first broke the ground at the onset of the wet season, the Mayali people held a ceremony to encourage its growth. At the commencement of banggerreng, the period of last rains, yamidj, the long horn grasshopper *(Caedicia* sp.), whose progenitor brought anginjdjek to the people of the plateau during the Dreaming period, was said to call out that the yams were ready to eat. In this season, when little other food is available, these tubers were an important food resource.

The increase ceremonies and other manipulative rituals concerning yams were deliberate acts that ensured the continued existence of the tuber and, by directing the plant to grow in specific localities, made its collection easier. The powerful properties of the round yam were feared by the 'clever men', as they could cause them to lose their special powers, however they were used to strengthen young children. After a baby was able to turn to its side, it was exposed to the steam and smoke of baking anginjdjek. Later, when the yams were

peeled but still hot, they were pressed on to the child's chest, back, forehead and other parts of the body. This treatment was said to make the child grow strong and fearless.

There are no evident representations of yam plants in the preceding rock art styles, although in the dynamic figures period females are shown carrying digging sticks and dilly bags, some of which are filled with rounded tuber-like forms. The focus of this whole yam figures style on a plant subject suggests the timeframe for the rise in the importance of the *Dioscorea* to the local populations. As the genus *Dioscorea* requires about 120 centimetres of rainfall annually for growth, it possibly was either absent from or of restricted range in the wider plateau region during the last glacial maximum. The plant was to recolonise or extend its range only with the increase in precipitation accompanying the rising sea, to become an important food resource.

It is possible that the Aboriginal groups which reoccupied the continental shelf area and the Arafura plain during the glacial times may have come into contact with their New Guinea neighbours, to whom wild yams were perhaps already of considerable importance, and brought back with them traditions associated with the yam species. However, the cultivation of wild yams and the accompanying rituals found in New Guinea and elsewhere in Melanesia, which have been described as major features of a 'yam civilisation', developed subsequently to the glacial period. The enigmatic paintings of the yam figures style in the Arnhem Land Plateau region are thus expressions of an earlier 'yam civilisation'.

The complete stylistic breaks between the yam figures and the preceding as well as the following art style suggest major ideological and cultural shifts. It seems that the importance of the yams during this period had less to do with their importance as a food resource than with the religious aspects of these tubers, which, perhaps in a very abated form, was reflected in the yam rituals of more recent times.

The yam figures style is unique, there being no analogy to it anywhere in the world. It will be only after detailed analysis of the imagery, symbolism and themes found in this style that some layers of the underlying beliefs and meanings may become apparent. In the following styles within this region's rock art sequence, vegetable foods are only occasionally depicted; in such cases, they are usually naturalistic representations of long yams.

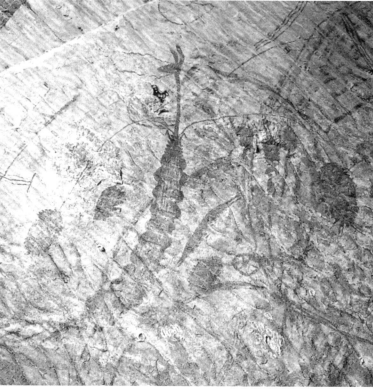

*Above* The concept of the awesome Rainbow Snake – brought about by the encroaching sea, increasing rainfall and the accompanying wet season floods – has its origin within the period of the yam figures style, when the first representations of this being appear in rock art. It went on to become this style's major subject. The Rainbow Snake is generally depicted as a composite zoomorph with an animal's head, a snake's body and a serrated crocodile's tail. In this example, the Rainbow Snake has a human head, and one arm and one leg that each terminate in three-digit claws. The elongated body tapers to a tail with a fish-like set of neural and hemal spines. Lines leading from the head envelop the body, while other lines enclose two unidentified quadrupeds, one shown with a decorative feather from the back of its neck. Location: Ubirr site complex. 105 cm.

*Right* Detail of a weathered yam figure style composition, parts of which were too indistinct to copy. In this scene a yam-headed being extends a hand over a snake. The snake has the knobbed body of a Rainbow Snake but cannot be identified with that being as it lacks the macropod-like head and the serrated tail which usually typify this being in this art style. Two smaller snakes, a lizard, a flying fox, fish and a centipede are associated figures. Location: Merl. 52 cm.

*Above* A painting of a Rainbow Snake with a slightly curved body and prominently raised knobs. Two long lines ending in yam tubers extend from the upper part of the body above the hook-like extensions. Three flying foxes hang from one of the lines. Below is a long-arm prawn, a segmented circle and a yam tuber, while beneath the second line is a stylised freshwater crayfish. At left, adjacent to the Rainbow Snake, is a simple yam figure overlaid by three parallel lines joined by a crossbar. Location: Djarrwambi. Rainbow Snake height 94 cm.

*Below left* This, the most accomplished painting of a Rainbow Snake yet seen, is associated with an anthropomorph and a yam figure. The Rainbow Snake, with its fine head and long ears, has two lines leading from the head along the coiling body to the base of its deeply serrated tail. A long-arm prawn holds on to one of the lines, while yam tubers and a fringed object can be seen extending along the snake's body. An anthropomorph in a long headdress also holds on to the line with one hand and in the other hand holds a yam 'string' which envelops the adjacent yam figure. Location: Gorrogorro. Rainbow Snake 90 cm.

*Below right* Birds are frequently represented in the yam figures style, in particular those associated with water such as ibises and egrets. Except for wings, the images are usually featherless, their bodies bearing the imprint of the yam. In this painting of an ibis, the contours of its neck, body, wings and legs are knobbed. Long tendril lines float from beneath the wings and past the body to end in yams. Location: Djidomdjud. Ibis 45 cm.

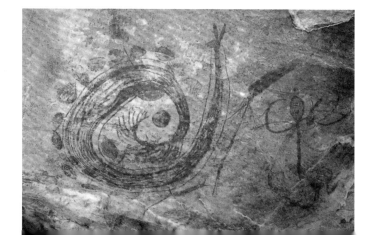

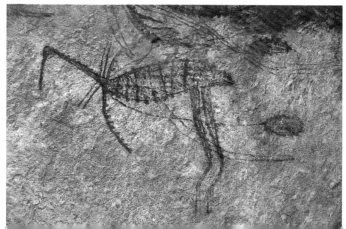

*Right* The yam figures finally became fully human, with just a hint of their origin. The head lost its rootlets and large knob, although its circumference is covered with small nodules. The male has a prominently depicted penis, while the female has a series of knobbed strings across the head and a series of lines from her abdominal region extends diagonally down the rock wall. A stylised dilly bag is near her hands. Location: Anburdgorrang. Length of male 67 cm.

*Below left* An anthropomorph with a yam head has a multiple series of lines extending from his face diagonally along his arm. The body widens from the top of the chest, and there is a slight bulge above the constricted hip. The feet have elongated macropod toes. Location: Djuwarr site complex. 76 cm.

*Below right* In this composition, the only motif that identifies the style and period is the segmented circle. It depicts a male figure associated with his weapons and with a small macropod enveloped by three lines. Two of the lines completely enclose the body and adjacent motifs, while the third reaches the feet and then turns up and outwards to become attached on each side to the legs of short-necked turtles. Where the two lines closely contour the legs and feet, a blue-tongued lizard is seen approaching. To the right is a thin, elongated skink-like reptile shown in profile, with a knobbed body. A similar creature, with one limb on the upper part of its knobbed body, lies above and to the left of the man's body. Location: Budmiyi. 165 cm.

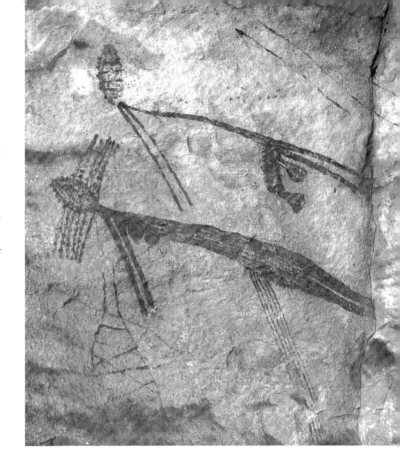

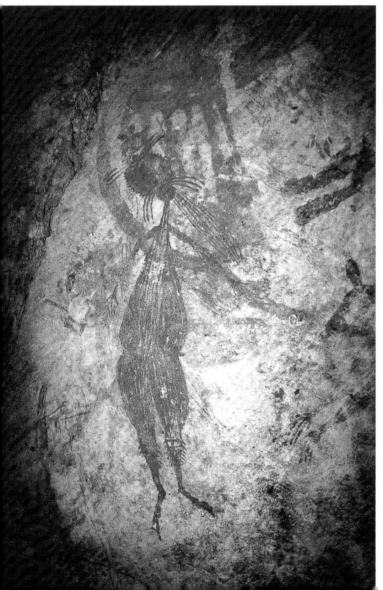

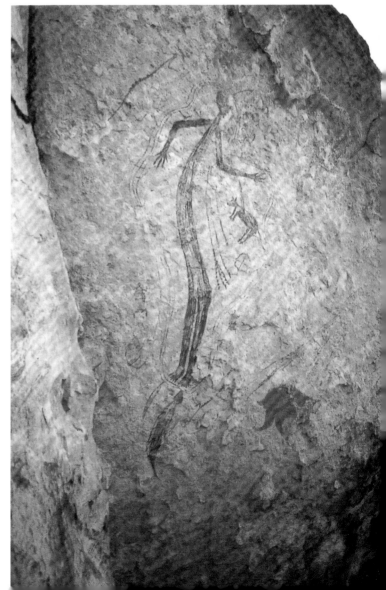

# Spears

The rock paintings provide an important ethnographical record detailing many items of the Arnhem Land region's material culture that otherwise would not be known today. In this record, the accuracy and detail of depicted spears and spearthrowers is governed by the particular artist's skill and inclination at the time of execution, the stylistic conventions of the period, the type of brushes used, and the nature of the rock surface on which the art has been executed. Fortunately, a large number of clearly depicted spear and spearthrower types have been recorded throughout the rock art sequence.

The spears documented in the rock paintings suggest that, like boomerangs, almost all the known Australian spear types were made at one time or another by the local groups in this region. The oldest known specimens in the art are one-piece multibarbed spears, which were made from a single piece of wood with uniserial barbs cut in the solid. This type of spear was the only one used during the dynamic and post-dynamic figures styles. It is most probable that a much simpler spear – a hard wood shaft sharpened to a point – would have been its precursor. Such spears have been recorded in later styles and were still being made in the contact period.

Composite spears first appear in the simple figures with boomerangs style. There are two types depicted in this art period: uniserially barbed wooden heads, with barbs cut in the solid and attached to the wooden shaft; and more complex three-pronged multibarbed hafted spears. However, it is not possible to establish which of the two is older. It was perhaps during this period that light wood and bamboo shafts began to be used and necessitated the invention of a spearthrower. As such spears had a reduced mass compared with earlier spears, a spearthrower would have given the greater projectile force required for an effective result with a lighter weapon.

Following the schematised images of the simple figures with boomerangs style, the human body was portrayed with increasing naturalism and the associated weapons and implements were shown in greater detail. These depictions reveal the hafting techniques employed in constructing spears, spearthrowers and fighting picks. Composite spears with hafted, hard wooden points of variable length and complexity appear. Some are shown with barbs cut uniserially or biserially, others with a double row of barbs. Two-, three- and four-pronged multibarbed spears are represented, as are two-pronged plain and barbed spears which appear to have been cut from the solid. Spearheads with a main blade and two side blades or with a long blade and two side hard wooden points are also found, as are spears with heads made by embedding a series of small sharp stone chips in a resin or by inserting bone or wooden barbs in the blade using resin or gum. Some spears have a head with eight short prongs, perhaps depicting stingray spines.

Stone-headed spears are also depicted in the paintings. These heads are triangular, with the central ridge of the flake blade clearly evident and looking much like the hafted stone-bladed fighting picks. As stone blades seem to have been used in fighting picks at the time of change from the dynamic style to the post-dynamic style, it is possible that the stone-headed spear may have had an early origin.

Simple spears with oval, flattened or spatulate wooden heads are also identifiable. The four-pronged fish spear appears for the first time during the estuarine period, shown being used to spear fish. A short, light spear with a reed shaft and a single hard wooden tip, developed for the specific purpose of hunting the magpie geese which inhabited the area after the establishment of the freshwater wetlands, is also depicted.

Most of the spear types used in this region during the historical period and remembered by my colleague Kapirigi were composite spears. Only two spears were made from single pieces of hardwood. One was garrarr, a long, slender, straight spear sharpened to a simple point that was hardened by firing. It was said that in the past a bone tip may have been inserted into the shaft's distal end. The second was barrawo, a heavy stabbing spear referred to in the Aboriginal English of the area as a 'crowbar',

*Left* This complex composition of human beings with their associated weapons and implements is found on the ceiling of a low, deep overhang. Of the two hafted spear types represented here, one has a uniserially barbed head, while the head of the other spear is composed of a long central blade flanked by two smaller ones. Several men in this composition are shown with wooden pins inserted in their headdresses. At the time of execution, or perhaps later, the artist made pubic fringes for these figures from unknown organic material, which has weathered into a powdery substance. Location: Djarrwambi. Tallest male 30 cm.

*Right* A male figure associated with 13 uniserially barbed hafted spears and two three-pronged, composite spears with barbs aligned inwards. This is one of two such compositions executed on this ceiling. A long spearthrower that is part of the second composition is seen in the upper left. Location: Djarrwambi. Male figure 55 cm.

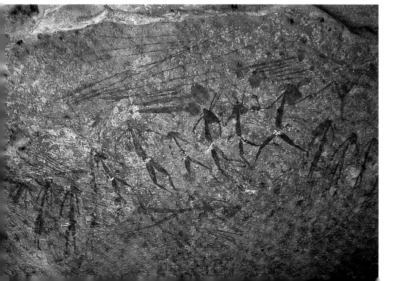
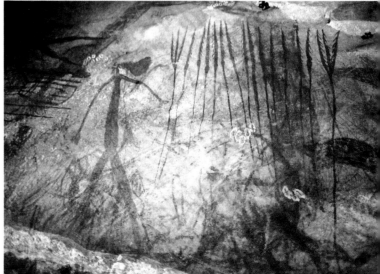

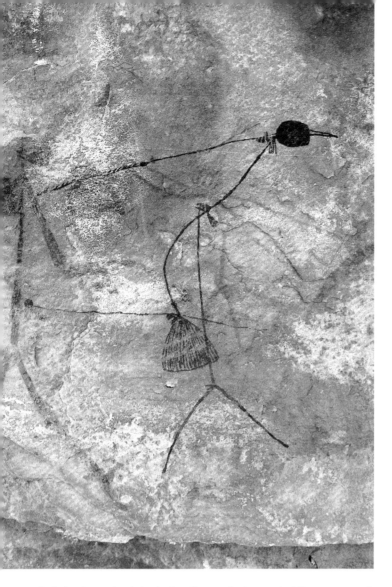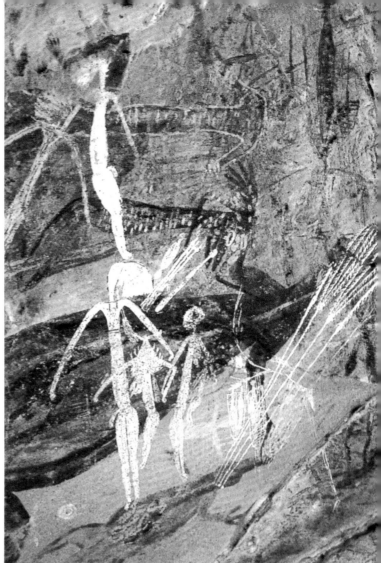

*Left* A schematised single-line figure of a hunter holding a composite uniserially barbed spear engaged in a complex long-necked spearthrower that has a wide central panel. The other spear is a simple one-piece example with a knob at its proximal end. These simple spears were made out of hard wood, and the cup in its shaft for the insertion of a spearthrower's peg was sometimes reinforced with lashings fixed with ironwood resin or beeswax. Location: Djawumbu-Madjawarrnja complex. 34 cm.

*Right* A family group with their weapons and implements, which include four hafted and tasselled spears and a spearthrower. Two of the spears are uniserially barbed; one, with a short head, has only four barbs, while the other has a much longer head with 15 barbs. The other two spears are four long-pronged, uniserially barbed spears with up to 26 barbs on each prong. The spears are leaning against a tree, from whose branches hang three dilly bags. A spearthrower and fighting sticks form part of the weaponry complement. Location: Gunbilngmurrung. Male figure 26 cm.

a term also used to refer to a woman's digging stick. It was made from a shorter, thicker piece of timber than was the garrarr type.

The composite spears consisted of heads of hardwood or stone – or more recently of glass, iron or steel – inserted into light wood, reed or bamboo shafts, then secured with resin or beeswax and tightly bound with string. Good shafts were treasured and carefully maintained. If they were broken, repairs using the resin extracted from the roots of the ironwood tree and bindings of string, sinew or the small intestines from macropods would be effected.

The following composite spears were made or used by the Gundjeihmi and Mayali

| | |
|---|---|
| *andanj* | three-pronged, each uniserially multibarbed |
| *belbban* | oval wooden blade, 'shovel-nosed' |
| *bokko* | 'hooked', uniserially barbed with small hooks |
| *dalhgurr* | simple, with sharp hardwood point of varying length |
| *lama* | steel 'shovel-nosed', short ovate blade |
| *namarngor/ gunbarrebarnmo* | 'hooked', biserially barbed |
| *madjawarr* | 'goose' spear |
| *madjubali* | 'hooked', barbs point alternately backwards and forwards |
| *marrgidjba* | 'hooked', uniserially barbed with long, slender angular barbs |
| *murrnginj* | steel 'shovel-nosed', long lanceolate blade |
| *yorndidj* | stone-tipped with simple elongate, pointed flake-blade |

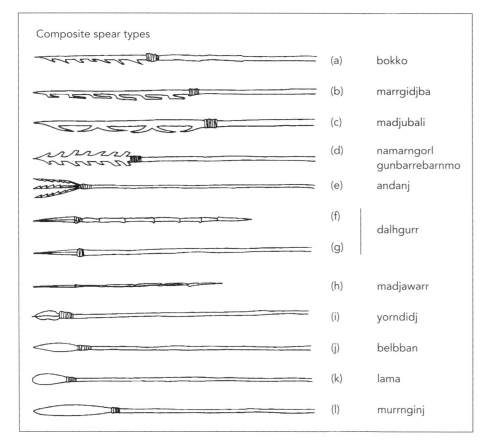

Composite spear types

| | | |
|---|---|---|
| (a) | bokko |
| (b) | marrgidjba |
| (c) | madjubali |
| (d) | namarngorl gunbarrebarnmo |
| (e) | andanj |
| (f) | dalhgurr |
| (g) | |
| (h) | madjawarr |
| (i) | yorndidj |
| (j) | belbban |
| (k) | lama |
| (l) | murrnginj |

groups and are depicted in rock art:

Bokko, one of the two spearhead types with uniserially and unidirectionally barbed heads, was the best known and the most widely used of all the spears (*Figure a*). The 'stone country' people such as the Badmardi claim it as their own. They say that it was first made by Namangeminj, one of the ancestral beings, and thrown into the country to indicate what languages and customs the people should follow. The similar Marrgidjba has longer, angular barbs (*Figure b*). Although it was made by the Mayali people, it is said to have originated in the Gune language group's territory in central Arnhem Land.

Madjubali, the uniserially, bidirectionally barbed spear (*Figure c*) has long, slender, curved barbs that point alternately backwards and forwards, making it difficult to pull the spear out of the target body without further damage. This feature suggests that perhaps it was primarily a fighting spear.

Namarngorl gunbarrebarnmo, which is

translated as 'barramundi's backbone', is a spear with biserially arranged backward-pointing barbs (*Figure d*).

Andanj is the 'stone country' multi-pronged spear, and is not to be confused with djeligrad, the pronged fish spear made by groups living in the riverine environments. It usually has three prongs (*Figure e*), though in rock painting representations the number of prongs may vary from two to six. In several compositions, spare prongs are seen in men's dilly bags. The prongs are slender and uniserially barbed. Kapirigi's father used andanj to spear rock wallaroos, as did many hunter figures seen in rock art compositions. Andanj spears are said to be also used by the Mimi people.

Dalhgurr spears feature a hardwood point and are of two types, having either a short or a long shaft (*Figures f, g*).

Madjawarr, dubbed the 'goose' spear, is named after the plant *Phragmites karka* which forms its shaft. It is a short, light spear, with a long, thin, sharpened hardwood head, and is

used specifically in hunting magpie geese and other birds (*Figure h*). Its flight is said to be silent, and more than one bird may be killed with a single spear, without disturbing the rest of the flock. Aboriginal hunters observed by Ludwig Leichhardt speared geese in flight using this weapon. In the recent past, this spear was thrown with a long, thin, rod-like spearthrower that had a spur made of resin to engage the spearshaft. The presence of madjawarr in rock painting identifies them as from the freshwater period.

Yorndidj is a stone-headed spear (*Figure i*). Several types of stone spearheads have been identified. The most common stone blade within the region is lauk, made of the light-coloured orthoquartzite. There are a number of locations right around and across the plateau where stone for lauk was quarried and worked on. As the stone heads usually broke after a single use, they were replaced in the field, and spare lauk, beeswax and gum were included in the contents of murrga or malakka, the dilly bags carried by hunters.

The final group of spears consists of those designated as 'shovel-nosed'. They are the belbban, which has a long, flattened wooden blade (*Figure j*), and lama and murrnginj, the steel shovel-nosed spears. Lama has a short blade, while the murrnginj blade may be up to 40 centimetres long (*Figures k, l*). The murrnginj spear is said to have originated in north-eastern Arnhem Land, hence its name. Its primary use was in hunting buffaloes. Rust marks in sandstone surfaces identify sites where the steel shovel-nosed spear blades were sharpened in the past. Wooden belbban

Right A group of three male figures shown holding and using simple one-piece spears and uniserially barbed composite spears. The spearthrowers in this composition are 'hooked' or beaked sticks carved out of solid wood. The main figure holds two of these implements. A knobbed beaked implement is raised above his head, while the other is clasped in his hand along with two simple and two composite spears, and what may be a knotted string pubic fringe. The second spearthrower is a double-headed example which may have been used to both launch spears and serve as a fighting pick. Location: Daberrk. Tall male 30 cm.

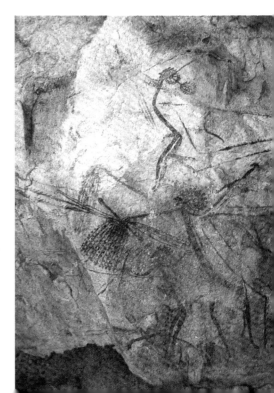

are frequently depicted in rock art.

Baldwin Spencer, while at Oenpelli in 1912, collected two spears not mentioned by Kapirigi. They were both four-pronged, hafted, bone-tipped spears, one with a long and the other with a short shaft. The long-shafted version was called kumbarta and the short-shafted one kujorju by the Gagudju people. These and all the other recorded spear types and varieties of spears, most of which are no longer made or used, can be identified in the rock art of this region.

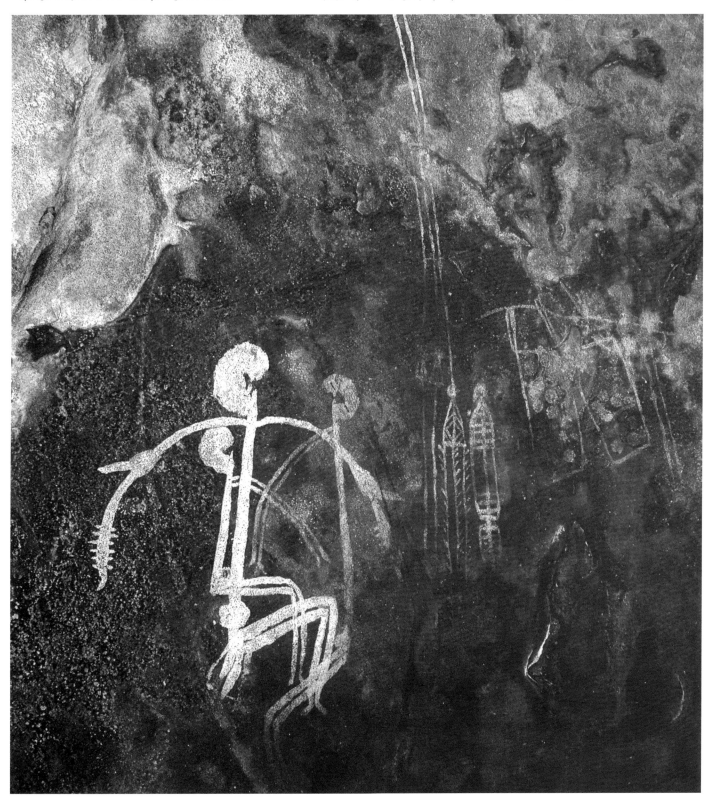

*Above* A camp scene of 'hooked-faced' figures. Shown are a man, his weapons and his two wives. Their dilly bags filled with bush tucker are seen hanging from a tree branch. Two of the spears have a long, hard wooden point, while the third is a three-pronged spear with its barbs aligned outwards. The spearthrower is shorter than those shown with other 'hooked-faced' figures and represents a type used around the plateau in the ethnographic present. Location: lnagurdurwil. Male 25 cm.

## Spearthrowers

Although not universally used across the continent, the spearthrower is one of the most characteristic of Australian Aboriginal implements. It varies in shape and size in different parts of the country but the basic feature is a blade, one end of which has a small spur or peg that engages into a hole at the proximal or butt end of the spearshaft.

This implement effectively extends the length of the hunter's arm, providing added leverage and increased force when launching the weapon. As the entire force is concentrated along the shaft, the spear travels further and with greater accuracy.

The oldest Arnhem Land rock paintings that depict weapons show men using boomerangs and one-piece multibarbed spears thrown by hand. Later, in the simple figures with boomerangs style, spearthrowers are seen hooked into the ends of spears. It was during this time that the composite spear of a hard wooden head hafted on to a light wood or bamboo shaft was developed. The spearthrower is most efficient when used with these lightweight spears. For the remainder of the rock art sequence, spearthrowers appear in a great variety of forms.

The most common spearthrower used around the plateau in recent times is the tapering lathe-like borndok which is usually made of a strong light wood, although hard timbers such as those of acacias may be used.

The body or blade is usually 4 centimetres wide, narrowing to 1.5 centimetres at the distal end where the hard wooden spur is inserted and secured with the use of kangaroo sinew and resin or beeswax. The blade is usually about 90 centimetres long and tapers slightly from just over a centimetre to half a centimetre at the distal end. Both faces of the blade are slightly convex. The 'grip' is formed by cutting into the sides of the blade some 12 centimetres or so from the proximal end. Dimensions vary, however, depending on the type of wood used in construction and the skill and individual preferences of the maker.

A shorter and overall wider and thicker spearthrower also known as borndok was used throughout the region. So, too, was a round, thick, rod-like design with a fringe of twisted

fibre or hairstring attached at the handle. This latter spear continued to be used until recently. As with the common borndok, these two implements are depicted in the rock art of the region.

When hunting with madjawarr – the short, hard wooden-tipped, reed-shafted 'goose' spears – a special type of a spearthrower was used. This spearthrower was made of a thin stick, or rounded rod of hard wood, 1 to 1.5 centimetres in diameter. A coating of gabbai resin, extracted from the roots of the ironwood tree, was moulded into a raised rim some 12 centimetres from the end of the handle, making an efficient grip. As well, a pointed knob of the same resin was obliquely fixed to the other end of the implement and served as a spur. Sometimes the shorter version of the borndok type of spearthrower was also used when hunting with madjawarr spears.

If a spearthrower was accidentally broken or left behind, a temporary replacement would be made from a branching stick – known as a 'hooked stick'. The branch forms the body of

the garlbbu, as this implement is known to the Mayali, while the adjacent portion of the stem is fashioned into the spur.

It is highly possible that such a design was the origin of spearthrowers. The earliest spearthrowers evident in the rock paintings are indeed 'hooked' shafts – narrow, straight and stick-like. As the implement developed, it was given a knobbed handle and occasionally a second spur. Other examples have a small head with a peg and the blade is broadened at the centre. Later, there was a transition from a tapering type with a tasselled handle to an overall broader and more leaf-like spearthrower with a distinctly knobbed handle. In the more recent period the thin, long tapering borndok and its associated designs were introduced, as was a long-necked spearthrower with a flat, broad, decorated central panel that occasionally had an exaggerated, fanciful shape resembling a violin. However, this latter complex spearthrower was not being made at the time of European contact and is known only from the rock art.

*Above* A male wearing a headdress holds an eight-pronged composite spear in one hand and two simple one-piece spears and a beaked spearthrower in the other. Location: Djawumbu-Madjawarrnja complex. 35 cm.

*Opposite* The multipronged fish spears made in the East Alligator region during historical times had bone bi-points inserted into the tips of the prongs. In this painting a hunter holds such a spear hooked into his spearthrower. He stands posed next to his quarry, a large barramundi. Location: Inyalak. Fish 30 cm.

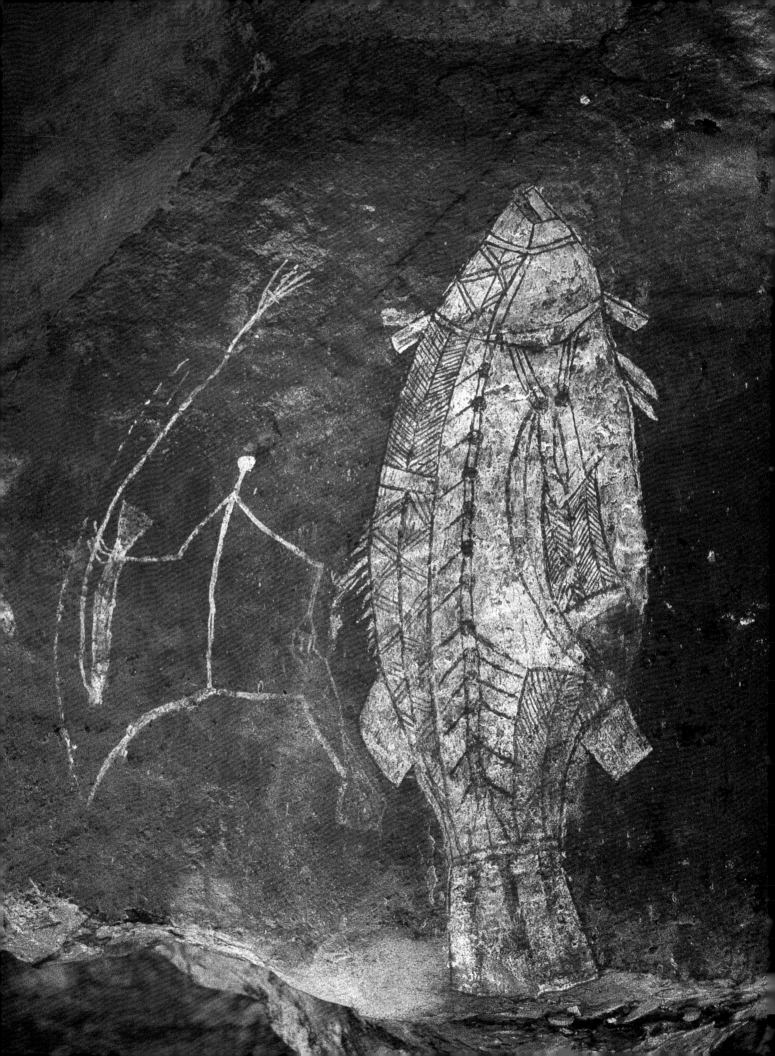

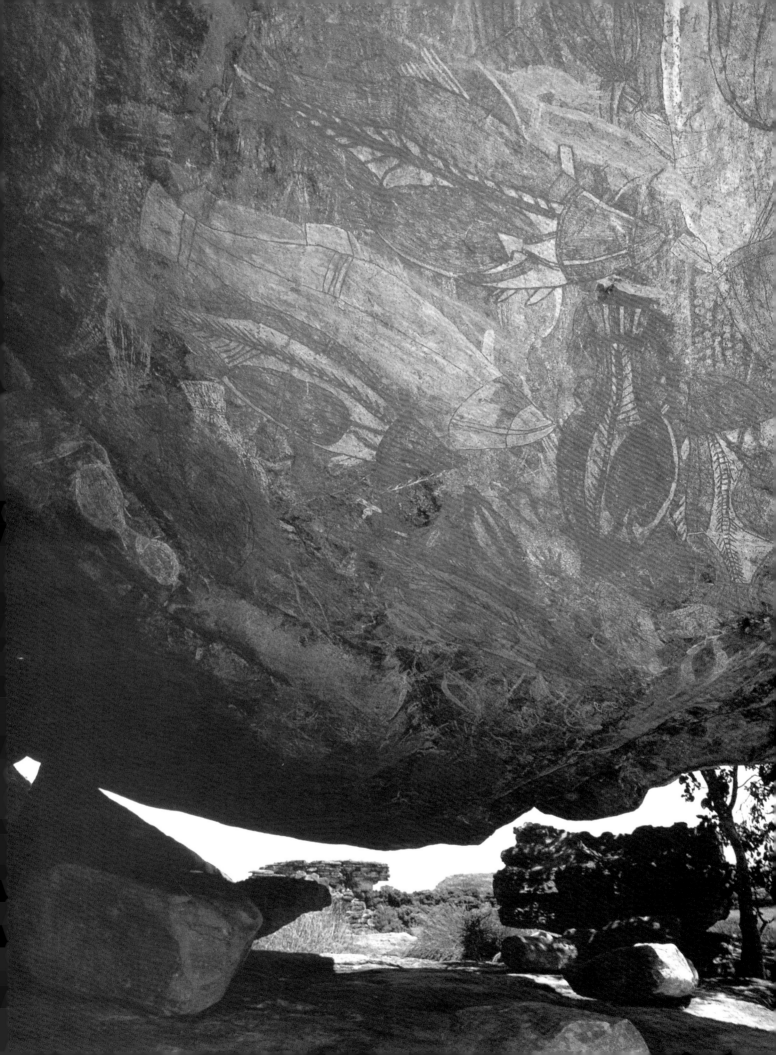

# Estuarine Period

The period of rock art commences with the appearance of paintings representing various animal species that colonised the Arnhem Land region as the sea rose to its present level. The key species that identify the beginning of this period are the giant perch or barramundi *(Lates calcarifer)*, which became the dominant subject in rock art, along with the mullet *(Liza diadema)*, the fork-tailed catfish *(Arius leptaspis)* and the saltwater crocodile *(Crocodylus porosus)*. From the very beginning of this period, these species formed the focus of economic exploitation of the resources of the area.

The earliest images of these species may have been executed some time before the sea levels peaked as all these animals also live in fresh water, their ranges being restricted by the physical aspects of a given stream, the gradient of the river bed and the presence of the dry season waterholes. On the East Alligator River, the only estuarine river reaching into the escarpment, these species are found for some 15 kilometres above the tidal reach. This suggests that the estuarine fish may have first inhabited the environs of this river's outliers – where their presence has been recorded in numerous rock paintings – several hundred years (or perhaps more) before the sea levels peaked. It is possible, however, that the first representations of these species may have been executed after an artist returned from a visit to his kin living in the lower reaches of the river or even on the coast.

Recent research based on a study of the South Alligator River system indicates the environmental conditions that existed along the western and northern margins of the plateau at the commencement and throughout the duration of the estuarine period. Some 8000 years ago, the rising sea invaded the shallow valleys and rapidly filled the rivers and creeks with estuarine muds. Between 6500 and 7000 years ago these areas were colonised by mangrove trees, creating extensive mangrove swamps. On the South Alligator River alone, the mangroves extended over some 80,000 hectares, an area equivalent to about 10 per cent of the total mangrove area of tropical Australia today. This 'big swamp' environment was at its peak for about a thousand years. Large shell middens of the size and frequency usually associated with coastal environments document the extent of this swamp on the plains of Murgenella Creek. Sedimentation continued after the sea level stabilised, progressively eliminating intertidal environments and leading to the development of saline plains with only tidal river channels and very few mangroves. The rains of the wet seasons eventually leached the saline plains, allowing the sedges and grasses to invade the area and trap the fine freshwater sediments of flooding streams.

This environmental change not only introduced a range of new animal species, but also caused shifts in the habitat of flora and fauna already present. The antilopine wallaroo, many of the smaller marsupials and also the emu, which all once occupied the pre-estuarine savannah, were forced to move inland. It is probable that the thylacine also retreated into the interior, or perhaps even became extinct at that time, as it is no longer represented in the rock art. A similar fate may also have befallen several other faunal species identifiable in the rock art, such as the numbat *(Myrmecobius fasciatus)*.

## Early estuarine paintings

At the commencement of this period, paintings of the fish species and contemporaneous representations of human figures and other subjects were depicted in a naturalistic manner and in several stylistic conventions. These early estuarine paintings are often overlooked, probably because most of the images are superimposed by later paintings depicting the same subjects in the large, colourful designs of the X-ray convention. However, some early estuarine representations are found in sites where the subsequent collapse of the ledges from which they were executed precluded any overpainting.

*Opposite* Barramundi are the main subject on this sloping ceiling of a shelter with a view over the wetlands adjoining the Ubirr complex. Twenty-one paintings of barramundi and 15 of mullet along with 10 fork-tailed and eel-tail catfish, four long tom, an archer fish and seven unidentified species represent the estuarine period. Location: Ubirr site complex. Largest fish 130 cm.

Other examples of this style can be recognised in weathered remains of open sites.

In shelters situated along the tidal reach of the East Alligator River, there are remnants of paintings which at first appear to be enigmatic symbols, but on closer inspection are recognisably segments of fish designs. These paintings were originally executed in two or more pigments. The strange shapes which endured the weathering processes are those parts of the designs which were painted in the long-lasting red ochres. Sometimes, the red paint has penetrated through the secondary pigment to again appear on the rock surface. Most of these early estuarine paintings are of mullet, which moved up the northern rivers with the rising sea levels. The mullet were easily caught in fish traps or speared as they swam over or between rocks which form a river crossing in this area.

Paintings of hunter figures with weapons and tool kits document the changing suite of implements used during this period of dramatic environmental changes. Boomerangs were no longer used, being superseded by a number of new spear types and spearthrowers.

It is in this period that the flying fox (*Pteropus alecto*) was portrayed for the first time in its fully animal form, being shown in its typical head-down position. Previously, flying foxes were present in the rock art only in their Dreaming guise

*Above* This group of early estuarine paintings situated high above ground level was executed from a ledge which has since collapsed. Represented are a number of fork-tailed catfish (*Arius leptaspis*) depicted in two or more stylistic conventions, an outline of a barramundi (*Lates calcarifer*) and a large turtle-like zoomorph possibly depicting the pitted-shelled turtle (*Carettochelys insculpta*). Location: Ubirr site complex. Catfish at right 110 cm.

*Opposite above* An early representation of a fork-tailed catfish, adjacent to a running Mountford figure superimposing a group of four birds with partially hollow bodies. Location: Amarrkanangka complex. Catfish 90 cm.

*Opposite below* Representations of two mullet on the ceiling of a deep overhang show how such fish segments originated. In executing the fish, the artist painted the white silhouettes of the mullet and then applied red pigment over the upper part of the body and put in the tail. This method realistically depicted the species' dark back and silver belly. If the white pigment had, as in other instances, weathered away and the red pigment had not succeeded in permeating the white to stain the rock surface, only the shape of the tails where the red was painted directly on to the rock would remain, giving an ambiguous impression of the original image. Ubirr site complex, 27 cm.

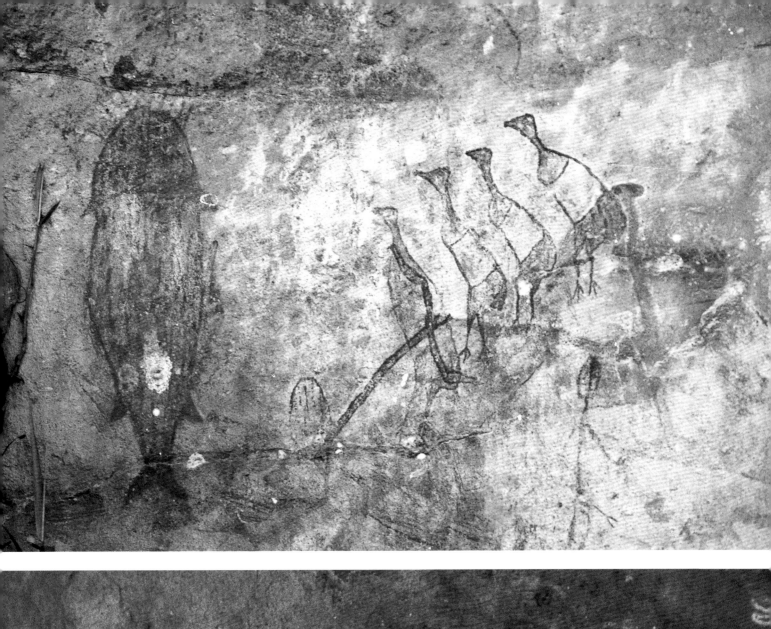

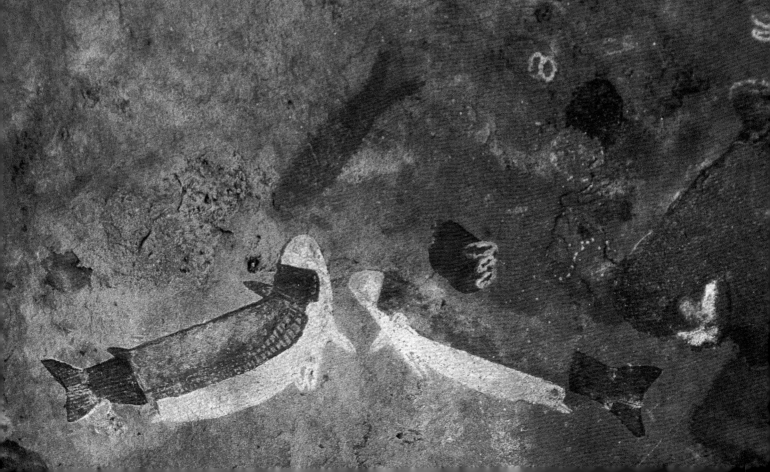

as mythological beings. The Lightning Man, Namarrgon, is also now depicted for the first time, confirming the evolution of the wet season, a period of violent electrical storms with heavy rainfall and cyclonic activity. This being is usually represented in rock art – and today in bark paintings – in its male form, brandishing the stone axes with which he splits the clouds (and with other stone axes attached to different parts of his body), while a band that encircles his body symbolises the lightning. In some instances the lightning's spirit essence is portrayed as a female or a composite being.

The naturalistic phase of this period developed into the intellectual realism of the X-ray art complex. Although the concept of depicting internal features when portraying animals and humans in rock art was already used in paintings of the pre-estuarine period, it became the dominant (though not the only) form of expression during the later part of the estuarine period. The detailed, colourful images typifying this form of stylistic expression continued to be used throughout the following periods and into the ethnographic present.

A uniquely Australian form of rock art, beeswax figures, commenced in the middle of this period. Due to the organic nature of this material, designs made from pieces of beeswax were formerly considered by many scholars to be at most only a few hundred years old, however recent evidence has revealed their great age.

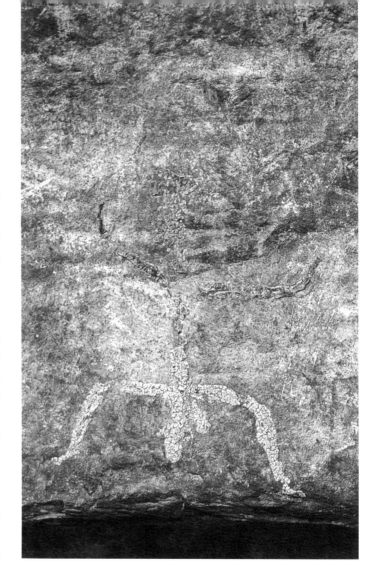

## *Gunbirdi bim*

### BEESWAX DESIGNS

Beeswax designs, made from the wax of wild bees, are an integral part of the rock art tradition of the Arnhem Land Plateau. They are made by pressing shaped pieces of wax onto the rock surface. The designs vary in complexity, from simple rows of waxen pellets to elaborate non-figurative designs composed of several hundred individual pieces. Human figures and spirit beings are common motifs, occasionally found arranged in detailed compositions. Beeswax pieces were also used in decorating or enhancing painted designs.

Beeswax is the by-product of successful searches for 'sugarbag' – the honey-filled hives of stingless bees of the genus *Trigona* – which is the sweetest and one of the most sought-after items of the Aboriginal diet. Bee-bread – the larvae, pollen and eggs found within the wild beehives – is also relished.

The people living in this region identify six species of wild bees, differentiated by their nesting preferences and the choice of plants from which they gather nectar and pollen. Five of the wild bee species build their nests in hollow trunks and branches of trees, while one is ground-nesting, utilising abandoned ant and termite nests for its hives. Access to the nests of the various species is either through an external entrance tube or through a natural opening with an internal entrance tube. Nests with external entrance tubes are glossed as having a 'long nose', while those with natural openings are

*Above* A weathered male figure wearing a headdress is shown with open arms, widely spread legs and a prominent circumcised penis. The body of this figure was moulded from rolls of beeswax. It is of considerable antiquity, as the surface is deeply crazed and oxidised. Location: Gunbilngmurrung. 26 cm.

*Opposite* Remnants of a 4000-year-old representation of a short-necked turtle executed in beeswax over several layers of paintings – the earliest example of this art form yet located. Location: Gunbilngmurrung. 27 cm.

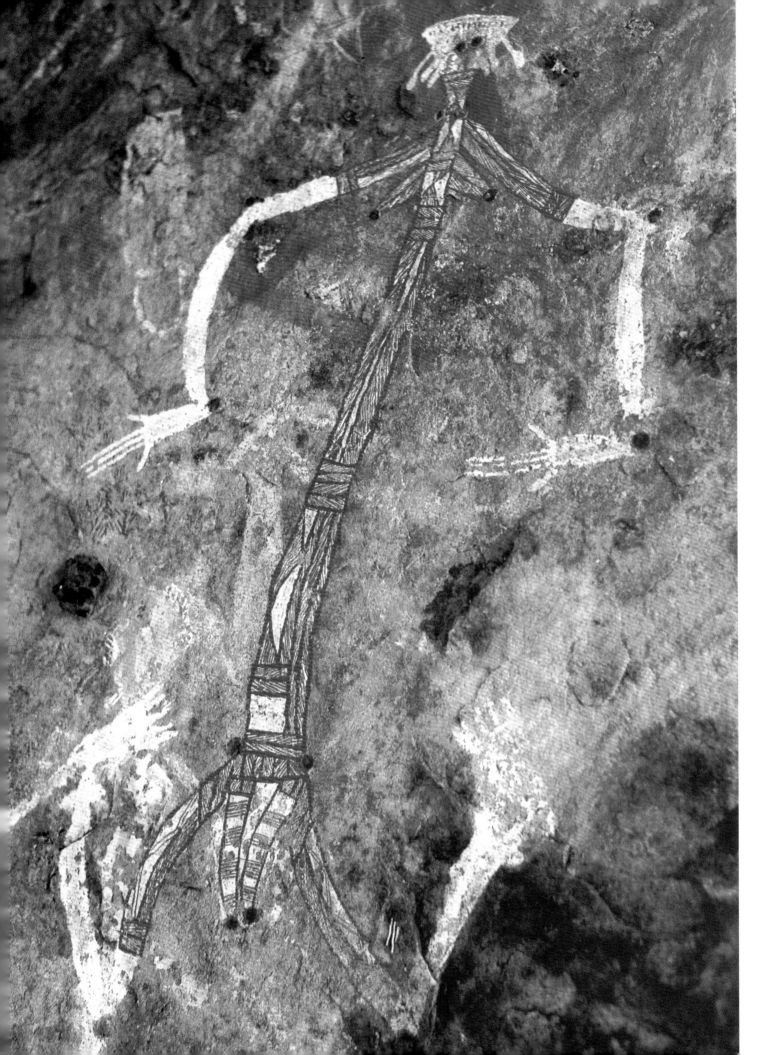

*Left* The simplest form of beeswax designs are roughly parallel lines of small rounded pellets of wax. Location: Anbangbang. 25 cm.

*Right* A moulded ball of beeswax, perhaps left intentionally in a shelter for future use. Its crazed, desiccated surface suggests that it was cached some considerable time ago.

*Opposite* Small pellets of beeswax were used to further enhance this decorative female figure. They have been placed at the joints, hips and vulva, and also form the eyes and nipples. Location: Yirrwalatj. 45 cm.

called 'short-nosed.'

The six species listed in their order of importance as producers of honey are: marrgardba, nabiwo, long- and short-nosed anyalk (the two species being distinguished by the presence or absence of an external entrance tube), gardderre and lorlbban. They occupy different niches in the environment. Marrgardba make their nests in paperbark trees along waterholes and streams, while gardderre, lorlbban and the anyalk types are found throughout the savannah woodland and woodland areas. The ground-nesting nabiwo is found in the woodland and in the escarpment. It is the marrgardba and nabiwo nests, which produce copious amounts of the best-tasting honey, that produce the good quality wax. These two species are referred to as 'lubra (woman) sugarbag', the term perhaps tacitly recognising the diligence of females in providing for their families.

A ball of beeswax was an important item carried by men in their dilly bags, alongside prepared bush gums, string, stone blades, fire-sticks and ochres. It was used in many technological processes, such as hafting of spears and stone axes, and was the raw material for forming mouth pieces for the didjeridu and for repairing any holes or cracks in this instrument. It was also used to wax and thus preserve string and in making decorative hairpins, necklaces, pendants and headbands, as well as in fashioning toys, such as spinning tops, and model animal and human figures.

Many of the sculpted figures incorporated other materials, notably stones, feathers, flowers, seeds, sticks and stems of grasses. Small white quartzite stones were used to form the eyes of human and spirit figures, and also to represent the eggs of some animal species. Some figures were decorated with relevant totemic or clan designs, and used as teaching aids when instructing the young in the intricacies of their religious tenets and the deeper levels of meaning within the painted designs. Other figures were used in the increase and other rituals, in love magic and in sorcery.

Beeswax from marrgardba hives is soft, and because of this quality it is said to have been preferred over that of nabiwo hives when executing some of the more complex designs. However, it was the wax of the nabiwo species that was considered to have been vested with special powers and thus this variety was used to create most of the images. Oral traditions describe a close association of bees, bee products and the Rainbow Snake – a being with which Nabiwo, the ground-nesting bee, has an especially close relationship as they share a subterranean home. In a number of myths the sound of swarming bees draws the Rainbow Snake to its victims, or conversely alerts people to its presence. The Rainbow Snake is also said to attract its human prey by imitating the sound of wild bees. As the humans search for beehives, lifting and looking under rocks, water floods out and the Rainbow Snake swallows them. The beeswax from this species was perceived as potent and potentially dangerous, having the Rainbow Snake's power and attributes, which was perhaps why it was used in the execution of the majority of beeswax designs. When not fresh, the beeswax was softened over a fire to make it more malleable.

The most common beeswax images are abstract designs formed of parallel rows of small pellets of wax. The pellets were usually moulded with great care. Most are perfectly

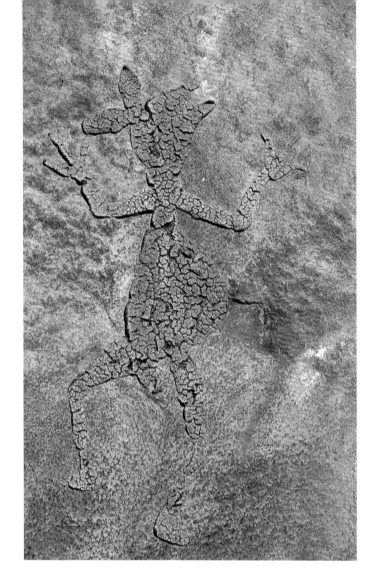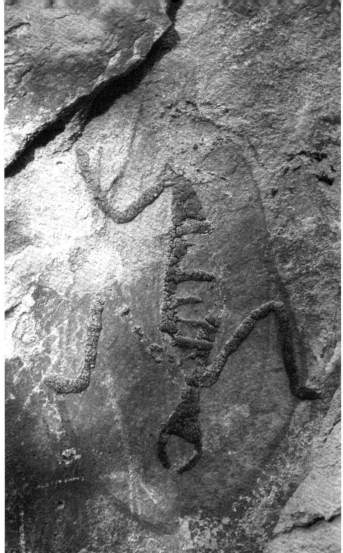

*Left* A beeswax figure depicting a pregnant female with an animal head and three-clawed hands. Location: Djarng. 23 cm.

*Right* This subincised male figure formed from thick pieces of wax has a hollow head and body divided by parallel bars. The design may represent a person from an area of the plateau where both circumcision and subincision were practised. Location: Ginga wardelirrhmeng. 28 cm.

rounded and raised, each element being identical to the others, and generally they are regularly spaced. There are also designs in which the pellets are flattened, or indented with a pointed object or fingernail, and others where they are elongated ovoid shapes. In some designs the pellets diminish in size towards both ends of a line. These beeswax lines also vary in shape and length. The majority are straight, but others are curved, or even of a zigzag pattern. Some appear haphazard or randomly orientated.

Many of these simple linear designs and some human-like figures were primarily made to rid a shelter of infesting ticks that made the site uninhabitable. Two types of these blood-sucking ticks were frequently brought into shelters by animals: the large tick, called middurru, was carried in by wallaroos, while merk, a smaller tick, was introduced by echidnas. Once a shelter was infested with these irritating and fever-producing insects, people were forced to leave

and move elsewhere. Before departing, they pressed lines of rounded pellets on the walls of the rock shelter or formed pieces of beeswax into a figure of Namarnde, a malignant spirit. After the shelter was abandoned, the ticks are said to have moved into the rows of beeswax pellets or to have been killed by the power of the Namarnde. Occasionally, a free-standing beeswax sculpture of a Namarnde was placed on a rock within a shelter. Such a figure was thought to be more efficient than the other art forms in ridding the shelter of ticks. But whichever method was used, when the people returned the following year the s helter would be tick-free once again.

As well as the figures, beeswax art includes a wide range of non-figurative designs. Several are shaped, flaring double lines said to represent small decorative chest cicatrices. Some are spherical or formed as a cluster of circles. Others are long, meandering and arching forms, or rectangular designs

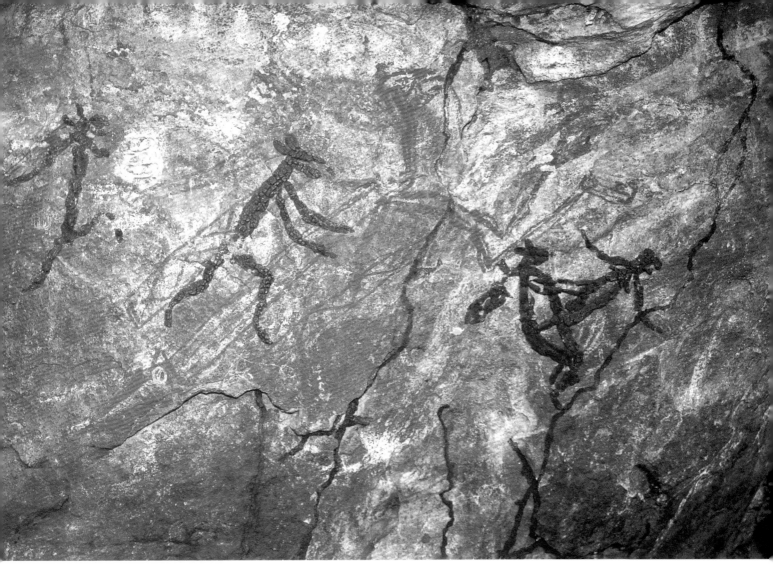

This composition is one of several narrative scenes expressed in the beeswax medium. A human female is shown in the act of sexual intercourse with an animal-headed being, while two other such beings are running towards them. Location: Ginga wardelirrhmeng. Figure at left 19 cm.

constructed of hundreds of pellets. Some of these designs are said to represent the hives of the two major bee species. However, many of the non-figurative constructs remain unidentified.

The majority of anthropomorphic figures in beeswax are male. Represented are humans, animal-headed beings, the Namarnde figures and images of other mythical beings in a variety of activities. Only six figures have so far been identified as women. Animals are also a minor subject in this art form, being represented by two short-necked turtles, a macropod's head and a buffalo. One of the most complex designs is a 3.5-metre-long Rainbow Snake.

Beeswax figures continued to be made throughout the subsequent periods. Even the European contact period is represented in a coastal site by a beeswax figure of a man wearing a hat, identified as representing a European trepanger named McPherson, and by letters of the alphabet presumably copied from a label on a tin or from the lettering of a boat's name.

Although most humans and anthropomorphs in the beeswax art are displayed as single figures, there are several detailed narrative compositions. In the western escarpment an artist has depicted himself in his role as a buffalo shooter, following this animal with a gun in one hand and a skinning knife in the other. Another composition shows a female copulating with an animal-headed being while two other such beings run towards them. A scene of conflict in which two male figures confront each other with raised spears and another representation of a copulating couple, along with several associations of figures and non-figurative motifs where the meaning of the composition is not quite clear, have also been recorded.

In a number of painted designs, beeswax was used to enhance motifs or to empower particular organs or other vital parts of human anatomy. Beeswax pellets form the eyes of fish, crocodiles, magpie geese and other faunal species in

several paintings. Pieces of wax were also used for the eyes of eight male figures depicted standing in a canoe. In another picture a painted female figure has small pellets of this material as eyes and nipples, and pellets were also placed at the hips, joints and vulva.

Beeswax, because of its organic nature, was once thought to last for only several hundred years and consequently this art form was generally believed to have begun in fairly recent times. The relative ages of the figures was believed to be indicated by their surface texture and the degree of oxidisation: changes observed in one design over a 25-year period showed that when first seen the figure looked as if it had been only recently executed, as its surface was smooth and glossy, but over time it became dull, and, as the wax dried out, cracks appeared on the surface and the material began to oxidise. However, the rate of weathering depends on the quality of the wax used and the degree to which the designs are exposed to the elements, in particular to the photochemical effects of ultraviolet light.

Since then, two discoveries have indicated the greater age of this art form. In the first site, complex non-figurative beeswax designs extending 14 metres along a red-stained wall were found to be not only differentially weathered, but in some arrangements the waxen pellets had either disintegrated or were dislodged from the rock surface leaving blanched spaces marking their original position. These lighter spaces may have been due to the effect of the beeswax's chemical components on a previously stained wall or because the red patina was formed over this surface after the beeswax designs were created. Such patina takes a very long time to form, suggesting a considerable age for this design. The antiquity of beeswax figures in the second site was indicated by the absence of paintings of the more recent periods. Minute samples of several figures from this site were successfully dated by Earle Nelson of the Simon Fraser University in British Columbia, Canada. The oldest beeswax figure, a representation of a short-necked turtle found on a low ceiling at the back of the shelter, was made some 4000 years ago.

It is possible that honey and beeswax became more readily available as a result of the ecological changes that followed the rise of the sea level. The increase in the varieties of flowering plant species throughout the region during this period created an environment that would have encouraged the proliferation of wild bees. However, evidence that the bees and their products were also of importance prior to this period can be found in a composition representing an

association of bees and humans in the dynamic figures suite of paintings.

Though not numerous, designs similar to the beeswax figures were made from gabbai, a resinous substance extracted from the roots of the ironwood tree *(Erythrophleum chlorostachys)*. This dark gum is produced by heating debarked roots over a low-flame fire, then scraping the exuding substance onto a rock surface or a sheet of bark. The gum was always prepared with great care and some distance away from the camps, as it is toxic and reputed to contain other harmful properties. In fact, all parts of this tree are poisonous and contain a substance resembling the alkaloid erythropleine. Mammals, including humans, are very susceptible to its effects. Only birds seem to be immune.

Gabbai was the most popular bonding agent used in hafting, as it sets hard almost the instant it cools down. However, this property meant that in rock art it was very difficult to produce anything other than quite simple designs. The hastiness with which rows of rounded pellets and simple figures were prepared is reflected by their splayed appearance: when applied as a thin layer, the gum tends to dry and lift from the surface. It is probable that human figures modelled in gabbai were created with sorcery intentions in mind.

Outside the Arnhem Land Plateau region, simple beeswax designs are found only in the Victoria River District in the Northern Territory and in the Kimberley region of Western Australia. Beeswax images are not known to occur anywhere else in the world.

The importance of bees and bee products to local populations is reflected by the naming of one of their social divisions as nawalganj, with nabiwo, the ground-nesting bee, as its principal symbol. The subdivisions of this phratry, identifying subjects to their places of origin, have birdirayek, the hard beeswax, and birdigelh, the soft beeswax, as their symbols.

Two main areas are associated with the wild honey Dreamings, where the essence of the bees permeates the land and where increase rituals for the species and their products were held. One is on the upper Liverpool River in the estates of the Mayali-speaking Berdberd and Mok clans, and the other is in the Magarni country of the Madjawarr clan.

The section of the Liverpool River flowing through the two Mayali estates is called Angung, the 'Honey' River. The Dreaming site itself is named Angungmayorrk. It is the totemic centre of garddere and marrgardba bees and also of the three major trees whose blossoms they pollinate and gather

nectar from: the woollybutt *(Eucalyptus miniata)*, the scarlet gum *(E. phoenicea)* and the stringybark *(E. tetrodonta)*.

In the Madjawarr's Magarni country, extending south from Nimbuwah Rock across the lowlands to the outliers and the escarpment of the plateau, are several sites associated with a Wild Honey Man, as well as an increase centre for marrgardba and nabiwo bees. At the latter site, images of the bees and their hives were formed in beeswax, depicting both tree- and ground-dwelling species.

## X-ray art complex

The intricate X-ray convention which began in the estuarine period and has persisted into the ethnographic present is typified by finely hatched, detailed life-size representations of human and animal species which developed from earlier and less elaborate X-ray forms. The exact date of commencement of these evolved X-ray images is not known, but their early genesis within this period is suggested by the numerous superimpositions found in many of the rock shelters.

The X-ray art is defined as intellectual realism – as the artist was not only depicting the subject's external form but also what he knew of its internal structures – and there are clear descriptive and decorative phases. It became the dominant stylistic form of expression throughout this and the following periods. However, a number of other forms, considerably divergent and distinct, were used concurrently, in some instances by the same artist. In a composition of a fish and its hunter, for example, the fish may be depicted in a detailed X-ray form with a number of internal organs and muscle masses, in two or more colours, and be shown dwarfing the hunter, who may be represented as a simple, stick-like figure holding the spear which he used to procure it. To the artist of this period, the outcome of the hunt was of more importance than himself. Stylistic definitions for these divergent art forms, apart from the broadly based X-ray, have not been formulated as yet. It is possible that where several styles appear contemporaneously they may have been used for different purposes and functions. Throughout this complex, human figures, in particular, were expressed in a number of stylistic forins.

Most of the X-ray paintings are found in shelters along the base of the plateau's escarpments, in the valleys leading into the plateau and on outliers along the East Alligator River. They are less common in shelters situated on top of the plateau and in its interior, being restricted there to sites

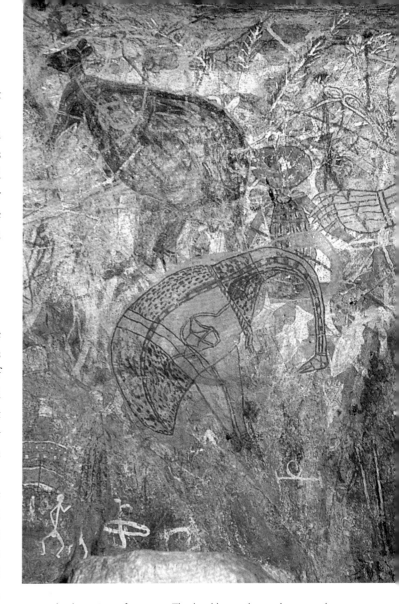

A simple depiction of an emu. The backbone, heart, lungs and intestines are indicated, as are the vestigal wings extending from the breast. The body is painted within a yellow silhouette, where the yellow base extending over the body outline represents the bird's soft feathers, while the muscle masses are suggested by the subdivisions infilled with dashes. During the execution of this pointing, the artist changed the position of the emu's neck. The emu overlies a unique pointing of a black wallaroo *(Macropus bernardus)*. This macropod is frequently depicted in the plateau's rock art, but it is seldom executed in black pigment. Here, its black base silhouette is outlined and the internal features are depicted in yellow ochre. Location: Wellington Range. Emu 120 cm.

along traditional walking routes or in resource-rich areas. The number of representations of animal species in a given shelter reflects their presence, in order of magnitude, in the immediate environment. Fish predominate in the riverine systems of the western and northern parts of the plateau, while further inland various land animals come to the forms.

Most paintings in the X-ray mode have been executed as individual representations of a subject. Compositions depicting groups of human beings or schools of fish, some of considerable complexity and of a large scale, are found in

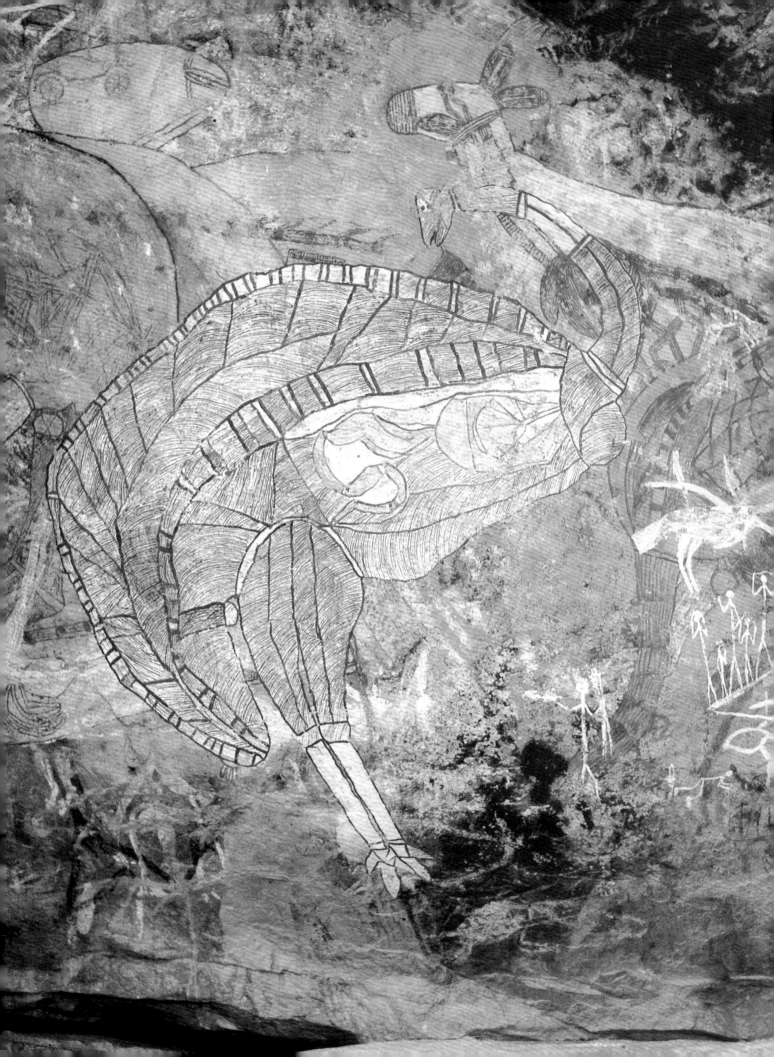

the shelters associated with the Gundjeihmi-speaking groups. Many animal subjects are depicted larger than life, while the human beings vary in size and can be from half-height to life-size. The paintings appear as mainly static, enigmatic and seemingly timeless images. Very few figures of this style are shown in action, that aspect of the art perhaps having been lost with the increase in painting size and the use of different techniques in their execution. Among the limited animated images are several hunter figures in spirited action with spears held high above their heads. A number of female figures are depicted with a raised leg, but the movement is arrested in a specific pose.

In the descriptive X-ray stylistic convention, the artist depicts the maximum number of internal structures of a given subject within its external form. The animals are portrayed in their most recognisable aspect, generally in profile, with their internal organs and bone structure clearly defined. The basic internal features, many of which were present in the early X-ray representations, include the backbone, ribs, spine, heart, lungs, liver, kidney, diaphragm and digestive tract, and in the fish the swim bladder. However, a number of interesting new additions and emphases were introduced in this more recent form of X-ray art. Types of tissue, muscle masses and layers of fat are emphasised by divisional line markers, solid pigment infill, stippling or hatching. Optic nerves, breast milk in women and testes in males are evident, and joint marks (single or double lines) at the neck, waist, knees, ankles, hands and arms have been used on human and animal figures to represent points of articulation. The human body in this stylistic mode is usually portrayed with a schematised skeletal form of backbone, ribs and long bones. Inanimate objects such as rifles, introduced during the contact period, may show a bullet within its breach, while a Makassan *kris* is depicted in its sheath. Although at a superficial level all the X-ray paintings of a given subject may look similar, there is a definite regional variation between the paintings of adjacent language and clan groups, and often the work of an individual artist may also be recognised.

In this stylistic form, the subject was generally painted first as a solid white figure, then outlines and internal subdivisions were added in other pigments. Consequently, in sites where

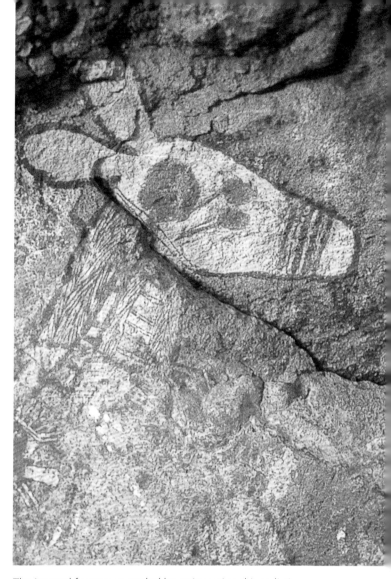

The internal features recorded by artists using this stylistic convention include the brain, shown here in the head of a now badly weathered painting of a macropod. Location: Nomorrgon site complex. Head 25 cm.

the X-ray paintings predominate, examples of earlier styles tend to be concealed. During this period some subjects were also executed on a red or yellow base. The outline and internal detail of motifs on a red base were usually painted in white, while red was used over the yellow pigment. Although in many examples the added detail has completely weathered away, leaving only a coloured silhouette of the particular subject, partial weathering of other paintings document this process.

In the majority of X-ray depictions over a white silhouette, two types of red pigment – usually a red ochre and the purple-red haematite – were used to outline the subjects and detail their features. Polychrome figures, in which the artist used

*Opposite* An elaborate painting of an emu, a much sought-after prey now scarce in this region. Although the heart, lungs and intestines are shown, the artist has devoted much time to dividing the areas of muscle tissue and infilling them with closely set hatching. Location: Wellington Range. 150 cm.

*Following spread* Paintings of macropods and fish species dominate this ceiling of a shelter in the middle reaches of the Liverpool River. The male and female common wallaroos are the most recently executed paintings. Location: Manaamnam. Male wallaroo 125 cm.

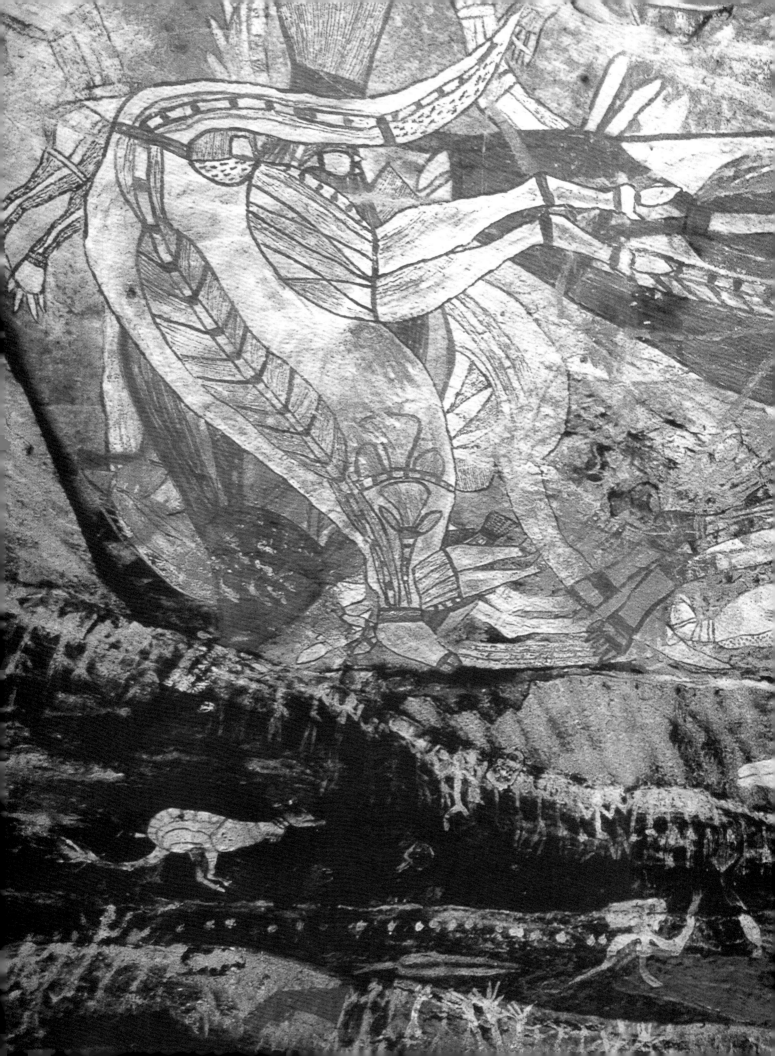

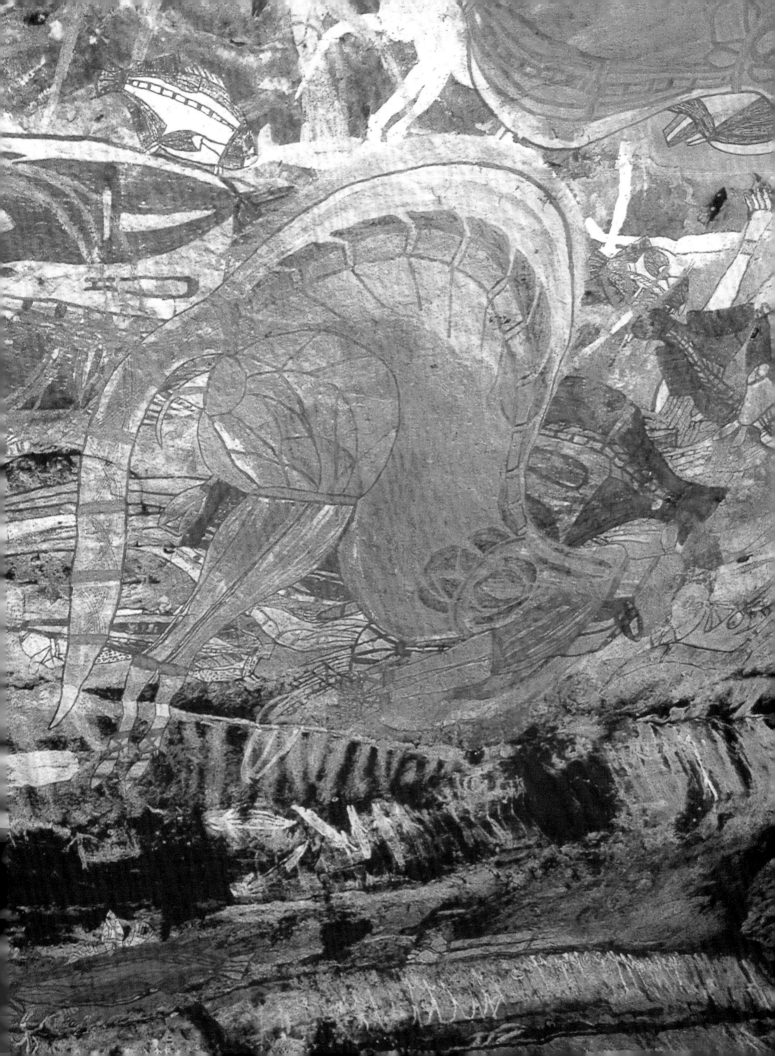

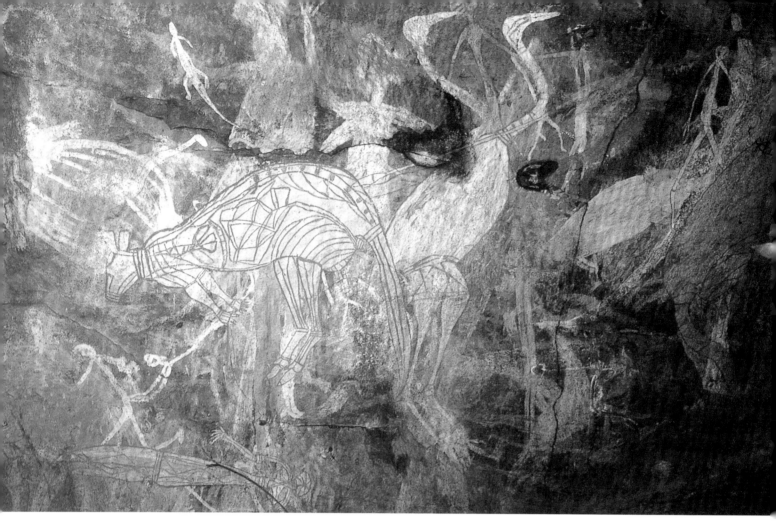

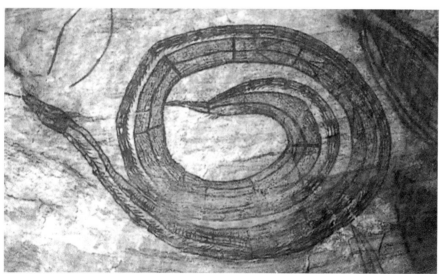

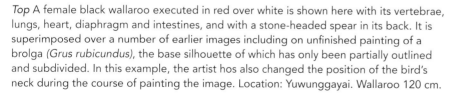

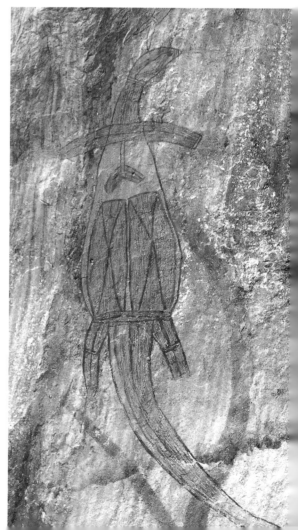

**Top** A female black wallaroo executed in red over white is shown here with its vertebrae, lungs, heart, diaphragm and intestines, and with a stone-headed spear in its back. It is superimposed over a number of earlier images including on unfinished painting of a brolga *(Grus rubicundus)*, the base silhouette of which has only been partially outlined and subdivided. In this example, the artist hos also changed the position of the bird's neck during the course of painting the image. Location: Yuwunggayai. Wallaroo 120 cm.

**Middle** Some snakes, such as this water python *(Liasis fuscus)*, were also a popular item of diet. Here, a python is represented with its head in plain view and its body in profile. The vertebrae and the needle-like bones are clearly shown. Location: Inyalak. 66 cm.

**Right** A vivid painting of a Gould's goanna *(Varanus gouldii)*, depicted with lungs and decorative blocks in its lower half representing the favourite areas of flesh. Location: Inyalak. 85 cm.

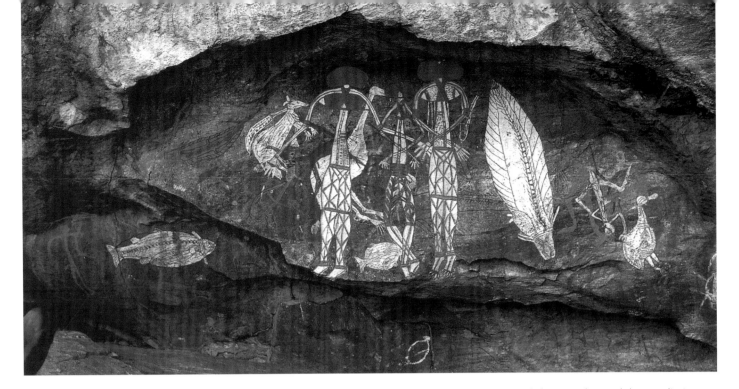

A composition which may represent a man and his wives. The women's head element, originally an oval shape outline with lines radiating from its centre, has been later infilled with solid pigment as if to obliterate or change their identity. The breasts on one figure were also infilled with pigment. Each female is shown with a segmented backbone, and with one half of the body subdivided and its lower segment infilled with marks which may suggest pregnancy. The male seems to be expressing an interest in the female to his right, as his arms are extended towards her. The females' legs and the male's thighs are decoratively subdivided. Location: Namarrgon site complex. Female figures 105 cm.

three or more pigments in the one design, are also common. As the style continued to develop into the more recent period, all the colours found in the region's earth pigments spectrum, as well as the introduced washing blue, were used. Represented in this body of art are monochromatic examples of X-ray, where the artist applied a single colour directly on to the rock surface rather than onto a prepared background. In some instances weathered remains of earlier paintings were used as backgrounds.

From these already quite elaborate paintings depicting the subjects' internal features, the X-ray forms continued to evolve in complexity. The various features, along with areas of flesh and fins, were blocked with solid pigment and further decorated with several types of hatching, stipples, dashes and dots. In some examples at least 10 different types of hatching were used in the one design, creating optical mixes of colour well beyond the four basic pigments used.

In the continuing elaboration of the X-ray convention some artists appear to have lost interest in anatomical details and subdivided their subject for purely decorative purposes, hence the term decorative X-ray. The subject's interior continued, to a greater or lesser degree, to be subdivided into its fundamental parts, but these were then infilled with decorative elements rather than internal organs. The commencement of this decorative phase is not quite clear. Most of its representations are found in paintings of the following freshwater period, when the descriptive form alongside the decorative variant continued to be used.

## Humans in X-ray

Most of the human beings in this stylistic mode appear as single, static frontal figures, although compositions of two or more figures are also found. The largest known composition is a group of people depicted at the Anbangbang shelter of Nourlangie Rock. A sense of movement is expressed in only a few paintings in this mode, the best known being a figure at Djarlandjal Rock executed in the later freshwater period.

In depicting the human body, an artist followed a certain basic formula, introducing new elements or emphases and varying the degree of the painting's complexity according to the meanings and messages that he wished to incorporate. Multiple superimpositions of human figures indicate a considerable time span for this X-ray motif. Its spatial distribution is virtually plateau wide, extending from the upper reaches of the Fergusson River in the west to the Cadell River in the east, however in several discrete areas such figures, females in particular, were more frequently depicted than elsewhere.

Human beings in the X-ray convention are usually depicted with just a few internal features, the most common of which are the backbone and long bones, along with joint

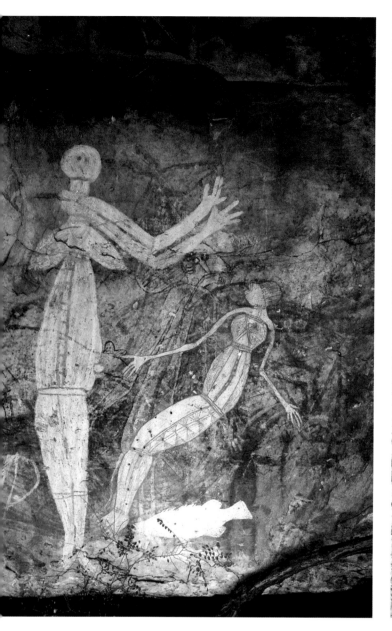

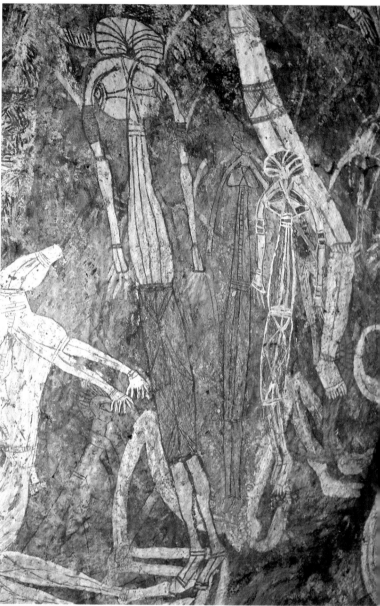

*Left* Three superimpositions of human figures, the two most recent images being female. The taller female was executed as a white silhouette with detail drawn in black. The rounded head lacks hair, but the eyes are depicted. The arms are painted orientated to one side to enable the artist to depict shoulder-blades protruding from the opposite side – a convention used to suggest an emaciated person, though this does not seem to be the case here. Joint marks, a segmented backbone and a breast girdle are also indicated. The adjoining figure gives the impression of floating in space, and is executed with the delicate line work usually associated with the Jawoyn X-ray style. The male figure in the background is depicted with an elaborate hairbun, and with a life line which extends, as a continuation of the backbone, to his mouth. Attached to this are optic nerves. Location: Malakandanjma. Tallest female figure 180 cm.

*Right* The tall figure, at left, has been executed by the same artist who depicted the two women in the previous plate. The distinctive lines with which he drew the shape of the breasts and milk ducts, as well as the stylised hair, are identical, as is the subdivision of the torso, although in this instance it lacks the decorative infill. Location: Namarrgon site complex. 85 cm.

*Opposite* Decorative female figures, found in shelters across the plateau, were a popular subject for a considerable period of time. Location: Madjana. 105 cm.

marks placed at the points of articulation. The backbone may be segmented or simply indicated by two parallel lines drawn longitudinally through the body, while the long bones are shown by pairs of parallel lines through the limbs. In some instances these features may be only inferred from the body subdivisions used in the construction of the figures. Occasionally, ribs or processes (natural outgrowths, projections or appendages of bones) are attached to the spine, and the oesophagus may be shown. In female figures, the breasts may be contoured with lines to suggest their volume

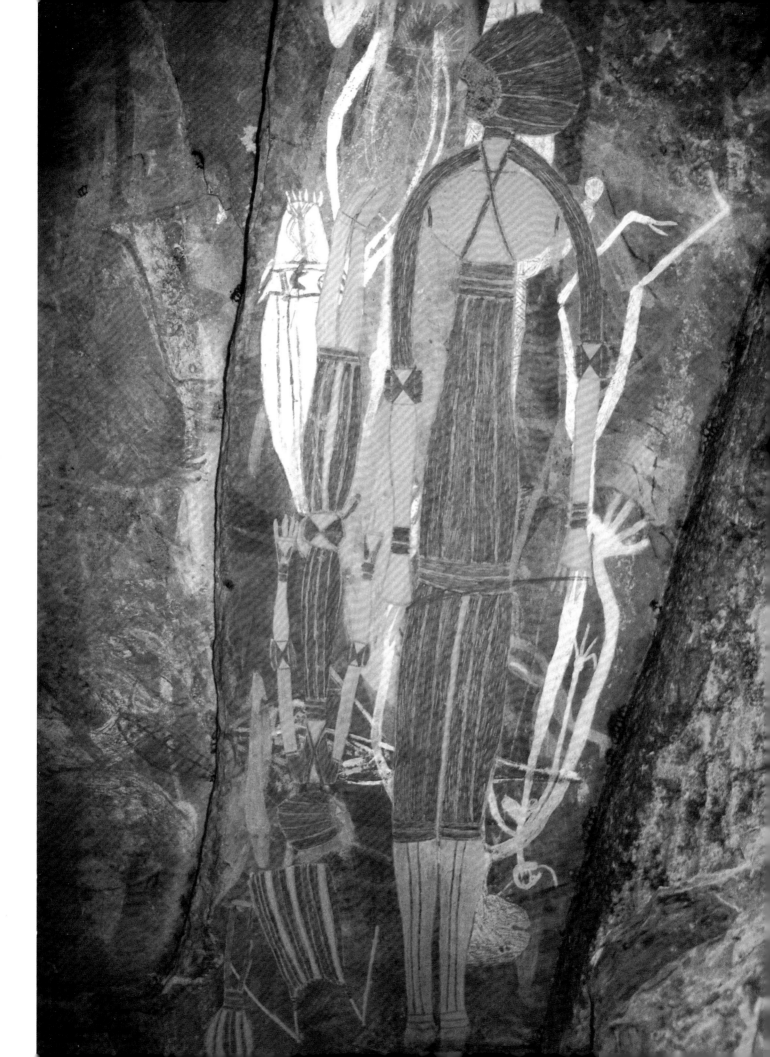

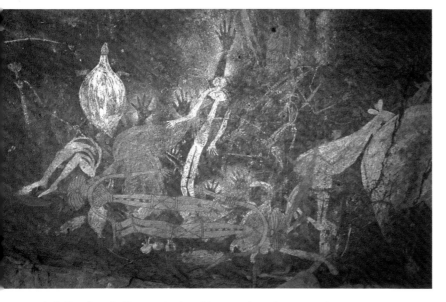

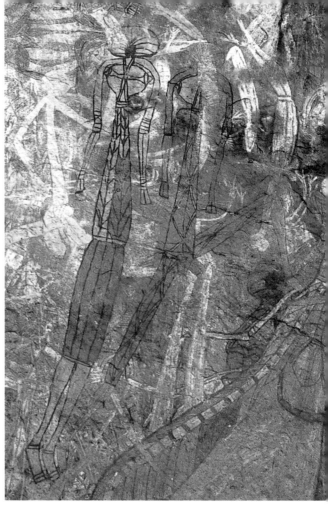

*Left* Two female figures depicted in recumbent but opposing postures were outlined and decorated in fine lines over a tan-coloured silhouette. Both figures are shown with a segmented spine and with breasts infilled with dashes. The crossing lines in the thighs are the only decorative feature. Location: Namarrgon site complex. 75 cm.

*Right* A composition of two female figures, one with a raised leg exposing her vulva. These figures display certain characteristics of form which are peculiar expressions of a specific artist, and by which his other works may be identified. Location: Yuwunggayai. Figure at left 158 cm.

or infilled with dashes suggesting milk and have nipples and milk ducts detailed. In some representations, one side of the body is subdivided and the lower segment is infilled with dashes. These markings are said to represent either a pregnancy or small cicatrices which were made to regulate the menstrual cycle. In female figures shown with their legs together, the vulva is usually indicated by a triangular form. When the legs are apart, the design includes the labium and vulva opening. Male figures may be depicted with testicles in the scrotum.

The portrayal of human facial characteristics is another early achievement of the region's artists which is found in X-ray paintings, especially when the head is depicted in profile.

Many human figures also have a decorative element. The upper legs and torso may be subdivided by longitudinal lines and infilled with hatching, or they may be divided by crossed lines forming diamond shapes and triangular patterns which likewise may be infilled with hatching. However, the decoration does not extend to the lower legs, which occasionally also lack the parallel lines suggesting the long bones. The majority of figures of both sexes are shown wearing breast girdles.

Although certain variations of style and colour preference can be detected between neighbouring groups and even between individual artists, one of the most noticeable regional differences is seen in the X-ray art of the northern Jawoyn clans. From the perspective of their neighbours, these clans and their members are identified as being Jawoyn-Mayali 'mixed', expressing the close social and cultural ties of these two language groups. This cultural alignment is evident in their rock art, as it is stylistically different from that of other Jawoyn groups.

The basic differences between the X-ray paintings of the northern Jawoyn artists and their Gundjeihmi and Mayali neighbours are the thickness of the lines used in their execution and the size of the subject. Where the former use a line as fine as a millimetre to outline a design, a Gundjeihmi artist may have used one ten times wider. Although this delicacy of design is encountered in most of the northern Jawoyn paintings, including those of the animal species, it is most obvious in depictions of the female body. These are the most graceful figures found in the more recent art. With their elongated bodies, knees slightly bent and arms partially extended as if in invitation, they are ethereal figures. They are sensitive and sensuous paintings, the subtlety of the expressed eroticism and intent suggesting that they may be depictions of desired women.

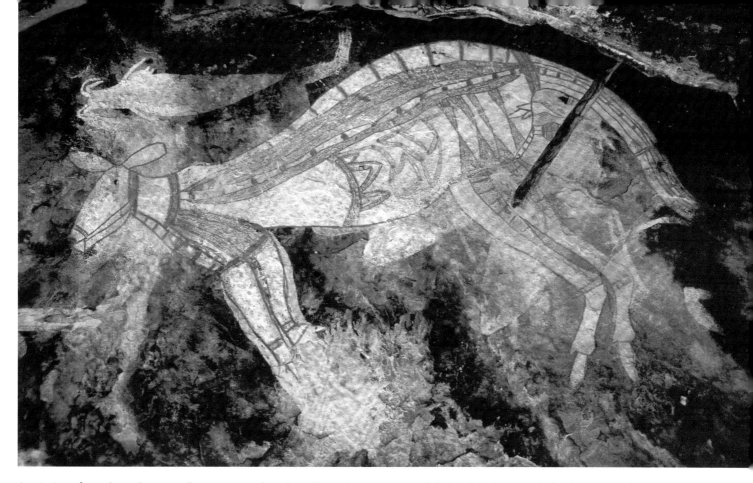

A painting of a male antilopine wallaroo executed on the ceiling of an occupational shelter. It is shown with the diaphragm, the intestines and the vertebrae with adjoining areas of flesh. Human occupation at this site is further indicated by the stick lodged in a cleft of the ceiling. Dilly bags would have been suspended from this simple hanger. Location: Manaamnam, 105 cm.

## How the X-ray form of painting originated

Although it is usually said that images representing ancestral beings and mythological figures are not paintings but rather their 'shadows' where they placed themselves on the walls and ceilings of rock shelters, there is one instance in which this did not happen. Two of the Dreaming characters painted their own portraits long before they entered them at the end of their active lives.

At this time, many of the rock shelters were already decorated with paintings of most of the animal species inhabiting this region. However, only the outside form of each creature was depicted as nobody knew what their insides looked like.

Gandagidj, later the antilopine wallaroo, and Duruk, the dog, when men, came out of the sea at Cape Don on the tip of the Cobourg Peninsula. They went hungry because the grass was too tall to hunt animals and the billabongs and creeks were in flood, making the water too deep for spearing fish. So they went further inland, looking for food and for people. After a few days the two friends reached higher country and shortly afterwards came to Wurragag, where earlier in the creative period Warramurrunggundji's companion had decided to stay – and where he remains to this day as a high tor rising starkly from the surrounding plain. This is now the traditional land of the Iwaidja-speaking Galardju clan.

Gandagidj and Duruk liked that place and stayed there for some time. There were wallabies to be hunted on the plain and wallaroos in the 'stone country' beyond the tor. One day Duruk, while hunting in the hills, found a deep rock shelter with its back wall and ceiling alive with paintings of land animals, fish and even human beings. Next day, he brought his friend to see the shelter. They both admired the brightly coloured images, identifying and talking about the subjects. Nearby, they found another painted shelter in which a number of emus were depicted as if marching across the rock wall.

Later, they continued on their journey. When they reached the Magarni country, not far from Nimbuwah (another high, stark rock feature), they decided that it was a good place to stay. Their home was a deep rock shelter from which they could see both Wurragag and Nimbuwah. In the evenings, they sat around a smouldering fire recollecting their experiences and the things they had seen during their journey. They often talked about the paintings in the two shelters they had come across. As their own shelter had a smooth rear wall, they one day decided to paint each other's image.

First they went to find the right pigments, and then they made brushes. Gandagidj painted his friend as he really looked and then Duruk painted his image of Gandagidj. But Duruk was nagurdangyi, a 'clever man', whose special gift was the vision to see through human and animal bodies. In his painting, he not only depicted his friend's external features but also included the bones that he saw in his arms and legs, as well as his backbone, heart, lungs and intestines. When Duruk finished, both he and Gandagidj stepped back from the wall to admire their work. To their amazement they found that instead of men, they had painted a dog and a wallaroo so they changed themselves into those two animals. At the end of their lives they returned to this, their shelter, and placed themselves into their paintings, making them Dreamings. A white silhouette of a dog represents Duruk, while a detailed X-ray painting depicts Gandagidj, the antilopine wallaroo.

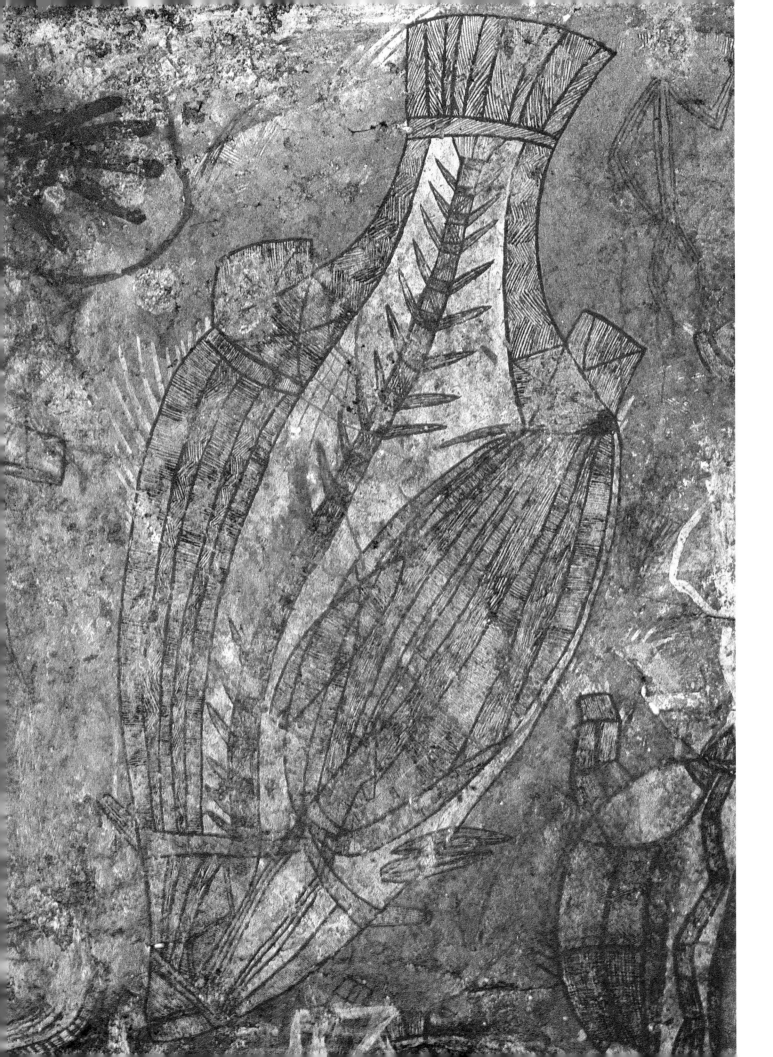

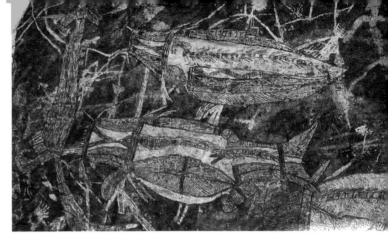

Depiction of two catfish species. The lower specimen is the fork-tailed catfish (*Arius leptaspis*) while the upper is the toothless catfish (*Anodontiglanis dahli*). Location: Mabirrarnja, Fork-tailed catfish 50 cm.

# *Djenj*
FISH

The people of the Arnhem Land plateau region observed fish in a number of aquatic environments and depicted a wide range of species in their rock art. Images of 19 fish taxa from freshwater, estuarine and marine environments have been positively identified. The images of fish are depicted with a remarkable degree of accuracy, as can be seen when comparing them with scientific illustrations of the given species. In most instances they are represented as individual subjects, but compositions of numbers of fish are also found. The majority of fish are depicted in profile, although the twisted perspective convention is used to portray the characteristics of the fork-tailed catfish, the eel-tail catfish and the bull shark (also known as the river whaler shark).

As with the images of mammals, the representation of fish species in the rock art usually reflects their status in the local environment. The most frequently depicted fish are those of economic importance, with smaller and less common species generally being not so numerous.

The greatest number of paintings depicting fish species are found in shelters along the estuarine reaches of the East Alligator River and the adjacent outliers and escarpment. The most frequently represented species are barramundi, fork-tailed catfish and mullet. Barramundi and fork-tailed catfish are also often found in shelters along the middle reaches of the northern rivers and streams, where freshwater species such as archer fish, black bream, long tom, saratoga and eel-tail catfish are more common subjects. In most instances the fish depicted in the paintings of the X-ray convention are easily identifiable.

The most accomplished paintings of this type are found in the Ubirr complex of outliers, extending from the East Alligator River to the Ngardab plain. It is located in the midst of a vast resource-rich area, the magnitude of which is reflected in the art which decorates more than a hundred rock shelters. The largest and most stunning site within this complex is known as the Main Gallery. In what looks like a designed stage setting, a deep overhang above a high ledge protects a long frieze of paintings. Most of the images are of fish from the nearby river and billabongs, but there are also representations of rock wallabies, goannas and long-necked turtles, as well as depictions of white men who came to shatter the artists' Dreaming. Barramundi and fork-tailed catfish are shown in their mature form, executed in the X-ray mode and in painstaking decorative detail.

Namarngorl, the barramundi *(Lates calcarifer)*, is a fish of the perch family, known in the past as the 'giant perch' in acknowledgement of the great size it can reach at maturity. A major food source, barramundi inhabits rivers, estuaries and coastal waters of the tropical and subtropical north. It is a biologically intriguing species, commencing its life cycle as a male, then as it ages changing sex to become a female. In the Alligator Rivers region many barramundi spend most of the year in the freshwater streams where, during the dry season, they become isolated in waterholes and billabongs. On reaching sexual maturity at the age of three to five years, they migrate with the first floods of the wet season to coastal spawning areas. They remain as adult males and continue to spawn for the next few years, changing to the female sex at about seven years of age.

In all the representations of barramundi found in the region's rock art, the artists clearly depicted its pointed head separated from the arched back by a marked concavity above the eyes, along with its large mouth, spiny and soft dorsal fins, and the rounded caudal fin. As the males are generally elongated and the females wide, it seems that the painters usually chose a female fish as their subject as most images are full-bodied. The majority of paintings representing this fish at Ubirr show mature specimens that would have reached

*Opposite* This large barramundi from Ubirr's Main Gallery is representative of the most accomplished X-ray rock paintings found in the region. It faithfully depicts the body of the species – with its pectoral and ventral fins, opercular openings, spiny and soft dorsal fins and the anal fin – and details its internal organs – vertebrae with neural and hemal spines, gut, heart, liver lobes, swim bladder and the sought-after muscle masses. The interior of the fish and all its parts, with the exception of the body cavity, has been filled in with a variety of fine parallel hatchings. Location: Ubirr site complex. 125 cm.

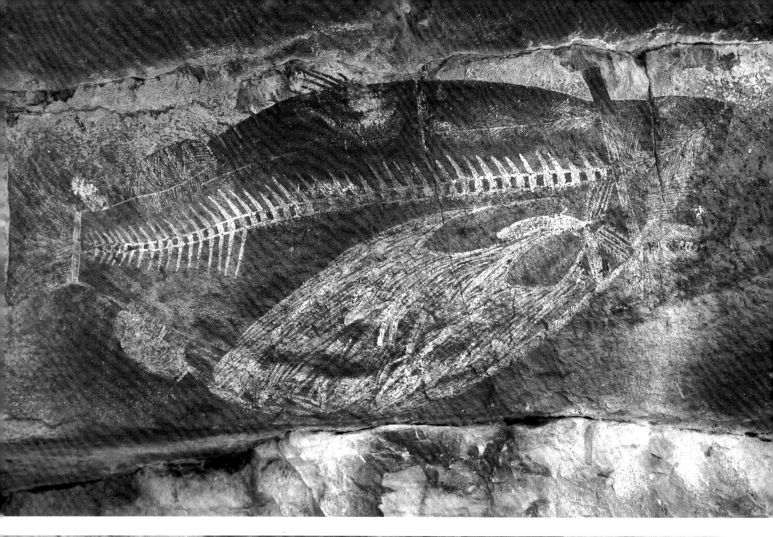
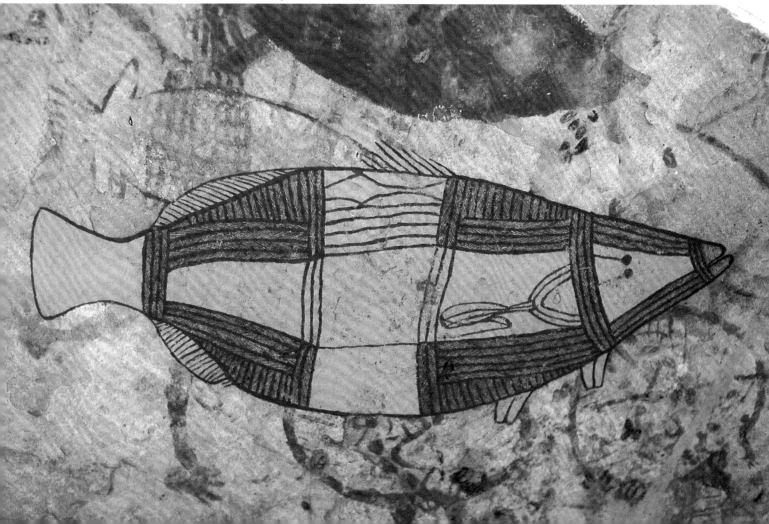

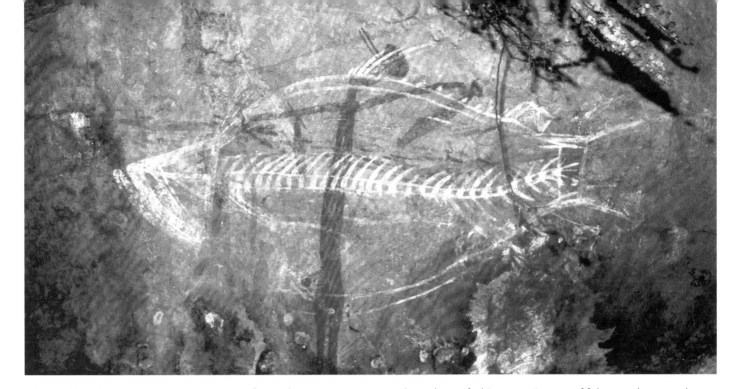

*Above* Although most X-ray representations of animal species were executed on a base of white, some images of fish were done on a base of red or yellow pigment, while others were executed in white alone on the natural rock background. Location: Djawumbu-Madjawarrnja. 115 cm.

*Opposite* Different faces of barramundi as seen in paintings of the X-ray convention around the plateau: (above) Gundjeihmi language group, Dadjbakgu clan; (below) Amurdak language group.

perhaps 40 kilograms in weight – a size reputedly captured by the most skilful hunters.

Although many of the paintings share a common set of attributes from which the fish is constructed, the individual representations reveal a cultural sequence with subtle differences that distinguish the works of adjoining language and clan groups and even those of particular artists.

Almakkawarri, the fork-tailed catfish *(Arius leptaspis)*, is a fish common to coastal drainage systems of northern Australia and New Guinea. It is an unusual species in that the male incubates the eggs in its mouth, having collected them from the female after fertilisation. One of three fish species depicted in its X-ray form in a twisted perspective, it is shown with its head in plan view and the rest of its body in profile. The artists have selected this convention in order to depict the most typical aspect of this species: the head with its wide mouth and three pairs of barbels, and its protective bony armour. In many examples, this catfish is depicted with its stomach everted in preparation for cooking.

Nagurl, binjdjarrang and ganbaldjdja – the three species of eel-tail catfish identified in rock paintings – all have an elongated, eel-like body tapering to a point at the tail, and a flattened head with four pairs of mouth barbels. Their representations depict these features together with either both the dorsal and the pectoral fins or the pectoral fins alone. Nagurl, the toothless catfish *(Anodontiglanis dahli)*, is a

large species which may attain a length of 40 centimetres and 1 kilogram in weight. In rock paintings, this fish is recognised by its elongated dorsal and pectoral fins. Binjdjarrang, the narrow-fronted tandan *(Neosilurus ater)*, reaching nearly 50 centimetres in length and 2 kilograms in weight, is the most frequently depicted of the eel-tail species. The third species, ganbaldjdja, the black tandan *(Neosilurus* sp.)*, grows to only 15 centimetres in length, but makes up for this in numbers as it is usually found in large, closely packed schools in small shallow pools where it can be easily netted. The genus *Neosilurus* lacks the forward extension of the dorsal fin which is seen in other catfish, and this is reflected in the rock art depictions. The fish of this genus are found only in Australia and New Guinea.

Madjabarr, the mullet *(Liza diadema)*, is a species of a restricted range, being found in the Alligator Rivers region and in several other streams of the Timor Sea drainage systems as well as in New Guinea. Although this fish is of marine origin, it spends much of its life cycle in fresh water where it feeds on aquatic plants. In this region it has found a perfect niche, moving in the wet season from the estuarine rivers into the freshwater wetlands. The mullet is depicted in the rock art with an elongated body and a broad, flattened head, small mouth, two distinctly separated dorsal fins, and pelvic fins positioned in the mid-belly region.

Guluibirr, the saratoga *(Scleropages jardini)*, is a 'living

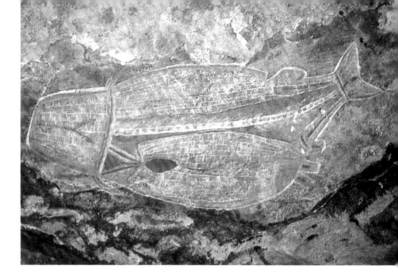

Fork-tailed catfish, with varying degrees of detail of internal organs and decoration, are depicted with the body in profile and the head in plan view to portray the bony head shield and barbels of the species. Location: Djalandjal. 90 and 60 cm.

fossil', belonging to a biological family group that first appeared 50 million years ago, in Eocene times. Several saratoga species occur in the Indo-Malayan area, in Brazil and in the Nile River. The species that inhabits the streams of the Arnhem Land Plateau, and which is depicted in the rock art, also occurs in rivers flowing into the Gulf of Carpentaria, in the Timor Sea drainages of north-western Queensland, and in some of the southward-flowing rivers of New Guinea. The saratoga, like the fork-tailed catfish and the mouth almighty, is a mouth-brooder, but while in the two other species it is the male that incubates the eggs in its mouth, in this instance the eggs are carried by the female. The young are released at the beginning of the wet season. Rock paintings of the saratoga clearly depict its oblong body, rounded dorsal and anal fins set well back, rounded caudal fin, large and oblique mouth, and, in most instances, the two small barbels found on its chin.

Nagenjhmi and galarrk, the male and female black bream (*Hephaestus fuliginosus*), are fish of the middle and upper reaches of the escarpment streams. They are much sought-after, and their flesh is considered to have healing properties. In rock paintings they are depicted with oblong to oval bodies, a blunt and moderately rounded head rising concavely to the shoulders, and a continuous first and second dorsal fin.

Burrugulung, the freshwater long tom (*Strongylura krefftii*), is another fish found in the rivers flowing into the Timor Sea and the Gulf of Carpentaria as well as in the southward-flowing rivers of New Guinea. The elongated body, slender beak and the dorsal and anal fins placed equally far back are aspects clearly portrayed in the paintings depicting this species.

Also found in the rivers draining into the Timor Sea and Gulf of Carpentaria, and in the streams of New Guinea, is Nabardebarde, the freshwater herring or bony bream (*Nematolosa erebi*). The body of this species is elongated with the last dorsal finray extremely drawn out and filamentous, and the caudal fin strongly forked. Both the body and the last dorsal finray became more elongated with age.

Garlalba, the ox-eye herring (*Megalops cyprinoides*), is found in tropical seas throughout the Indo-Pacific region. In rock paintings its oblong body, sharply pointed snout, large mouth with protruding lower jaw, elongated last dorsal finray and deeply forked tail with pointed tips are the identifying features. It occupies a range of habitats in the plateau region, including streams, landlocked lagoons and billabongs, and moves downstream with the wet season floods to spawn in the estuaries.

Njarlgan is the common archer fish (*Toxotes chatareus*), also known as the rifle fish. Both of these English names reflect this fish's ability to shoot down insects in overhanging vegetation by an accurately aimed jet of water. The Aboriginal people say, 'Njarlgan ganunjburriwe, ganunjhme maih ' – 'the archer fish is spitting, he is getting the insect with his spit'. This fish is usually found conjugating along stream banks or 'shooting' or leaping at prey. It is commonly featured in the rock art. The primitive archer fish (*Toxotes lorentzi*) hunts in a similar manner to the common species and in the most recent paintings of the X-ray convention it is depicted in considerable detail, enabling it to be identified. In earlier times, as far back as the last Ice Age, artists recorded this fish's remarkable skill at insect hunting in several other art styles.

The rock art includes several images of fish that are usually considered as marine species, although they can be found in waters as far inland as Cahill's Crossing on the East Alligator River and in the Yellow Water system of the South Alligator River. They include the Leichhardt's sawfish (*Pristis pristis*), the bull shark (*Carcharhinus leucas*), the estuary stingray (*Dasyatis fluvorium*) and an unidentified dolphin species.

The number of fish species found in the plateau's rivers and creeks which are also common to the rivers draining the southern slopes of New Guinea suggests the possible former existence, during periods of low sea levels, of a common river system which would have facilitated the movement of fish and also of the pitted-shelled turtle (*Carettochelys insculpta*), which was known only from the Fly River of Papua New Guinea until the early 1970s when specimens were found in the Arnhem Land region – though the species is depicted in the rock art, both in X-ray and in earlier styles.

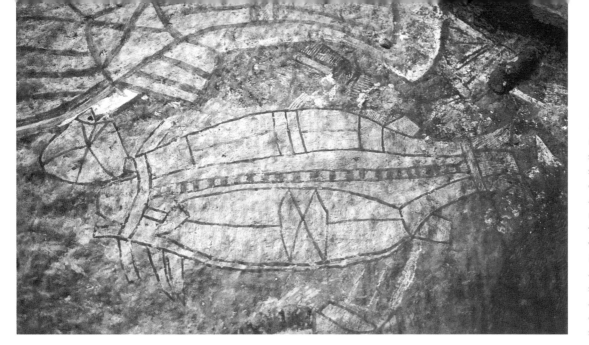

*Left* Mullet *(Liza diadema)* is the third most common fish species depicted in shelters in the vicinity of estuarine streams and wetlands. In the majority of instances the mullet are portrayed with dislocated heads, indicating that perhaps all the depicted animal species represent dead animals – the hunter's catch. Location: Ubirr site complex. 30 cm.

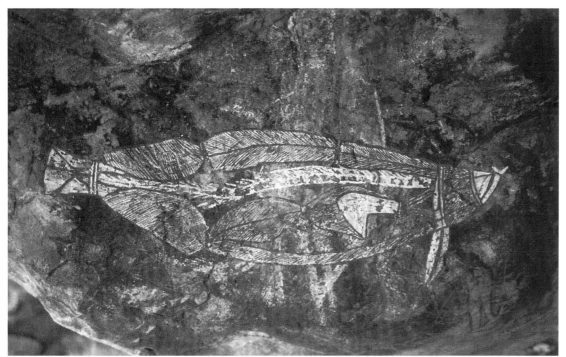

*Left* Saratoga *(Scleropages jardini)* is one of the four species most frequently represented in the region's rock art. In painting this species the artist clearly depicts its oblong body with the dorsal and anal fins set well back and its large and obliquely set mouth. Usually the two small barbels found on the chin are also shown. Location: Inyalak. 45 cm.

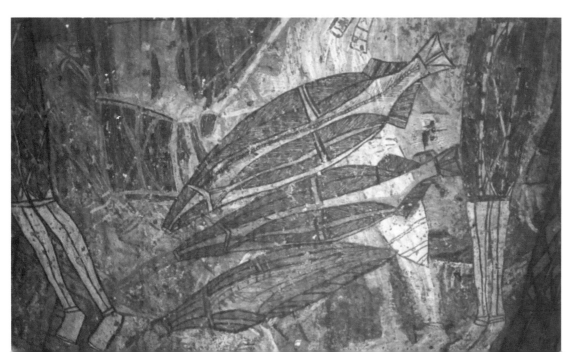

*Left* A composition of two long tom *(Strongylura kreffti)* and a narrow-fronted tandan *(Neosilurus ater)*. Location: Yuwunggayai. Long tom 45 cm.

*Above* In this detailed painting, the prey at which the archer fish *(Toxotes chatareus)* is directing a jet of water can be recognised as a spider. The fish has been executed with basic X-ray features, but traces of white pigment suggest that its original form was far more elaborate. Location: Ubirr site complex. Overall 47 cm.

*Below* Detail of an archer fish with a long jet of water extending for some 1.5 metres from its mouth. The fish is depicted in a simple X-ray form although this is a symbolic rather than representational attempt as its vertebrae are reversed. This painting is set amongst a number of representations of animal species from the large naturalistic figures complex. Location: Barndal. Archer fish 22 cm.

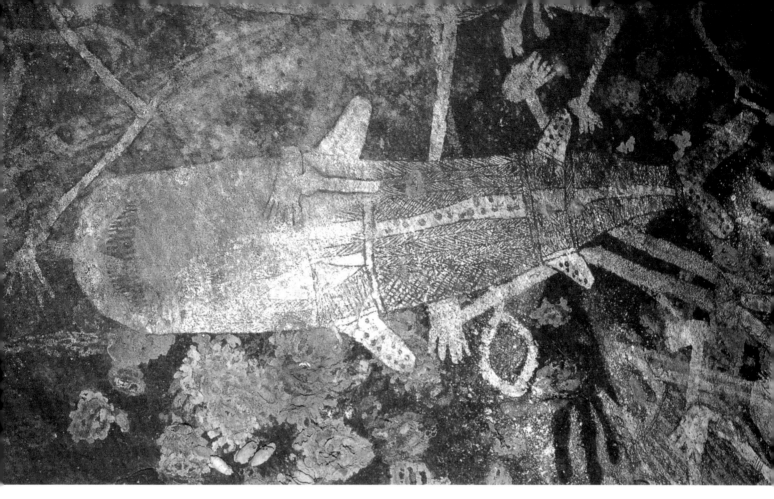

**Above** This painting of a bull shark (*Carcharhinus leucas*) with its mouth extending across the width of the head, reveals two rows of long, sharp teeth. The human leg emerging from the shark's mid-region may represent a shark attack, or a mythological transformation of a shark into human form or vice versa. Location: Nawayin. 85 cm.

**Left** Mammalian dolphins may swim far up the estuarine rivers, where this species was perhaps seen by a Gundjeihmi artist. Location: Nanguluwurr. 130 cm.

**Left below** The estuary stingray (*Dasyatis fluvorium*) which inhabits the estuarine rivers and, during the wet season, the flooded wetlands. Location: Yuwunggayai. 90 cm.

**Right** The extraordinary hunting ability of the archer fish (*Toxotes chatareus*) is also depicted in the yam figures style. In this composition representing a group of freshwater fish, four species are depicted – from the top: long tom (*Strongylura kreffti*), black bream (*Hephaestus fuliginosus*), ox-eye herring (*Megalops cyprinoides*) and the primitive archer fish (*Toxotes lorentzi*). The archer fish is seen ejecting a jet of water at an insect with 'yam' features. Location: Djuwarr site complex. Archer fish 20 cm.

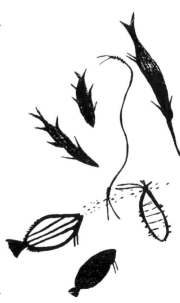

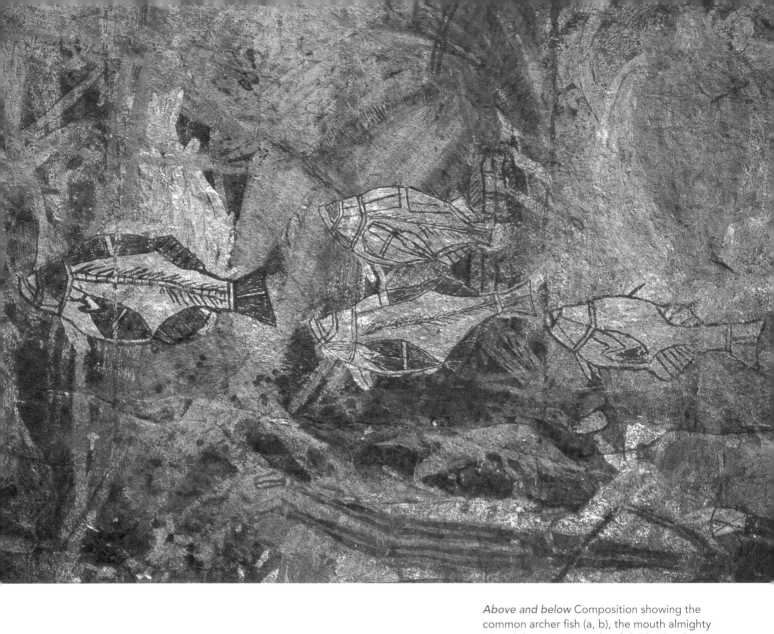

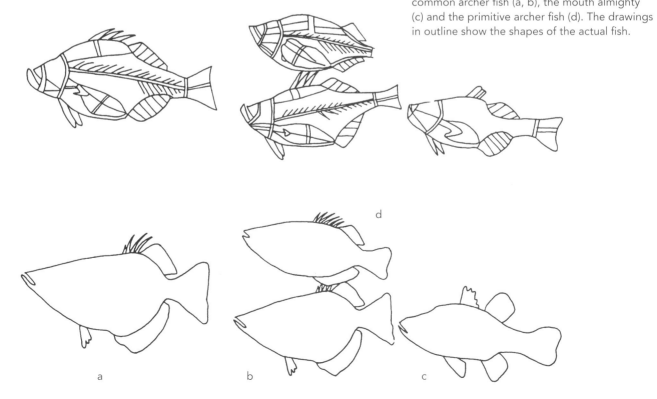

*Above and below* Composition showing the common archer fish (a, b), the mouth almighty (c) and the primitive archer fish (d). The drawings in outline show the shapes of the actual fish.

d

a

b

c

# The Aboriginal artist as a scientific illustrator

## FISH

Just how faithfully the artist has portrayed fish species is seen when his images are compared to the outlined silhouettes of the actual fish. This composition depicts three fish species that inhabit the small freshwater streams of the escarpment: (a, b) njarlgan, the common archer fish (*Toxotes chatareus*), (c) narranggi, the mouth almighty (*Glossamia aprion*), and (d) bodjdjalk, the primitive archer fish (*Toxotes lorentzi*). Two of the three fish shown swimming in a line are archer fish. They have deep and compressed bodies, with dorsal profiles that are straight from the tip of the snout to the dorsal fin set in the posterior half of the body. Such a profile enables the fish to swim directly under the surface with little disturbance. The third fish is a mouth almighty. Its oblong body, head with a marked concavity above the eyes and a slightly protruding lower jaw, as well as the caudal fin with rounded lobes, are aspects clearly represented by the artist. What he could not depict in executing the fish in profile is the large mouth of this bucal incubator – one of the region's three fish species which incubate their eggs in the mouth. The most interesting image is that of the fish in the upper centre. This is bodjdjalk, the primitive archer fish. It is considered primitive as it lacks the distinctive markings and the straight lateral line of the common species. While the common archer fish occurs in all coastal streams of the Northern Territory, the primitive archer fish species is restricted to the escarpment creeks, the tributaries of the South Alligator River and the upper reaches of the Daly River. Both species are also found in discrete regions of southern New Guinea.

## CRUSTACEANS

The Aboriginal people of this region call the long-arm prawn (*Macrobrachium* sp.) – one of the world's largest shrimps – djarlbinj. It is claimed that in this region these prawns may grow as large as 50 centimetres in length. The local people catch them by dragging branching lengths of anlarrbbe (*Acacia holosericea*) through shallow waterholes, entangling the crustaceans in the branches.

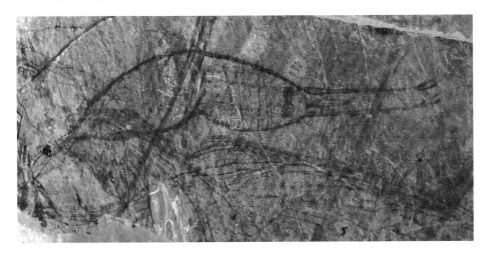

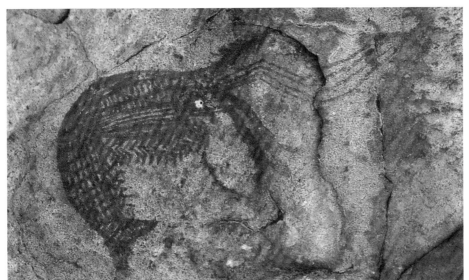

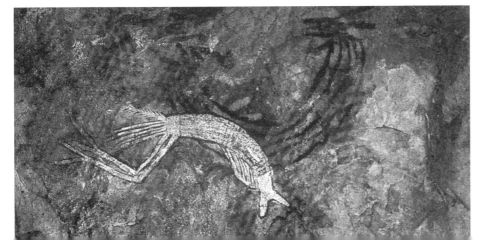

*Top* The earliest representations of the long-arm prawn appear in the yam figures style of the rock art sequence. In this painting the crustacean is shown in twisted perspective, with the head in a plan view detailing the eyes and the beaked rostrum lying between the two long arms, while the body is depicted in profile. Location: Djarrwambi. 80 cm.

*Middle* This detailed painting of the long-arm prawn could almost be a scientific illustration of the species. The artist has portrayed faithfully the long, pointed rostrum, the large elongated claws and the slender whip-like antennae. Location: Amarrkanangka complex. 22 cm.

*Bottom* The most recent and very stylised image of the long-arm prawn is found in X-ray art of the Amurdak people. The rostrum, long arms and antennae have lost their fluidity, yet they still accurately identify the species. Location: Awunbarrna complex. 22 cm.

*Right* A composition of internal organs – two swim bladders and a gut. In preparing barramundi the stomach is taken out, cleaned and filled with fat from the body cavity. The stomach is then roasted and eaten along with the other organs, while waiting for the barramundi flesh, which is baked in a ground oven. Location: Inyalak. 25 cm.

*Below* In the most typical division of smaller fish species, gungodj (the head) is dislocated but still connected to gunbodme (the back) and gunberrd (the tail part of the fish), with only gunmellem (the 'stomach') separated from the rest of the body. It was this latter fleshy part of the fish which was of importance to the painter, as he emphasised it with darker pigments and accentuated its size. The background for this image and that of the two adjoining mullet has been prepared by smudging the central area of a previously painted barramundi. Location: Inyalak. 60 cm.

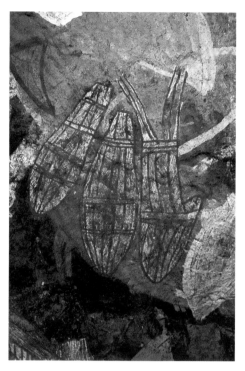

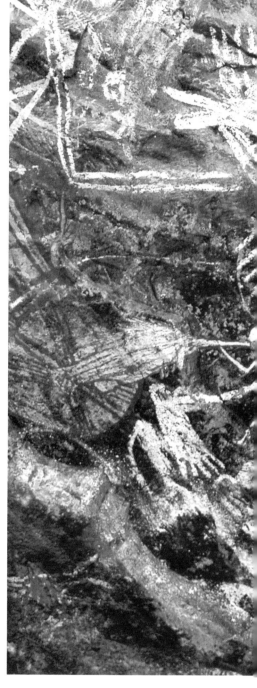

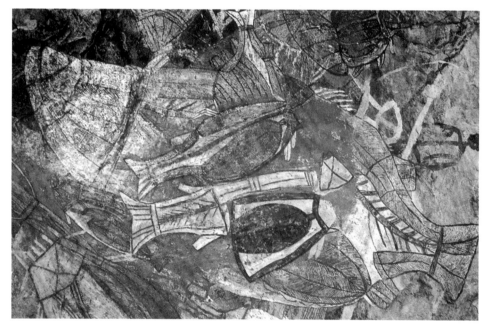

## Bagugyilkbun

### DIVISION OF FISH

Almost all aspects of Aboriginal tradition are documented in the rock paintings of Arnhem Land, including how to prepare different fish and land animal species for cooking and later how to distribute them. These paintings were not mnemonic devices nor teaching aids, as is sometimes claimed. Children, from the time they could sit, would hear and watch the adults discussing such procedures as they went about performing their daily tasks. By the time they reached adolescence, both sexes had a deep knowledge of all aspects of their physical and social environment, including the proper sharing and distribution of food resources. Only the deeper mysteries of the religious sphere were yet to be revealed to them.

However, paintings representing different parts of animals do not always reflect the traditional subdivision of a species on a ritual or social basis. This can be seen in several compositions where only certain parts of a fish have been portrayed: in such instances, the artist was perhaps depicting his favourite part of the animal. In other examples, the fish is divided in an idealised manner characteristic of the given species: the fish, after its internal organs are pushed or pulled out to be roasted separately, is, depending on its size, cooked on coals or baked in a ground oven. Afterwards, the cooked fish is apportioned by breaking it with the hands.

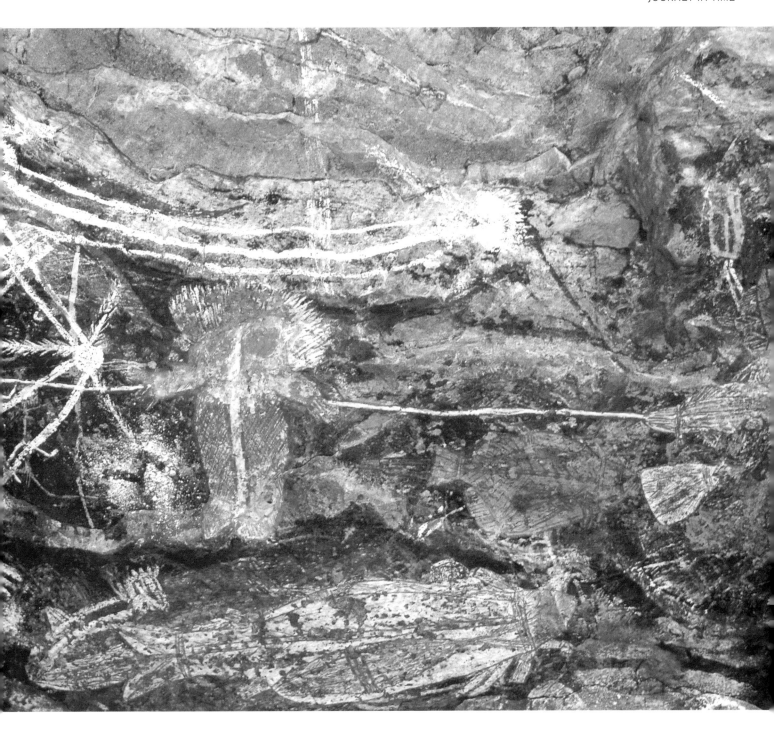

## Fishing spirits

Djidngug is a fishing spirit who can be seen only by 'clever people'. Others learn of his presence when they hear the call after which he was named – 'djidngug, djidn gug' – or when they find that their catch of fish has disappeared. Baldwin Spencer recorded a story about a similar spirit at Oenpelli in 1912, known to the Gagudju people as Bubba Peibi.

He is a short stout being who wades along the waterholes at night spearing fish, and carries a large bag for his catch. When he spears a barramundi, he bites into its nape to kill it. He kills fork-tailed catfish in the same way, but when he spears a mullet he dislocates its head. Both of these spirits will steal fish from humans if unsuccessful in their hunt.

*Above* Bubba Peibi, the short stout spirit, as depicted in a shelter situated in the estate of the Erre-speaking group. In this instance he is seen holding a babuli, a stick usually carried on the shoulder, with a fish at each end. Location: Ginga wardelirrhmeng. Babuli 120 cm.

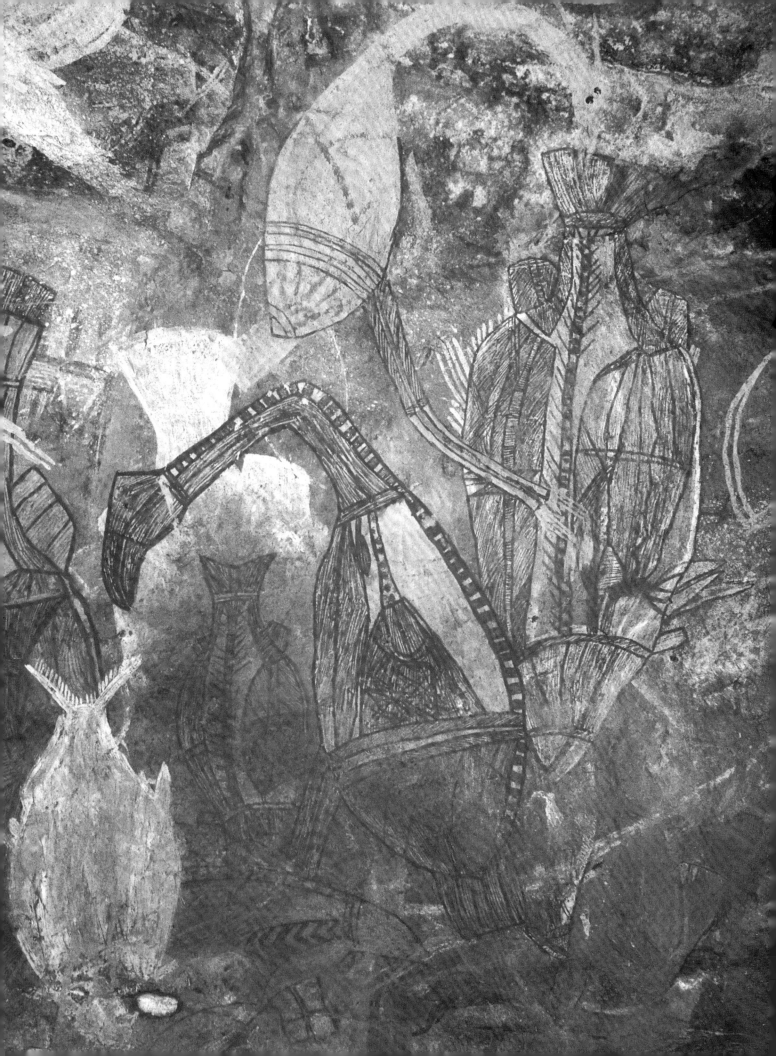

# Freshwater Period

## 1500 YEARS AGO TO THE PRESENT

The last major ecological change in the north-western sector of this region occurred about 1500 years ago. After a long period of freshwater sediment accumulation over previously saline plains, the last saltwater intrusion channels were blocked off, allowing the development of large wetland areas. The freshwater billabongs, lagoons, seasonally flooded plains and paperbark swamps became a major habitat of waterbirds and host to a new, rich floristic biota including a great number of food plants. Long before the declaration of the Kakadu National Park as a World Heritage area, these wetlands were recognised as being of international significance. They were also of great importance to the local Aborigines providing them with vast food resources which enabled them to organise major rituals attended by hundreds of people from throughout the region.

The environmental change from the estuarine 'big swamps' to the freshwater wetlands is reflected both in middens, where shells of estuarine mangrove species are covered by layers of those of the freshwater mussel (*Velesunio* sp.), and also in the rock art. To manage the bounty of the newly established wetlands, innovative hunting techniques, weapons and watercraft were developed. Most of the art depicting these adaptations is found in shelters along the Cooper and Magela creeks and the East Alligator River, where the wetlands extend to the base of the escarpment, and on the outlying residual rocks, which each year become islands as the wet season floods submerge the plains.

Magpie geese (*Anseranus semipalmata*), water whistling ducks (*Dendrocygna arcuata*) and grass whistling ducks (*D. eyton*) are the most numerous waterfowl species. Swamp hens (*Porphyrio porphyrio*), brolgas (*Grus rubicundus*), egrets, herons, ibises, spoonbills and Australia's only stork species, the jabiru (*Xenorhynchus asiaticus*), increased in numbers with the commencement of the freshwater period. Many species of fish colonised the wetlands, extending their habitats and providing easy hunting prey in the late dry season as they became concentrated in the temporarily shrinking bodies of water. File snakes (*Acrochordus arafurae*) also moved into the wetlands and flourished, while the northern long-necked turtle (*Chelodina rugosa*) occupied freshwater swamps and billabongs in preference to a riverine environment. The extensive paperbark forests allowed the flying foxes, a favourite item in the local people's diet, to form new colonies.

The vegetation of the swamps includes sedges and water lilies. Some of the sedges, the spike rushes (*Eleocharis* spp.), grow in dense and extensive beds and were the major plant food of the local population for part of the year. The stems, seed heads and root bulbs of the *Nymphaea* water lilies and the red lotus lily (*Nelumbo nucifera*), the wild rice (*Oryza* spp.) and many other less well-known plants formed part of the traditional diet. The wetlands and the adjoining riverine areas became the region's richest environment, a vast 'supermarket' that was replenished each wet season. It was

*Opposite* In most instances, representations of magpie geese and other birds frequenting the wetlands are the most recent paintings. They are usually executed in the descriptive X-ray style with internal organs detailed. The goose here is shown with its spine, heart, oesophagus, gizzard, intestines, eyes and optical nerves, while the cross-barred rear identifies where its fat is stored. In this example, both the magpie goose and the white egret are depicted as dead birds with their necks broken. Location: Inagurdurwil. 60 cm.

*Right* A female figure with a long dilly bag hanging down her back poles a paperbark raft carrying nine containers full of bush food, perhaps goose eggs collected towards the end of the wet season. The dashes emanating from her mouth may signify auditory exclamations. This composition is situated immediately behind Guliyambi, the paperbark raft Dreaming. Location: Djawumbu-Madjawarrnja. 27 cm.

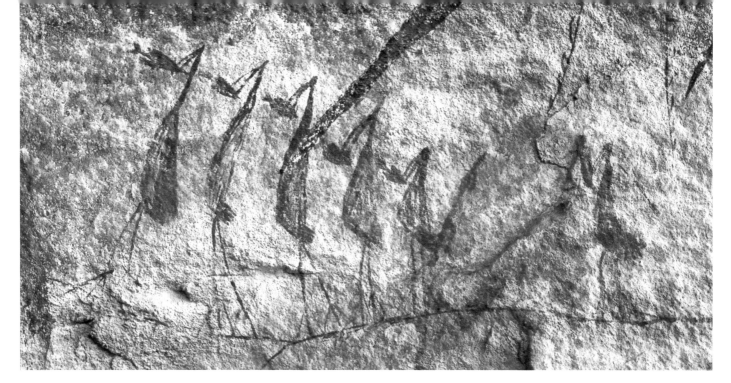

*Above* A group of six jabirus *(Xenorhynchus asiaticus)*, each with a fish in its beak. This painting is one of the few in which a ground line unifies a group of individual images into a realistic rather than a notional composition. Location: Garrkkanj. Jabiru at left 28 cm.

*Opposite above* Four swamp hens *(Porphyrio porphyrio)* executed in the descriptive X-ray style as they search along the bottom of a marsh for frogs and molluscs. Location: Inagurdurwil. Bird at left 35 cm.

*Opposite below* In this painting of three magpie geese, the bird at the upper left is shown with an extended windpipe amongst other internal organs, while the lower bird is depicted as plucked and singed, ready to be placed on a fire and roasted. The geese have been superimposed by paintings of decorated hands, a motif originating in the contact period. Location: Amurdak. Upper bird 60 cm.

perhaps this wealth of food resources which led to the growth of a large and diverse Aboriginal population, evident in the complex mosaic of language and clan groups living at the time of contact in this part of western Arnhem Land. In November 1845 Ludwig Leichhardt and his party, guided by local Aborigines, traversed the wetlands and the plains between the South and East Alligator rivers. In his journal the explorer describes the rich environment and records the presence of several hundred people in a number of groups exploiting the resources. Men, young and old, each with a bundle of spears and a spearthrower, demonstrated how they speared magpie geese in flight. The party also observed people fishing, collecting fruit and digging for spike rush corms – favoured both by the local Aborigines and by the magpie geese – in the drying out swamps. Leichhardt was much impressed with this latter food item, which he found to be sweet and nourishing. He was also given the fruit of the red apple tree *(Syzygium suborbiculare)*, the heart of the cabbage palm *(Livistona benthamii)*, and a number of other fruits to eat. When his party reached the permanent lagoons at Amarrkanangka (Cannon Hill) they were offered the lower stems of the red lotus lily to eat.

Rock paintings of magpie geese and of their hunters, each depicted carrying a bundle of specialised 'goose' spears and

a goose-wing 'fan', typify this period. The fan is still used in the region today by both sexes and has a multiplicity of functions, the most obvious being to fan the embers of a fire into flame.

Paperbark rafts, which people poled into the wetlands to collect goose eggs in season or to spear fish, are also portrayed in rock paintings, as are the water lilies they gathered later in the year. The majority of these paintings are of the descriptive and decorative X-ray convention, although other forms of expression were used concurrently. Slender one-line-thick running hunter figures with spears poised in spearthrowers held aloft also carry goose-wing 'fans'. The distinctive Aboriginal aerophone, the didjeridu, was probably invented or introduced during this period for in the compositions depicting rituals or entertainment in which this instrument is used, the participants carry a goose-wing 'fan'. Environmentally, this period has persisted into the present. Feral animals, especially water buffaloes and pigs, have done great damage to the region. In certain areas, their activities have caused the incursion of saltwater. However, these animals are being removed and the wetlands are beginning to return to their original state.

Although magpie geese would have colonised the area when the wetlands developed some 1500 years ago, their

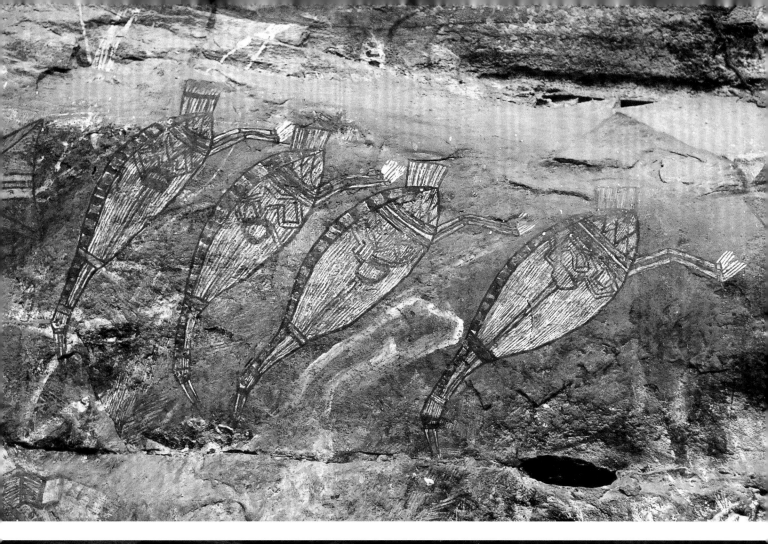
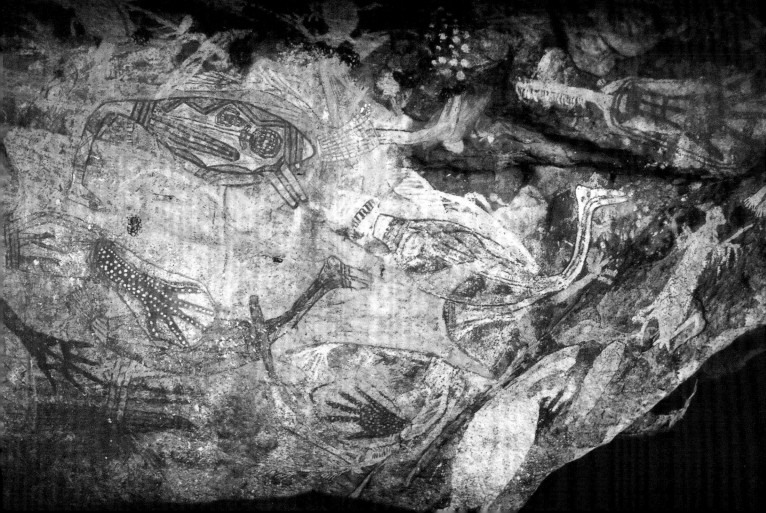

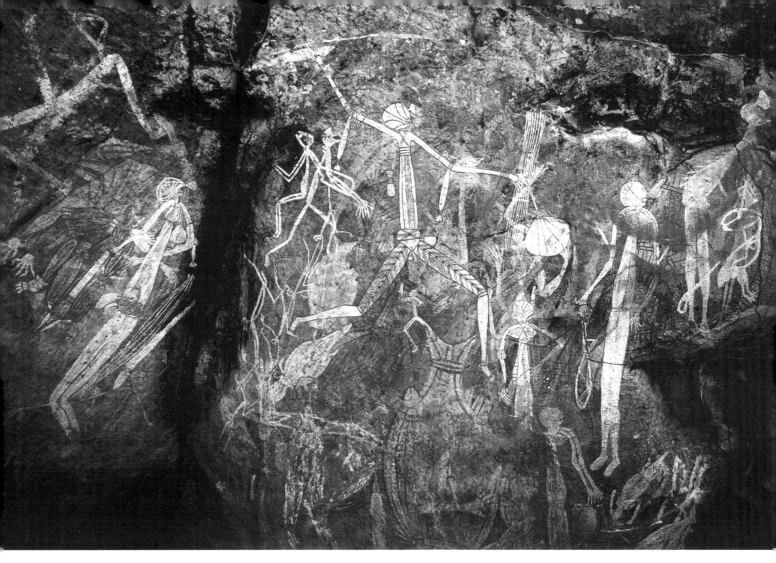

*Above* An exquisite decorative X-ray painting of a hunter of the freshwater period. A wooden-bladed spear is engaged in the spearthrower poised above his head. In the other hand he holds nine 'goose' spears and a goose-wing 'fan'. Location: Djalandjal. 87 cm.

*Right* Wurrmarninj, the red lotus lily *(Nelumbo nucifera)*, executed over an earlier female figure and superimposed by a barramundi. The artist faithfully depicted the very large, rounded leaves and long stems of the plant. The leaves of this lily do not float, but stand erect and cupped above the water. The prominent seed pods are clearly seen. Location: Mabuludu. 130 cm.

representation in the rock art is frequently amongst the most recent paintings and they are only a minor subject in shelters bordering their habitat. Magpie geese, with their relatively large masses of flesh and copious amounts of fat, were amongst the most sought-after food items, so it is surprising that relatively few representations of this species exist. Images of animal species in a given area usually indicate their presence in the immediate environment and their popularity with the artist. The paucity of magpie geese representations suggests that painting was not an incessant activity and that the accretion of paintings in a shelter, at least in some instances, took considerable time.

# Mole

## DIDJERIDU

Mole is the indigenous musical instrument generally known as the didjeridu – or casually as 'bamboo' to the local people. It makes its first appearance in rock art during the freshwater period, when the magpie geese and other waterbirds colonised the emergent wetlands. Paintings of people in detailed compositions in which this instrument features are generally shown to be carrying a goose-wing 'fan'. The didjeridu, a lip-buzzed aerophone or 'drone pipe', originated in the coastal lowlands adjacent to the Arnhem Land Plateau. In recent times, it has found its way into the Kimberley and Pilbara regions of Western Australia and to the east has extended along the Gulf of Carpentaria and into Queensland. In the past, the didjeridu was made from a length of angole, the bamboo (*Bambusa arnhemica*), from which the name mole was derived. A dry length of bamboo was broken off, burned at both ends, then the rims were ground smooth on a rock surface and the nodes along the bamboo were pierced through with a digging stick. Didjeridus are now usually made from saplings of a number of eucalypt species that have been hollowed by termites; nevertheless, the local groups continue to use the English term 'bamboo' when describing this instrument.

A wooden didjeridu may also have been made in the past, though this type is clearly common after contact, when steel hatchets and axes became available to cut through the hardwood saplings. To make a wooden didjeridu a length of termite-hollowed tree is cut down, the bark is removed and the interior cleaned of any remaining debris. The mouth end is then shaped, and finished off with a rim of beeswax. The sound and resonance produced by blowing through the didjeridu depends on its length, shape and the thickness of the hollowed wood walling.

The didjeridu varies from 1 to 1.5 metres in length, although specimens 2 metres or longer are known. A skilful player can produce a range of different tonal and rhythmic effects. The didjeridu is seldom used as a solo instrument. Usually it is played to accompany a singer, who may also use clapsticks. In several of the paintings, the didjeridus are decorated with linear designs.

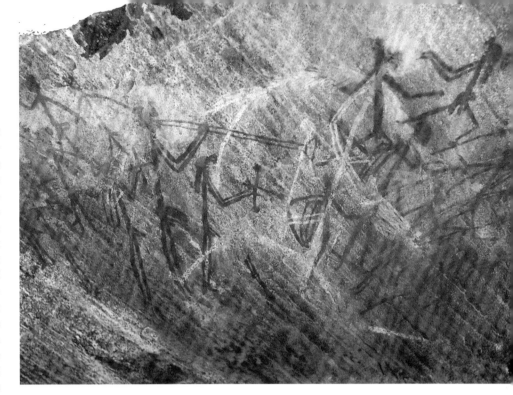

*Top* A didjeridu player and two songmen using clapsticks knobbed on both ends are the central performers in a ceremonial performance. The depicted didjeridu is not only of considerable length, but its distal end is trumpet-shaped – the only known example of this type. Location: Ginga wardelirrhmeng. Didjeridu player 29 cm.

*Bottom* Profile of a bearded musician sitting on his haunches and playing a didjeridu. The transverse bands across the length of the instrument may be purely decorative or may suggest that it was made from bamboo, representing its nodes. Location: Yuwunggayai. 90 cm.

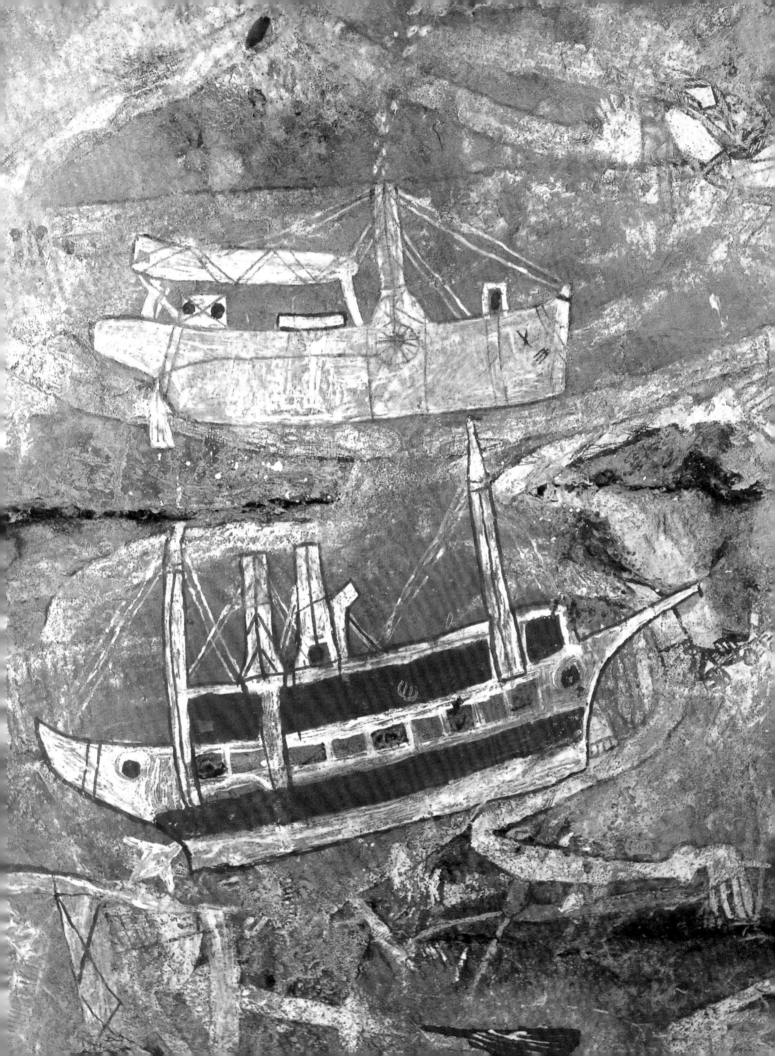

# Contact Period

## Barrigerrnge
### 'THE NEW LOT'

Paintings of the contact period reflect the Aboriginal experience of aliens – Makassans and Europeans – and the consequences of such intrusion and continuing presence on Aboriginal society and lifestyle. Despite the dramatic changes in subject matter, stylistic conventions and painting techniques of the previous styles continued to be used. The only innovations are the introduction of the decorated hand motif, and, in later paintings, the use of a blue pigment originating from the laundries of the European settlers, though there is also a noticeable increase in decorative hatching and patterning.

The contact period commences with the first visits by Makassan fishermen to the northern coast several hundred years ago. It was then that Aboriginal people became subject to continuous, ever increasing influences from the outside world.

It is probable that there were previously some unintentional visitors to the northern coast – castaways blown across the Arafura Sea by the north-west monsoon which brings the wet season rains (accidental voyages were recorded by early European settlers, and even at present flimsy fishing canoes and boats from Indonesian islands still wash up on the beaches). During one landfall between 8000 and 3500 years ago, the dingo, already a domesticated animal, was possibly aboard such a craft. Perhaps, too, landfalls like these gave rise to the myths that record ancestral beings coming out of the sea and entering the land.

The contact period can be divided into Makassan and European phases, but this division is not absolute. It is probable that Makassan subjects continued to be painted for some time after the region was colonised by Europeans, as their visits did not cease until 1907 (when they did so as a direct outcome of that colonisation). The boats that brought the Makassans and their material possessions are depicted both in the coastal shelters and in the interior, where objects of trade such as steel axes and knives reached the distant groups and were recorded in stencilled or painted form.

Like the Makassan visits, the history of European

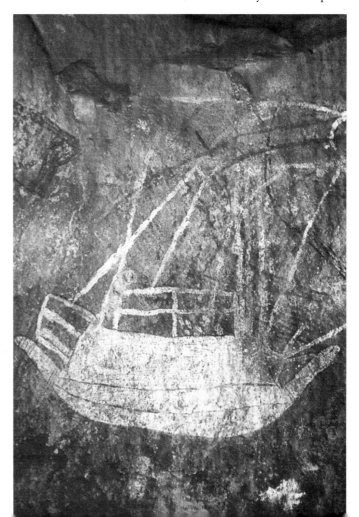

*Opposite* Two boats, from one of the most colourful rock art sites, which displays a number of contact motifs. The artist executed his paintings on a prepared surface, after smudging earlier images so that they would not distract the viewer from his subject. His intellectual curiosity is revealed by the detail of the two vessels. The lower boat is a steamship with its mode of propulsion, a screw, prominently displayed. The other, although clearly a paddle steamer, is also shown to have a shaft leading to a smaller screw alongside its large rudder. Location: Awunbarrna. Paddle steamer 36 cm.

*Right* A weathered painting of a Makassan perahu with a large rectangular sail raised on a tripod mast. The sail on this type of boat was made of matting and was attached to the mast so that it could be set in any direction. According to an early observer, some of the perahu were quite large boats with their superstructure high out of water and overloaded with decking, cabins and huts. Location: Mabuludu. 45 cm.

The Makassans brought with them 'prefabricated' hut panels of woven cane, which they erected as living quarters and as smoke-houses for curing trepang. Location: Mabuludu. Height 47 cm.

Another artist told his countrymen of the strange animals he had seen during a visit to the Indonesian islands, illustrating his story with a painting of two monkeys in a tree. Location: Mabuludu. Height 107 cm.

settlement in the north and its far-reaching effects on local populations is reflected in the region's rock art. The earliest images are of boats and ships that sailed along charting the coastline, seeking safe harbours and assessing the worth of the land. These vessels were followed by other craft bringing colonists and their exotic animals, and they, too, are recorded in the rock art. There are also paintings of early explorers, the construction of the railway line to the Pine Creek goldfields, Darwin wharf in the 1890s, buffalo shooters pursuing their prey, and a portrait of the first missionary who came to the region. The labour-intensive buffalo shooting industry commenced in the Alligator Rivers area in the 1890s and was at its peak in the 1920s when the rock art tradition along the western and northern escarpment generally ended, although individual artists did continue to paint occasionally when visiting their estates. The majority of sorcery paintings are also associated with this period and are perhaps a direct product of stresses induced by the spread of diseases following contact. There are well documented epidemics of influenza, measles and leprosy, which at first affected the coastal populations

but quickly extended through the Alligator Rivers country and other areas.

The early contact between coastal Aboriginal groups and people from the islands of the Indonesian Archipelago was considerable. The Makassan fishermen, from the island of Sulawesi, commenced their annual visits to Marege, as this part of the northern Australian coast was known to them, more than 300 years ago. They came to exploit the shallow seas for trepang (a sea-slug sought by Chinese traders as a culinary delicacy with aphrodisiacal properties) and for tortoise-shell, pearl-shell and pearls. But as well as the 'fruits of the sea', they also cut and took back with them sandalwood and hardwood logs and later buffalo horns. In Ujung Pandang, the Makassar of old, there remain today buildings made of timber from Arnhem Land. The Makassans' boats, perahu, along with other items of material culture which they introduced, are depicted in rock paintings of this early part of the contact period.

Large and regular fleets of perahu, with up to 2000 men aboard, sailed in with the north-west monsoon each

December. They spent the next few months sailing along the Arnhem Land coast, gathering and curing trepang, and returned home with the south-east trade winds in March or April. The Makassans camped in sandy sheltered bays, close to the trepang beds and to stands of mangrove trees required for the curing process. Today their camps, many last used a century ago, can be identified from the sea and the air by the presence of densely crowned tamarind trees which grew from the discarded seeds of this astringent fruit, which they brought with them from their homeland. Other indicators of their presence are parallel lines of stones, which are remnants of structures that held the huge metal cauldrons in which they boiled the trepang, and slight depressions, marking the sites of shelters in which they smoked the slug after it had been dried. Aboriginal wells, originally small soaks, were enlarged and deepened by the Makassans to obtain the fresh water necessary to maintain their large populations and are found in the vicinity of their old camps.

The Aboriginal people in whose estates these camps were established, and others attracted by promises of exotic goods, worked alongside the Makassans, participating in all their endeavours. As payment, they received cloth, rice, tobacco and Dutch gin, and the treasured iron knives and tomahawks. Although there are historical records of hostilities, and even of massacres of perahu crews, amicable relations are said to have generally existed between the two groups. The Makassans, in fact, usually had a superiority of numbers in any given area, but it was in their interest to maintain peace. Even as late as 1878, Europeans recorded some 60 to 70 perahu in the vicinity of Port Essington on Cobourg Peninsula, their crews quietly going about their business of fishing for trepang and cutting timber.

During their extended period of contact, the Makassans developed close social as well as economic ties with the local groups. Many Aboriginal men sailed with Makassan crews along the coast of Arnhem Land and into the Gulf of Carpentaria to exploit trepang beds in areas other than their own. At the end of the season, some would journey with the Makassans to Manggadjarra, their gloss for Makassar. It is likely that these early travellers saw their first white man some hundred or more years before Captain James Cook's journey to eastern Australia, and well before the establishment of the first European settlement on the Arnhem Land coast. Most returned the next season with news and tales of the wider world, while others stayed away for a number of years, visiting many other parts of Indonesia before returning to Australia to describe and illustrate the exotic things they had seen. But there were also men and women who were taken away against their will, some of whom did not return. To the coastal populations, Makassar and other parts of the Indonesian archipelago became the first extensions of the Aboriginal universe.

The Makassans had a profound and lasting influence not only on the art but also on the myth, ritual and material

Many coastal Aborigines travelled with the Makassans to Sulawesi. Some returned the next season, others stayed away for a number of years, while yet others married and remained in Makassar. The female depicted in this painting wearing a short, patterned sarong with a suggested fold may have been the artist's Makassan girlfriend. Location: Mabuludu. 120 cm.

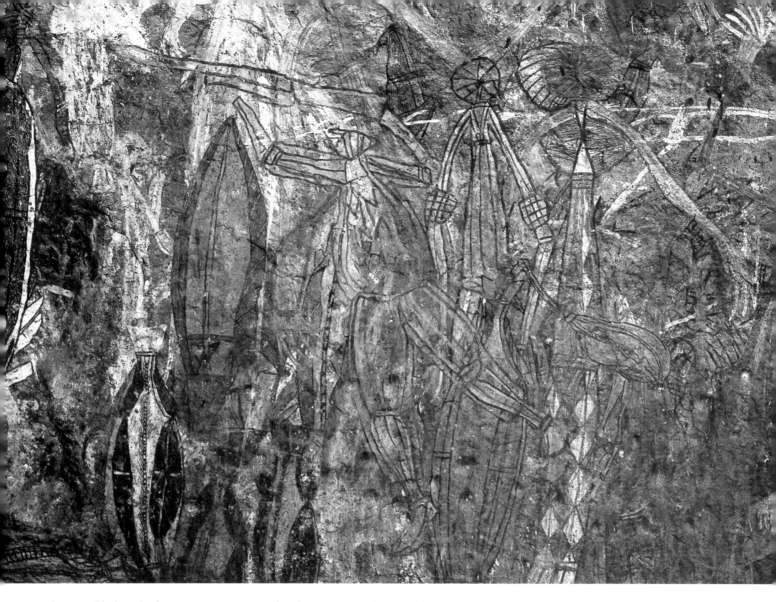

*Above and below* The first Europeans to cross the plateau were Ludwig Leichhardt and his exploration party. This painting of a fully dressed European, shown with an animal head and holding a gun above his head, may represent one of the explorers. The Aborigines, learning that the gun kills, portrayed the weapon being hurled in the same way that they used their spears. Location: Yuwunggayai. 128 cm.

culture of the wider Arnhem Land region. Even now, almost 90 years after this contact ended, contemporary song cycles and ceremonies are permeated with Makassan associations. Many Aborigines learnt a 'Makassan' language – a coastal lingua franca spoken by all the groups visited by the trepangers – and, to this day, there are Aboriginal languages with hundreds of words of Indonesian origin. Even the inland groups still use Indonesian terms for Europeans, matches, paper and money. The dugout canoe, which the Makassans introduced and then taught the locals how to construct, is still occasionally made, as are long tobacco pipes which are sometimes seen being smoked by men with wispy Makassan beards. In the rock shelters, their long association with the region is documented by shards of traded pottery, flakes from the thick, green glass of Dutch gin bottles and paintings depicting Makassan subjects.

Aborigines from the Wellington Range region who visited

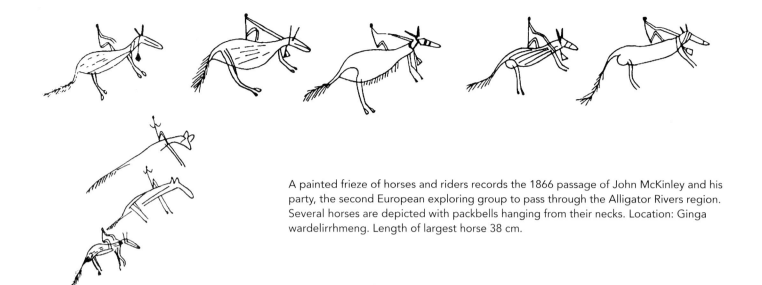

A painted frieze of horses and riders records the 1866 passage of John McKinley and his party, the second European exploring group to pass through the Alligator Rivers region. Several horses are depicted with packbells hanging from their necks. Location: Ginga wardelirrhmeng. Length of largest horse 38 cm.

Makassar were very much impressed with the beautiful sarongs worn there. They called them liba, from the Makassan term *lipa*, a name still used by the descendants of the voyagers to identify such items worn by human figures in the rock art. A painting of one such figure with a short, patterned sarong is thought to be a depiction of the artist's Indonesian girlfriend.

Many of the decorative elements in the art of the northern shelters are similar to patterns seen in Indonesian weavings and textiles. Although the majority of the trepang fishermen were Makassan, there were also Bugis, Bajau and members of other ethnic groups wearing a wide variety of clothing made from a range of textiles. The decorative hatching, diamond and lozenge designs as well as the patterned parallel, horizontal and vertical blocks found in the art could be based on such fabrics.

Although the Aborigines adopted many of their visitors' customs and practices, the prolonged contact did not appear to disrupt their lifestyle to any major extent. In many aspects, Makassan life was very much like their own. Most of the Europeans who were to follow were of a different ilk. They came with inflexible attitudes, ingrained prejudices and a lifestyle incompatible with that of the Aborigines. Moreover, the Makassans were annual visitors, from whom the people had a regular respite, whereas the Europeans came to stay, and to dispossess the local populations of much of their land.

Although there is no actual record of their landing along the northern coast, Dutch explorers commenced charting the seas to the north of Australia in the early 1600s and may have been the first Europeans to come in contact with the local populations. In 1623 the *Arnheim* and the *Pera*, two vessels of the Dutch East India Company, were exploring the eastern side of the Gulf of Carpentaria when they became separated. Captain W. Joosten Van Closter, commanding the *Arnheim*, decided to return to the Dutch East Indies and in doing

*Left* A detail of a rider and a horse, one of nine seen in the McKinley frieze. The artist depicted the horse's rear in the same manner used to portray macropods. Location: Ginga wardelirrhmeng. 27 cm.

*Right* Guns are frequently shown alongside other European motifs. The two-masted lugger was originally executed in white and red, and blue was later used to outline the hull and indicate the ropes to the sails, as well as to depict the revolver below. Location: Awunbarrna. Boat 60 cm.

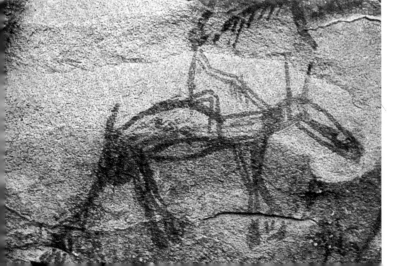

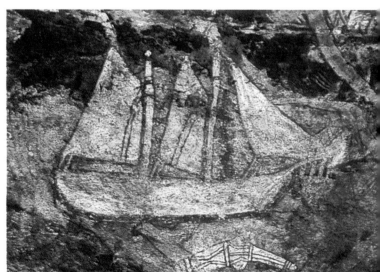

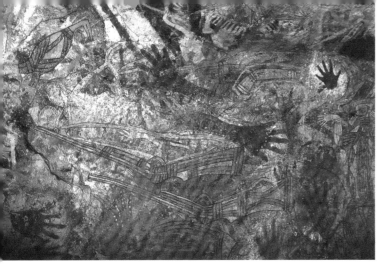

The people of this region had their first experience of firearms when visiting either Fort Wellington or Victoria, the early nineteenth century settlements on Cobourg Peninsula. The artist who executed this painting closely observed the rifles and flintlock pistols. The lower pistol clearly shows the hammer with flint pulled back, as well as the steel and flash pan cover. The upper gun is enclosed by a thick line which may represent a holster. Location: Amurdak. Upper gun 22 cm.

A painting of a Chinese man with a long plait hanging down his back, wearing short trousers and holding a gun. The size of the gun in comparison with the body is grossly exaggerated, suggesting the strong influence this weapon exerted over Aboriginal people. Chinese workers and fossickers from the Pine Creek goldfields carried out raids across western Arnhem Land as far as the East Alligator River, where this painting is located, to capture and kidnap females. Location: Merl. Height 55 cm.

so took a course which led to his discovery and naming of Arnhem Land. In 1644 Abel Tasman sailed along and charted the entire Arnhem Land region and the north-western coast of the continent to Port Hedland. During this expedition he mapped and named Van Diemen Gulf, the basin of the Alligator and Wildman rivers and Cooper Creek. His was one of the most important voyages of discovery as he charted hundreds of kilometres of unknown and hazardous coast, a survey not superseded until the nineteenth century. The Alligator rivers themselves were named during Captain Phillip Parker King's survey of 1818, one of four separate voyages in which he mapped the north and north-west coast of Australia, a task commenced in 1802 by Matthew Flinders. The first shots fired at Aboriginal people of this region by Europeans echoed along South Goulburn Island's beach during King's visit, not an auspicious start to European contact. As most of this early contact with Europeans occurred on the coast, and as the sea was later the only means of access to the fledgling European settlements, boats are the main subject of the rock art of the contact period.

The first of several attempts to establish a permanent settlement on the north coast was at Fort Dundas, in Apsley Strait on Melville Island, in 1824. It was a series of unmitigated disasters, resulting in the garrison of military men and convicts withdrawing after only three years and leaving as their most significant legacy a herd of water buffalo imported from Timor. However, before the abandonment of Fort Dundas, another military post was established at Raffles Bay on the Cobourg Peninsula. Called Fort Wellington, it proved to be an equally unsuccessful venture, a situation

exacerbated from the beginning by strained relationships between the Europeans and the Aborigines, which soon culminated in tragedy. After a soldier was wounded by Aborigines, the first commandant, Captain Henry Smyth, ordered a reprisal attack on a nearby camp along Bowen Strait, killing some 30 people including a woman and two of her children. A third child, Riveral, a six-year-old girl, was taken back to the settlement to become a servant called Mary Raffles. In 1829, when Fort Wellington was abandoned, Riveral was taken from her country and people to continue her days of servitude far away in Sydney, where she eventually died. News of this Bowen Strait massacre and the power of the gun became widely known throughout the region. A contemporary observer commented on the grief it caused, especially as the most severe conflicts amongst Aboriginal groups seldom involved the loss of more than one life, and even that loss gave rise to the deepest sorrow and remorse.

Smyth was replaced as commandant in 1828 by Captain Collet Barker, a humane man who established cordial relations with the local people. That year more than 1000 Makassan trepangers entered the port. Barker promised them that trade goods would be available on their next visit, but when they returned they found the settlement abandoned.

In 1838, following rumours that the French were fitting out an expedition to take possession of Australia's north, Sir J. J. Gordon Bremer, accompanied by a group of military people and convicts, set out from England, via Sydney, to claim the region for the British Crown. He established what would become the third abortive British outpost, in Port Essington, and named it the Victoria Settlement. Bremer's

backers hoped the settlement would prove to be Australia's equivalent of Singapore, but the only trading vessels to call there were the perahu of Makassan trepanging fleets, and they sailed into the harbour only because it was their traditional port of call and one of their trepanging locations.

The population of the Victoria Settlement, predominantly male, varied from 70 to more than 300, depending on the number of visiting vessels. Some ships brought distinguished visitors who left graphic records of life in the settlement. In 1843 H. D. Melville, a naval artist, made watercolour sketches of the settlement and its surrounds. He documented the peaceful presence of Aboriginal people and their stages of European acculturation. Aborigines moved freely around the settlement, although many visitors observed that pilfering was habitual. Those who were caught stealing were punished with a caning or a week's confinement in irons. John Sweatman, a naval clerk who served on two occasions at the Victoria Settlement, commented in his journal that Aborigines constantly camped in the vicinity of Europeans for the sake of what they could get. He acknowledged that this was considered by Aborigines as a fair arrangement, as they provided the Europeans with a constant supply of oysters, honey and the tender hearts of the cabbage palm. Through the traditional exchange networks, goods of Makassan and European origin as well as ideas and news were passed on to groups living far beyond the frontiers of British settlement.

In 1846 Reverend D. Angelo Canfaloniere, an Italian Benedictine priest, reached the Victoria Settlement at Port Essington after the vessel in which he was a passenger sank in adjacent waters. The north's first missionary, he was respected by the Aboriginal people but he died two years later, having made no converts. Nevertheless, in that short time Canfaloniere travelled around the peninsula with the Aborigines, learning their language and something of their country. He left a vocabulary, a map of local language groups and a translation of simple prayers as his contribution to contact. His map reveals the extent of Makassan influence, as the names he recorded to represent various language groups were the Makassan rather than the Aboriginal names of the localities.

Before his death, Canfaloniere accompanied John Sweatman to the Kai Islands where they bartered for fresh produce including pigs, goats, fowls, yams, pumpkin, coconuts and bananas. They took along Jim Crow, an Aboriginal friend of Sweatman's, who like many of the local people enjoyed travelling. Sweatman remarked in his journal on the fact that the Aborigines frequently accompanied Makassans on their homeward journeys and that some of them had also visited Sydney and the intermediate ports as crewmen on European merchant ships.

The naturalist John McGillvray also spent some time at Victoria. When he left on a collecting journey to Java and Singapore, he selected Neinmal, an outgoing member of a local group, to be his assistant. Neinmal returned home in a roundabout way, sailing around Australia's coast and visiting Sydney. The European passengers found him to be a most amusing companion, a reasonable singer with a good command of English, and very particular in his dress. In 1848 an Aborigine was killed in the settlement while escaping from custody. In revenge, the relatives of the deceased killed Neinmal, whom they perceived as being too close to the Europeans.

The Victoria Settlement was abandoned in 1849. The expected trade had not eventuated, the potential of the land for agricultural and commercial development had been found to be poor and, perhaps most importantly, the British Government had lost interest in the venture. The garrison left behind dogs, Timorese ponies, horses, bartteng (Balinese cattle), buffalo, pigs and goats. All these animals, except the goats, successfully adapted to a feral existence. By this time, the local groups had experienced more than 20 years of contact with the Europeans, adopting many of their material possessions and acquiring considerable knowledge for their own use.

In 1845, however, four years before its abandonment, the Victoria Settlement was the destination of Ludwig Leichhardt and his party. It was this explorer who, in his *Journal of an Overland Expedition from Moreton Bay to Port Essington*, left the most informative account of the nature of the Arnhem Land Plateau and Alligator Rivers region and its people last century. Traversing the country between the South and East Alligator rivers, Leichhardt was addressed by a member of a local group in both English and Makassarese. He described the people as 'my friends the Aborigines' and noted that they shared with his party the bounty of their land and led them through the swamps, locating wells and finally directing them to Port Essington. In one of the escarpment shelters, a painting of a European holding a rifle above his head may depict this explorer. The figure is fully clothed, but has an animal instead of a human head as do some of the portrayals of spirit beings. He was perhaps the first European the artist's group had encountered. The Aborigines apparently were

made aware that the gun in the strange man's hand could kill, but they did not conceive that it worked by any other means than a spear, hence the gun is in the position of being launched. Included in Leichhardt's 1847 publication was a reasonably detailed map of his journey.

Astoundingly, Leichhardt's journals and maps of the Alligator Rivers area were ignored by the next explorer to visit the region, some 19 years later.

In 1866 John McKinley, an explorer of some repute, led the second European expedition to enter the Arnhem Land Plateau region, although prior to this journey, in 1862, John McDouall Stuart had crossed the continent from the south, passing by the western margins of the plateau. McKinley set out from Escape Cliffs, a fourth and again short-lived settlement in the north, to explore the country between the Adelaide and the Liverpool, Roper and Victoria rivers, and to report on suitable sites for a permanent settlement, which would be a new capital of northern Australia.

The fifteen-man expedition with 45 horses, 60 sheep and seven dogs commenced its journey at the height of the wet season. The party headed eastward towards the Liverpool River, where it was to meet up with the survey vessel HMS *Beatrice* on the 1st of April. Five months later, tired and weary, the party had only reached the banks of the East Alligator River. The months of fording flooded creeks, negotiating boggy swamps and riding through the high grass and thick scrub had taken their toll on both animals and men. Here, after killing the remaining horses, the party made a punt of saplings covered with horse hide and sailed west down the crocodile-infested river back to Escape Cliffs.

During their trek across the land they had met with only two groups of Aborigines, the first in the vicinity of Jim Jim Falls and the second on the East Alligator River. That they were closely observed by the Aborigines on other occasions is documented in a painted frieze of eight horses and riders at Djirringbal, in the vicinity of McKinley's Camp 39. Whilst the animals bear some resemblance to kangaroos, with foreshortened front and elongated rear legs along with a typical macropod rump, they are clearly horses. Their hooves are distinctly shown, and they have carefully painted bushy tails. Riders are depicted holding on to the reins. Around the necks of the horses are suspended the bells used to locate wandering animals. The sound of these horse bells may well have first attracted the Aborigines' attention.

After McKinley's failure, Francis W. Cadell explored the coast in 1867 looking for a location to build a future city and for other areas of land suitable for settlement. On the north-eastern margin of the plateau, the name of Cadell River commemorates his journey. As a result of Cadell's findings, Darwin, then known as Palmerston, was established in 1869, and the ever-increasing permanent presence of Europeans began.

Large tracts of land were surveyed and sold, and each year the incursions extended further inland causing the displacement of many Aboriginal groups. This process was accelerated dramatically by the discovery of gold at Pine Creek in 1871.

David Lindsay explored the interior of Arnhem Land in 1883. Starting from Katherine, he skirted the southern edges of the plateau, followed the Wilton River for some distance and reached the Gulf of Carpentaria at Blue Mud Bay. Returning along the coast, he then followed the Liverpool River south and discovered the Mann River. In an effort to expand European enterprise further to the west, Captain F. Carrington in 1885 made a survey of the lands of the South and East Alligator rivers. On the vast floodplains extending along both sides of the East Alligator River he saw large herds of buffalo, often counting several hundred beasts. He noted that their numbers were increasing rapidly and that, if not checked, they could in time become a 'serious evil'. It was he who first suggested that many men could be profitably employed in killing these animals for their hides. Investigating Barron Island, located at the mouth of the South Alligator River, Carrington also found that Chinese wood-cutters had denuded it of the cypress pines that once grew there. On nearby Field Island he found bark shelters whose inside walls were decorated with paintings.

The explorers who passed through the plateau region had only a limited effect on the Aborigines they encountered on their journeys. The buffalo shooters, the Chinese and the missionaries who were to follow became the agents of destiny for the majority of the plateau's population.

## Chinese influence

In 1865 traces of gold were found on the Finniss River, south-west of Darwin. Subsequently, during the construction of the overland telegraph line in 1871, gold in some quantity was found in the Pine Creek area. Within a few years of this discovery, a major goldrush commenced. As Europeans found the climate and working conditions in this tropical part of Australia too harsh, it was suggested that 'coloured'

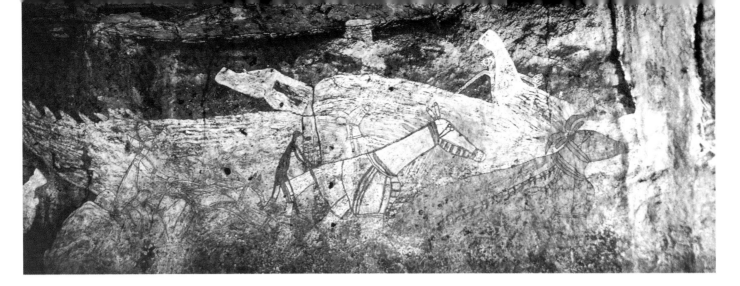

*Above and right* Several of the region's best artists worked for buffalo shooters and became skilled horsemen, enjoying the excitement of the hunt. In this almost life-size composition superimposed over a painting of a crocodile, a buffalo is seen chased by two men on horseback. The buffalo – which is going to be killed and, after being skinned, perhaps also eaten – is shown in the X-ray convention with its internal organs clearly depicted. This animal is followed by a pipe-smoking Aborigine on a horse – perhaps the artist, who portrayed himself as quite insignificant but exaggerated the size of his mount. The rider behind him is a European in a high-crowned hat. Location: Mikginj. Horse at left 240 cm.

labour be brought in to work the mines. However, there were also other reasons for this move. To reduce working costs, companies found it imperative that the gold mines and associated enterprises employ cheaper labour. The obvious place from which to get a suitable workforce was Asia.

The first Chinese contingent, a group of 184 migrants from Singapore, arrived in 1874. Initially, most of these labourers were employed on the construction of the Darwin–Pine Creek railway line, but later almost all of them fossicked for gold. By 1880 there were 4358 Chinese on the gold diggings. In 1888, when immigration restrictions were placed on them, there were between 6000 and 7000 Chinese in the Northern Territory, vastly outnumbering the European population.

The Chinese had a profound effect on the Aboriginal groups, not only in the immediate Pine Creek area but also in neighbouring regions including the plateau. Almost all the Chinese were male and many sought Aboriginal concubines. Frequent raids for women are said to have been carried out by the Chinese as far away as the East Alligator River. The devastating spread of leprosy, a disease first noted in the Northern Territory amongst the Chinese, is generally attributed to their contact with the Aboriginal women.

## Buffalo shooters

The presence of buffalo shooters in the northern floodplain areas had perhaps the most profound effect on the Aborigines. The shooter's camps, where tobacco, sugar and other goods were bartered for various services, and later, participation in this enterprise, chasing the buffalo on horses and using

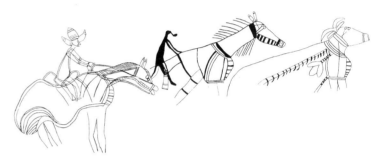

guns, enticed members from even the most distant clans to the 'buffalo country'. Some of the Aboriginal men became skilled horsemen and shot as accurately as their European bosses. Exploits of a number of Aboriginal shooters became legendary. The last of these men, 'Yellow Charlie' (Charlie Whittaker), was thought to have been born in 1896 and died only recently, in his ninety-sixth year. His younger mate, 'Yorky Billy' (William Alderson-Nakan djewili), was laid to rest at his beloved Ngurgdu in 1979.

Water buffaloes were brought to Fort Wellington in 1827, from Timor, to provide a reliable food supply. Vast herds grew from the few animals that escaped and a small number of others that were released on the abandonment of both this settlement and later the Victoria Settlement in Port Essington. Buffaloes are eminently suited to the floodplain environment and in time became the scourge of the land. Here they found a habitat rich in grasses and soft black mud in which they made cooling wallows. During a single season they could almost totally consume the vegetation, including young trees and shrubs, and trample any remaining growth into the ground. In some areas their well-worn pads became deeply eroded gullies, which drained the once permanent swamps and breached the levees separating the freshwater and saltwater

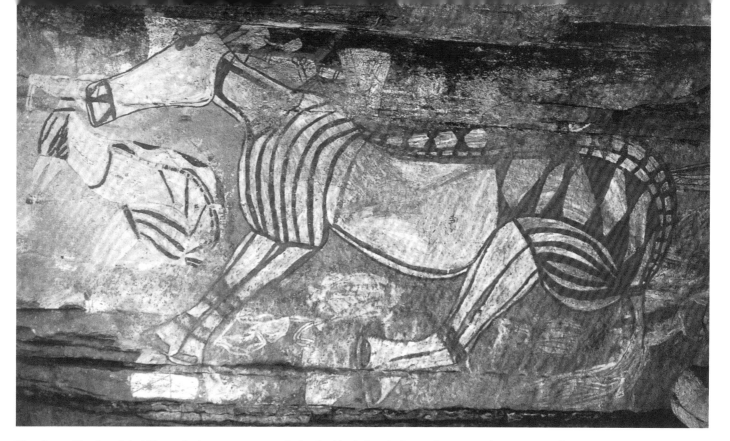

The almost life-size piebald horse is the most recent painting in this shelter. In front of it is an earlier painting of a goat, while behind the horse's head is a man with a pipe in his mouth. Location: Bonorlod. Horse 212 cm.

habitats. High tides caused saltwater intrusions, which in certain locations destroyed the freshwater environment.

By 1845 the buffalo herds had spread throughout the Cobourg Peninsula as far south as Cooper Creek, where they were seen by Leichhardt's party. By the mid-1880s they were reported, already in their thousands, between the East and South Alligator rivers and spreading westward. The Aborigines were much impressed by the size of this animal and in their rock art portrayed it in life-sized images. Later, when they joined the buffalo shooters' camps, they depicted the hunters along with their horses, guns and knives.

Although the Cobourg Cattle Company had taken a buffalo shooting lease on the Cobourg Peninsula in 1876, it was Paddy Cahill with his partner named Johnson who were the first to exploit the buffalo. In the dry season of 1894 these two hunters established a camp on the East Alligator

River, in the land of the Gagudju-speaking Bunidj clan, and commenced shooting buffalo. Later, they were to be followed by many others. The tough buffalo hides were in great demand for belts to drive industrial machinery. More than 100,000 hides were exported during the first 25 years of this enterprise and a further 193,000 in the years before World War II.

Shooting of buffalo, skinning and proper curing of hides were essential to the success of the endeavour and required a large labour force. The number of people working for each buffalo entrepreneur varied according to the scale of his operation. Workforces generally numbered between 10 and 60 people, although there are claims that up to 100 men, women and youths were employed in a single camp. Once removed from the carcasses, the hides were washed clean of blood, and any adhering flesh and fat were removed. The hides were then brought to a bough shed and salt was rubbed into the hide each day for about a week. After each salting, the hides were stacked one on top of the other to ensure that the salt penetrated from both sides. A hide that weighed up to 100 kilograms wet, dried out to about 35 kilograms.

In 1914 Cahill settled, at Oenpelli, where he established

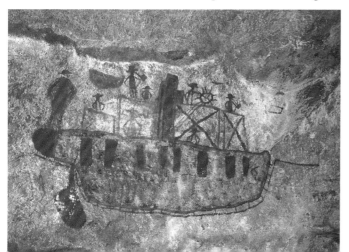

A steamboat with eight Europeans on board, executed in two shades of red pigment as well as grey. The men, one of whom is standing-by attending the steering wheel, are shown wearing hats and smoking pipes. Location: Djurlirri. Boat 50 cm.

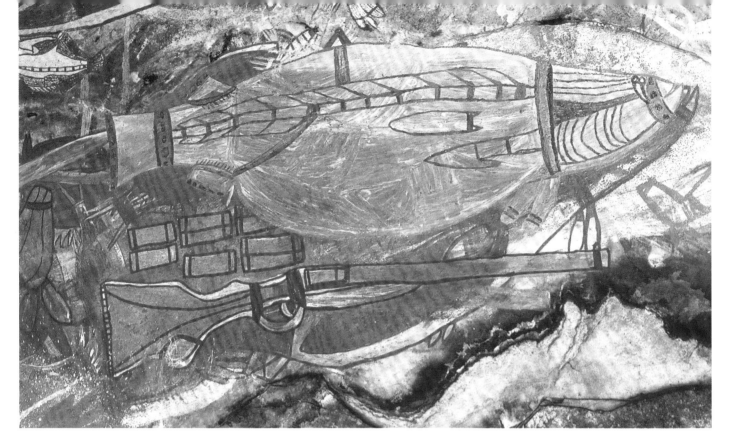

The most commonly used weapon of buffalo shooters in the region early this century was the Martini-Henry rifle, shown here with a cartridge in its breach. Location: Manaamnam. 85 cm.

a dairy. He is known to have commented that the station was deserted each year at the onset of the buffalo shooting season. One of the most dramatic long-term effects of this intensive contact was the severe permanent reduction of local populations. During their working days in the buffalo camps the people suffered not only physical hardship, but also came in contact with carriers of diseases. The decline of the original inhabitants encouraged groups from further east and the interior to move to the Oenpelli 'buffalo country'.

The ecological balance of the environment was drastically changed by the introduction of various exotic animals. Today, after more than 150 years of rampaging through the fragile landscape, the buffalo is being systematically removed from the national parks. Under a brucellosis and tuberculosis eradication campaign, all wild bovine stock will also be removed from other parts of the plateau. Since the demise of the buffalo, the plains are again covered by wild rice and spike rush, waterholes spill over with red lotus lilies and paperbarks are reclaiming their ground.

Several other introduced animals have also wreaked havoc on the environment, however they are more difficult to eradicate. Budji (feral cats) are well established and extract a heavy toll of smaller native animals and birds. Bigibigi (feral pigs) are highly mobile, reproduce prolifically and because of their wide range of habitats are more difficult than the buffalo to eradicate. These animals and nenigud (goats) which

were kept later at the Oenpelli Mission, are recorded in the rock art. The most admired and loved of all the introduced animals, at least by those who worked for the buffalo shooters and learned to ride them, were landol (horses), which are also featured in rock paintings.

From the beginning of the contact period, Aborigines of the plateau region, like the neighbouring coastal groups who sailed with the Makassan trepangers, were eager to find out about the world beyond their horizon. Many people ventured far afield, seeking information about the activities of those they came upon. On their return home they illustrated their tales with vivid rock paintings. They also carried back images of European development. In a rock shelter some 300 kilometres to the east of Darwin is a painting of the town's wharf in the 1890s with two boats in the harbour. On the same wall are copies, as the artist recalled their shape and lettering, of signs on the town's buildings and a depiction of a typical Darwin house of that period. However, despite the fascination with these exotic subjects, artists of the time continued to depict the more traditional motifs. In some instances, traditional themes are found superimposed on images of the contact experience.

Another group which had considerable influence on both the physical and spiritual welfare of the region's populations were the men of the cloth. In 1914 church representatives made

That Aborigines were good horsemen and very fond of their mounts can be seen in this sentimental portrayal of the artist's favourite horse. Location: Djimubarran. 60 cm.

In this portrait of a European, the head – with its pointed nose, lips, prominent chin and hair – was sketched in white first, then the hat was painted over it. Location: Djurlirri. Shoulder to top of hat 18 cm.

proposals for the development of missions in this region, which were to act as refuges for Aboriginal people from the impact of European and Asian incursions. The Goulburn Island Methodist Mission, located on South Goulburn Island, was established in 1916. In its construction, the mission workers were helped by members of a local Maung-speaking group. At first, only a few of the locals arrived and offered assistance, but before long there were a hundred men, women and children encamped at the mission station. A portrait

of the founding missionary was painted on the wall of the Djurlirri rock shelter, located in the northernmost outlier of the Wellington Range. The walls of this shelter are covered in brilliant paintings depicting many contact subjects. One image can be dated to 1916. In that year a daring European photographer, Ted Reichenbach, known as 'Ryko', bicycled across the dry trackless floodplains of the Mary, Wildman and Alligator rivers carrying a glass-plate camera to record buffalo and crocodile shooters and local Aborigines. Fording rivers and creeks, he met Aboriginal groups and photographed them making mock attacks on him. He also documented a 'letter-stick man' bringing mail, held in a forked stick, to Oenpelli. From there he made his way across the seemingly never-ending woodlands to the northern coast and was taken by a boat to Goulburn Island Mission. It was an incredible feat for the time. A weathered rock art image of his bicycle commemorates his journey.

Around that time, Paddy Cahill sold his Oenpelli holding to the government. The pastoral lease became the Alligator

In 1916 a Methodist mission was established on South Goulburn Island. This portrait of a missionary is found in a rock shelter of the nearby Wellington Range. Location: Djurlirri. 15 cm.

This rock painting made in the late 1940s replicates an advertisement, the Qantas Airlines slogan promoting the 'Kangaroo Route' to London, and was perhaps originally seen in a magazine. The aeroplane is a twin-engined Lancaster bomber bearing RAAF roundels on the sides. The use of roundels on civil airlines became necessary after World War II when aircraft operating under military charter flew to Japan. This painting shows the influence of European illustrative art concepts, found in magazines and comic strips, upon younger Aboriginal artists. Location: Garrkkanj.

Rivers Reserve and was operated as an Aboriginal cattle station. Cahill was appointed the Protector of Aborigines in 1917 and stayed on to manage the station until his retirement in 1924. In 1925 the Church Missionary Society took over Oenpelli and established a mission. The aim of some of the missionaries working in Australia was to congregate Aboriginal groups around their stations, not only to 'smooth their dying pillow', a sentiment of the day which the Aborigines refused to take notice of, but also to change their 'pagan' ways. The methods used to achieve this latter aim varied depending on the personality of the superintendent and the evangelising zeal of the given faith. A rock painting of a missionary with a sharp-featured face and upraised arm heralds this, the last era of contact. From then, only occasional paintings carried the rock art tradition into the most recent years. The last known painting of the contact period depicts a steeply rising twin-engined plane, a kangaroo and the Qantas slogan advertising the 'Kangaroo Route' to London.

In 1931 the Commonwealth Government gazetted the area between the East Alligator River and the Gulf of Carpentaria as the Arnhem Land Reserve, and it was added to in 1963 when the Oenpelli area was resumed. After the Aboriginal Land Rights (Northern Territory) Act was proclaimed in 1976, the Arnhem Land Reserve became freehold Aboriginal land with unalienable title, while the land to the west of the East Alligator River reverted to Aboriginal ownership after a successfully defended land claim. The traditional owners then gave this area back to the nation as the Kakadu National Park. Since then, the Jawoyn people, following another successful land claim, have established the Nitmiluk National Park in the Katherine Gorge area, in the south-western part of the plateau.

*Overleaf* Djurlirri shelter, a deep overhang high above ground level in the northern outliers of the plateau, houses the most important suite of contact paintings known. The main subjects of the most recent painting at this site are vessels of many kinds. Sailing boats, survey ships, supply boats, merchant craft and a passenger ship are represented. Amongst the boats is a painting of a biplane, WH-UJY, flown to Oenpelli in 1932 by Keith Langford-Smith, a missionary then stationed at Roper River who introduced aviation to the scattered mission stations of Arnhem Land. Location: Djurlirri. Upper boat 105 cm.

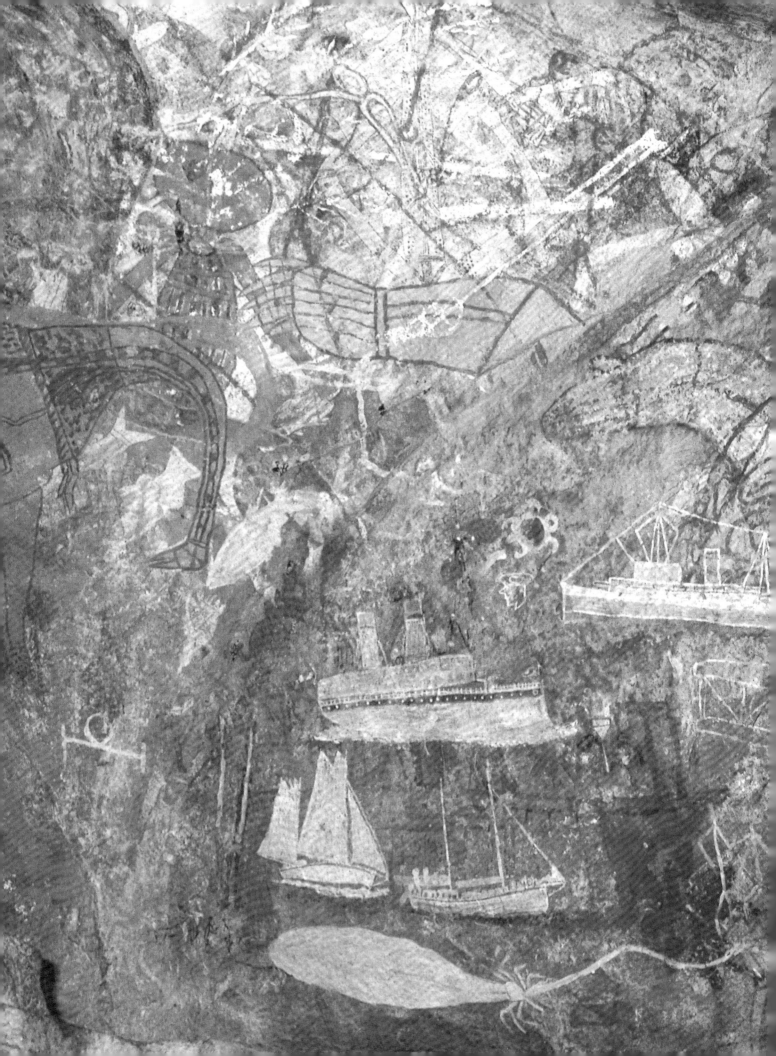

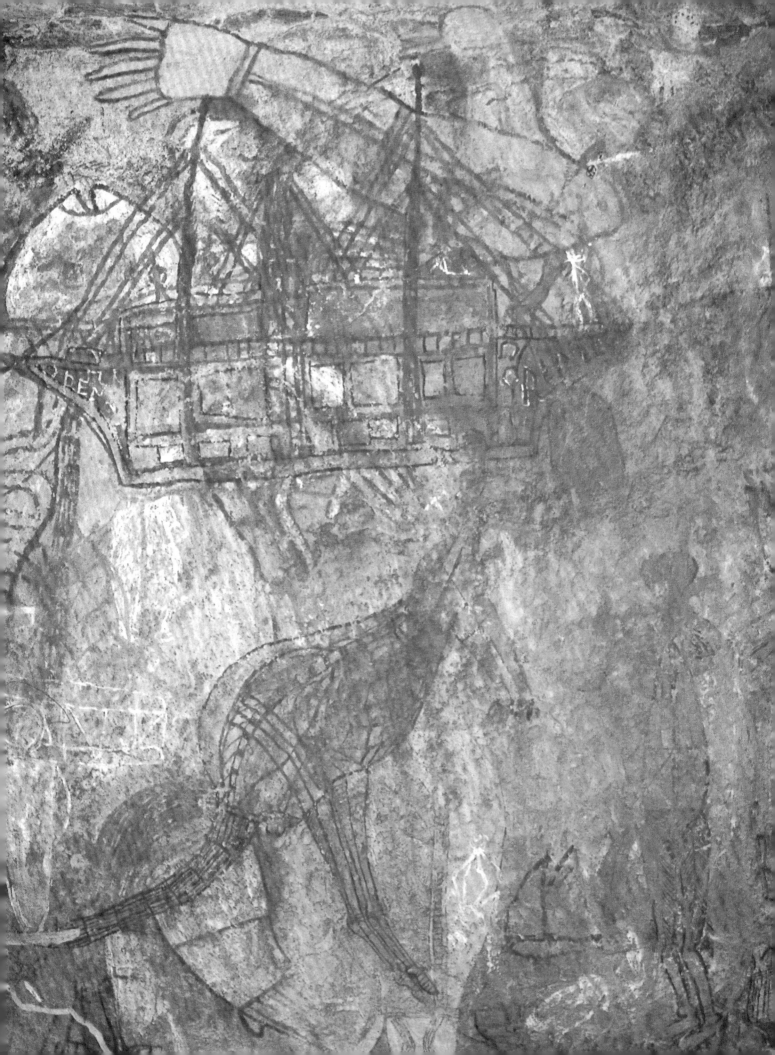

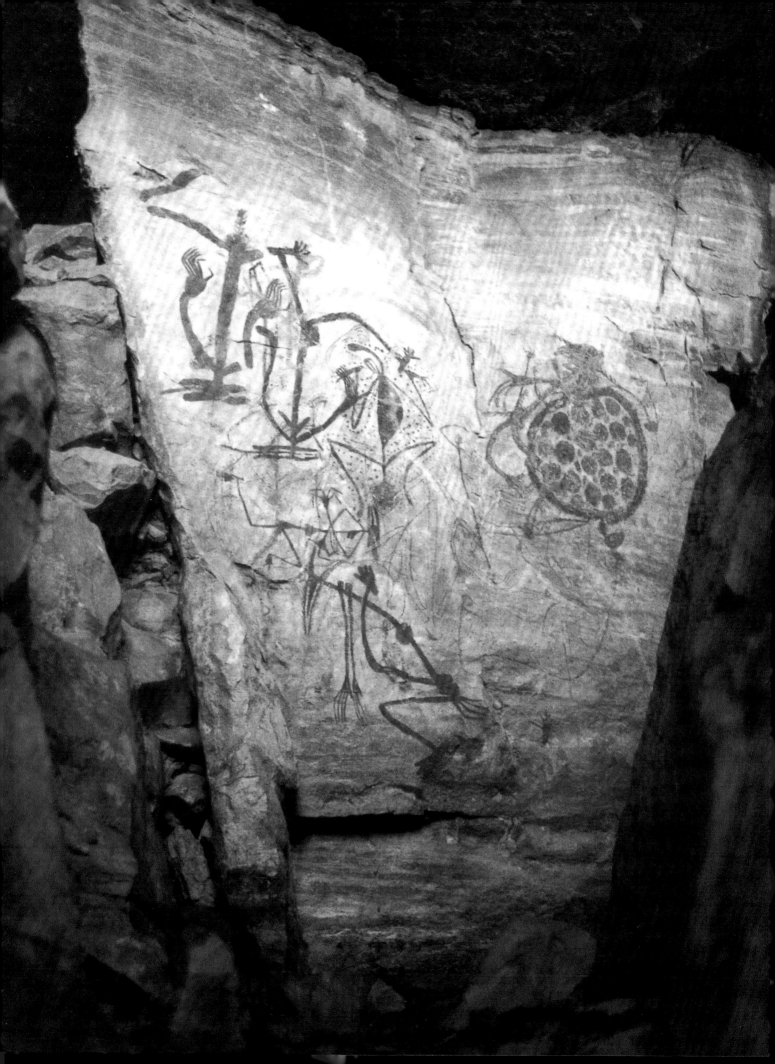

## Bim bawabon
SORCERY PAINTINGS

### 'People don't die for nothing, young boy/girl.'

The majority of rock paintings executed with sorcery intentions, to cause harm to others, are of the contact period. They are concentrated along the north-western margin of the plateau, adjacent to the 'buffalo country' where contact with the intruding aliens was most intense. Although the Aborigines are aware that many indigenous ailments have natural origins, they also reason that everything has a cause including sickness, accidents and bad luck. In the past, these negative occurrences were attributed to a person's transgression against the established order or to sorcery. Paintings with sorcery intentions were an element of the region's traditional culture, but there are surprisingly few examples of them in the rock art styles that predate the contact period. A dramatic increase in sorcery appears to have occurred after the initial and continuing contact with Europeans.

Records suggest that before the arrival of Europeans, the Aborigines were a relatively healthy people. Duncan, the Assistant Surgeon on HMS *Success*, when visiting Fort Wellington in 1827, the first year of the earliest European settlement, noted in his journal that there was evidence of very few diseases and that, in general, Aboriginal people lived to a ripe old age. Comments by various early European observers of the people from the Alligator Rivers region indicate that they were physically the largest and strongest of all Aborigines, many of the men being more than 1.8 metres tall.

But with the establishment of European settlements along the northern coast, diseases to which the Aboriginal people were not resistant were quickly introduced. Smallpox, measles and influenza swept far inland from these coastal points of contact. In one of his earliest reports Captain McArthur, Commandant of the Victoria Settlement, wrote that the people were discontented with the usurpation of their land. In a later report he described the misery the local groups suffered during an influenza epidemic which resulted in a number of deaths. McArthur felt that no language could convey an adequate idea of such scenes of destitution and wretchedness as he witnessed. Other insidious and debilitating ailments brought by the Europeans also took their toll. In 1848, only 20 years after the first contact, McGillvray, a naturalist who spent some time at the Victoria Settlement at Port Essington, observed that 'the last importation of the whites was syphilis

and by it they will probably be remembered for years to come'.

Smallpox seemed to be the disease most dreaded by the Aboriginal people. At least three smallpox epidemics ravaged the region's population, each of them spreading swiftly along the coast and a considerable distance inland. The first of these epidemics occurred around 1789, before the arrival of Europeans, and was a consequence of Makassan contact, the second in 1829–30 and the third about 1869. It was said that so many people died during the last epidemic that not all the bodies could be buried. According to the people of the Cobourg Peninsula, the epidemic reached them from the east and continued on to the East Alligator River, but Aborigines in Darwin claimed that the disease came from the Alligator Rivers region.

Leprosy, which became endemic in the East Alligator-Liverpool rivers region, was introduced by contact with infected Chinese. The Aborigines' first contact with the disease may have occurred at the Pine Creek goldfields where several thousand Chinese worked in the 1880s and 1890s, on Barrow Island at the mouth of the South Alligator River, or on Cobourg Peninsula where the Chinese were cutting timber in the early 1880s.

The virulent and usually fatal diseases spreading through the region must have created terrifying experiences for the Aboriginal people, while the associated European incursion caused social fragmentation, displacement and rapid, enforced social change. Undoubtedly, high stress and anxiety were experienced by all Aboriginal groups within the region.

When called upon to treat people suffering from any of the foreign diseases, Aboriginal healers were unable to

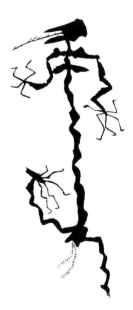

*Right* A female sorcery figure with a violently contorted, convulsed body. A barbed tongue protrudes from her beaked head. The hands and feet are claw-like, and namarnde plants emerge from her vulva. Location: Ngarradj wardedjobkeng. 90 cm.

*Opposite* Although many sorcery figures were painted in occupational shelters and other easily accessible sites in order to be seen, others were executed in restricted places associated with other potent powers. Such a site is this well protected wall, situated below the top of a high and prominent rock face in the immediate vicinity of the East Alligator River, where several sorcery figures and other images depicting ailing persons are represented. Location: Daberrk.

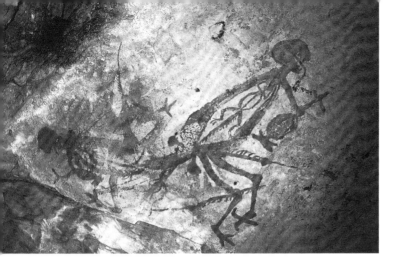

In this early sorcery painting of a copulating couple, each of the victims is depicted with a flying fox hanging from one arm and with a spear through one knee. An additional spear is piercing the male's pubic region, and a freshwater crocodile is biting his penis, while another crocodile, seen within his body cavity, devours his organs. Both figures are shown with painful grimaces and protruding tongues. Flying foxes and freshwater crocodiles are an integral element of early sorcery figures. Location: Yuwunggaya. Overall 120 cm.

The head of this female sorcery figure has a crocodile-like jaw and long protruding tongue. The body swells below the breasts, enclosing a group of stick-like humans. Within the body is a diagrammatic representation of the backbone and intestines. She is shown squatting, or perhaps lying down with her legs pushed back. Her elbows and knees are grossly swollen. A freshwater crocodile with a distended body has its head partially within her vulva, while a number of marks, perhaps depicting blood discharge, are painted along its body. Location: Inyalak. 85 cm.

cure them with their own bush medicines and traditional practices or with spiritual intervention. Consequently, the symptoms and resultant deaths were attributed to sorcery. A perpetrator of such a hostile act was then sought, and violence or sorcery were used to exact revenge. Thus, contact resulted in an increased number of deaths due not only to the introduced diseases, but also to the generated social conflict. Sorcery became widely practised, especially along the north-western edge of the plateau, the point which experienced the maximum and most prolonged contact. There, sorcery was initially applied to suspected murderers and wrong-doers of similar ilk, but later it was commonly used against an unfaithful wife, a woman's lover, a woman who had rejected a man's attentions and others perceived to have acted outside a social code.

The use of images representing the intended victim in rock art is just one of a number of sorcery techniques practised in this region to settle grievances. In sorcery paintings, humans are commonly depicted with deformed and twisted bodies, with lumps and swellings or with long, tenuous or claw-like fingers and grossly distorted sexual organs. These malformations represent the afflictions the aggrieved wished upon his victim before death. Some images have one or more limbs missing, while others are depicted with the body infilled with marks which may represent tumours, the lesions of leprosy or blemishes left by smallpox.

It is possible that not all such images were associated with sorcery, but may instead depict victims of an actual illness or disease. In some paintings a body is surrounded by lines

or marks suggesting a person consumed by fever, and in others the head is in profile and clearly showing blood being coughed up from the lungs.

Many sorcery images are compact and complex compositions with the violently contorted, grotesque bodies often having animal heads. The artist's imagination had no limits, and the list of implied deformities found in the art is endless. In several shelters the most recent layer of paintings consists solely of sorcery effigies, suggesting that although such images could be painted anywhere, certain locations were considered to have greater potency.

Sorcery effigies were also sometimes depicted pierced by spears or stingray barbs or with the leaves of angarnbubbu or anbinjdjarrang (unidentified plants) attached to many parts of the body and emerging from the mouth, the penis or the vagina. These plants are traditionally associated with Namarnde, the malevolent spirits of the local environment. It is said that after death the human body joins the realm of these spirits, and both the human ghost and the corpse are referred to as namarnde. By attaching the plants associated with the Namarnde spirits to the effigy, the painter seeks the victim's death. This feature of the sorcery design is referred to as the namarnde plant.

Sorcery paintings could be practised by any person who knew the process. However, when seeking a more assured effect, people called on the powers of an acknowledged marrgidjbu, a 'powerful' sorcerer, who often lived elsewhere but whose reputation was renowned throughout the region.

The painted sorcery images vary in complexity, from single-

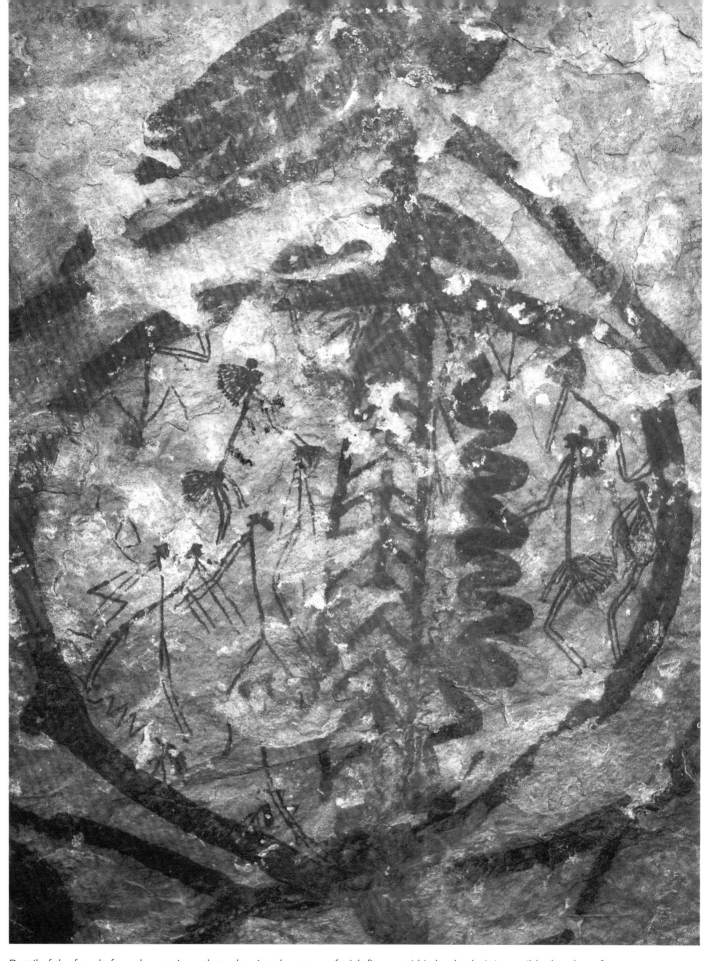

Detail of the female from the previous plate, showing the group of stick-figures within her body. It is possible that these figures were present on this wall prior to an artist painting the major figure, as the stomach appears deliberately extended to encompass them all. The thick walls of the female's body cover portions of several of these figures.

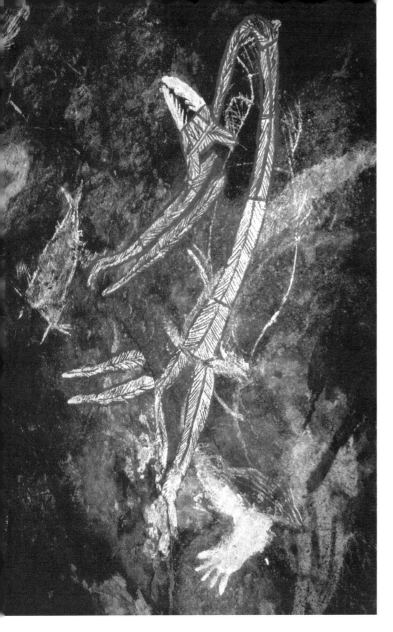

A sexually undifferentiated sorcery figure with animal head, broken back and separated limbs. Location: Ngarradj wardedjobkeng. 65 cm.

Some paintings may depict the symptoms of a person afflicted by introduced ailments. This weathered painting shows a human, with the head in profile, coughing blood. Location: Inagurdurwil. 74 cm.

line monochromatic sketches to complex multicoloured figures with elaborate decorative infill. To give paintings added potency, the white pigment used for the base silhouettes of the images was combined with crushed anginjdjek, the toxic round yams *(Dioscorea bulbifera)*, which if eaten untreated cause violent illness. The incorporation of the raw yam in the image was said to enhance the efficacy of the curse.

Other images were completed by scratching with a stingray barb or catfish spine, those poisonous bones that can cause painful swellings. To project the destructive magic, the artist verbally described the suffering and illness he wished to inflict on the intended victim. Usually the name of the victim was also called out while the image was being made, although this was not necessary. Sometimes a fire was lit, its smoke drifting over the painting and out of the shelter into the countryside,

conveying the magic to the victim's spirit. Flames from a fire were also used to scorch the painted effigy, magically harming the victim. It was possible for the aggrieved or another person to change or remove the painted images and thus the sorcery. Consequently, to ensure that nobody dissipated the magic, the artist could talk to the painting, instructing that only he had power over the image.

Several images with sorcery intent are moulded from gabbai, a toxic resin extracted from the roots of the ironwood tree. This substance was also used in other sorcery techniques.

Stone flakes or barbed fish spines were also used to scratch human images into the bark of white gums *(Eucalyptus alba* or *E. papuana)*. As the smooth bark dried and cracked, the victim grew sick. Later, when the bark sloughed from the tree, the victim died. If a destructive magic image was cut

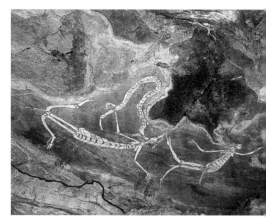

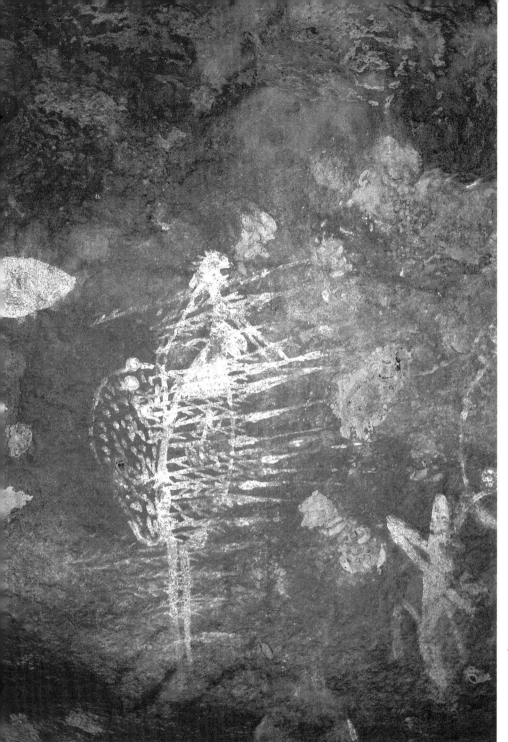

*Above left* This pregnant female carrying a large dilly bag is pierced with 18 single and multi-pronged spears. Location: Mikginj. 33 cm.

*Above right* Two female figures with beaked heads, fish-like vertebral columns, human hands and macropod feet. The adjacent Rainbow Snake is an integral part of this composition. Location: Dugulah djarrang. Female at left 110 cm.

*Right* The victims of sorcery are often shown with one or more limbs disarticulated from the body. In this example, the head, arms and one leg have been severed. The lower arms are separated from the upper part by a narrow constriction, which is sometimes used instead of the more usual convention of two parallel lines to indicate joints. One of the legs ends in a human foot, the other in an animal pad. Location: Amarrkanangka. 95 cm.

*Overleaf* In this shelter, the decorated hand motif became the dominant artistic expression. The painted and decorated hands together with hand and arm stencils are seen in their full range of complexity, from the most simple form of a hand stencil infilled with contrasting pigment to stencils outlined, subdivided and decorated with various patterns and colours. Location: Amurdak.

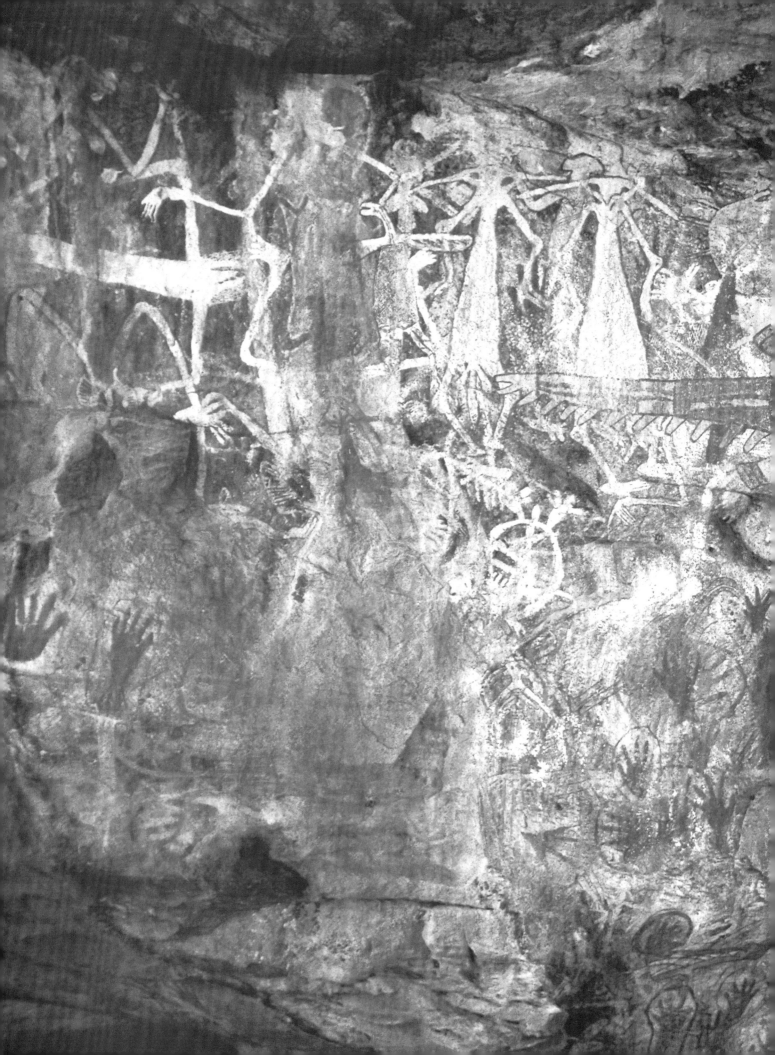

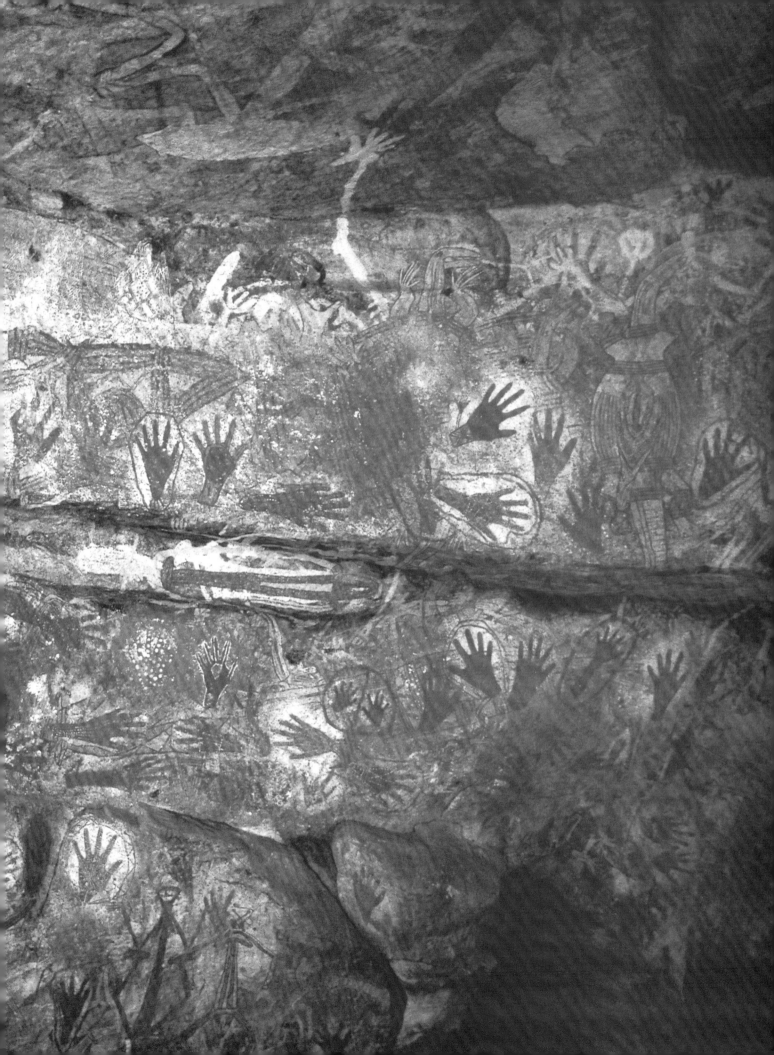

rather than simply scratched into the bark of a white gum, the process was said to be irreversible because it could not be obliterated either by washing it off as was sometimes done to a painted image or smoothing over scratchings.

## *Gunbid bim*
### DECORATED HANDS

Decorated hand stencils, painted and decorated hands as well as hand and arm designs form an integral part of the suite of contact paintings. Their distribution extends from the northern outliers of the Wellington Range at the base of Cobourg Peninsula to the Oenpelli and Ubirr-Cannon Hill region, with occasional individual representations being found elsewhere along the northern and western margins of the plateau.

A group of simple hands executed in outline and internally subdivided is found in the Nanguluwurr shelter of Nourlangie Rock, while a more complex example of this type of rock art is located in the Deaf Adder Creek valley.

Most of the elaborately decorated images are found in the estates of the Amurdak-speaking groups, whose social and ritual ties were with the Iwaidja and Garrig people of

A decorated hand enclosed in a double-lined frame and with an interior zigzag design. After the hand was stencilled, its interior was finely hatched in red and then further decorated with dotted outlines and subdivisions. This image probably represents a European glove. Location: Amurdak.

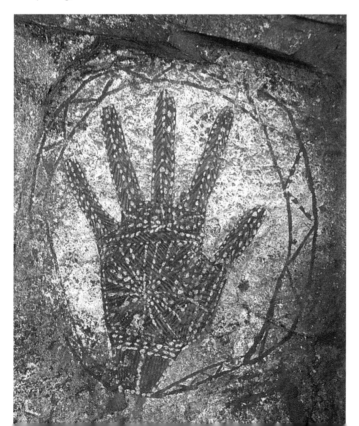

Cobourg Peninsula. Namadbarra, a knowledgeable man of the neighbouring Galardju clan with ritual responsibility for this area, said that the decorated hand motif has its origin in the gloves worn by Europeans at the Victoria Settlement. The concentration of such images at this location also suggests that it was the point of origin of this art form. It seems that some of the many variations of the design depict the gloves alone, while others are portrayals of hands showing life-lines and nails. The concept of painted and decorated hands, however, may have had an earlier origin, as gloves were worn by Dutch settlers in Sulawesi and other Indonesian islands and would have been seen there by Aborigines visiting those regions with their Makassan friends. The most recent examples of glove-like images were painted after 1925, when a 'reliable' source of the blue pigment used in their execution became available from the laundries of Oenpelli Mission. Before that time, treasured samples of this 'washing blue' were brought in from Darwin.

The simplest form of the decorated hand motif is a stencil with its interior filled in with solid colour. In the next step of elaboration, as seen at the Ubirr site, such hand images were encircled by a thick band of the same pigment. Another basic form of the motif is a stencil in which a silhouette of the hand was outlined and its interior infilled with spots or other marks. In the continuing development of this theme, two or more pigments were used to outline and subdivide the stencil and also to decorate it with a geometric pattern. This decorative trend was further extended by using various types of hatchings to enhance the motif. Several designs have an almost lace-like quality, suggesting that they may have been based on this type of glove. Markings on other hand designs may represent the individual pieces of leather forming a glove.

Many of the decorated hands are 'framed', in that they are surrounded by linear designs. In the simplest form of this design, the hand is encircled by a band which separates the image from others that may surround it and also from paintings which it overlies. Occasionally, the band is left open and small decorative arms extending outwards may be attached to the hand. The enveloping band, varying in width, is sometimes further decorated on the outside by a scalloped line. In other images, a double band encasing a zigzag line surrounds the hand. This design, more than any other, focuses attention on to the image and its effect is very much like that of a European picture frame – perhaps the concept of such an enclosure was based on framed pictures seen at settlements or missions.

The hand motif, as expressed during the previous periods in its stencilled form, allowed identification of its maker by members of the group to which he, or perhaps she, belonged. (Women occasionally made hand stencils, but did not fill them in with designs.) The hand stencil also appears to act as an artist's signature in some compositions of the dynamic figures style. When an artist started to infill the hand stencil with painted forms, the distinguishing contours of his hand were lost. It was perhaps to retain identity that, as well as using distinct elements to decorate the hand, the image was placed in a unique frame that emphasised the artist's presence and identified his work. The encircling of a sign is a tradition used today by some Aborigines when endorsing a document. The typical mark, a cross, is either placed within a circle or the circle is made over it.

## 'Rubbish' paintings

### CASUAL ART

In the western part of the plateau, a consequence of the European incursion was the movement of Aboriginal groups from the 'stone country' to the 'buffalo plains' with their townships, mission and settlement. Young people brought up in such communities were not able to acquire many of the traditional skills, a fact reflected in some of their attempts at painting in the local rock shelters. Whilst the majority of the most recent paintings were executed by accomplished artists, these others done by persons lacking the appropriate skills were usually carelessly constructed in roughly prepared pigments from locally obtained clays, which were daubed on to the rock surfaces with the fingers or applied with European brushes. I refer to them as casual art, but to the Aboriginal people they are 'rubbish' paintings. The former term is also extended to those paintings which, although of a more accomplished mode, were executed on the behest of non-Aboriginal people, as these images are in most instances noticeably different from traditional work.

In the casual paintings, human beings or animals were usually portrayed as crude silhouettes. Other designs with mazes of lines, tentative figures and graffiti were drawn in charcoal. In some shelters, previously used ochre pieces were recycled in their dry form as chalk to draw simple designs. However, this short phase of inept image-making was an aberration. It ended with the establishment of outstations, which encouraged people to return to their traditional lands. The inception of self-governing communities where

Although the person who made these images used red ochre instead of the white slurry generally used by unaccomplished artists, his execution of the fish-like object, the solid bar, the imprints of hands and the simple structure of a house identifies these as belonging to the casual art phase. Location: Awunbarrna. House 30 cm.

the people could decide their priorities, and the advent of empowering land rights legislation that placed the traditional owners in control of their estates again, soon followed. It was then that the traditional artistic systems came to the fore once more, albeit in other forms. On the outstations people visit the rock art shelters to acquaint themselves with their Dreaming, but they paint on sheets of bark. Those who live at Gunbalanya (Oenpelli) though occasionally continuing to use bark as a canvas for their paintings, now prefer heavy, handmade watercolour paper for their work. Gunbalanya is one of several art centres producing paintings sought-after by the world's foremost museums and art galleries, and exhibited at prestigious events such as the Venice Biennale.

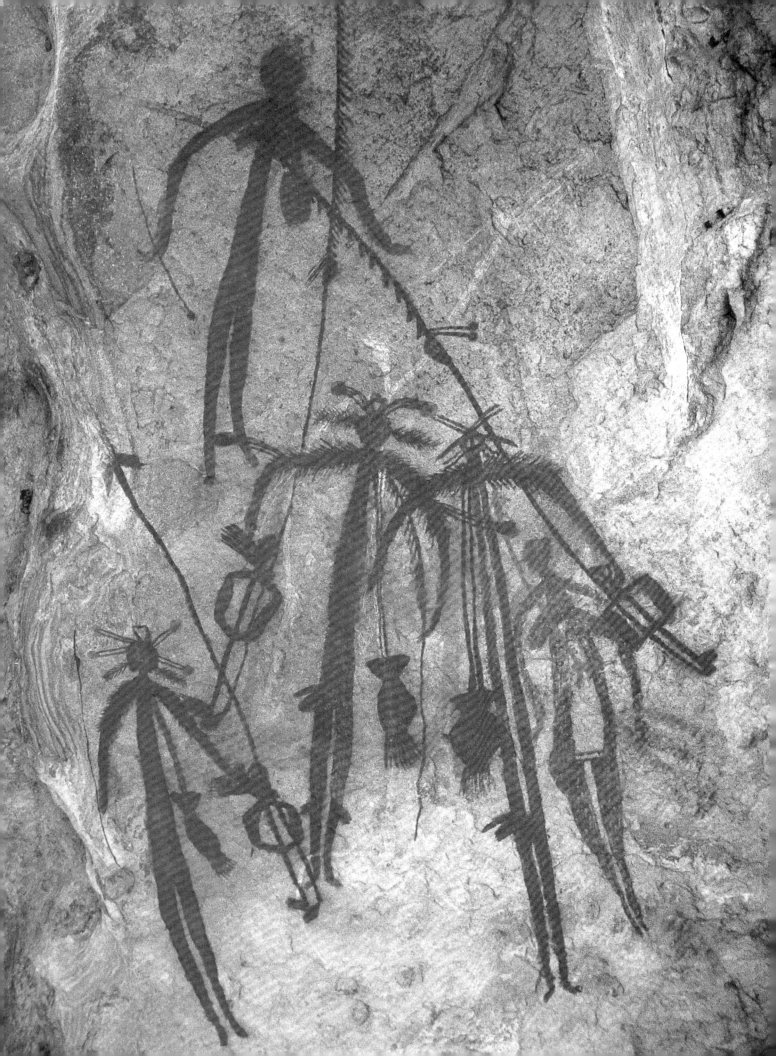

# Some Art Techniques, Motifs and Themes

Throughout the tens of thousands of years of Aboriginal creative endeavour, artists of the region have depicted the changing aspects of their physical, social and religious environment. A substantial number of portrayed subjects are known, though many symbolic images remain unidentified. Variations on themes occurred in different periods and styles, and concepts were abandoned and rediscovered or have continued in other expressive forms such as poetry and dance. In almost all the paintings, one can recognise the artist's intimate knowledge of the subject, an aesthetic commitment, and mastery of the media used in their execution.

## East Alligator figures

Several types of human figures, of very limited spatial distribution, are found along the north-western margin of the plateau. The type site for these figures is Inyalak, but they are also found in a number of other shelters throughout the Mengerrdji and Erre language group estates, centred on the East Alligator River. The best known of these paintings are the masterpieces of stylised human form, the graceful Mountford figures, which are usually portrayed in vivid movement. Mountford also recorded human figures of simple body form with large heads and tall beings with hairy arms, which he identified as Munimunigan and Nalbidji spirit beings. Unique to the area, it is said they share the 'stone country' environment and have several characteristics in common with the Mimi spirit people.

The Munimunigan, which have large masses of hair on their heads, are tall and so thin that it is said they can only search for food during calm weather, as their bodies could break in the slightest breeze. However, only one such elongated figure is present at Inyalak. The other figures at this site are small, quite robust images executed as silhouettes. One of these figures is associated with boomerangs and a fighting pick, suggesting this stylistic form is of considerable antiquity. In the Merl site complex the figures are depicted in dark red outline, with parallel lines across their oversized heads, possibly indicating the string binding of a hairbun or headdress. The bodies are depicted frontally but with their heads, and the penis in male figures, shown in profile. Testes delineated within the scrotum provide an X-ray element to these figures. One figure is infilled with a wash of lighter coloured pigment and decorated with body markings, perhaps indicating cicatrices. These large-headed beings are not found in numbers great enough to allow reliable analysis or interpretation.

The Nalbidji figures, the 'hairy armed' people, are clearly human beings and are depicted performing traditional activities. They occur in individual representations and in compositions, and seem to represent a local group of people. The paintings of the 'hairy armed' people are of a more recent period than those of the Munimunigan, as indicated by the range of spear types and the complex spearthrowers with which they are associated. However, they do not form a clear stylistic unit as considerable variation in execution of the figures is evident. Some of the bodies are stick-like while others are well proportioned, and in height they vary from short dumpy beings to average-sized figures and extremely elongated representations. Their common features are the hairy arms, square hollow eyes and their association with complex spearthrowers. Some are also shown to have hollow bodies, occasionally with a backbone or decorative infill. The hair on their arms extends from the shoulders to the elbows.

The most beautiful example of 'hairy armed' people is this composition of three male and two female figures. With the exception of the hollow-bodied female at right, which remains in the original pigment, these figures have been carefully enhanced with brilliant red ochre. The men are holding complex, tasselled spearthrowers engaged to single- and three-pronged multibarbed spears, which are also decorated with tassels. Fluted and tasselled dilly bags hang on long strings from their shoulders. Feathers, 'power' bags and single and double wooden hairpins decorate their heads. Although only one male figure has hollow eyes, others were also originally depicted in that convention before being overpainted. The accompanying female figures lack arm hair and wear no decoration, though the female at upper left is shown with a dilly bag and carrying a slender, knobbed digging stick. Location: Inyalak. Male figure at left 41 cm.

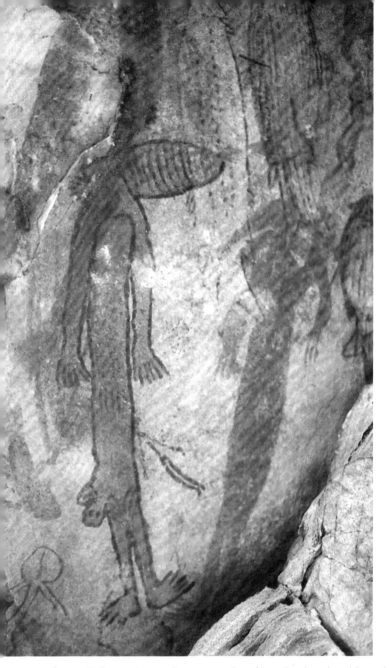

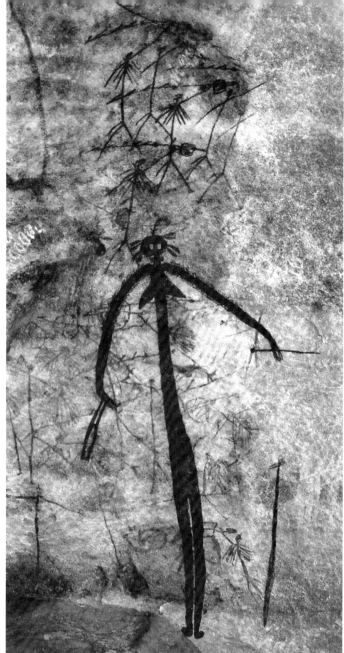

*Left* A male figure depicted in a twisted profile. A beehive headdress, bristly beard and testicles enclosed in his scrotum are evident, and he may be subincised. The curving lines may represent his buttocks or cicatrices. Further cicatrices are suggested by the lines and marks on his abdomen. Location: Merl. 72 cm.

*Right* This graceful, elongated female has 'hairy' arms and hollow eyes. Her head is decorated with feathers, and she wears a broad necklet and carries a dilly bag in one hand and a knobbed, pointed digging stick in the other. Positioned above her head, and perhaps executed at the same time, is a group of one-line-thick stick-figures usually found associated with the 'hairy armed' people. These figures wear capes and are using complex spearthrowers. The elongated female is superimposed over an earlier group of such figures. Location: Garrkkanj. Female figure 90 cm.

Generally the hair is bristling up the arms, although it also occurs aligned in the opposite direction. There is a possibility that this hairy design on the arms may represent feathers, pelts or other such objects attached as decoration rather than actual hair growth, as in one example strings hang from it suggesting that the covering was tied to the arms. Although many of the figures are frontal and static, some are depicted in profile and others of simpler configuration are shown running with their spears poised ready to launch. In several compositions, full bodied and decorated figures are associated

with a group of stick-like warriors.

The 'hairy-armed' figures are also associated with many items of material culture. Fluted dilly bags with tasselled decorations usually hang on long strings from the men's shoulders, while small 'power' bags, giving the wearer strength in fights, are worn on their foreheads. Some of the male figures wear a cape-like covering extending over the upper part of their bodies. This adornment may have been a plaited matting similar to mosquito mats or it may have been made from grass or pandanus leaves. Some of the men

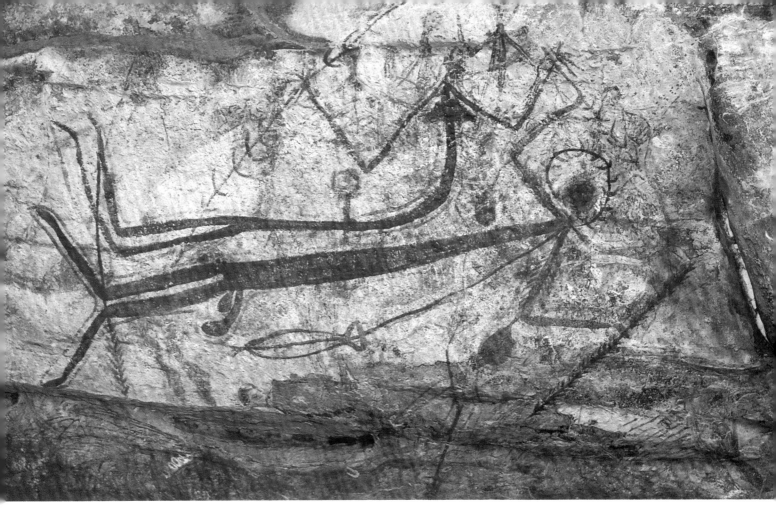

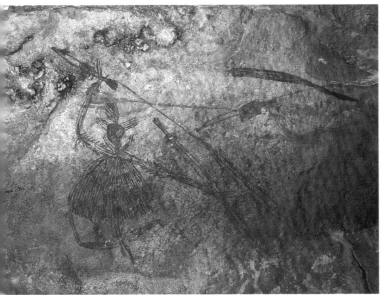

*Above* An enigmatic, graceful composition of a human couple, in which only the male has 'hairy' arms. He lies prostrate, with a biserially barbed spear across or through his knees and with his head encircled by a plant-like vine similar to that held by the female. Bags on strings hang from his elbows and a fluted dilly bag attached to a long string leading to his shoulders lies alongside his body. A similar bag hangs from the woman's shoulder, its meandering line crossing the male's body. The male holds an object which is barbed on both sides, except where he grips it. His body, like that of the female, is contoured below the chest by a continuous line. The square-panelled complex spearthrower associated with the male figure is placed some distance away, as if not to disturb, by its angularity, the flowing lines of the composition. Location: Dangurrung. Female figure 150 cm.

*Left* An active portrayal in which a running man is holding a three-pronged multibarbed spear engaged in a complex spearthrower in one hand, and three composite uniserially barbed spears of two hooked types in the other. The 'hair' projects up his arms. Strings hang from his elbow, suggesting that the 'hair' could have been a covering that was tied to the arms. Further areas of hair can be seen at his wrists. Location: Dangurrung. 30 cm.

are depicted using complex tasselled spearthrowers and other single- or multi-pronged composite barbed spears decorated with tassels and pendants at the junction of the head and the shaft. Others are shown with 'goose' spears or with spears tipped with long wooden lanceolate blades. Female figures have utilitarian dilly bags hanging from the back of the head or carry a bag in the hand. Some male and female figures carry slender sticks that are knobbed at one end, which may be either digging or throwing sticks.

## *Powerful women*

Like all artists, the men of the Arnhem Land Plateau usually portrayed what they were most concerned with: in their case, it was the sought-after prey, the beings of their ancestral and religious domain, the spirits of their environment and the subjects of their sensuous desire, women – often depicted in the most revealing poses. Occasionally, they also acknowledged that women held a key role in the life of their group and expressed this in their paintings. That such respect and admiration existed in the distant past through to the period of contact can be seen in two similar compositions, shown here. The confident female standing between two elaborately dressed men in the first example was portrayed by an artist of the very early dynamic figures style, while the dominant female figure reaching for a gun in the second example is clearly from historical times.

The authoritative central figure and her two male companions in the other composition below is also of the historical period. This remarkable lady was widely admired and consequently well remembered. Her name was Maudie Maralginigini and she belonged to the Amurdak-speaking Gamulkban clan whose traditional land extends north of Cooper Creek. At the time this image was executed she was the 'boss' of the Kapalga camp while Fred Smith, the local buffalo shooter, was ailing. A skilled horsewoman, Maudie was left in charge of running the camp as well as overseeing the shooting and processing of the buffalo hides. Carla Ngaldjorrun, who at that time also worked at Kapalga, recalled that there were about a hundred young men and youths working there: 'Old Fred was no good then, he was too old. Maudie, who had a daughter named Rosie, was the boss.' Maudie's deeds were well known throughout the region and it is possible that the painting showing a dominant female figure extending her arm towards a gun, found in a shelter at Golbon in the Godjgarndi's estate, may also represent her.

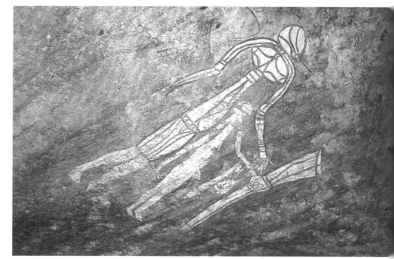

*Top* A confident woman depicted in the dynamic figures style. She is standing with her feet apart, holding a digging stick and wearing a large dilly bag down her back. Associated with her are two men in large, elaborate headdresses. The male figure at right seems to be moving towards her with a stick raised in one hand and a boomerang in the other. The meaning behind this narrative scene is not known. Location: Djarrwamb. Female figure 31 cm.

*Middle* A female figure wearing a skirt is shown extending a hand towards a gun. Below her arm is a small male figure associated with a spearthrower and holding a dilly bag. The woman and the gun are enhanced with red pigment. Location: Golbon. Female figure 105 cm.

*Above* Maudie Maralginigini shown standing with her hands on her hips – the position of authority – between two smaller images of men, one of whom, like her, is smoking a pipe. As the male figures are also shown in the powerful hands at hips position, they may represent buffalo shooter Fred Smith and another European. Location: Ubirr site complex. Maudie 35 cm.

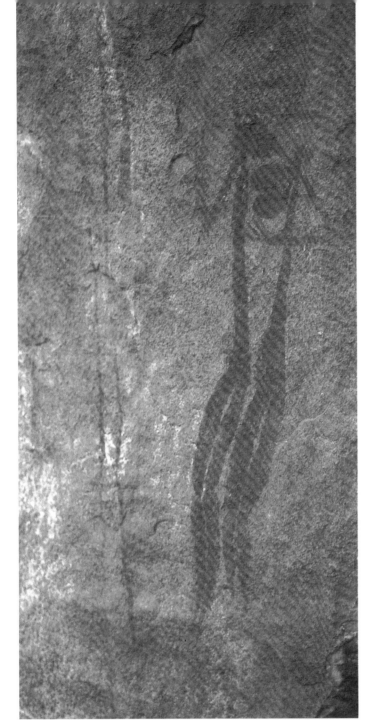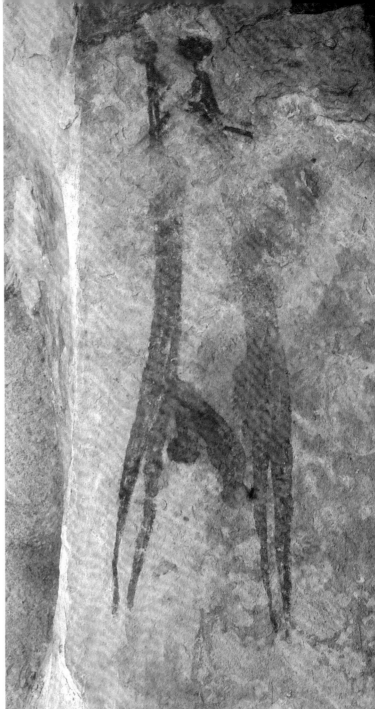

*Left* In these elongated figures, the prominence given to sexual organs is opposite to that in the following plate – the male has a diminutive penis, while the female has swollen breasts and a prominent pubic region. Location: Mabirrarnja. 43 cm.

*Right* Tall elongated and sensuous figures – the female with minute breasts and the male with an exaggerated, uncircumcised penis – represent one form in which sexual relationships are depicted in rock art. The figures, shown embracing, evoke a feeling of tenderness. Location: Djuwarr site complex. 60 cm.

## *Human sexuality*

Human sexual relationships have been expressed in rock art images from the commencement of this art form. Later, with the beginning of the mythogenesis, union between humans and spirit beings is also depicted. In one small area of the plateau region, human sexuality dominates the themes and imagery of the rock art. All forms of male–female relationships are vividly and often explicitly depicted. Although some of this sexual imagery represents actual relationships, others are said to be expressions of love magic in which the artist depicted wished-for encounters or admired female stereotypes. Many paintings show the pure physicalities of sex, but in several compositions, whilst emphasis is seemingly given to the sexual organs, the depicted relationship transcends mere sexuality and exhibits sensitive, sensual human responses.

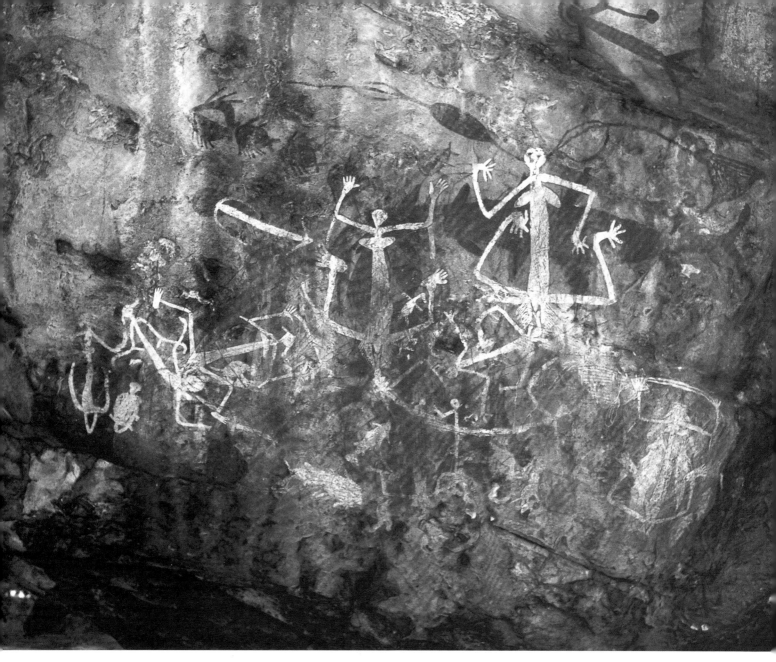

*Above* A composition of three copulating couples, together with a female figure holding a doubled string between her hands and with splayed legs exposing her vulva. Similar string is also held by one of the females engaged in sexual union. It is possible that this scene depicts a ritual act. Location: Wulirak. Single female figure with string 53 cm.

*Right* Love play is one of the many forms in which human sexuality is expressed in rock art. Location: Yuwunggayai. Male figure 25 cm.

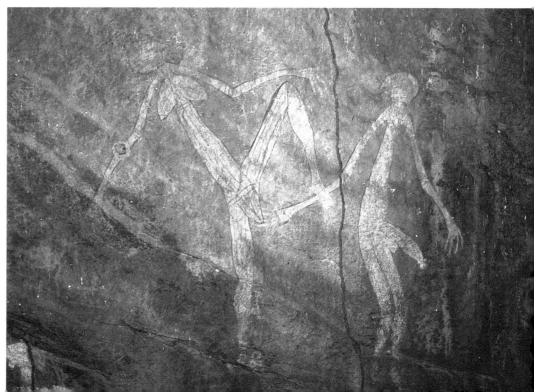

## Dismembered bodies

The artists of the region depicted the human mode of existence through all stages of life, to the body's demise and final interment. The cycle begins with images of a child's conception, a baby at breast and an initiated neophyte. Adult men and women were portrayed participating in all the traditional activities, finally being shown placed on mortuary platforms. The cause of death is also indicated, perhaps with a spear through the back or an ensorcelled body.

After a preliminary ritual, the body of a deceased person was traditionally placed on a mortuary platform – a free-standing structure or one made in a branching tree – where it remained for two years. By then, only the skeleton remained. It was disarticulated and brought back for the final ritual, after which the remains were placed in a hollow log or dilly bag, or wrapped in paperbark, to be deposited in a rock shelter. This was the general practice throughout this region, although burial also sometimes took place.

The death of a person and the stages of decay to which the body was subjected formed the theme for a minor but plateau-wide motif. Both dismembered bodies, some associated with animals that are attracted to carrion, and disarticulated skeletal forms are found in a number of stylistic periods from the pre-estuarine to the most recent.

The representations of disarticulated limbs and dismembered bodies symbolise the process of decomposition, while the skeletal assemblages depict the burial bundles that were to be placed in ossuaries. Once the spirit has left a person's body, it is referred to as Namarnde, the general

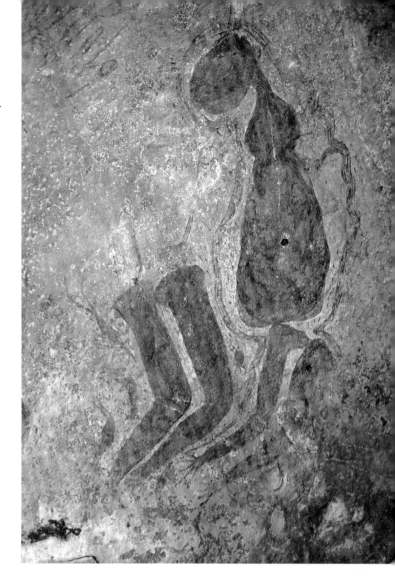

term for malignant spirits, and later the skeleton is known as namarnde gunmurrung ('Namarnde's bones'). Plants associated with these spirits, used in sorcery imagery, are also depicted on some of the dismembered bodies and skeletons.

*Above* A limbless torso and the separated arms below it are enclosed by a contoured band and dashes. The legs and buttocks set outside this enclosure are surrounded by small unidentified animals. It is possible that the contouring band may represent an interment or a bark shroud. The head of the deceased is shown in profile, with facial features displayed. This painting is the earliest example of this motif in the stylistic complex of the large naturalistic figures. Location: Liverpool River. 200 cm.

*Right* Two human skeletal assemblages, representing either two separate figures or two stages in the process of disintegration of a single figure. The figure on the right may still be decomposing as the arms continue to be connected to the body, while the head shows some external and internal features. The spinal processes (or outgrowths) of this figure are only beginning to appear from the torso, while on the other figure they are very prominent and a namarnde plant is protruding from the buttocks. Both images show the penis and testes as a continuation of the spine. That the phallus remains attached to the body's skeletal form indicates that the deceased person was male, and may also be a symbol of power or represent a generative force. Location: Djuwarr site complex. Figure at right 85 cm.

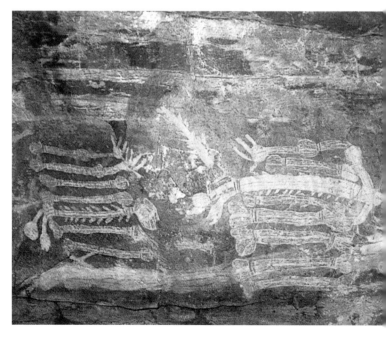

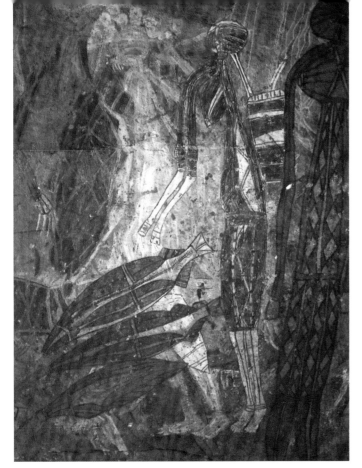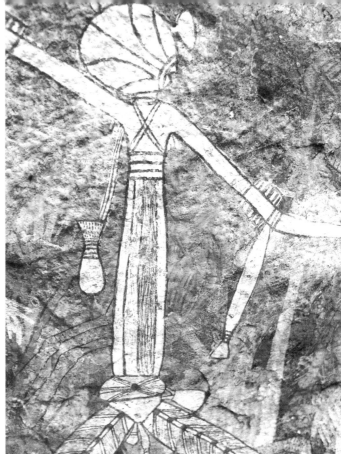

*Left* A female figure executed in the decorative X-ray mode is shown in profile, with a dilly bag decorated in painted bands hanging down her back. Location: Yuwunggayai. 120 cm.

*Right* Detail of a hunter figure with a 'fighting' bag attached to a band on his forehead and a small, tightly woven, fluted dilly bag with his magical and secret possessions hanging from his shoulder. Location: Djalandjal.

## Dilly bags and string bags

Many rock paintings depict men and women using a variety of dilly bags and string bags. These bags were present in the region from at least the commencement of the dynamic figures style. However, considering the number of bag types evident in that style, bag making was probably already an inherited craft. An increase in the variety of bags is noticeable later, in the compositions of the estuarine and freshwater periods, and may have been due to the introduction of new plant species which were more suitable for producing smaller bag types.

Dilly bags – twined baskets made from grass stalks, rushes or split cane – are made in several shapes and sizes. Depending on the material from which they are constructed and their intended use, the rigidity of the meshwork and the tightness of the weaving also vary. The more open-netted types are used to carry plant food and as general containers, and also for food preparation such as leaching the toxic yams. The most closely woven type is made to carry honey. Tightly woven bags are often decorated with bands of interwoven lorikeet feathers. In the past they were also decorated with painted designs in which bands of different colours alternated with panels infilled with hatchings or stylised human figures. A rock painting of such a dilly bag replicates one that was collected in 1912 at Oenpelli by Baldwin Spencer.

Across most of the region, men carried over their shoulder a small bag in which they kept their prized possessions. In the estate of the Mengerrdji and Wurningak clans, they are also commonly depicted with a long, fluted dilly bag. Men also wore a smaller bag on their chest in which they carried secret and magical objects. An even smaller bag, sometimes worn on the chest but often depicted attached by a band to the forehead, was their 'fighting' or 'power' bag. Padded with paperbark, wild cotton, grass or feathers, these bags were held in the mouth and bitten into when engaged in conflict. The dilly bags carried by women were larger and more utilitarian.

There were also many types of string bags made by knotted or knotless techniques. Some of them had decorative bands in which the string was interlaced with birds' down or animal fur. In more recent times the fibres used in string bag manufacture have been dyed, using a variety of colours obtained from the roots, flowers and berries of native plants.

## Crocodiles

The names of the region's three alligator rivers indicate the similarity in appearance between crocodiles and the other members of the ancient order of Crocodilia – the alligators, caimans and gavials. When Captain Phillip Parker King sailed up the three rivers flowing into the Van Diemen Gulf in 1818, he was impressed by the large numbers of these reptiles and, mistaking the crocodiles for alligators, named the rivers after them.

Crocodiles are found throughout the world's equatorial region. Of the 21 surviving species, two occur in northern Australia – the freshwater crocodile *(Crocodylus johnstoni)* and the estuarine or saltwater crocodile *(Crocodylus porosus)*. The freshwater species has a long and slender snout, and inhabits permanent freshwater streams, lagoons and billabongs where it feeds on crustaceans, fish, frogs, reptiles, birds and small mammals. The saltwater crocodile has a relatively short and blunt snout. Its range extends from coastal waters, through estuaries into freshwater rivers and swamps. As well as feeding on fish, reptiles and birds, it also preys on larger mammals, including buffaloes and horses, and human beings. Aboriginal

*Above* A saltwater crocodile enjoying the last of the day's sun at Yellow Water in Kakadu.

*Below* Detail of a saltwater crocodile's head, shown in profile. Both eyes and the optic nerves are placed on this side of the head. The animal's snout is slightly open revealing rows of large teeth. Location: Birradak.

people hunted both species. Freshwater crocodiles were either speared or, if not too large, caught by hand in the water. Spears and, after contact, iron-tipped harpoons were used for saltwater crocodiles.

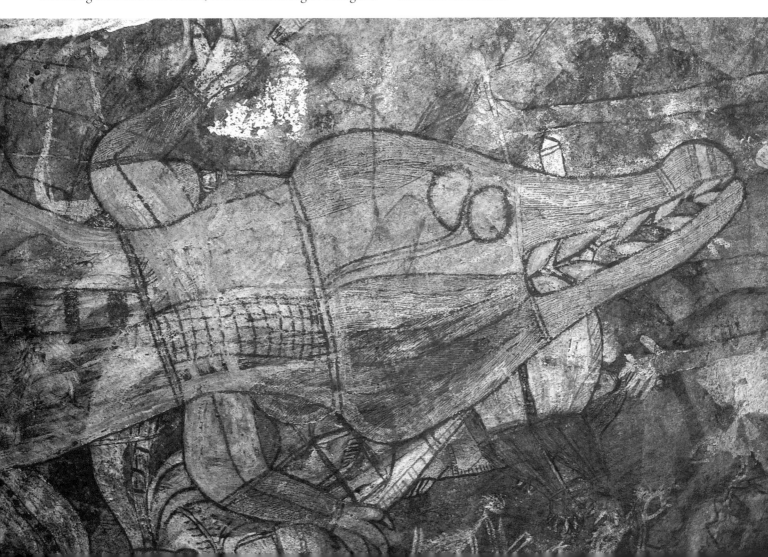

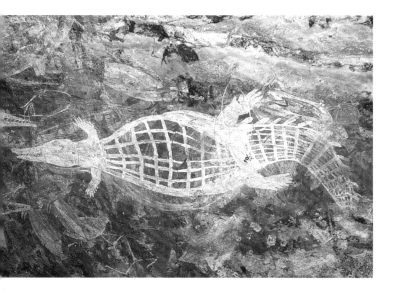

Although the majority of paintings depicting crocodiles in this region are of the X-ray convention, those found in the estate of the Erre-speaking Mirarr clan are painted in a naturalistic mode, replicating the pattern and texture of the skin. This clan's territory straddles the estuarine East Alligator River, an environment inhabited by the saltwater crocodile, though the majority of the images in nearby shelters are of the freshwater species.

*Left* This image is probably a representation of the saltwater crocodile, although it has sometimes been identified as the freshwater species. Its head is depicted in profile. The pattern of its body and tail depict the animal's scales, while its limbs are in solid pigment. Location: Inagurdurwil. 170 cm.

## Turtles

The two most common turtles found in the rock art of the region – the pitted-shelled turtle *(Carettochelys insculpta)* and the long-necked turtle *(Chelodina rugosa)* – reflect their importance in Aboriginal cuisine. The pitted-shelled turtle has a more restricted distribution than the long-necked turtle, but it makes up for this in size, growing to some 0.7 metres. It is a heavy-bodied turtle with a pitted shell and distinctive two-clawed flippers, and is commonly also called the 'pig-nosed turtle', referring to its pig-like snout. In the past this turtle was known as the 'Fly River turtle', as before its recent discovery in several Northern Territory rivers it was known only from that New Guinea river system. The long-necked turtle, as its common name suggests, has an exceptionally long neck. It is found throughout the region inhabiting swamps, billabongs, waterholes and slow-moving river systems.

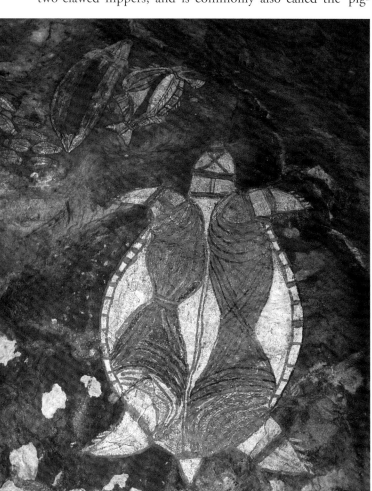

*Left* In the plateau's rock art the pitted-shelled turtle *(Carettochelys insculpta)* is usually portrayed in an inverted position with its 'pig-nosed' head facing downwards. The first clue that this species, known previously only from Papua New Guinea, also lived in Australia come when a scientist identified its representation in the rock paintings. This depiction clearly shows its peculiarly shaped head and sea-turtle-like flippers. The original painting was executed in white, red and black, and was later enhanced with the addition of a blue pigment. Location: Nawurlandja. 65 cm.

*Opposite* A representation of a pitted-shelled turtle in its Dreaming form, holding a spearthrower engaged to a spear in its raised hand and throwing sticks with the other. This painting was executed above a group of female figures by an artist of the Godjgarndi clan. Location: Narmarrgon site complex. 60 cm.

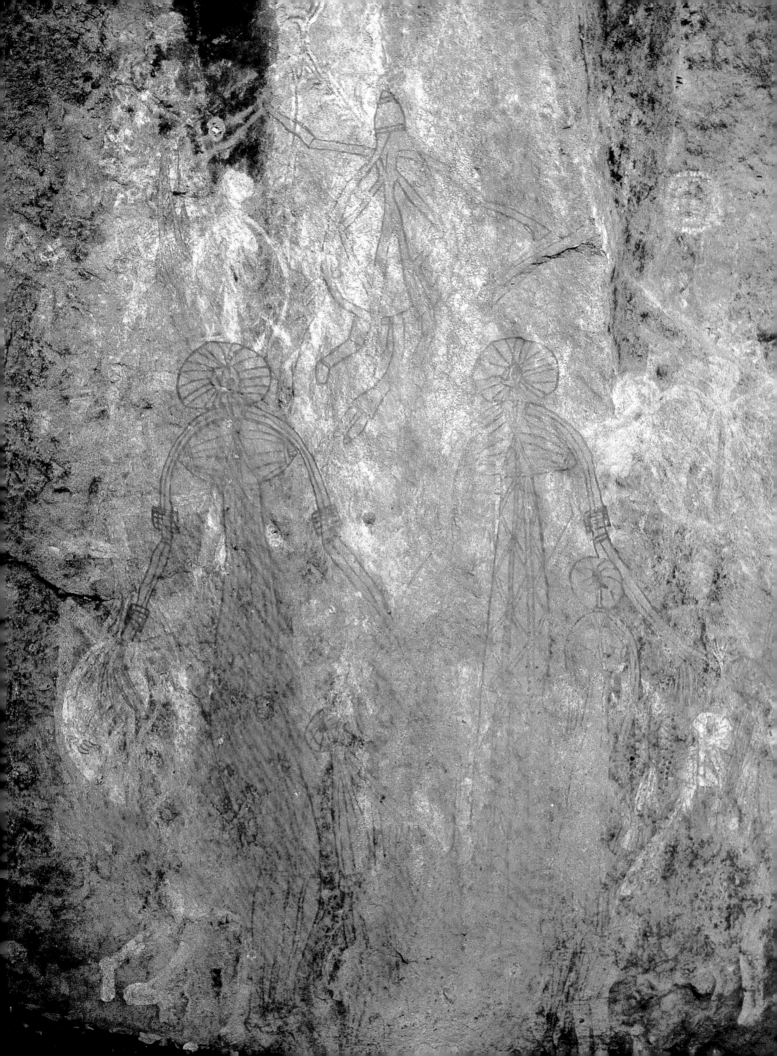

## Ceremonies

The painted representations of culture heroes, spirit beings and natural species may have several levels of disparate meanings associated with them. Some of the images have been, and continue to be, key elements of rituals. The best-known being is the frequently depicted Rainbow Snake, which is the personification of regenerative and reproductive power in the natural and human world, an agent of punishment and the main personage of the region's rituals. Other images depict the progenitors of animals and plants, the paintings being the species' Dreamings and the subjects of increase rites. There are also paintings of narrative scenes, depicting details of ceremonial acts. Some such paintings may reveal rituals no longer observed by the groups in whose estates they are located.

Most ceremonies of groups living around the plateau are intended to promote the spiritual development and social maturation of their members, the procreation of human beings, animals and plants, the maintenance of the seasonal cycles, and the continuation of the society and culture. In the past, large scale ritual gatherings occurred each year at a number of localities and some are still practised. There were also purely social ceremonies with entertaining songs and dances, some having erotic overtones. During these periods of social bonding, friendships were formed, gifts were exchanged and wives were promised.

During the more recent period, circumcision was not a part of male initiation ceremonies in the north-western part of the plateau, but a painted composition depicting this act shows that this ritual was practised in the past. In this painting a man, whose ritual stature is indicated by his headdress, kneels over a bare-headed, prostrate adolescent. He is holding an object, perhaps a stone flake, over the boy's pubic region. The man is identified as nabalukgayen, the initiator, who cuts the foreskin, while the adolescent undergoing this operation, his transition to manhood, is referred to as 'walk'.

To the groups living on the plateau the ubarr ceremony, which emphasises the increase of natural species, was brought and established by the 'plains' kangaroos (antilopine wallaroos). The principal characters are known by different names according to the language used. As they travelled across the land the pairs of kangaroos, each comprising a male and a female, left their images on the walls of local shelters. In some representations these animals are depicted with a feathered ornament on their heads and also with a dilly bag in which they carried the ceremony. To the people living north of the escarpment – the Amurdak, the Iwaidja and the Maung – the originator of this ritual was Yirrbardbard, later the western brown snake *(Pseudonaja nuchalis)*, and it is the representation of this species that symbolises the rite in their rock art.

In the Madjawarr myth the ubarr was brought and first enacted by Gandagidj, the antilopine wallaroo, who came to this clan's estate with his 'big mob' of wives, after parting from other wallaroos who carried this ritual to the southern part of the plateau. Gandagidj settled with his wives at Roberrawogwog, an open rock shelter used later by members of both the Madjawarr and the adjoining Murrwarn clans, where he decided to hold the ubarr ceremony for the local groups. After locating a source of white pigment, he painted a large representation of himself on the wall of this shelter so that the following generations would know what to do. Then he sent his wives to invite the people to attend the ceremony. Before they arrived he cleared a space in front of this shelter, formed the sacred ground and made the hollow log drum used in this ritual. Since then, many people have followed Gandagidj's instructions and participated in this ceremony.

Most of the ubarr ceremonial grounds along the northern edge of the plateau were located in the immediate vicinity of the escarpment or near rocky outcrops on which the ceremonial leaders painted the image of the kangaroo

A group of six male figures standing in forked trees. During the ubarr ceremony, men climb forked posts or branching pandanus palms from which the leaves have been removed and call sacred invocations over the assembled participants. Location: Ginga wardelirrhmeng. Male figure at right 16 cm.

This detail of an extensive composition shows two groups of male figures separated by a plant-like form. Most of the male figures are depicted with erect penises, although a line of figures at the lower left, with bowed legs, do not have the male organ, perhaps indicating that they are novices. The majority of figures hold weapons, either boomerangs or three-pronged spears. One uniserially multibarbed spear is also seen, but the spearthrower is absent. The artist may have depicted a ritual gathering, perhaps a peace-making ceremony. Location: Ginga wardelirrhmeng. Male at right 11 cm.

ancestor who introduced them to this rite. In locations where rock surfaces were not available, a bark shelter was erected and its inner walls were decorated with his image. A large white painting of the antilopine wallaroo can still be seen at the Roberrawogwog site. The locations of all the other representations of this species executed in white perhaps mark the presence of past ubarr ritual grounds.

Lorrkgon is a mortuary rite which traditionally involved the deposition of bones in a specially prepared hollow log. It usually takes place some two years after death. In the intervening period, the corpse lies exposed to the elements on a gundjuban (mortuary platform) which may be free-standing, constructed of four tall forked posts and cross members, or made in branching trees. A group of mourners surrounding such a mortuary platform are depicted in a shelter within the Madjawarr estate. During the lorrkgon ceremony, as in the rites performed immediately after the death of a person, accusations are made against any person or persons who are thought to have caused the death. The accused are faced by the aggrieved relatives, who throw spears at them until they are wounded and blood is drawn.

The lorrkgon ceremony is held with the waning moon, and, indeed, the principal spirit beings associated with this rite are Dird, now the moon, and his friend Djabbo, now the native cat, who brought death to the world. There are several versions of the myth which explains why people, once immortal, die, but these two characters are central to all of them. In the Gundjeihmi myth, the two beings travelling through the country came to camp one night near two small waterholes. One was a clear, clean pool of water, while the other had a decomposing animal with maggots crawling over it lying partially submerged near its bank. Dird warned Djabbo not to drink from the polluted pool, but to use the waterhole from which he himself was drinking. Djabbo did not listen to his friend, drank the polluted water and shortly afterwards died. That is said to be the reason why people and animals die, whilst the moon, although it also dies, nevertheless returns – but, although the period between the

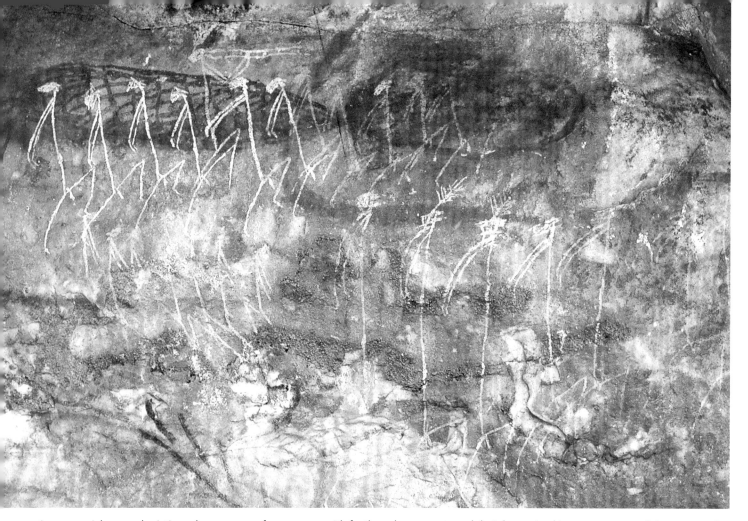

A ceremonial scene depicting a large group of men, some with feathered ornaments and their legs raised in an exaggerated dance step. A didjeridu player with a feathered ornament in his hair is seen at the top of the painting. Location: Djawumbu-Madjawarrnja. Upper left figure 23 cm.

'death' of the old moon and the appearance of the new moon is only a day according to a moon chart, the Aborigines see it as three days. There are two moon Dreaming sites, one on the western edge of the plateau and the other in the Maburinj country in the Warddjak clan's estate. In this latter location, at Dird kabaryo, the moon placed himself on the wall of a large rock shelter.

Some paintings of animal and plant species are imbued with the subjects' life essence – they are their Dreaming, their spiritually potent increase centres. Rites carried out at these localities to ensure the increase of the species take many forms. The paintings are addressed or sung to, they may be struck with a leafy branch, rubbed, scratched with the fingernails, a bone or a stick, or permeated with smoke. In many instances the increase rite was a selfless act on the part of the owners of the land where the painting was located, as the actual habitat of the particular species was in the estates of other groups. The increase rituals strengthened the bonds that linked the people of this region.

Increase rites are carried out at the Dreaming sites of most, but not all natural species. The exceptions are those species which are considered undesirable or dangerous. They include creatures of nuisance such as mosquitoes, flies, ticks and scorpions, and life-threatening species such as the deadly djurrang, the taipan *(Oxyuranus scutellatus)*. The Dreaming of this snake is at Djurrangbim, where it placed itself on the wall of a shelter and remains there as a painting. This site, in the Badmardi clan's estate, is avoided as a dangerous locality. If disturbed, the taipans would overrun the country and kill everybody.

The spiritual essence of the plant species also remains at their individual Dreaming sites, and must be tended to ensure their survival and propagation. In one instance the Dreaming of anginjdjek, the 'cheeky' round yam *(Dioscorea bulbifera)*, is a rock painting of that species located in a slightly protected shelter high up in the escarpment. During the rite, a fire is lit close to the painted wall, then covered with green branches so that the smoke rises and drifts over the painting before passing out of the shelter. As the smoke leaves the shelter, the names of all the localities where this yam should grow are called out. A similar activity was carried out over a painting of wurrmarninj, the red lotus lily *(Nelumbo nucifera)*, at its Dreaming site in the Mirarr Erre estate.

*Left* This narrative scene of the dynamic figures style records that circumcision, an operation not carried out in the region in the ethnographic present, was formerly practised. A man in a headdress, shown kneeling over a bare-headed novice, is possibly holding a stone flake with which he will perform the operation. Location: Djawumbu-Madjawarrnja. Kneeling male 55 cm.

*Below* A composition depicting a scene from the lorrkgon mortuary ceremony. The body of the deceased, placed on a mortuary platform, is surrounded by a large number of mourners. Location: Djarng. Figure at left 18 cm.

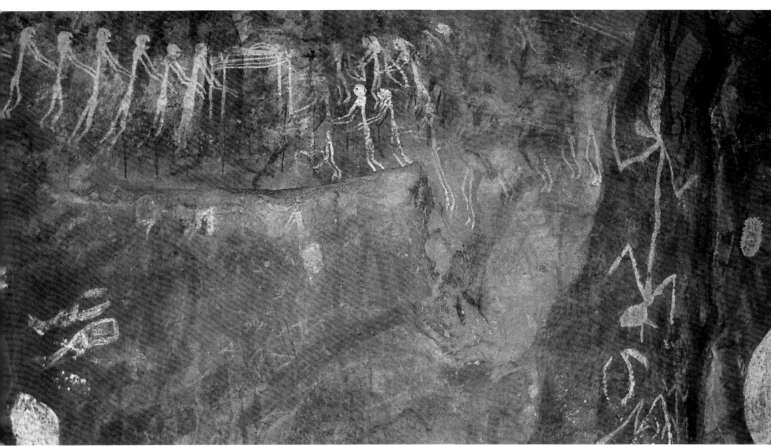

C. P. Mountford was told that a large snake design at Ubirr, identified by others as a personification of a Rainbow Snake, was an increase centre of aniau-tjunu, a water snake. When the people wanted to increase the numbers of this species, they came to this site during the appropriate season and, standing before the painting, struck it lightly with a bough to hunt out the spirits of the snake and direct them to the various waterholes. A similar rite was said to be held before the Dreaming paintings of cycad nuts at Gundulkyau in the Madjawarr's estate.

A frieze of hand stencils of the three middle fingers closed convention. All the images seem to have been executed at the same time and, as they are of varying sizes, they probably represent different individuals of the one group. These stencils are associated with the paintings of the dynamic figures style. Location: Dangurrung.

## Stencils

The stencilling technique – in which a hand or an object is placed firmly against the rock surface and a mouthful of pigment is sprayed over it – is an early form of rock art found first amongst the images of the large naturalistic figures stylistic complex. The technique came to the fore in the succeeding dynamic figures style, where it was used to produce the hand and also the hand and arm stencils of the three middle fingers closed (3MF) convention, as well as the more common open hand form. Around the same time, stencilling was also used to record items of material culture, notably the boomerang which lends itself well to this technique. Indeed, boomerang stencils documenting the varied shapes and sizes of this implement are, after the hands, the most common subject. Other stencils record a uniserially barbed spear, spear tips, clubs, a hafted stone axe, baskets and string bags.

The stencilling technique continued to be used throughout the subsequent periods, mainly to depict the open hand. But with the advent of the contact period, the introduced and much sought-after Makassan and European goods became the subjects of many stencils. Stencils of axes and tomahawks appear in a number of shelters. Other images are more difficult to identify. A rectangular stencil was perhaps a sheet of paper, a letter or a container. Knives, matchboxes and tobacco tins were also documented.

Nevertheless, the most common stencils through all the periods are those of hands, and hands and arms. Stencils of feet also occur, though less frequently. The stencils were mostly made by men, although women and children stencilled their hands. Young boys made a peculiar type of stencil in which the hand is shown in profile with the forefinger bent forward. The resultant image is said to represent the body, neck and head of the partridge or chestnut-quilled pigeon or some other bird that had been hunted. Stencils of animals and parts of animals, including small marsupials, emu feet and dog paws, have occasionally been found. One puzzling stencil of a forked stick has been identified by a man with the required level of knowledge as a symbol for the ubarr ritual.

Many hand stencils are situated far above the reach of a person's hand. Some of these motifs were executed from ledges which have since collapsed, others were made from platforms or bush ladders.

An old man showed me a stencil of his hand made when he was a young boy. His father had cut down a tall, forked pandanus, placed it against the rock, put his son on his shoulders, climbed up, and when his son pressed his hand firmly against the surface he sprayed red pigment over it. Almost every person of that generation knew the localities of their own hand stencils and could identify those belonging to others. Some people made stencils of their hand a number of times during their life time, in many instances in estates other than their own.

The main function of the stencils was to record people's presence and association with a site, or to identify a particular painting. In some of the dynamic figures compositions, the stencil appears to be the artist's signature, or at least an integral part of the painting. At the Warlkarr shelter where Narlim, a Mengerrdji

A unique site with early stencils of string bags and necklets, associated with a hand and arm stencil and hand prints. Location: Djawumbu.

man, painted a boat and wrote his name across its bow, he also left a stencil of his hand by which he was remembered by those who could not read. An old lady who identified his hand was asked why the people used to do this in the past. She said that the hand stencils were made to remind their contemporaries, and also those of future generations, of their existence.

The 'mutilated hand' stencils, in which a digit or part of a finger is missing, are not very common in this region. It is possible that while some of these paintings record hands from which digits have been amputated, other such hands may have been playfully constructed by bending a finger under the palm and pressing it against the rock surface before stencilling. However, a stencil of a hand with six digits, one of which was amputated, has been recorded.

Although hand stencils may appear as individual images, they are usually found within a shelter in some numbers. Occasionally, they are arranged into compositions in which all the stencils were executed at one time.

Stencils of animals and their parts are not common. The two emu feet were stencilled later than the adjacent open hand. Location: Djalandjal.

Other stencil compositions appear to have been created by different people over a long period. Some stencils were also made over earlier hand imprints.

The majority of recorded stencils are in red, which was the colour preference for the earliest art styles. Only one example of yellow hand stencils of the three middle fingers closed convention from the pre-estuarine period has been located. The most recent stencils, those of the contact period, are mainly in white, although yellow pigment was also used. These two pigments in most of their forms are fugitive, so if they were used during the earlier period the stencils would have weathered away.

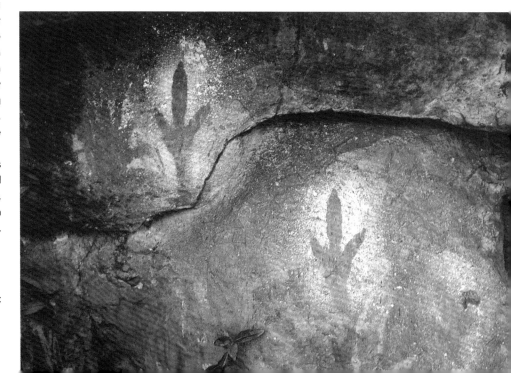

# Other art forms

Apart from painting on rock surfaces and sheets of bark, some artists living in this region used additional art forms. A number of techniques were developed to engrave simple as well as more involved designs on rock surfaces, and rock arrangements were also a form of visual expression. Another art form, used exclusively in the lowlands, consisted of pounding an image into the surface of alluvial plains.

*Left* A densely engraved wall on which a combination of bird and macropod tracks and randomly inclined grooves forms an interesting pattern. Location: Durrkgamerng.

*Right* A boulder with numerous pecked hollows extending over its face. This is one of several types of rock engraving motif found in many parts of the world. Location: Madjawarnja.

## *Bawarde garruy*
### ROCK ENGRAVINGS

Rock engravings are designs which are incised, abraded, pecked or scratched, or made out of a combination of two or more of these techniques. This art form is not very common in the Arnhem Land Plateau region, with only a few engraved surfaces in its northern sector, though they do become more numerous as one moves south-west towards Katherine. The disparity in the occurrence of engravings is probably due to the nature of the host rock. In the north the sandstone formation is composed mainly of hard orthoquartzitic rocks, while further south the rock matrix includes clay minerals and mica, making it considerably softer. An alternative

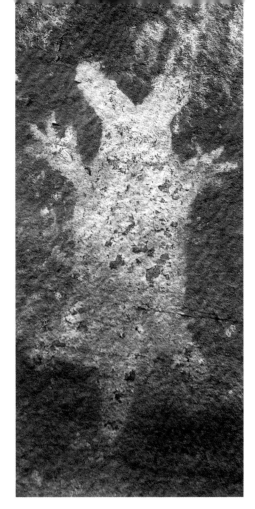

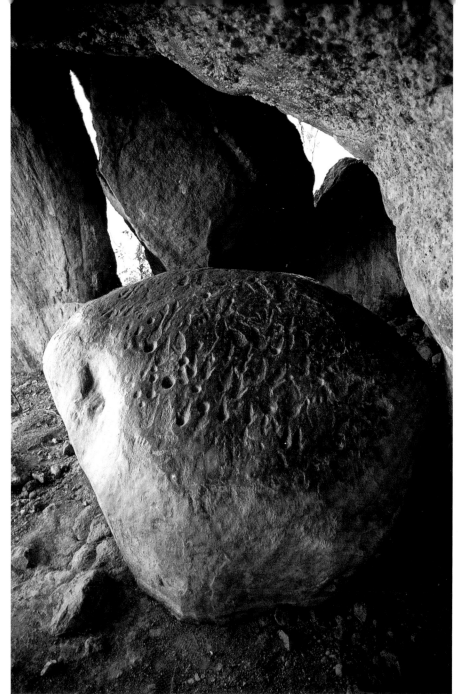

*Left above* This reptile-like zoomorph was executed in a twisted perspective, the body being in plan view while its gaping head is in profile. The red-stained surface on which this creature was executed is not only bleached but also etched, as is documented by the disintegrating surface. Location: Dird kabaryo. 90 cm.

*Left below* A back-to-back composition of two animals, the echidna *(Tachyglossus acuelatus)* and the Tasmanian devil *(Sarcophilus harrisii)*. The presence of the latter animal, a species which disappeared from the region long ago, suggests that these etched images are of considerable antiquity. Location: Dird kabaryo. Echidna 87 cm.

*Right* Deeply pecked macropod tracks, human feet and pits are covered at this site with a thick layer of varnish, suggesting considerable antiquity. Location: Delekbim.

explanation for this differentiation may be the inclination of the northern artist to produce more complex images than his southern counterpart that are best achieved when using pigment.

The range of engraved motifs is fairly limited. The majority of the designs are simple abraded grooves made by rubbing a hard, pointed object on a soft sandstone surface. Their most common form consists of narrow vertical lines of varying length, found singly or in rows. Diagonal, horizontal or crossing lines in composite arrangements are also found. Occasionally the lines are combined into stick-like human beings, and more frequently into bird tracks. Some grooves link pits and pecked hollows. In shelters with exposed mudstone layers, long lines are incised into its smooth surface,

varying in depth from fine marks to deep slashes made with sharp-edged flakes repeatedly dragged through the original cut.

Pecked engravings and those made by a combination of pecked and abraded techniques seem to be of greater antiquity than those that are simply abraded, a supposition supported by their patinated appearance. By far the most common of these motifs are pecked hollows. They are usually grouped in quite large numbers on vertical walls, and occasionally also on ledges and boulders, and are found even in the hardest surfaces. The number of pecked hollows found in a particular panel, their depth and their diameter vary from site to site, but within each panel the hollows are quite uniform. The most extensive panel of these hollows is found in the Yuwunggayai shelter and is covered by several layers of painted images.

At some sites figurative motifs, most of which are deeply patinated, are found alongside the pecked abstract engravings. Animal and human tracks, fish and several bird forms are known from a number of locations. One pecked design, a set of concentric circles with spiral outrays, found in the upland valley of Mt Brockman, does not fit the northern model, but instead bears the imprint of the desert where such designs are common.

The most extensive engraving site so far recorded in the Arnhem Land region is located in a shelter on the southern margin of the plateau, where engravings extend for some 30 metres along its wall. Most are abraded grooves of varying depth, length and inclination. Some of these grooves seem to be arranged into abstract designs, others form bird tracks and simple stick-like human figures. Deeply engraved macropod tracks and vulvas are also evident. However, the site is dominated by a life-sized engraving of an emu. This site was first recorded by Agnes Schulz in 1954.

Another image-making technique which is essentially an engraving form was effected by painting with some corrosive material which 'etched' the image into a rock surface. The term 'etched' is used quite judiciously as the substance used not only bleached the red-stained rock on which it was applied, leaving a white silhouette of a given subject, but it has also 'eaten' into and disintegrated the rock matrix. The identity of the substance used in executing these images is unknown today, but it was probably the latex-like sap of a plant with corrosive-acidic properties. The effects of the sap of two plant species on a similarly stained wall is presently being investigated. These plants are *Hoya australis* and *Alstonia actinophylla*, both of which produce copious amounts of

milky fluid that was once utilised by Aboriginal people for other purposes. Quite possibly, the effect of the corrosive sap on the rock surface may not have been immediately noticeable; current experiments with the milky sap of the *Hoya* and *Alstonia* plants show that when it is applied to a rock surface it becomes translucent within minutes, leaving a glossy surface coating.

The first of the region's etched engravings to be known to Europeans was located in the 1970s at a shelter in the Djawumbu-Madjawarrnja site complex, and was considered at the time to be a slightly abraded outline of a macropod. Re-examination of this engraving after the more recent discoveries of etched figures revealed that the naturalistic representation was the westernmost example of this technique. Another etched outline of a macropod has been found in residual rocks of the lower Cooper Creek area. The most recent and best examples of this technique, however, are situated in a narrow ravine east of the Gumadeer River. One design at this location is a reptile-like zoomorph depicted in plan view, with its gaping head possibly in profile. In an adjoining shelter are representations of three animals executed in stunning naturalism. The artist, using fluent brush strokes, depicted a female black wallaroo (*Macropus bernardus*), its deeply distending pouch suggesting a joey within its interior, an echidna (*Tachyglossus aculeatus*) and a Tasmanian devil (*Sarcophilus harrisii*).

In the Northern Territory etched engravings also occur on Chasm Island in the Gulf of Carpentaria, but they have not been reported as yet from other parts of Australia. In the late 1980s, I visited a Chasm Island site previously recorded by Frederick McCarthy in 1948. Some of the subjects that McCarthy had described as being executed in yellow pigment were found to be now etched, in places quite deeply. It would seem that during McCarthy's visit this 'etching' process was still in action. In the intervening 40 years the substance used to sketch the motifs bleached the red-stained rock surface and 'bit' into its matrix.

## Earth art

The Aboriginal groups living on the floodplains and the adjacent lowland areas north and west of the plateau were familiar with, but did not participate in, the rock art tradition. Nor did they paint on sheets of bark. Their wet season shelters were beehive-shaped huts made of saplings and covered with paperbark, a material unsuitable for such an activity. Despite

the lack of rock surfaces and suitable bark, they succeeded in expressing their aesthetic drive by making large designs in the surface of the plains towards the latter part of the dry season when the land completely dried out. This unique, alas most impermanent, art form was described in 1884 by Captain F. Carrington, whose party found several of these designs while investigating the nature of the land in the Alligator Rivers region:

> … on the west bank of the south river, about sixty miles from the mouth, in walking across the plains, a part of which had lately been burnt clear of grass, we came upon what may be called a very curious drawing. At first sight it looked like a gigantic cart-wheel; but after careful measurements were taken, and a sketch of it made in my pocket-book, it was manifest it was an excellent representation of a spider's web. It measured fourteen yards in diameter, and its production involved an immense amount of labour. The plains are at this part subject to inundation, and it appeared that after the water had subsided, and the ground still damp, the artist, or artists, for I can scarcely think it was done by one man, had taken a flat stone and patted the ground and thus made it smooth, and leaving the various radial lines and their concentric circles as plainly visible as if it had been done with a pavior's dolly. Outside this large circle were depicted, in outline, a man in the act of throwing a spear, and two or three animals that were possibly intended for kangaroos in the act of feeding. The sketch taken has unfortunately been lost.

These pounded earth art forms continued to be executed even after the buffalo shooters established their camps in the area. A photograph taken in the 1930s shows such a depiction of a saltwater crocodile.

## Stone arrangements

Stone arrangements of rocks placed in meandering, crossing or enclosed lines as well as in piles and cairns are found on bare rock surfaces in many parts of the plateau. In most instances they document activities of the creative beings or identify the location of ceremonial grounds of both the human groups and the spirit people. Rocks formed in small circles may represent the ritual site of the Mimi people. Some of the linear arrangements are as much as 50 metres in length.

*Above* An earth art depiction of a saltwater crocodile, photographed in the 1930s.

*Below* A meandering line of rocks found on top of a large outlier seems to point to Namarrkananga, Cannon Hill.

# Artists of recent times

## *Nawu gabarribimbom*
### 'THOSE THAT PAINT'

'*N*angale babi mbom' ('who painted this?') is the question I ask when visiting a painted shelter in the company of its traditional owners. Occasionally, they remember seeing the older male members of their family or other visiting kin or friends painting at that site when they were young. They may recall the artist's name, or if the name has been forgotten they may recall a kin term, clan affiliation or some peculiarity of his physique by which he was known and which may lead to his identification. However, in most instances the reply would be 'garre nangale babimbom' ('I don't know who did the painting') or, if at a site unknown to them, they would admit 'ngaye djama anayin' ('I haven't seen this before'). During 30 years of inquiry, my colleagues and I were able to identify a number of artists who painted in the rock shelters of the region, along with some of their works. Today, most of the people who had knowledge of the last of the painters have themselves passed away.

During this time, I noticed that the identity of the artist was not of great concern to my Aboriginal friends. They were more interested in what was depicted, how the subject's different levels of meaning were expressed and the skill, or lack of it, used in the execution of the art. 'Ibimbom, namakgaygen' ('That's a good painting, he was very good'), they would say, and go on to remark about a well executed figure or the fineness of the hatched lines used to embellish a motif.

As is often pointed out by those who question the use of the term 'rock art' in this region, there is no word in any of the local languages for art, nor for an artist. But there are a number of terms for a painting as an image depicting a subject and for the act of creating it, and other expressions describing the embellishment of a painted or stencilled design with hatching, dotting, stencilling or imprinting.

This lack of a special designation or category for those who paint or carve underlies the Aboriginal view of all the creative activities; that is, it is the act of creation which is considered as most important. After all, everybody is aware that the person carrying it out is only an agent of the Dreamings, which instituted all the aspects of their culture. Creativity of one kind or another is expected of every person throughout his or her life. 'Art' is an integral part of the Aborigines' social and religious life, in which individual artists share and reinterpret the traditions of the group. This is in direct contrast with the contemporary European experience of art, which reflects the alienation of the artist. For most Western artists, their work no longer represents the social and religious views of the wider society: the expression of individual rather than group experience is the underlying philosophy of much contemporary art.

The term 'art' is usually defined as a human skill in creating an object, or as an imitative or imaginative skill applied to design such as in painting. In the past every male member of the local Aboriginal populations expressed himself in the widest sense of this term, if only while decorating his weapons and tools, and occasionally his wife's dilly bags. Some, the more accomplished artists, depicted their favoured animal species, themselves, desired situations and beings of their mythological cosmos on the inner walls and ceilings of their wet season bark or rock shelters. The gifted artists were also assigned to carve or construct ceremonial objects and paint them with the relevant sacred designs, and to execute such designs on the bodies of ritual participants.

The process of learning all traditions, including how to paint, began with the local group. Children were encouraged to take part in and enjoy all forms of self-expression. They made stencils of their hands, moulded beeswax figures and drew figures in the sand. Young people were closely observed by adults in order to identify their skills and aptitudes. If they showed promise in a particular area, they were encouraged to pursue it. The necessary teaching would usually be undertaken by a close relative from either the same clan or an adjacent one. Occasionally, a boy would be sent to a distant group to learn and improve his skill. As the children grew into

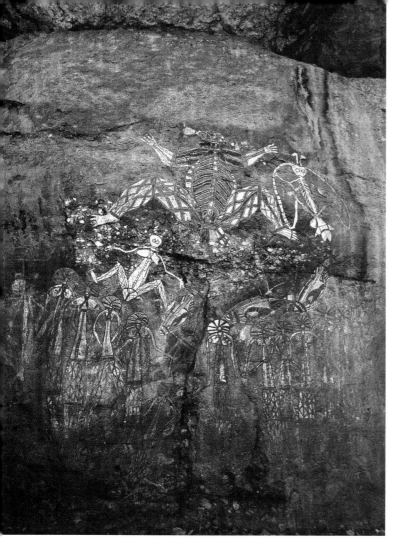
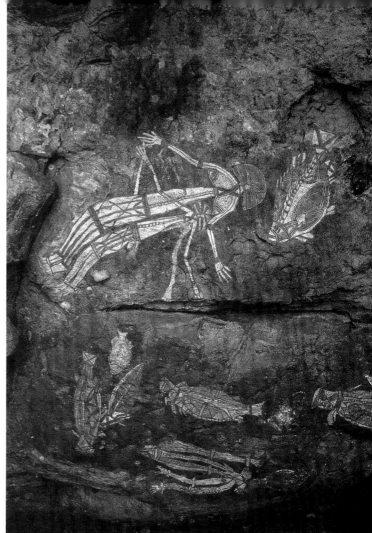

Paintings of human beings and spirit figures in the Anbangbang shelter, Nourlangie Rock. The large group of humans in the lower half of the gallery is the work of Nayombolmi. This artist and his friends Djimongurr and Djorlom, who are the creators of the other subjects, executed the paintings during the 1963–64 rainy season. The frieze of human beings consists of two groups separated by both space and a rock fissure, perhaps suggesting that they represent two discrete families. The group on the right comprises four females and a male. With the exception of one female, the group is interlinked by crossed arms, forming a tightly knit unit. The two females at the left and another at the right are wearing skirts. The females are also differentiated by the colours used in their stylised fan-shaped hair, which encloses a small circle representing a featureless head. Two women have hair in white and red, the others in yellow and two reds. Although two of the females have marks suggesting milk in their breasts, none of the bodies is subdivided nor are there marks on the abdomen.

The 'blue paintings' at Nawurlandja were painted by Djimongurr, although in the past they have been attributed to Nayombolmi. Represented are a human couple, a barramundi and, on a lower level, two mullet with dislocated heads, eel-tail catfish, archer fish and fork-tailed catfish. Amongst these lower subjects is also a female figure with her legs pushed back alongside her body, exposing her vulva. For a number of years, a long sheet of stringybark raised off the ground by timber immediately beneath the figure was said by the tourist guides to be a 'nuptial' bed. The human couple is in a resting position. The female, larger than the male, is depicted with the left side of her torso subdivided, its lower half and the prominent breasts being infilled with dashes. This subdivision of the body and similar infill can be seen on the Anbangbang figures recorded by David Attenborough and also on the paintings of female figures found further along Mt Brockman. It is a feature not found in any of Nayombolmi's known paintings. The adjoining barramundi also bears Djimongurr's imprint. The elements used in its construction are similar to those present in his Nanguluwurr fish. Horizontal female 65 cm.

puberty and then young adulthood, visiting their relations and friends, and attending and participating in ceremonies, they absorbed and were influenced by a variety of symbolic expressions of all art forms used in the different localities.

All vocations were considered to have been introduced during the Dreaming, and in some locations rituals inducting the 'apprentice' to the more profound aspects of his craft were performed. When a young man was identified as a potential painter, he was taken by a group of elders – recognised artists – to a shelter with Dreaming images. There, they would teach him the practical skills and reveal the esoteric knowledge of painting techniques used to express deeper levels of meanings. At first the young artist was taught to paint animal and simple human figures, and as his knowledge of traditions increased he commenced to depict ancestral figures and spirit beings. He would stay at this site for some time, eating special foods

and painting while the old men sang the verses that described the accomplishments of the Dreamings, seeking spiritual support for the young neophyte.

The best known rock painter, at least to the wider Australian public and to international audiences, was Nayombolmi – who, due to his great skill in spearing fish, was known to Europeans residing in the region as 'Barramundi Charlie'. He came to prominence after photographs of a spectacular frieze of paintings at the Anbangbang shelter of Nourlangie Rock, executed sometime during the 1963–64 rainy season and attributed to him, were published in numerous newspapers, magazines and books.

Although it is usually Nayombolmi's name which is associated with the most recent paintings at Nourlangie Rock, he was not the only artist then painting in the area. 'Old Nym' Djimongurr and 'Old Hector' Djorlom, whose own estates were located further in Arnhem Land, were also accomplished artists who, with their wives and children, spent most of their adult life with the local people in the 'buffalo camps' of the Alligator Rivers country. After the collapse of the buffalo shooting industry in the mid 1950s, they stayed on in the region and worked at the Nourlangie Timber Camp cutting cypress pine. And when all the mature trees had been cut, and the lease was bought in 1959 by Allan Stewart, a safari operator, they stayed on to help and act as guides. Ten years later Stewart wrote *The Green Eyes Are Buffaloes*, a book of recollections of his time in this part of western Arnhem Land in which he mentions the three Aboriginal artists, his 'discoveries' of rock paintings around the Nourlangie Rock massif and details of a visit to this region by the noted British naturalist David Attenborough – a visit which proved to be of some importance to the history of Australian rock art studies.

Attenborough was not an ordinary tourist. At the time he headed a BBC-TV unit making television nature series. His photographs in the accompanying publication *Quest Under Capricorn* record the state of two Nourlangie Rock shelters, Anbangbang and Nanguluwurr, as they were in 1963. Some time after Attenborough's visit, new paintings were found overlying the earlier designs seen and photographed by him. The new paintings at Anbangbang were said to have been done by Nayombolmi, while those at the Nanguluwurr shelter, situated on the northern side of the massif, were the work of Djimongurr. It was also suggested that these designs, as well as the 'blue paintings' at the nearby Nawurlandja shelter, were executed at the request of one or more of the tourist operators using this area.

Nayombolmi, Djimongurr and Djorlom were not the only artists to be remembered. Members of every surviving clan group whose estates extend along the western and northern margin of the plateau recalled that one or more of their own kin, or those of an extinct clan, made paintings on the walls of their rock shelters. A number of well-known bark painters, one of whom is still alive, have identified images which were their own work. Some of these works, reflecting the times, were of contact, depicting the European buffalo shooters, their horses, guns and prey.

In most instances the best artists were men with great knowledge of the law, myths, rituals and ceremonies, who in the execution of their paintings were innovative, exercising their intellect and imagination. As ritual leaders they were a link between the mythic past and the present, and as many were also 'clever men' they could recreate what was revealed to them in a vision or a dream. They were the mediums through whom the Dreaming lived on. However, an artist's activities were not constrained by the spatial extent of his estate. There were no sanctions to prevent him from painting anywhere throughout his social range, the extent of which was governed only by the vigour with which he participated in the public and religious affairs of his people. The social milieu of a great many people extended far across the plateau. Paintings which unmistakably typify the stylistic convention of one area can be found in shelters situated at the opposite end of the plateau. The activities of Djimongurr and Djorlom at the Nourlangie Rock sites are among evidence of this far-flung practice. Artists were also not restricted to a set of sanctioned subjects limited by their social ordering, although some would constrain themselves to paint selected items from the constellation of subjects with which they were totemically affiliated.

When looking at the corpus of the region's art for the first time, one is overwhelmed not only by the beauty of the paintings but also by their sheer numbers. Considering, however, the tens of thousands of years during which this tradition was practised, it is obvious that the production of art was not a compelling activity in which an individual artist produced several hundreds of paintings. If this were the case, there would be even more paintings. Although the region's population in the first half of this century was only a fraction of that existing at contact, the number of known artists suggests that over a lifetime each artist added only an occasional painting or compositional group to the existing galleries.

# Epilogue

Most visitors to rock art shelters of the Kakadu National Park and to sites elsewhere in the Arnhem Land Plateau are astounded by the magnitude of images covering the walls and ceilings in many layers of superimposition. There are thousands of rock art sites and hundreds of thousands of individual paintings. Yet this treasure represents only a fraction of all the images which were executed since the commencement of this art form. The artist, as if not concerned with the permanency of his work, frequently executed paintings on exposed rock faces or only slightly inclined walls. Subjected to the elements, coloured stains are all that now remain to indicate their presence. Even within the protective shelters, much of this artistic splendour is at the mercy of relentless weathering processes. How to prevent or arrest such damage exercises the minds of conservators and site managers throughout the world. In Europe a number of governments provide considerable financial support for rock art conservation research and for the physical conservation and protection of sites. Australia is well endowed with rock art – in fact, nowhere else did humans leave such a heritage. How do we care for this treasure? The state of the Yuwunggayai shelter epitomises our cavalier attitude to this, the world's longest continuing rock art tradition.

The Yuwunggayai gallery is – by its size, the number and magnitude of its paintings, and the range of styles and subjects – one of the greatest Australian rock art sites. Located in the Kakadu National Park, which is listed as a World Heritage area, it is also of universal importance. The shelter extends for some 70 metres along the base of an overhanging cliff face, a wall of a narrow gorge through which Djurrubu, a tributary of the Deaf Adder Creek, flows during the wet season. During the dry season a deep permanent waterhole full of black bream, archer fish, short-necked turtles and freshwater crocodiles lies immediately below the shelter. Other waterholes extend upstream into the narrowing gorge, while shallower pools, surrounded by massive paperbark trees, are found downstream, outside the gorge, separated by a wide sandy bed. From there, rock platforms with sculpted residual rocks move back in steps towards the escarpment. One such rock protects modjirra, a bone ring within a circle of rocks, signifying the location of an ubarr ceremonial ground. People from many parts of the plateau came here to participate in rituals, some perhaps contributing to the number of paintings in the Yuwunggayai shelter during their visits.

Eric Brandl, the first European to see the Yuwunggayai paintings, referred to the site as Bala-uru, but this was later found to be a version of Balawurru, the name of the Deaf Adder Creek and its escarpment valley. Prior to visiting the shelter with my friend Kapirigi, one of its traditional owners, and learning its proper name, I called it the 'Leichhardt Gallery'. This name was deliberately chosen to make the site of importance to public servants and politicians, few of whom were at the time interested in the Arnhem Land Plateau, its original inhabitants and their incredible rock art heritage. Yet these people were in the process of making decisions about the region's future, comparing the value of the proposed national park against plans for the mining of vast deposits of uranium. Their support was needed to achieve a manner of protection, not only for this shelter but also for the other rock art sites, before any development took place.

An empathy with rock art was created by bringing attention to one of the most recent paintings at this shelter, depicting a fully dressed European holding a gun. I proposed that this may be a representation of the well known explorer Ludwig Leichhardt or one of his party, as they were the first strangers to traverse the artist's domain. This shelter was also referred to as the Main Gallery of the Deaf Adder Creek to distinguish it from all the other rock art sites found in this escarpment valley and to indicate its great number of accomplished paintings.

Yuwunggayai is, indeed, an incredible site. It is not possible to say how many layers of large and colourful human and animal figures cover its wall, obscuring from view paintings of earlier periods. That these are also represented at this shelter is revealed where they appear above the main body of art, in places extending up to 6 metres above ground

level. Amongst the examples of earlier techniques and styles are grass imprints and subjects in the yam figures style. Several dynamic figures are found outside the main painted area, at the periphery of the site where the wall extends over the scree. The wall above the central occupational area is not only densely painted, but a large number of small hollows are pecked into a part of its surface. Although these pits do not seem to extend below ground level, they do commence immediately above it, suggesting that they may have been made when the shelter's floor level was much lower than it is at present. The majority of the more recent paintings at this site are of the X-ray convention.

The density of paintings and their numerous superimpositions do not allow for full statistical consideration of all subjects. A count of the most recent identifiable images reveals that there are at least 168 paintings of human figures and 212 animal representations. The majority of faunal paintings are of fish, predominantly freshwater species, reflecting the site's location in the physical environment. Macropods – notably antilopine, black and common wallaroos, and agile wallabies, of either sex – are the next most frequently depicted subjects. Among the 40 representations of macropods, one portrays a little rock wallaby. The avifauna is represented by 22 paintings of six species. Three of the images are emus, while others are magpie geese, egrets, ibises, darters and a brolga. Reptiles are represented by turtles, lizards, snakes and a crocodile. Twelve paintings of turtles depict the four common species; the long-necked (*Chelodina rugosa*), the short-necked bambdrrek (*Emydura australis*), naderrwo (*Elseya dentata*) and the pitted-shelled turtle (*Carettochelys insculpta*). Gould's goanna, Mertan's and Mitchell's water monitors and a Centralian blue-tongued lizard are also represented in 12 paintings. There are three snake representations, but the species are not identifiable. The vertebrate images are completed with a single depiction each of a flying fox and a dingo. Invertebrates are represented by a painting of two land snails.

The vast majority of human figures are females, which appear to be, after food items represented by the animal species, the artists' favourite subject. Most of the human figures were executed with some X-ray detail and geometric decoration, although they also occur in other stylistic forms. Among the more recent paintings, very few figures are sufficiently alike to be considered the work of the any one artist. The females are portrayed in various stances: as frontal figures in profile, inverted, or in a provocative position with one leg raised exposing the vulva. Several figures are oriented horizontally, a deliberate choice as space would have allowed for a vertical representation. Female symbols, in the form of triangular vulva designs, are also present. The male figures are also depicted in a variety of stances and engaged in a number of activities. Some artists represented themselves as hunters, others are shown resting or declaiming with their arms crossed over their body. There are also men associated with females, in one instance in erotic play. One bewhiskered male is shown in profile, playing a didjeridu. The only paintings of the contact period are the fully dressed European holding a gun and a stylised representation of a similar firearm.

The only obvious and identified mythological figures are Mandjawilbil, the owl-like creature painted at one end of the shelter, two representations of Namarrgon, the Lightning Man, and one of an unidentified bisexual figure with macropod legs and feet. Several female figures are also portrayed holding string between their extended hands, but it is not known if they represent human females playing a string game or participating in a ceremony in which they dance with strings, or if they depict spirit beings who use the string to levitate and travel between localities.

The only non-figurative motif at this site is a prominent shield-like design, representing an object belonging to the marrayin ceremony. Beeswax figures also occur in considerable numbers, as both anthropomorphs and abstract designs, and some are superimposed by layers of paintings.

The rock paintings of the Yuwunggayai gallery, as those of other rock art sites throughout Australia, are at present in a state of degradation. The damage to this site, which is not open to the public, is due to natural causes. Yet except for replacing an earlier fence to keep out animals, very little has been done in recent times to conserve and protect the paintings. If we cannot ensure conservation of a site of international importance within the greatest of our national parks, what chance is there of protecting other rock art sites, all of which are unique?

The major damage to paintings in this shelter, as to most other rock art sites in this region and elsewhere in Australia, is brought about by water. Most of this damage is caused when the water actively runs over the paintings, flowing either out of seepage cracks or over the ledges of once protective overhangs which have substantially weathered away. During the monsoonal rains, the water flowing over the edge of the Yuwunggayai site's overhang falls within 2 metres of the painted wall and at no point further than 5 metres from it.

Although the narrow gorge in which this shelter is situated is well timbered, thus reducing the wind velocities, at times of cyclonic disturbances or intense monsoonal activity the direct rainfall and driven overflow reach parts of the painted wall. As the rainy season progresses, the water saturates the sandstone massif through the cracks, crevices and faults of the rock mass directly above and beyond the gallery, then seeps out through the faults in the wall surface and flows over the painted surface.

Damage is also caused by a streamlet of water which during the rainy season meanders through this gallery, running for the most part along the painted rock face. If the site is not cleared of fallen leaves and branches, the build-up of debris raises the level of the stream higher than it would otherwise be and washes away a further layer of the painted wall. The existence of the stream also raises the site's moisture content, providing ideal conditions for the proliferation of bacteria as both the temperature and humidity levels are high. The growth of the bacteria, present mainly in the thick pipeclay pigment, which is the base for some of the more recent paintings, causes it to swell, lift from the rock surface and fall. The high moisture content also manifests itself by the growth of algae, fungi and moulds, thus accelerating the physical and chemical weathering of the rock surface.

Insect nests and passages formed over painted surfaces have also caused considerable damage, as has the regrowth of vegetation. At several points bushes and trees grow alongside the painted wall and come into contact, especially during high winds, with the painted surfaces.

When will the conservation and protection of this and other important sites commence? Considerable funds are expended throughout Australia to preserve the nation's heritage, but they are directed, in the main, towards the European estate. We build cultural complexes and art galleries costing hundreds of millions of dollars to celebrate, for the most part, the art of other cultures. Yet little funding is generated for the preservation of ancient Aboriginal galleries that enable us to view the art of untold generations in its original and often dramatic setting. People from all over the world come to marvel at these accomplishments. They take a journey in time, portrayed here in vivid images of astonishing art forms.

In France the government spent several million dollars, at first to conserve the paintings within the Lascaux Cave, and then when it was realised that the only real solution was to close the cave to the public, expended further funds to build its replica, Lascaux II. A French colleague, after a short visit to Kakadu, commented on the 'many Lascaux galleries' he saw in this national park.

The recent Australians, of whom the first reached the shores of this continent little more than 200 years ago, will not be truly Australian until they acknowledge and respect the rights of the first Australians and show that they care for and are willing to conserve their cultural heritage.

The traditional owners refer to the painted rock shelters as their 'history books'. They want these sites protected so that their children and their children's children may see, enjoy and learn from their heritage. In the late 1970s 'Big Bill' Neidjie, one of the senior traditional owners of the East Alligator River sites told me: 'I am the last one who has culture. Our culture might be gone soon. It might go with the wind, the yellow-cake will take it away.'

His words were prophetic. What we tend to call 'progress' has overwhelmed this region. Sealed roads, a township, mining development (the 'yellow-cake' in the traditional owner's expression), a national park and the concomitant tourist infrastructure have changed the face and the spirit of the land. And a senseless visitor has already tried to destroy manifestations of the Aboriginal culture, using wet rags to smudge and efface a section of the exquisite paintings of the Ubirr Gallery.

We must protect this, Australia's greatest cultural heritage.

# Appendix I  *Neighbouring rock art*

The rock art of the Arnhem Land Plateau provides a unique documentation of perhaps 50,000 years or more of human endeavour, and evidence that from the very beginning the Aboriginal artist expressed himself in forms which transcended simple symbols for any given subject. The details discernible in the individual paintings and in the many complex and narrative compositions of all periods not only allow us to reconstruct the economy, social structure and the cosmogony of the local populations, but also reveal the aesthetic dimensions of their human experience. The ideologies reflected in the remarkably diverse art styles are sensitive indicators of past cultural relationships, and of systems of communication and exchange. When the individual styles and stylistic complexes are arranged by their order of superimposition into a chronological sequence, they are found to form the longest continuing rock art tradition yet recorded. This sequence of periods, phases and styles provides a basis for considering stylistic sequences of rock art complexes found elsewhere in Australia and in the wider geographical region.

A similar chronological sequence, and perhaps of the same antiquity, is evident in the body of rock art found in the Kimberley region of Western Australia. There, too, hand and grass imprints are found in the earliest art period, followed by paintings of large animal forms and by the Bradshaw figures. These figures, named after the first European to discover them, are graceful silhouettes of humans, contemporaneous with, and perhaps sharing common ancestry with the artists of, the dynamic figures style of Arnhem Land. Like the dynamic images, they are shown wearing elaborate headdresses, pubic aprons and bustles, tassels and armlets, and using the same weapons – boomerangs and barbed, single-piece wooden spears. The tradition of the large multicoloured paintings of the religiously based Wandjina figures and accompanying subjects commenced perhaps at the same time as the predominantly secular X-ray paintings of the plateau region. In between the Bradshaw figures and the emergence of those of the Wandjina, stylisation and then schematisation of the human form and the subsequent return to naturalistic representations can be identified as corresponding to that of the plateau.

Similar forms of expression may be found in the future amongst the rock art of Irian Jaya, the western part of New Guinea, however to date very little research has been carried out there. During the last Ice Age, groups from both New Guinea and Arnhem Land probably would have re-occupied the emergent continental shelf and the Arafura plain which formed a landbridge between the two areas, and come into prolonged contact. The possibility of such contact was suggested in rock paintings recorded during the 1938 Frobenius Institute Expedition to MacCluer Gulf, illustrated in J. Röder's book *Felsbilder und Vorgeschichte des MacCluer Golfes West Neu Guinea*. This work documents stencils of acutely angled boomerangs, hand stencils and faunal representations with X-ray features. On a recent exploratory visit to MacCluer Gulf, now the Teluk Berau, I located the previously recorded boomerang stencils and also found others. Boomerangs were not used in this area, nor in Arnhem Land or the Kimberley, during the ethnographic present. My search for similar forms of expression extended south to the Kaimana region, a virtually unknown and archaeologically unexplored area. There, several important sites were located along the western and eastern margins of Bisyari Bay and in the narrow strait separating Namatoto Island from the mainland. This preliminary survey indicated that although the Bisyari Bay body of art shares several basic features with the MacCluer Gulf corpus situated some 170 kilometres to the north, it is also considerably different, and in its complexity more akin to the art of the Arnhem Land Plateau. Further study of the rock art of this part of Irian Jaya is of some importance, as during the periods of low sea level, this region was only as remote for an enquiring Arnhemlander as were the Kimberleys.

# Appendix II  *International rock art*

Many thousands of rock art sites have been described around the world and discussed in numerous publications. The famous Franco-Cantabrian caves of Altamira and Lascaux (see page 15) have been well documented this century, though the earliest records of rock art date back 1400 years ago in China (see page 16).

The earliest recording of rock art images in Europe was in 1627 when a Norwegian school teacher, Peter Alfsson, made the first tracings of Swedish rock engravings in Bohuslan. Engravings are also the dominant art form in Austria, Bulgaria, the Scandinavian countries, Ireland, Italy, Portugal, Switzerland and the United Kingdom, as well as in France and Spain where they are found amongst the painted images. Further east, major rock art complexes are found across the length and breadth of Russia. The Hermitage Gallery in St Petersburg has since the beginning of the century exhibited three rock slabs with engraved images alongside its other world art treasures.

In Africa, rock paintings and rock engravings are found throughout the continent from the Atlas Mountains to the Cape of Good Hope. In the north, the narrative scenes of animals and humans portrayed in rock paintings and engravings of the Sahara confirm that this vast desert was once a fertile land. The earliest paintings and engravings depict the now extinct buffalo (*Bubalus antiquus*), rhinoceros, hippopotami, elephants, giraffes, lions, wild cattle and sheep. A later period is characterised by paintings of herds of domesticated cattle accompanied by their herders. These subjects were replaced by representations of horse-drawn chariots, and in the continuing desertification of the region by depictions of camels. After the Arab conquest in the seventh and following centuries, Islamic laws forbade the making of representations of living creatures and the rock art tradition ceased. The first documented recording in this region dates to 1849 when Heinrith Barth came across large engraved animals in Fezzan, Libya. The now world-famous pastoral paintings of Tassili n'Ajjer, in the Algerian Sahara, noted as early as 1909, were first documented in 1933 by Lieutenant Brenans. His tracings of Saharan paintings were eventually brought to the notice of the general public in Abbe Henri Breuil's and Henri Lhote's 1954 publication, *Les Roches Peintes du Tassili, d'apres les releves du Colonel Brenans*. Since then the rock art of the North African region – which extends from Algeria and Libya over Chad, Egypt, Ethiopia, Mali, Mauritania, Morocco, Niger, Tunisia, Somalia and the Sudan – has been studied by many distinguished scholars. In central Africa, numerous rock art sites were recorded in Kenya, Malawi, Tanzania, Uganda and Zambia.

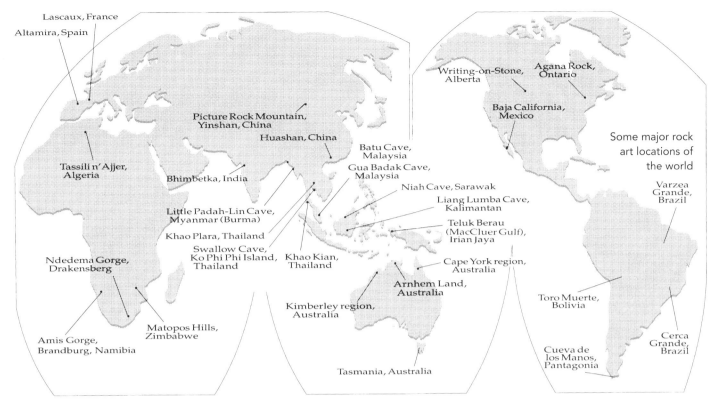

Some major rock art locations of the world

In southern Africa, thousands of painted shelters and engraved sites extend from the Zambezi River to the tip of the Cape of Good Hope. The rock art of this vast area has so many common elements that it is considered as one art zone. However, regional variations do exist. The first mention of rock art from the northern sector of this zone was a 1721 report by a priest from the then Portuguese colony of Mozambique to the Royal Academy of History in Lisbon. In the southern sector an exploration party led by A. F. Beutler found rock paintings in the Great Fish River valley, 320 kilometres from Cape Town, in 1752. Although many discoveries of rock art followed during the next century and a half, and an occasional copy of paintings or engravings was published, it was not until the first decades of this century that publications dealing specifically with rock art were produced. These publications revealed the wealth of the tradition throughout Zimbabwe, Zambia, Lesotho, Namibia, Mozambique, Botswana, Swaziland and the whole of the Republic of South Africa. The major rock art concentrations in the Drakensberg-Maluti Mountains of Lesotho and Natal, in the Brandburg of Namibia and in the Matopos Hills of Zimbabwe are renowned. Because of its immense wealth of rock art, the Drakensberg region has been more intensely studied than the others. A. R. Wilcox, Patricia Vinnicombe, Harald Pager and David Lewis Williams – the big names of South African rock art studies – all climbed its steep and rocky ridges. Harald

Pager's monumental work on the art of the Ndedema Gorge, *Ndedema*, and Patricia Vinnicombe's *People of the Eland* marked a new direction in rock art research. Their works were followed by the publication of David Lewis-Williams' research, which has radically altered perceptions of southern African rock art. In his work, Lewis-Williams considers records of the Bushmen's beliefs that many of the enigmatic paintings depicting human beings and animals, and the puzzling geometric patterns, are the work of medicine people, or shamans depicting their trance visions and symbols of potency. Pager's next challenge was Namibia's Brandburg, where Abbé Breuil made copies of numerous paintings in the 1940s. Another monumental work by Pager, *Amis Gorge, the Rock Paintings of Upper Brandburg*, was published posthumously in 1989. Since then, detailed studies in many parts of this vast area have revealed further concentrations of rock art, and confirm its early development. Radiocarbon datings of painted fragments together with a small painted stone recovered from the Apollo II shelter in Namibia indicate that the tradition of rock painting in southern Africa commenced at least 26,000 years ago. The excavated material showing representations of animals executed in more than one colour is stylistically similar to the more recent rock paintings found in other parts of southern Africa, suggesting the existence of a widespread tradition. In South Africa, rock art has always been considered an important part

of African prehistory.

In Asia, the rock art tradition extends through the countries on the Arabian Peninsula – Israel, Jordan, Oman and Saudi Arabia – to Turkey and Iran, and continues across Afghanistan and Pakistan to the major rock art regions of India. There, the largest number of sites is found in the state of Madhya Pradesh, in central India. The best known site complex in this region is Bhimbetka, where several hundred individual rock art sites and shelters with deep archaeological deposits attest to their long occupation and the early commencement of rock art in this region. The art sequence here begins with small human figures in exaggerated movement, and depicts many of the activities of the early hunters and gatherers, the fauna present in their environment, and cultural changes that occurred over time. It also records the development of the complex civilisation that developed there some 4000 years ago. Horse-drawn vehicles, Hindu and later Buddhist religious personages, royal processions and battles with caparisoned elephants and horses are subjects featured in many shelters. This Bhimbetka complex was discovered in 1957 by V. S. Wakankar, who went on to discover the greater part of the Indian rock art sites known to us today. A detailed study of the Bhimbetka art was subsequently made by Yashodhar Mathpal, while a student at the Australian National University in Canberra. Other site complexes are found in Rajastan, Jammu and

Kashmir, Uttar Pradesh, Kerala, Tamil Nadu and then across the Palk Strait in Sri Lanka.

In the Himalayas, the rock art tradition extends through Ladakh, Nepal and Tibet, and north into Armenia, Azerbaydzhan and Dagastan. The rock art found in the Central Asian republics of Kazakhstan, Kirgizia, Uzbekistan and Tadzhikistan, and also in neighbouring Mongolia, shows the tradition continued into the historical period. Pictures of caravans, battles and Buddhist and Islamic religious imagery feature in these countries. Rock art is also found throughout Siberia, where ancient images are still sought out and visited by hunters who continue to believe in their magic powers. In Russia's Far East, rock engravings extend along the valleys of the Lena, Amur and Ussuri rivers.

From Siberia the early hunters crossed the Bering Strait to the Americas, where art of their descendants is found from Alaska to the southernmost tip of Patagonia.

In Canada, the rock art tradition extends from British Columbia on the Pacific coast to Nova Scotia on the eastern seaboard. The first study of this rock art, describing the Agana rock in the Superior Provincial Park, was published in 1851, while the 'Writing-on-Stone' engraving site in Alberta was discovered in 1855.

The United States of America has a wealth of rock art. The first of these rock art images known to Europeans were deeply incised abstract designs and highly stylised human figures found in the seventeenth century in Massachusetts. There was some dispute among scholars as to their origins. Instead of recognising them as the work of native Americans they were attributed, in turn, to Norsemen, Phoenicians, Scythians and Portuguese explorers. In 1673 Father Jacques Marquette, while exploring the upper Mississippi River, saw and described in his journal paintings of horned and winged anthropomorphs situated on a cliff in what is now Illinois. As the settlement of the United States over the next two centuries moved ever westward, rock art finds were progressively reported from across the continent.

In 1886 the US Bureau of Ethnology published *Pictographs of the North American Indian* by Garrick Mallery, who for the previous ten years had studied the symbolism in Indian visual picture writing. This smallish publication was followed in 1893 by his monumental work, *Picture Writing of the American Indian*, which was partly devoted to rock art. American rock art studies stood dormant until the 1929 publication of *Petroglyphs of California*

*and Adjoining States* by Julian H. Steward. This study encouraged others to undertake detailed regional studies. From then on, amateur researchers and scholars extended the knowledge of individual sites and rock art complexes, an endeavour which continues to this day.

Their discoveries and analyses are described in Klaus P. Wellmann's *A Survey of North American Indian Rock Art* published in 1979, an encyclopaedic work with 900 illustrations and based on more than 1000 references. A landmark general study of North American rock art was Campbell Grant's *Rock Art of the American Indian* published earlier in 1967. Another important work, published in 1980, was Polly Schaafsma's *Indian Rock Art of the Southwest*, a survey of sites of Utah, Arizona, New Mexico, northern Mexico and West Texas.

Rock paintings and rock engravings are also found in other parts of Mexico, as well as in Central and South America and many of the Caribbean islands. The first reports of these sites reached Europe in the first decades of the seventeenth century, and discoveries continued for the next 200 years as Spanish and Portuguese missionaries penetrated the interior of the region. Amongst other subjects, the missionaries came across engravings of human feet. A common enough motif in rock art, the men of God interpreted them as imprints left by the Apostle St Thomas, who they believed had preached on this continent.

From the middle of last century, there have been numerous publications describing the South American rock art, reflecting the increasing interest in the study of this art form. Thousands of sites are known, extending from the Baja California in Mexico to southern Patagonia and Argentina, and from Cuba to the islands of Lesser Antilles. Recent discoveries in Brazil indicate an early date of human colonisation of the Americas and consequently the early commencement of rock art traditions. Here, an archaeological excavation of a painted rock shelter produced a date of 30,000 years for the beginning of its occupancy, while rock fragments with traces of red ochre have been recovered from another site and are dated to 17,000 years ago.

In Thailand, the first rock art site to be discovered in recent times, in 1912, was Khao Kian ('Mountain of Paintings'), in the vicinity of the fishing village of Ko Pannyi. At its base is a shallow cave with naturalistic paintings of animals and geometric designs. Since the discovery of this site, only 168 others have been recorded across Thailand, from the

shelters along the Mekong River in the northeast to Swallow Cave on Ko Phi Phi Island in the Andaman Sea. Perhaps the most important of the recent finds is the rock art site at Khao Plara, 250 kilometres north of Bangkok.

In neighbouring Myanmar (Burma), the first painted cave discovery was made as recently as 1960, in the south-western Shan Highlands. It is now known as the Little Padah-Lin Cave. In 1969 the Rangoon Archaeological Service recorded the art of this cave and investigated the occupational deposits. Stone tools present in the cave's sediments were dated to 11,000 years ago.

Further down the peninsula, in Malaysia, the first report of rock paintings was made in 1879, following the British exploration of the Batu massif limestone caves near Kuala Lumpur. In 1927 the treasures of Gua Badak Cave near Lenggong in Upper Perak were revealed – hundreds of designs executed in black and white pigments. The well known rock shelter in the Kinta Valley near Ipoh was discovered in 1959, but within a short time its paintings were almost totally covered by graffiti and only a few designs, high above human reach, are still identifiable. In Sarawak, rock paintings were found in the famous Niah Cave in 1958, and also in two other caves situated in the same massif. In 1973 the painted Sarang Caves were discovered.

Rock paintings and engravings are also found throughout the chain of islands that form the Indonesian archipelago. The first report came from a Dutch trader, J. Keyts, in 1678 after he found rock paintings on a cliff face in Speelmans Bay, south of the present-day administrative centre of Fakfak in Irian Jaya, the western part of New Guinea. Two centuries later another Dutch trader, T. B. Leon, discovered a large complex of sites in Teluk Berau (MacCluer Gulf). Thirty-seven sites extending along its southern coast were recorded by the Frobenius Institute's expedition of 1937–38. In 1883 paintings in the Liang Lumba cave in Kalimantan were located, and in 1889 those of Little Kai Island were found. Since 1945 rock engravings have been reported from Kalimantan and Alor, and rock paintings from Sulawesi, Flores and Timor. There were also further discoveries of rock art on Kai Island and in Irian Jaya, where rock art sites extend from the Birds Head to Jayapura. The tradition continues eastward through Papua New Guinea, the Solomon Islands and New Zealand, and across the Pacific to Hawaii in the north and to remote Easter Island in the south.

# Acknowledgements

One of the most notable aspects of Aboriginal society is the concept of sharing and reciprocity. Over the past 30 years I have been privileged to know many Aboriginal men and women who accepted me as a friend and gave generously of their time and knowledge. Revisiting rock shelters, in many instances after a considerable period of absence, where as youths they lived with their family groups and friends, they became aware that some of the painted images were of ephemeral nature. On our visits we found that only animals used the shelters, shrubs grew against the painted walls and streams of water had broached the once protective overhangs to flow over, dissolve and wash away the ochreous paintings, the creations of untold generations. It was then that the traditional owners of these sites encouraged the recording of their rock art and traditions, as 'their history' – to be passed on to their children and their descendants. This book was written to fulfil their wish for a record of their art and Dreamings, and as an expression of my appreciation for allowing me as far as possible, to be a bininj, one like themselves, and not just an inquisitive outsider. I have shared in their joys and triumphs, but also in their grief and sadness for the many people and for a way of life that have passed away.

My closest friends and mentors were Kapirigi and Namingum, the two brothers to whom this book is dedicated. They were of the Gundjeihmi-speaking Badmardi clan, but others, representing other language groups from across and around the plateau, also shared their knowledge. They included Madjandi, Namarabundja, Gangele, Ganangu, Yarnmalu, Yorawadj, the Balmanas, Kalinowa, Namadbarra, Lamilami, Winungoyd, Nalowerd, Wilirra, Namilg, the Marlanguras, Djawida, Mandarrk, Balmanidbal, Djorlom, Murrumurru, Midjawmidjawu, Nabardayal, the Wagbaras, Neidjie, Barraway, Djadbula, Kulanjinga and many others. I would also like to thank Dr Colin Jack-Hinton, the former director of the Northern Territory Museum of Arts and Sciences for his continuing support of my research, and to Professor John Mulvaney, Professor Jack Golson and Dr Rhys Jones for their encouragement.

My special thanks go to Pina Giuliani for her meticulous assistance in preparing the manuscript, and to Kim Akerman who read it and made numerous helpful corrections and comments. I would also like to thank Mick Alderson, educated and knowledgeable in 'two ways', who identified many of the faunal species and also advised and commented on the use of 'language' terms, and to Nicholas Evans who corrected the Gundjeihmi language text used in this work.

The book owes its conception and presentation to Helen Grasswill, as editor, and Bruno Grasswill, as the original designer, who worked to their previously proven high standard. Bill Templeman is acknowledged for his support in publishing the book in such a lavish form.

# Select bibliography

Alexander, J. and Coursey, D. G. 1969. The origins of yam cultivation. In P. J. Ucko and G. W. Dimbleby (eds) *The domestication and exploitation of plants and animals*: 405–425. G. Duckworth: London.

Allen, J. and Corris, P. (eds). 1977. *The journal of John Sweatman*. University of Queensland Press: St. Lucia.

Allen, H. 1987. Review of R. Jones (ed.) 1985 Archaeological research in Kakadu National Park. Australian National Parks and Wildlife Service, Special Publication (13), Canberra. *Australian Aboriginal Studies* **2**: 95–97.

Allen, H. and Barton, G. 1989. *Ngarradj Warde Djobkeng: White Cockatoo Dreaming and the prehistory of Kakadu*. Oceania Monograph 37.

Allen, J., Golson, J. and Jones, R. (eds). 1977. *Sunda and Sahul: prehistoric stud ies in Southeast Asia, Melanesia and Australia*. Academic Press: London.

Attenborough, D. 1963. *Quest under Capricorn*. Lutterworth Press: London.

Bednarik, R. G. 1992. Oldest rock art – a revision. *The Artefact* **15**: 30.

Berndt, R. M. 1951a. Ceremonial exchange in Western Arnhem Land. *Southwestern Journal of Anthropology* **7**: 156–176.

Berndt, R. M. and Berndt, C. H. 1951b. *Sexual behaviour in Western Arnhem Land*. Viking Fund Publications in Anthropology No. **16**. The Viking Fund Inc.: New York.

Berndt, R. M. and Berndt, C. H. 1954. *Arnhem Land: its history and its people*. F. W. Cheshire: Melbourne.

Berndt, R. M. and Berndt, C. H. 1970. *Man, land and myth in north Australia: the gunwinggu people*. Ure Smith: Sydney.

Blainey, G. 1975. *Triumph of the nomads: a history of ancient Australia*. Macmillan Company of Australia: South Melbourne.

Bowler, J. M., Hope, G. S., Jennings, J. N., Singh, G. and Walker, D. 1976. Late Quaternary climates of Australia and New Guinea. *Quaternary Research* **6**: 359–394.

Brandl, E. J. 1968. Aboriginal rock designs in beeswax and description of cave painting sites in Western Arnhem Land. *Archaeology and Physical Anthropology in Oceania* **3**(1): 19–29.

Brandl, E. J. 1972. Thylacine designs in Arnhem Land rock paintings. *Archaeology and Physical Anthropology in Oceania* **7**(1): 24–30.

Brandl, E. J. 1973. *Australian Aboriginal paintings in western and central Arnhem Land: temporal sequences and elements of style in Cadell River and Deaf Adder Creek art*. Australian Aboriginal Studies No. 52, Prehistory and Material Culture Series No. 9. Australian Institute of Aboriginal Studies: Canberra.

Brandl, E. J. 1980. Some notes on faunal identification and Arnhem Land rock paintings. *Australian Institute of Aboriginal Sudies Newsletter New Series No.*: **14**: 6–13.

Calaby, J. H. 1976. Some biogeographical factors relevant to the Pleistocene movement of man in Australasia. In: R.L. Kirk and A. G. Thorne (eds) *The origins of the Australians*: 23–28. Human Biology Series No. 6. Australian Institute of Aboriginal Studies: Canberra.

Calaby, J. H. and Lewis, D. J. 1977. The Tasmanian devil in Arnhem Land rock art. *Mankind* **11**(2): 150–151.

Calaby, J. H. and White, C. 1967. The Tasmanian devil (*Sarcophilus harrisi*) in northern Australia in recent times. *Australian Journal of Science* **29**: 473–475.

Carrington, F. 1890. The rivers of the Northern Territory of South Australia. *Proceedings of the Royal Geographical Society of Australasia, South Australian Branch* **2**: 56–76.

Chaloupka, G. 1977. Aspects of the chronology and schematisation of two prehistoric sites on the Arnhem Land Plateau. In: P. J. Ucko (ed.) *Form in indigenous art: shematisation in the art of Aboriginal Australia and prehistoric Europe*. Prehistory and Material Culture Series No. 13: 243–259. Australian Institute of Aboriginal Studies: Canberra.

Chaloupka, G. 1979. Pack-bells on the rock face: Aboriginal paintings of European contact in north-western Arnhem Land. *Aboriginal History* **3**(1–2): 92–95.

Chaloupka, G. 1980a. *Bardmardi year of seasons*. Limited edition paper. Northern Territory Museum, Darwin.

Chaloupka, G. and Kapirigi, N. 1981. *Cultural survey of Yamitj gunerrd*. Report to the Australian National Parks and Wildlife Service. Limited edition manuscript. Museum and Art Galleries of the Northern Territory, Darwin.

Chaloupka, G. 1982. *Burrunguy, Nourlangie Rock*. Northart: Darwin.

Chaloupka, G. 1983a. *Back to my country, Namarrkananga and Guwarrda ngarrdug narrunden Balawurru, I am going home to the Deaf Adder Creek*. A progress report to the Australian National Parks and Wildlife Service. Limited edition manuscript. Northern Territory Museum of Arts and Sciences, Darwin.

Chaloupka, G. 1983b. Kakadu rock art: its cultural, historic and prehistoric significance. In D. Gillespie (ed.) *The rock art sites of Kakadu National Park: some preliminary research findings for their conservation and management*. Special Publication (10): 1–33. Australian National Parks and Wildlife Service: Canberra.

Chaloupka, G. 1984. *From palaeoart to casual paintings: the chronological sequence of Arnhem Land Plateau rock art*. Monograph Series 1, Northern Territory Museum of Arts and Sciences: Darwin.

Chaloupka, G. and Giuliani, P. 1984. *Gundulk abel gundalk: Mayali flora*. Limited edition manuscript. Northern Territory Museum of Arts and Sciences: Darwin.

Chaloupka, G. 1985. Chronological sequence of Arnehm Land Plateau rock art. In: R. Jones (ed.) *Archaeological research in Kakadu National Park*. Special Publication (13): 269–280. Australian National Parks and Wildlife Service: Canberra.

Chaloupka, G., Kapirigi, N., Nayidji, B. and Namingum, G. 1985. *Cultural survey of Balawurru, Deaf Adder Creek, Amarrkananga, Cannon Hill and the Northern Corridor: a report to the Australian National Parks and Wildlife Service*. Limited edition manuscript. Museum and Art Galleries Board of the Northern Territory: Darwin.

Chaloupka, G. 1987. *Arnhem Land Plateau rock art survey 1986, Wellington Range*. Report to the Heritage Branch, Department of Community Development, Northern Territory. Limited edition manuscript. Northern Territory Museum of Arts and Sciences: Darwin.

Chaloupka, G. 1988. *Arnhem Land Plateau rock art survey, 1987, northern sector*. Report to the Heritage Branch, Department of Community Development, Northern Territory. Limited edition manuscript. Northern Territory Museum of Arts and Sciences: Darwin.

Chaloupka, G. 1989. *Groote Eylandt archipelago rock art survey 1988*. Report to the Heritage Branch, Conservation Commission of the Northern Territory. Limited edition manuscript. Northern Territory Museum of Arts and Sciences: Darwin.

Chaloupka, G. 1990. *Rock art of Teluk Berau and Maimai, Irian Jaya*. Limited edition manuscript. Northern Territory Museum of Arts and Sciences: Darwin.

Chaloupka, G. 1991. *Rock art survey 1990, Arnhem Land Plateau – southern margins*. Report to the Heritage Branch, Conservation Commission of the Northern Territory. Limited edition manuscript. Northern Territory Museum of Arts and Sciences: Darwin.

Chaloupka, G. 1992. *Rock art survey, Arnhem Land Plateau, central region*. Report to the Heritage Branch, Conservation Commission of the Northern Territory. Limited edition manuscript. Northern Territory Museum of Arts and Sciences: Darwin.

Chappell, J. M. A. 1976. Aspects of late Quaternary palaeogeography of the Australian – east Indonesian region. In R. L. Kirk and A. G. Thorne (eds) *The Origin of the Australians*: 11–22. Human Biology Series No. 6. Australian Institute of Aboriginal Studies: Canberra.

Coursey, D. G. 1972. The civilizations of the yam: interrelationships of man and yams in Africa and the Inda-Pacific region. *Archaeology and Physical Anthropology in Oceania* **7**(3): 215–233.

Crawford, I. M. 1968. *The art of the Wandjina*. Oxford University Press: Melbourne.

Crawford, I. M. 1977. The relationship of Bradshaw and Wandjina art in north-west Kimberley. In P. J. Ucko (ed.) *Form in indigenous art: shematisation in the art of Aboriginal Australia and prehistoric Europe*. Prehistory and Material Culture Series No. 13: 357–369. Australian Institute of Aboriginal Studies: Canberra.

Dashwood, C. J. 1897. Government Resident report on the Northern Territory. *Parliamentary Papers of SA*. **24**: 8.

Edwards, R. 1979. *Australian Aboriginal art: the art of the Alligator Rivers region, Northern Territory*. Australian Institute of Aboriginal Studies: Canberra.

Elkin, A. P., Berndt, R. M. and Berndt, C. H. 1950. *Art in Arnhem Land*. Cheshire: Melbourne.

Elkin, A. P., 1952. Cave paintings in southern Arnhem Land. *Oceania* **22**(4): 245–255.

Flinders, M. 1814. *A voyage to Terra Australia*. 2 Vols. G. & W. Nicol: London.

Galloway, R. W. 1976. Geology of the Alligator Rivers area. In R. Story *et al.* (eds) Lands of the Alligator Rivers area, Northern Territory. *Land Research Series* **38**: 50–51. Commonwealth Scientific and Industrial Research Organisation: Melbourne.

Gillespie, D. 1982. The artist as scientist. In P. Cooke and J. Altman (eds) *Aboriginal art at the top*: 17–20. Maningrida Arts and Crafts: Maningrida.

Gollan, K. 1980. *Prehistoric dingo*. Unpublished PhD thesis. Australian National University: Canberra.

Golson, J. 1971. Australian Aboriginal food plants: some ecological and culture-historical implications. In D.J. Mulvaney and J. Golson (eds) *Aboriginal man and environment in Australia:* 196–238. Australian National University Press: Canberra.

Golson, J. 1972. The remarkable history of Inda-Pacific man: missing chapters from every world prehistory. *The Journal of Pacific History* **7**: 5–25.

Grant, C. 1983. *The rock art of the North American Indians*. The Imprint of Man Series. Cambridge University Press: Cambridge.

Haskovec, I. P. and Sullivan, H. 1989. Reflections and rejections of an Aboriginal artist. In H. Morphy (ed.) *Animals into art. One world archaeology* **7**: 57–74. Unwin Hyman: London.

Haudricourt, A.G. 1964. Nature et culture dans la civilization de l'igname: l'origine des clones et des clans. *L'Homme* **4**: 93–104.

Hiatt, L. R. 1975. Swallowing and regurgitation in Australian myth and rite. In L. R. Hiatt (ed.) *Australian Aboriginal mythology*: *essays in honour of W. E. H. Stanner:* 143–162. Australian Institute of Aboriginal Studies: Canberra.

Hope, G., Hughes, P. J. and Russell-Smith, J. 1985. Geomorphological fieldwork and the evolution of the landscape of Kakadu National Park. In R. Jones (ed.) *Archaeological research in Kakadu National Park*. Special Publication (13): 229–240. Australian National Parks and Wildlife Service: Canberra.

Jiang, Z. 1991. *Timeless history, the rock art of China*. New World Press: Beijing.

Jones, R. and Bowler, J. 1980. Struggle for the savannah: northern Australia in ecological and prehistoric perspective. In R. Jones (ed.) *Northern Australia*: options and implications: 3–31. Research School of Pacific Studies, Australian National University: Canberra.

Jones, R. 1985. Archaeological conclusions. In R. Jones (ed.) *Archaeological research in Kakadu National Park*. Special Publication (13): 291–298. Australian National Parks and Wildlife Service: Canberra.

Jones, R. and Johnson, I. 1985. Deaf Adder Gorge: Lindner site, Nauwalabilal. In R. Jones (ed.) *Archaeological research in Kakadu National Park*. Special Publication (13): 165–227. Australian National Parks and Wildlife Service: Canberra.

Kamminga, J. and Allen, H. 1973. *Report of the archaeological survey*. Alligator Rivers Region Environmental Fact-Finding Study. Government Printer: Canberra.

Kusch, H. 1986. Rock art discoveries in Southeast Asia: a historical summary. *Bollettino del Centro Camuno di Studi Preistorici* **23**: 99–108.

Leichhardt, L. 1847. *Journal of an overland expedition in Australia, from Moreton Bay to Port Essington, a distance of upwards of 3000 miles, during the years 1844–1845*. T. and W. Boone: London.

Leubbers, R. A. 1975. Ancient boomerangs discovered in South Australia. *Nature* **253**: 39.

Macintosh, N. W. G. 1951. Archaeology of Tandandjal cave, south-west Arnhem Land. *Oceania* **21**(3): 178–204.

Macintosh, N. W. G. 1952. Paintings in Beswick Creek cave, Northern Territory. *Oceania* **22**(4): 256–274.

Macknight, C. C. 1976. *The voyage to Marege: Macassan trepangers in northern Australia*. Melbourne University Press: Carlton.

Maddock, K. J. 1970. Imagery and social structure at two Dalabon rock art sites. *Anthropological Forum* **2**(4): 444–463.

Maddock, K. 1978a. Introduction. In: I. R. Buchler and K. Maddock (eds) *The Rainbow Serpent:* 1–21. Mouton: The Hague.

Maddock, K. 1978b. Metaphysics in a mythical view of the world. In I. R. Buchler and K. Maddock (eds) *The Rainbow Serpent*: 99–118. Mouton: The Hague.

McCarthy, F. D. 1960. The cave paintings of Groote Eylandt and Chasm Island. In C.P. Mountford (ed.) *Records of the American-Australian scientific expedition to Arnhem Land*, Vol. 2: 297–414. Melbourne University Press: Parkville.

McCarthy, F. D. and Setzler, F. M. 1960. The archaeology of Arnhem Land. In C. P. Mountford (ed.) *Records of the American-Australian scientific expedition to Arnhem Land*. Vol. 2: 215–295. Melbourne University Press: Parkville.

Mountford, C. P. 1949. *Australia*: *Aboriginal paintings – Arnhem Land*. United Nations Educational Scientific and Cultural Organization, World Art Series Vol. 3. New York Graphic Society: New York.

Mountford, C. P. 1956. *Art, myth and symbolism. Records of the American-Australian scientific expedition to Arnhem Land*, Vol. 1. Melbourne University Press: Carlton.

Mountford, C. P. 1958a. Aboriginal cave paintings at Sleisbeck, Northern Australia. *South Australia Museum Records* **13**(2): 147–155.

Mountford, C. P. 1958b. *The Tiwi, their art, myth and ceremony*. Phoenix House: London.

Mulvaney, D. J. 1975. *The prehistory of Australia*. Penguin Books Australia: Ringwood.

Murray, P. F. 1 978. Late Cenozoic monotreme anteaters. *The Australian Zoologist* **20**(1): 29–55.

Murray, P. and Chaloupka, G. 1984. The Dreamtime animals: extinct megafauna in Arnhem Land rock art. *Archaeology in Oceania* **19**: 105–116.

Nix, H. A. and Kalma, J. D. 1972. Climate as dominant control in the biogeography of northern Australia and New Guinea. In D. Walker (ed.) *Bridge and barrier: the natural and cultural history of Torres Strait*: 61–91. Department of Biogeography and Geomorphology Publication BG/3, Research School of Pacific Studies. Australian National University: Canberra.

Roberts, R., Jones, R. & Smith, M. 1990. Thermoluminescence dating of 50,000 year old occupation site in northern Australia, *Nature* 345 (6271): 152–6.

Röder, J. 1959. *Felsbilder und Vorgeschichte des MacCluer – Golfes West NeuGuinea*. L.G. Wittich Verlag: Darmstadt.

Schrire, C. 1982. The Alligator Rivers: prehistory and ecology in western Arnhem Land. *Terra Australis* 7. Department of Prehistory, Research School of Pacific Studies. Australian National University: Canberra.

Schulz, A. S. 1971. *Felsbilder in Nord Australien*. Franz Verlag: Weisbaden.

Smith, B. 1979. *Mexico, a history in art*. Gemini Smith Inc.: Brattleboro.

Spencer, B. 1914. *Native tribes of the Northern Territory of Australia*. Macmillan and Co.: London.

Spencer, B. 1928. *Wanderings in wild Australia*. Two volumes. Macmillan and Co.: London.

Stewart, A. 1969. *The green eyes are buffaloes*. Lansdowne: Melbourne.

Tresize, P. 1971. *Rock art of south-east Cape York*. Australian Institute of Aboriginal Studies: Canberra.

Ucko, P. J. and Rosenfeld, A. 1967. *Palaeolithic cave art*. World University Library Series. Weidenfeld and Nicolson: London.

Urry, J. 1978. Old questions: New answers? Some thoughts on the origin and antiquity of man in Australia. *Aboriginal History* **2**(1–2): 149–166.

Walsh, G. L. 1988. *Australia's greatest rock art*. E.J. Brill/ Robert Brown and Associates (Aust.): Bathurst.

Watchman, A. L. 1979. Summary and interpretation of petrological, geochemical and mineralogical studies. In P.J. Hughes, A. L. Watchman and D. Gillespie (eds) *The deterioration, conservation and management of rock art sites in the Kakadu National Park, N.T.* Department of Prehistory, Research School of Pacific Studies, Australian National University: Canberra.

Watchman, A. L. 1982. *Chemistry, mineralogy, and petrology of rock samples from Aboriginal rock art sites in the Kakadu National Park, N.T.* Report to Australian National Parks and Wildlife Service: Canberra.

Watchman, A. 1985. Mineralogical analysis of silica skins covering rock art. In R. Jones (ed.) *Archaeological research in Kakadu National Park*. Special Publication (13): 281–289. Australian National Parks and Wildlife Service: Canberra.

Watchman, A. 1987. Preliminary determinations of the age and composition of mineral salts on rock art surfaces in the Kakadu National Park. In W.R. Ambrose and J.M.J. Mummery (eds) *Archaeometry: further Australasian studies*: 36–42. Department of Prehistory, Research School of Pacific Studies, Australian National University: Canberra.

Welch, D. 1982. *Aboriginal rock art of Kakadu National Park, Northern Territory of Australia*. Big Country Picture Co.: Darwin.

White, C. 1967a. *Plateau and plain: prehistoric investigations in Arnhem Land, Northern Territory*. Unpublished PhD thesis. Australian National University: Canberra.

White C. 1967b. The prehistory of the Kakadu people. *Mankind* **6**(9): 426–431.

White, C. 1967c. Early stone axes in Arnhem Land. *Antiquity* **41**(162): 149–152.

White, C. and Peterson, N. 1969. Ethnographic interpretations of the prehistory of Western Arnhem Land. *Southwestern Journal of Anthropology* **25**(1): 45–67.

White, C. 1971. Man and environment in northwest Arnhem Land. In D. J. Mulvaney and J. Golson (eds) *Aboriginal man and environment in Australia*: 141–157. Australian National University Press: Canberra.

Woodroffe, C. D., Chappell, J., Thom, B. G. and Wallensky, E. 1986. *Geomorphological dynamics and evolution of the South Alligator tidal river and plains, Northern Territory*. Australian National University, North Australian Research Unit, Mangrove Monograph No. 3: Canberra.

Woodroffe, C. D., Thom, B. G., Chappell, J., Wallensky, E., Grindrod, J. and Head, J. 1987. Relative sea level in the South Alligator River region, North Australia, during the Holocene. *Search* **18**(2): 92–94.

# Index

Numbers in **bold** indicate a picture or a drawing

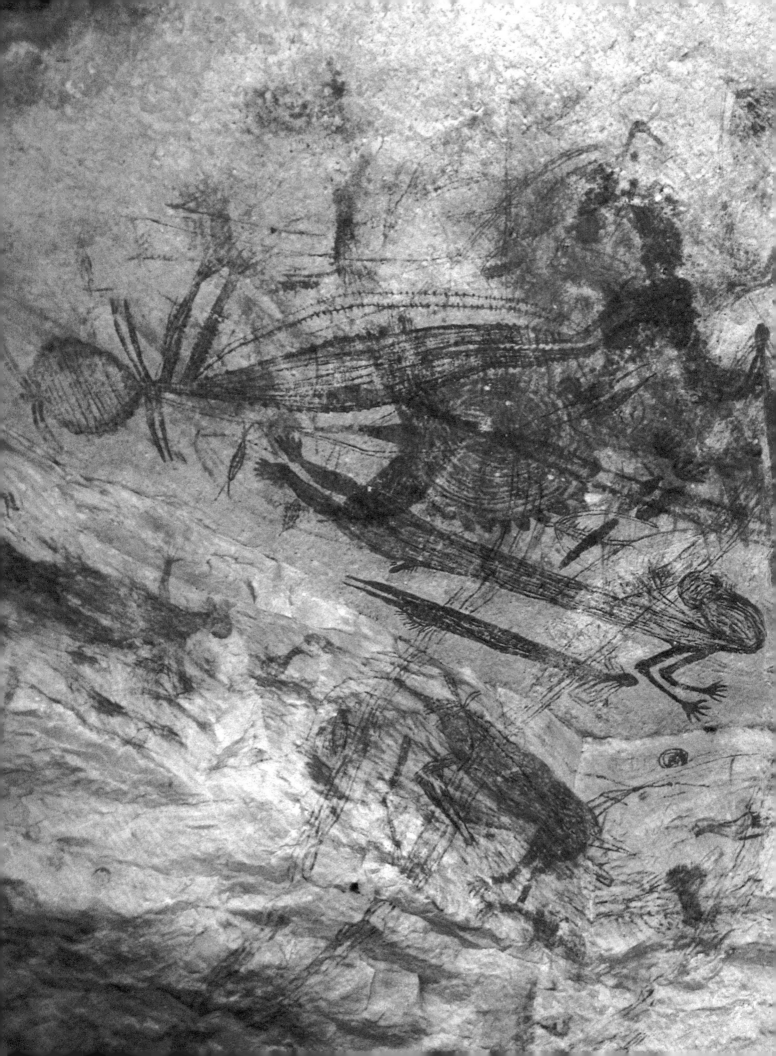